European Design
Since 1985

Shaping the New Century

European Design
Since 1985

Shaping the New Century

R. Craig Miller
Penny Sparke
Catherine McDermott

 DENVER ART MUSEUM

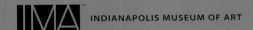 INDIANAPOLIS MUSEUM OF ART

MERRELL
LONDON · NEW YORK

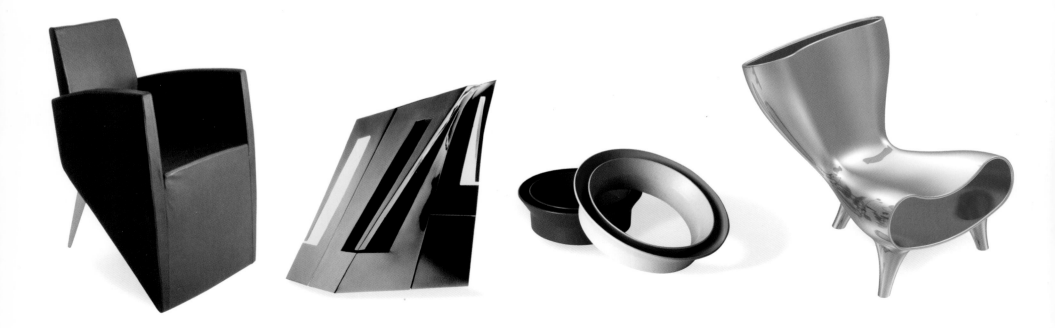

Foreword

Lewis I. Sharp Maxwell L. Anderson

hen many American museums were founded in the last quarter of the nineteenth century, they initiated active and multifaceted design programs since they were often closely affiliated with art schools that were training practicing designers. This was an arrangement that, in many cases, continued well into the first half of the twentieth century. With the transition into a new century, a number of American museums, including the Denver Art Museum (DAM) and the Indianapolis Museum of Art (IMA), began to look at that cogent tradition from a fresh perspective. Such museums would not only build important modern design arts collections but also develop innovative exhibition, publication, and education programs to help professionals and museum visitors understand important developments in contemporary design, one of the most dynamic fields in the art world today.

Extending this legacy, *European Design Since 1985: Shaping the New Century* is the third in a series of contemporary design exhibitions organized since the early 1990s by R. Craig Miller, an American design historian and curator. *Masterworks: Italian Design, 1960–1994* (1994–98) was one of the first shows organized by an American museum to document the simultaneous development of Modernist and Postmodernist design in Italy. Likewise, **US**Design 1975–2000 (2002–04) was the first critical examination of American architecture, decorative and industrial design, and graphic design from the last quarter of the twentieth century. Both of these exhibitions were organized by the DAM and traveled widely in North America. Building on these two influential precedents, *European Design Since 1985* examines the remarkable developments in Western European design over a period of some two decades. A collaboration between the DAM and the IMA, the project was begun in 2002. The Denver Art Museum has generously supported the research for the catalog and exhibition over the last six years. With Mr. Miller's move to the Indianapolis Museum of Art in 2007, the IMA assumed responsibility for the organization and tour of the show. The extraordinary collaboration between these two institutions has made it possible for the exhibition, with an accompanying publication, to open in March, 2009, at the IMA, followed by a national tour.

A host of people deserve special thanks. Two colleagues at Kingston University in London, Penny Sparke and Catherine McDermott, have worked closely with Craig Miller in developing the exhibition and catalog. Professor Sparke's essay for the publication provides an insightful preamble, succinctly outlining the major developments in European design from 1945 to 1985. Professor McDermott's chapter documents the European *Zeitgeist* from 1985 to the present, providing a larger cultural and social perspective from which to judge contemporary design. Such ambitious undertakings require extensive long-range planning, and David Hanks of David A. Hanks & Associates in New York has been invaluable in the organization of this project. Likewise, Julian Honer, Editorial Director at Merrell Publishers in London, has been unwavering in his support of the accompanying catalog over the last six years.

Given the scale of this project, there is, of course, an enormous number of individuals, institutions, manufacturers, and government agencies—noted all too briefly in the laconic acknowledgments—that deserve a special thanks, not to mention the lenders, financial sponsors, and museum venues that have made *European Design Since 1985* a reality. The exceptional staffs of the Denver Art Museum and the Indianapolis Museum of Art have worked tirelessly to make this collaboration an extraordinary success. To all of these remarkable people, we extend a profound thank you.

Lewis I. Sharp
Frederick and Jan Mayer Director
Denver Art Museum

April, 2008

Maxwell L. Anderson
The Melvin & Bren Simon Director
 and CEO
Indianapolis Museum of Art

Introduction

R. Craig Miller

A groundbreaking undertaking, *European Design Since 1985: Shaping the New Century* represents one of the first extensive and critical surveys of contemporary Western European design. This ambitious project was originated by the Indianapolis Museum of Art and the Denver Art Museum in the United States, in conjunction with Kingston University in the United Kingdom, and has entailed some six years of research and writing.

In examining different aspects of the complex development of European design since 1985, this innovative publication presents three incisive essays. Penny Sparke's section serves as a "preamble," providing a concise introduction to, and summary of, the major figures, movements, and cultural forces that have shaped European design from the end of the Second World War to 1985—in short, the formative years for many of the designers featured in *European Design*. Catherine McDermott's essay presents an overview of the European *Zeitgeist* from 1985 to 2005, to provide some perspective on the complex forces that have helped to shape European design during these two decades. Lastly, my essay defines the major conceptual and aesthetic movements that have transcended national boundaries; and it elucidates many of the quintessential designers and objects of the period in question. I have not attempted, in any manner, to offer overviews of developments in each country or surveys of individual designers' careers. Rather, the larger goal has been to document and define—from a number of perspectives—the driving, central role that Europe has played in design internationally since the mid-1980s.

Given the vast scope of this ambitious undertaking, the team—from the beginning—had to set very clear parameters for the project. These guidelines are concisely outlined below.

Geographical parameters

Geographically, we have chosen to look at the Western Europe that was created in 1946 following the end of the Second World War, an entity that remained largely intact until the dramatic expansion of the European Union (EU) in 2004, with the accession of much of Eastern Europe. Thus our research has focused primarily on some fifteen countries: Austria, Belgium, Denmark, Finland, France, Germany, Iceland, Italy, The Netherlands, Norway, Portugal, Spain, Sweden, Switzerland, and the United Kingdom. A central issue was how to define what constitutes a "European designer." One of the most significant developments since 1985, with the growth of the EU, has been the dissolution of national boundaries. Designers now routinely study, work, live, and teach in multiple countries. Consequently, we have defined a European designer as someone—regardless of his or her country of birth—who lives and works primarily in Western Europe.

Chronological parameters

In terms of a time frame, we have chosen to focus on two decades, spanning from 1985 to 2005. The mid-1980s, in no small part, marked a decisive break in European design. It was a moment that saw the dissolution of such earlier design groups as Memphis, the immensely influential leader of Postmodernism in Italy and beyond; but it was also a time that witnessed the emergence of a new generation of designers who would ultimately take European design in decisive new directions. We have chosen 2004/05 as a coda because, as noted earlier, it was at this point that a new, vastly expanded Europe emerged on to the world scene.

Generational parameters

Within the scope of our study, we have chosen to examine the careers of two generations of designers. The oldest group includes those individuals—such as Ron Arad, Jasper Morrison, Philippe Starck, and Maarten Van Severen—who were born after 1946 and who began to emerge as major international leaders in the mid-1980s. The second generation encompasses younger designers—including Tord Boontje, Erwan and Ronan Bouroullec, Konstantin Grcic, and Studio Job—who were largely born after 1965 and who began to attract attention in the late 1990s and early 2000s. There were, of course, more senior figures, such as Achille Castiglioni and Ettore Sottsass, whose careers began at mid-century and extended into our time frame; these designers have been presented in Sparke's essay, since they were central figures in shaping earlier design movements. There is also a third, nascent generation emerging in Europe; at this moment in time, however, their careers are still very much in a formative stage.

Media parameters

Our research has focused primarily on decorative and industrial design, although many designers, as we shall see, have sought to create new definitions of craft in relationship to the larger design arts field. The range of media is broad and includes furniture, glass, ceramics, metalwork, and a wide array of product design.

Conceptual and aesthetic parameters

In our multicultural age, it is of course possible to examine design from a multitude of perspectives, all of which are worthy of merit. But to give some structure to such a groundbreaking survey as this, it has been necessary to be circumspect in order to find balance and yet maintain diversity. Thus Sparke and McDermott have been more expansive, assiduously examining political, social, cultural, and economic issues. As a museum curator, I have looked at design from more of an aesthetic perspective, in which objects are judged not only by conceptual, technological, or functional criteria but also by whether the designer consciously sought to impart some poetic or artistic aspect to his or her work.

Given that *European Design* is one of the first surveys of contemporary design in Western Europe, we are cognizant of the challenges posed by such an undertaking. Thus, in many respects, this publication should be regarded as an "introduction" to an immensely complicated subject. Of necessity, we have been able to choose only a small cross-section of contemporary European design from a vast creative field. Moreover, we are keenly aware that we are examining developments very close in time. We believe, however, that the perspective offered by the larger time frame of several decades—versus the shorter overviews provided by biennales or triennales—has presented an opportunity to readily identify many of the major movements, designers, and quintessential objects that will ultimately be judged as characterizing the best in European design in the pivotal decades since 1985.

We extend our deepest thanks to our many colleagues—curators, professors, manufacturers, government officials, and critics—who have given so generously of their time and knowledge. It is, however, to the many remarkable designers—who face the daunting challenge of creating every day—that we dedicate this book. As artists, you forge our culture and, most importantly, bring joy to our daily lives in myriad ways, through your designs.

R. Craig Miller
Curator of Design Arts
Indianapolis Museum of Art

Note on dimensions
Unless stated otherwise, the dimensions in the captions indicate height followed by width followed by depth.

Tord Boontje
Dutch (b. 1968), resides France
Garland Hanging Light (detail), 2002
Steel
Mfr: Artecnica
10 × 10 × 10 in.
(25.4 × 25.4 × 25.4 cm)

Design in Europe 1945–1985

Penny Sparke

The four decades following the end of the Second World War saw the emergence and development of a remarkable design culture in Europe that profoundly affected the lives of many of its citizens on a daily basis—economically, socially, politically, culturally, and technically. By the early 1960s, an abundance of high-quality designed products flowed from the factories and filled the shops of many countries in Europe. Two decades later, the ubiquitous presence of design and designers in the glossy press, on television, in permanent museum collections, and at exhibitions and trade fairs marked the dramatic spread of that design culture. Such designers as the Frenchman Philippe Starck, and such design-led companies as Italy's Alessi (established in 1921), had, by the mid-1980s, become household names, and "designer goods" were available to almost everyone who wanted them.

Back in 1945, the picture had been very different. Europe had suffered the devastating effects of a traumatic war, which had caused a major rupture in its development. The period of the Cold War followed immediately afterward, in which Europe occupied a middle ground between the United States and the Soviet Union—between, that is, a future governed by liberal democracy or by Communism. It was against this backdrop that many of the countries of Europe developed their modern design movements, partly for economic reasons linked to reconstruction, but also as a means of establishing for themselves new political, social, cultural, and technical identities and agendas. A first priority of many countries, however, was to house their populations and to re-establish trade activities. Germany, divided in 1949, and Italy had the additional problem of ridding themselves of the spectre of fascism. All of these challenges were partially met by a focus on design and indeed acted as stimuli for a renaissance in that area, which was to bear significant fruit.

That is not to say that Europe acted as a single unit. Divided geographically, by religious and cultural differences, and by language, Europe in 1945 was still a grouping of highly disparate and individualistic nation states, all of which protected their boundaries very carefully. The new map of Europe drawn up in 1945 created an East–West divide that quickly became a defining feature of that continent, and which was to remain in place until the late 1980s. Already by the 1950s, however, a level of European integration was occurring through the membership of Belgium, France, Germany, Italy, Luxembourg, and The Netherlands in trade agreements, which, by 1957, were to result in the formation of the Common Market. Nor was Europe an isolated unit. Its relationship with the US was crucial in these years, especially in the re-establishment of manufacturing and trade. The Marshall Plan, initiated in 1947, involved the US pouring large amounts of financial aid into Western Europe in order to strengthen its industrial sector and to create a barrier against the Eastern bloc. It was to remain in place during the Cold War years and beyond, and played a key role in the reconstruction of Europe in those years.[1] The US not only got the wheels of industry moving, however; they also provided a model of a "consumer society," which found its way across the Atlantic to become another *force majeur* in the formation of Europe's post-war design culture from the late 1950s onward.

The legacy of Modernism

There was a need in 1945, above all, to find an appropriate philosophical and ideological framework for design that would enable it to confront the complex challenges faced by European countries at that time. A revival of the unfinished program of inter-war Modernism—in 1933, Adolf Hitler had closed the Bauhaus, the hothouse of Modernist design pedagogy and activity—provided the way forward, and many European countries embraced and implemented its principles enthusiastically, albeit with national variants that reflected their individual circumstances, contexts, and characters. Modernism's emphasis on design as a democratizing agent, as an adjunct of industrial mass production, and as a rational force that sought to improve everyone's standard of living had everything to offer the challenges of reconstruction in these years. Ernesto Rogers, an Italian architect–designer and editor of Italy's leading architectural and design magazine, *Domus*, which had been established in 1928 but which had experienced a hiatus during the war years, perhaps expressed it best when he wrote that "It is a question of forming a taste, a technique, a morality, all terms of the same function. It is a question of building a society."[2]

Not all the countries of Europe embraced the Modernist program at the same time, however. While some—the United Kingdom, Germany, Italy, and the Scandinavian countries in particular—were quick off the mark, others, including France and Spain, were slower to respond, the former because it remained committed to its longstanding involvement with craft-based, luxury production, and the latter because, until General Franco died in 1975, it was under fascist rule. The individual circumstances of the countries that were ready to move forward in the 1940s were, however, very varied in nature. While many of the strategies they adopted were similar, their interpretations of the Modernist message were multiple.

Italy's special challenge was to align itself with a model of Modernism sufficiently removed from that which had been embraced by Mussolini's

fascist regime in the inter-war years. Modernism had not been totally rejected in fascist Italy, as it had in Germany, and therefore the movement in Italy after 1945 had to take on a new face if it was to communicate effectively the message of the new, democratically elected republic. It resolved this dilemma by opting for a model that had a strong fine-art component, thereby creating a "new look" for the material culture of the post-1945 era. That "new look" was visible by the late 1940s and early 1950s. It manifested itself in what became known as the "Italian line," a new, organic aesthetic visible in a range of furniture and product designs.

Immediately after the war, Italy was governed by the Communist Party, but in 1947 the Christian Democrats took over and introduced a liberal regime that encouraged people to consume and to improve their quality of life through the acquisition of modern goods. Best known of the new Italian "lifestyle" products was perhaps Corradino D'Ascanio's *Vespa* motor-scooter, designed for the Piaggio company and launched in 1946. Italy in the 1940s saw many migrant workers move from the south of the country to work in northern factories. At first, many of them could afford only a bicycle for transportation. The *Vespa* was a bicycle replacement. It also provided women with a means of carrying their shopping. This little "wasp," a symbol of Italy's new democracy, and a replacement for the ubiquitous bicycle, "buzzed" through the backstreets of Italy's ancient cities. Its curved, streamlined metal forms concealed the mechanisms beneath, offering a striking image of modernity. Like Henry Ford's *Model T*, the *Vespa* was a standardized product available to all, but, unlike that highly utilitarian object, the *Vespa* offered a visual and material representation of a new democracy.

A range of other popular artifacts, among them Gio Ponti's shiny, chromed coffee machine for La Pavoni, which graced the surfaces of numerous coffee bars in these years, and Marcello Nizzoli's sculpted *Lexicon 80* typewriter for Olivetti, were joined by the "streamlined surreal" furniture forms created by Carlo Mollino, and Battista Pininfarina's elegant *Cisitalia* automobile of 1946. These objects combined American streamlining with the curves of contemporary European avant-garde organic sculpture to offer a new aesthetic of modernity to post-war Italian consumers.

The 1950s saw the development of a significant infrastructure to support the developing Italian design movement. The Milan Triennales, established in the 1920s, were revived; those of 1951, 1954, and 1957 acted as shop windows to the rest of the world, showing it the sophisticated achievements of Italian design. The Triennale of 1951 (fig. 1) was the ninth of its kind. The Italian exhibits were housed in a dramatic setting, created by the architects Lodovico Barbiano di Belgiojoso and Enrico Peressutti (the founders of the

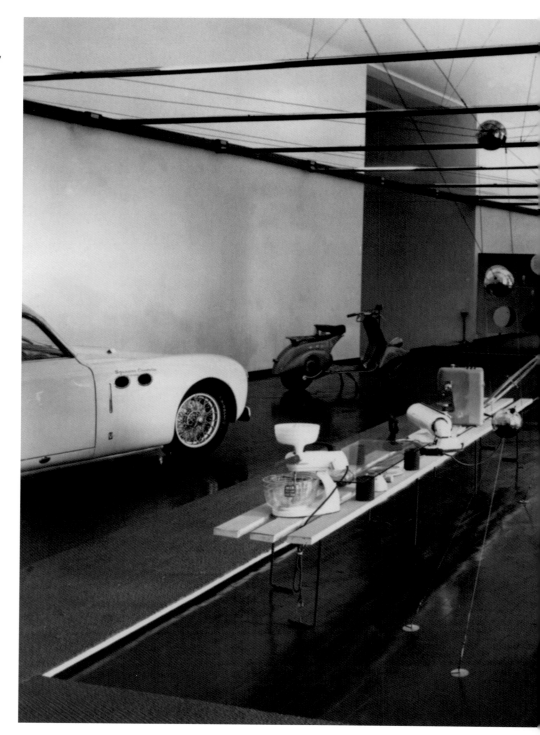

1
Italian exhibits at the ninth Milan Triennale—held in 1951—in a section entitled *The Form of the Useful*. The sculptural setting for the many striking products on display was created by architects Lodovico Barbiano di Belgiojoso and Enrico Peressutti of the firm BBPR.

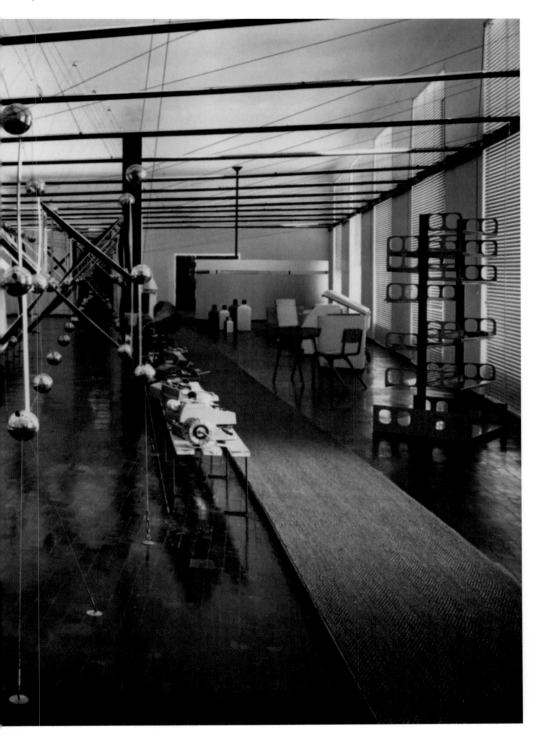

architectural firm BBPR, established in 1932), that contained within it a large piece of hanging, organic sculpture and balls suspended by thin wires suggesting atoms in space. An interest in atomic forms was also visible at London's Festival of Britain in the same year. It marked a popular commitment to science as the way forward, which was mirrored by the "space race" of the 1950s. The Soviet Union's launch of the first man-made space satellite, *Sputnik 1*, in 1957 received huge media attention and fed the general enthusiasm for all things scientific and technical. Olivetti's *Lettera 80* was included in the Triennale of 1951, as was the *Lettera 22*, a later Nizzoli design of the early 1950s, which was more compact and less bulbous in form. The *Vespa* was also there, as were lights by the Castiglioni brothers (Livio, Pier Giacomo, and Achille) and digital clocks by Gino Valle for Ritz Italora. Above all, the display demonstrated the progressiveness of Italian design at that time and its emphasis on the aesthetic of its products. The section was named *The Form of the Useful* to highlight the aesthetic preoccupations of Italy's designers. In 1954, a similar section was given the title *The Production of Art*, rendering that intention even more explicit.

The importance of Italy showcasing its products at the Triennales in these years, and of those exhibitions also becoming shop windows for products from European designers from a range of countries, was reinforced by Italy's strategic use of the press in positioning itself as an international design leader. *Domus* was joined by a number of other publications that headlined design, among them *Abitare* (founded in 1962), *Ottagono* (founded in 1966), and the short-lived *Stile Industria* (founded in 1954). The last, which was in existence only until 1962, contained sophisticated images of designed goods that could transform as mundane an object as a plastic bucket into a work of art.[3]

Importantly, Italy's achievements were the result not of government intervention but rather of a combination of the enlightened approach of its manufacturing industries—both large- and small-scale—toward employing designers, and the far-sightedness of a generation of architect–designers who had been trained in the Modernist tradition and who saw an opportunity in the post-war era to work across a range of projects, from architecture to interior design, furniture, and product design. This combination coincided with Italy's desire to renew its national image within the international marketplace, and to build a new democracy and create new standards of living for everybody. Italy's membership of the European Union from the mid-1950s meant that it could trade with other European countries without paying custom duties. As a result, Italian goods became increasingly visible, and were admired, in a number of those countries. Italy's goods provided a benchmark of design quality to which many European nations aspired

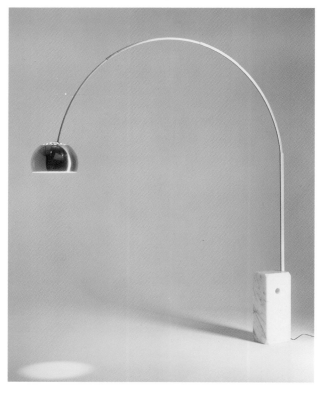

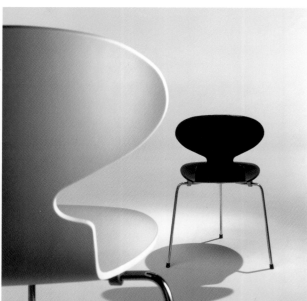

2 ←
Achille Castiglioni
Italian (1918–2002)
Pier Giacomo Castiglioni
Italian (1913–1968)
Arco Floor Lamp, 1962
Marble and steel
Mfr: FLOS S.p.A.
95⅛ × 84 × 12¼ in.
(241.6 × 213.4 × 31 cm)

3 ↙
Arne Jacobsen
Danish (1902–1971)
The Ant (Model 3100)
Chair, 1952
Wood, steel and rubber
Mfr: Fritz Hansen
30 × 19 × 19 in.
(77 × 48 × 48 cm)

4 ↘
Sony Corporation
Japanese (founded 1946)
TR-55 Transistor Radio, 1955
ABS plastic
Mfr: Sony Corporation
3½ × 5½ × 1½ in.
(9 × 14 × 3.8 cm)

through the 1950s and 1960s, as well as a model of post-war reconstruction at national level, in which successes in the area of design led to increased wealth and improved lifestyles.

By the late 1950s and 1960s, Italian designers had experimented widely with new materials—plastics in particular—and had created countless examples of innovative design, all of which contributed to the new lifestyle of modern luxury—the "good life"—that was being promulgated by the glossy magazines. Achille and Pier Giacomo Castiglioni's *Arco* lamp (fig. 2), a huge steel arch that, from its heavy marble base, hovered over an entire living room, became an international marker of modern living. It combined functionality with a strong sculptural presence and was at home in "chic" environments that also featured leather sofas, white rugs, and smoked-glass coffee-tables.

The Scandinavian countries were also quick to recognize the political, social, economic, and cultural importance of design in the years after 1945. Sweden had been largely unaffected by the war and had succeeded in maintaining a level of continuity with its pre-war traditions. Most importantly, the Scandinavians had focused on a socially oriented, democratic approach toward design, linked to their longstanding craft traditions. Rooted in the nineteenth century, which, in 1845, had seen the formation of the influential Svenska Sjlödforeningen (Swedish Design Society), Sweden's craft-based approach toward design had developed through the first half of the twentieth century. It manifested itself in innovative work produced by, among others, the Orrefors glassworks, established by the designers Edvard Hald and Simon Gate; by the ceramics firm Gustavsberg; and by the furniture designer Bruno Mathsson. The post-war years saw an intensification and an internationalization of this work, while the democratic program of Sweden's inter-war architects developed into a highly rational movement that sought to measure people's living spaces and create minimum standards. Sweden's main contribution was its humanized approach to Modernism, which emphasized the use of natural materials and the inclusion of modern decorative objects in living spaces.

In the years after 1945, Denmark also valued the use of natural materials in its designed goods. Like Sweden, it developed a craft-based approach, which manifested itself in strikingly modern designs for ceramics, glass, textiles, metalwork, and furniture. By the 1940s, a very strong modern Danish furniture movement had emerged, which lasted through to the 1960s and 1970s. A generation of designer–craftsmen—among them Hans Wegner, Borge Mogensen, and Finn Juhl—was joined by the architects Arne Jacobsen and Poul Kjaerholm. The collective work of this group of men made a huge impact internationally. They offered a softer, more tradition-oriented version of modern design than that of their Italian counterparts, which proved hugely successful.

Classic designs from this period included Wegner's famous *Armchair* of 1949, now known simply as *The Chair*. Its gently curved, solid-wood back, in combination with its elegantly tapered legs and simple rattan seat, offered a model of craftsmanship to a generation who wanted to combine tradition with modernity in their homes. By the 1950s, that innate sense of craftsmanship was combined in a number of classic Danish designs produced with modern manufacturing techniques. They included Jacobsen's little *Ant* chair of 1952 (fig. 3), an exercise in bent plywood and steel rod, which owed something to the Americans Charles and Ray Eames and their experiments with the same materials a few years earlier. Jacobsen's chair took modern Danish design to a new level that combined the country's existing craft traditions with a new, internationally oriented marketing approach and an architectural attitude toward furniture design. The elegant designs by Kjaerholm of the 1950s operated in that same new context and made a similar impact.

The other Scandinavian country to make an impact in the international marketplace in these years was Finland. Once again, craft traditions underpinned that country's achievement, which was manifested in strikingly sculptural designs for glass created by, among others, Timo Sarpaneva and Tapio Wirkkala for Iittala. In the field of ceramics, Kaj Franck created both handmade forms and designs for mass production for Arabia, which took the new aesthetic to a mass market. Franck's *Kilta* range of 1952, for example, was based on a modular system of shapes and a limited range of colours. By the late 1950s, a continuum between craft and design had been fully formed, and the heroic Finnish designers of that epoch, who had become household names by that time, applied their visualizing skills to a range of mass-produced domestic goods, from knives to cooking pots.

Although subtly different traditions underpinned the design achievements of Sweden, Denmark, and Finland, these relatively small countries, which sought to establish themselves in the international marketplace through their sophisticated craft and design objects, decided to work together to promote their creations and to emphasize their shared characteristics—their debt to craft, their humanistic variant of Modernism, and their commitment to democratic ideals. This had the effect of separating them from the rest of Europe somewhat and of creating what came to be known as Nordic culture. Between 1954 and 1957, an exhibition dedicated to Scandinavian design toured the US. It served to secure an American market for Scandinavian goods and to create a new collective, transnational identity for that group of countries, which has remained in place until the present. Through the 1950s, the Scandinavian countries sought to exhibit their products in a number of international venues and, with government and trade bodies' support, undertook a strategic program of design promotion that involved promoting "Scandinavian" values. They had an impact in Italy—the work of the Finns, for example, made a significant impression at the Triennale of 1954—while worldwide the idea of Scandinavian design became synonymous with the idea of "good design."[4]

Like Italy, Germany had the challenge of distancing itself from its immediate fascist past; unlike that other country, however, it had the clear opportunity in front of it of embracing inter-war Modernism head-on. Hitler's closure of the Bauhaus represented unfinished business in Germany, so the completion of that project became its immediate goal. The project took place on a number of levels: political, commercial, and educational. Like the UK before it, Germany was quick to establish a government body to promote design. The Rat für Formgebung, created in 1951, took on that role, promulgating the dissemination of what it called *Gute Form* (good form), while the revived Deutscher Werkbund, originally formed in 1907 and very active earlier in the century, operated as a support system for designers and manufacturers, organized exhibitions to promote modern design, and generally ensured that design was understood to be an important element within the programs of economic and cultural regeneration.

Whereas Italy had initiated its post-war design renaissance in the area of furniture, and moved from there to product design, and Scandinavia had concerned itself for the most part with the applied arts and the domestic sphere, Germany focused its efforts much more at the technical end of the spectrum, and on the creation of a modern aesthetic for its technically oriented consumer goods. Germany had been a recipient of Marshall Plan aid in the 1940s and 1950s, and had invested it in new manufacturing industries. By the 1950s, in spite of the severe challenges it had had to face in the immediate post-war years—military defeat, financial problems, and its east–west division—it had become an affluent society, like many of its neighbors. One of its most dynamic manufacturing companies was the electronics firm Braun, left by Max Braun to his sons in 1951. Fritz Eichler was brought in as its design director in 1955. His role was to bring product design into an engineering context and to develop a company aesthetic that would distinguish Braun's goods in the international marketplace.

It was at that time that Japan was beginning to direct its new technical goods at Europe. Such companies as Sharp and Sony were leading the way in the area of consumer electronics (fig. 4), but they had not yet developed the sophisticated approach toward the design of their goods that was to characterize Japanese design in the 1980s. Braun, on the other hand, sought to inject Modernist minimalism into its products, and in the 1950s created some striking pieces, which, once again, made an impact at the Milan

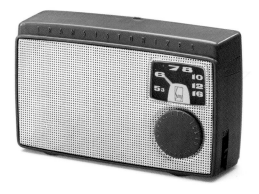

Triennales of that decade. Classic objects from those years included a food-mixer known as the *Kitchen Machine*, of 1957, and the *Multi-press* juicer of the following year. Both were designed by Dieter Rams, who began working with Braun in the middle of the decade. Over the next two decades, Rams went on to create numerous iconic designs for the company, from items of hi-fi equipment to radios, alarm clocks, and electric razors.

Several other German companies, including Siemens, AEG-Telefunken, and Bosch, embraced what became known as the "machine aesthetic," producing vast numbers of geometric, hard-edged, undecorated products that, in the 1950s and 1960s, helped to establish Germany as the home of good design in the area of electrical and electronic goods. The other notable German achievement in these years was the creation of a new design school, the Hochschule für Gestaltung in Ulm, which was intended, under the directorship of Max Bill, to continue the program of the Bauhaus, albeit in a new era. It was founded in 1951 from a fund set up by Inge Aicher-Scholl as a tribute to her brother and sister, who were killed by the Nazis. In 1957, the Argentinian Tomás Maldonado took over as director and the school adopted a new emphasis, which was more theoretically and less formally oriented. It became increasingly radical through the 1960s and, ironically like the Bauhaus before it, was closed by the local authority in 1968.

During its lifetime, the Ulm school contributed many designs that embraced the same formal approach and minimal aesthetic being promoted by the Braun company. The work of Hans Gugelot, who was linked to the school in the 1950s, stands out in this context. In the middle of the decade, he worked as a consultant for Braun. One of his most enduring creations was the Kodak *Carousel* projector, launched in 1963. Its simple geometric form and overt functionality made it a timeless design. An Ulm student, Hans Roericht, was responsible for another design classic, a set of plain-white hotel crockery, the *TC100* series (fig. 5), designed in 1958–59 and manufactured by Thomas/Rosenthal. It remains one of post-war Germany's most lasting designs and is in the permanent design collection of New York's Museum of Modern Art, in addition to many other modern design collections worldwide.[5] The striking minimalism and neo-functionalism of so many of Germany's designs of the 1950s and 1960s, along with those of Italy and the Scandinavian countries, helped to establish Western Europe as the home of good modern design in the international marketplace.

By the late 1950s, the key countries of Europe were becoming more integrated from a design perspective. Ideas developed in Italy, Germany, or the Scandinavian countries were quickly seen at fairs and exhibitions, and published in design-related journals. The UK, however, sat at the margins of Europe. It did not join the Union until 1973 (along with Denmark and Ireland), and the English Channel acted as a natural barrier. Moreover, it did not have the same traditional commitment to Modernism as those countries already described; but, like them, it made an effort after 1945 to develop a modern design movement that would earn it a new national identity in the marketplace. This effort was heavily driven by the British government, and by the Board of Trade in particular, which, in 1944, established the Council of Industrial Design (later the Design Council). Its role was to promote "good design," and to this end it organized the important exhibition *Britain Can Make It* in 1946 and the Festival of Britain in 1951.

Although Britain embraced Modernism only at the margins, it nevertheless made some significant contributions to the post-war European design scene. In furniture design, Robin and Lucienne Day, again influenced by Charles and Ray Eames, made an impact at the Milan Triennale of 1951 with a room furnished in the "contemporary" style; Ernest Race, meanwhile, created some memorable chairs in steel rod. Following the US's lead, Britain of the 1940s and 1950s also saw the emergence of a number of influential design consultancies: the Design Research Unit (established in 1942) and, in the late 1950s, Fletcher, Forbes and Gill (which became Pentagram in the 1970s). By the 1980s, design consultancy had become one of Britain's key contributions to international design, and British consultancies were active in many European countries, as they were elsewhere.

Another British contribution from these years lay in the area of design retailing. Terence Conran's Habitat store opened its doors in 1964; but before that, such shops as Heals, Liberty's, and Dunn's of Bromley had long been promoting "good designs" of international origin. The 1950s also saw the emergence of a generation of designers graduating from the Royal College of Art, another of Britain's important contributions to design. The furniture designers Ronald Carter and Robert Heritage and the metal designers Robert Welch and David Mellor owed much to Scandinavia, but they became part of a British design movement that had a significant impact internationally.

Britain was also the home of a number of innovative automobile designs. Although the US could talk generally about the idea of a "European car" more suited to the geography of Europe—by which they meant small cars, in comparison with their "gas guzzlers" (fig. 7)—within Europe the national differences were striking. While the Italian coachbuilders created luxurious, sculptural cars, France was known for its idiosyncratic yet highly innovative automobile creations, the *Citroen DS* of 1957 among them. The Germans produced solid, rational cars, such as the Volkswagen "Beetle" and the BMW series. Britain achieved its own distinctiveness in the field, not least through

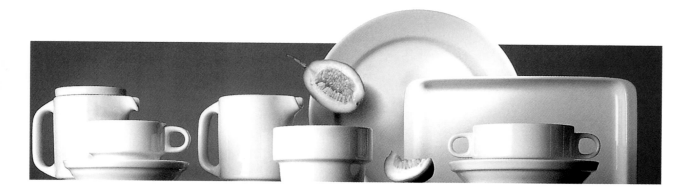

the work of the engineer–designer Alec Issigonis. His *Morris Minor* of the late 1940s was a little, characterful automobile that featured modest American-style streamlining on its small body. His greatest success came, however, in 1959 with the launch of the Austin *Mini* (fig. 6), a compact city car that was little more than a box on wheels. Through a feat of engineering, Issigonis succeeded in creating a small, simple car that was easy to drive and park, and yet spacious inside. It quickly became a second family car, proving particularly attractive to a growing female market.

The crisis of Modernism

By the mid-1960s, British society had changed dramatically, and the "good design" program initiated by the Council of Industrial Design ceased to have the potency it had had in the aftermath of the Second World War.[6] Whereas the UK had lagged behind other European countries in espousing Modernism, it led the way in the crisis of values that underpinned that hitherto dominant design ideology. As mentioned earlier, the influence of the US on Europe in the post-war years was twofold. On the one hand, American funds were injected into the manufacturing industry to enable the European economy to grow, in order to make Europe a trading partner and to protect the US from Russia. On the other hand, with that growth in wealth came enhanced levels of mass consumption. Here Europe looked once again to the US, this time to the model of individual mass consumption that had been developing there since the inter-war years. By the 1940s and 1950s, that model was represented by an expansion of suburban housing, large kitchens with bulbous refrigerators, and over-sized, gas-guzzling, finned automobiles. This model of conspicuous consumption, and the forms that represented it, were widely emulated in Europe, albeit on a more modest scale. The media-driven concepts of the nuclear family, of the teenager, and of popular culture; the mass-publication magazines; the movies; the designed goods, including streamlined food-mixers, refrigerators, and cars; the television programs—all were transferred directly on to European soil.

American popular culture had a significant impact in Britain in the 1950s, helping to fuel the developing generation gap that was at its most extreme in that country. At a high cultural level, this fact was recognized by a group of artists, architects, and critics, formed in the early 1950s, known as the Independent Group, which met at the Institute of Contemporary Arts in London to discuss popular culture and the influence of the mass media. The group included the artist Eduardo Paolozzi, whose collages from those years contained images published in American magazines showing overflowing refrigerators and streamlined automobiles. What the Independent Group had

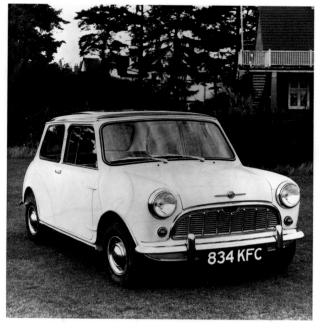

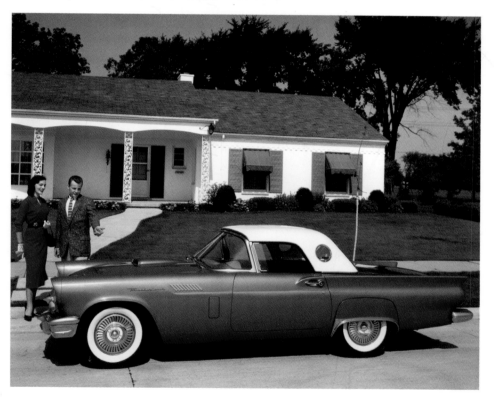

5 ↙↙
Hans Roericht
German (b. 1932)
TC100 Tableware, 1958–59
Porcelain
Mfr: Thomas/Rosenthal AG
Largest: 1 × 12⅛ × 8⅛ in.
(2.5 × 30.8 × 20.6 cm)

6 ←
Alec Issigonis's Austin *Mini* of 1959 was a revolutionary small car that transformed the streets of London in the 1960s.

7 ↓
The sleek lines of Ford's *Thunderbird* of 1957 introduced a new level of sophistication into American car styling.

noticed was that British society was changing. By the mid-1960s, a younger generation had dramatically rejected many of its parents' values and had embraced a new "Pop" culture, which manifested itself in music, clothes, and a range of other material lifestyle accompaniments, from drinking mugs to posters to carrier bags—the more ephemeral the better. Although this generation gap was visible to some extent in other European countries, it was more acute in Britain for a number of reasons, among them the UK's closeness to the US, the particular nature of the British class structure, and the nature of British art education, which produced many of Pop's artists and designers.

The shift in cultural values that occurred within the Pop revolution inevitably affected attitudes toward design. In particular, the universalizing, rational, and utilitarian values of Modernism were critiqued as no longer fulfilling the needs of a mass-consumer society, which was built, in the words of the architectural and design critic and Independent Group member Reyner Banham, on a material culture that operated on the basis of "massive initial impact and small sustaining power."[7] While this critique operated at the level of popular culture, it also affected the approach of professional designers to their work. In Britain, the furniture designer Peter Murdoch, for example, created an iconic Pop design chair (fig. 8). Made of laminated and lacquered paper, with green or red spots adorning its surface, his "ephemeral" chair self-consciously exploited the "expendable aesthetic" through the material used, and the "aesthetic of expendability" through the attention given to the "massive initial impact and small sustaining power" of its decorated surface. All the elements were in place for the Postmodernist design movement, which did not fully emerge, however, until the 1980s. Pop was the intermediary between Modernism and its "other." It served to question the values of the former and to seek alternatives to it.

What in Britain was largely a spontaneous reaction against Modernism— a part, that is, of the youth movement of the 1960s that reached its apogee in the student uprisings in Paris and elsewhere—was also visible in other countries of Europe. The influence of America's consumer society was felt across Europe in those years, and Pop culture flowed from Britain to several other European countries, especially the northern ones. In France, Italy, and Germany, students joined hands with workers, who had worked for small wages in the 1950s but who were now disenchanted with their situation, in what was a trans-European protest. The year 1968 was particularly turbulent in Europe, and the events of those twelve months put an end to the continuing pattern of growth and expansion that had begun in the reconstruction years. The *événements* in Paris (fig. 9), in which students and workers clashed violently with police, were a marker of the level of political, social, economic,

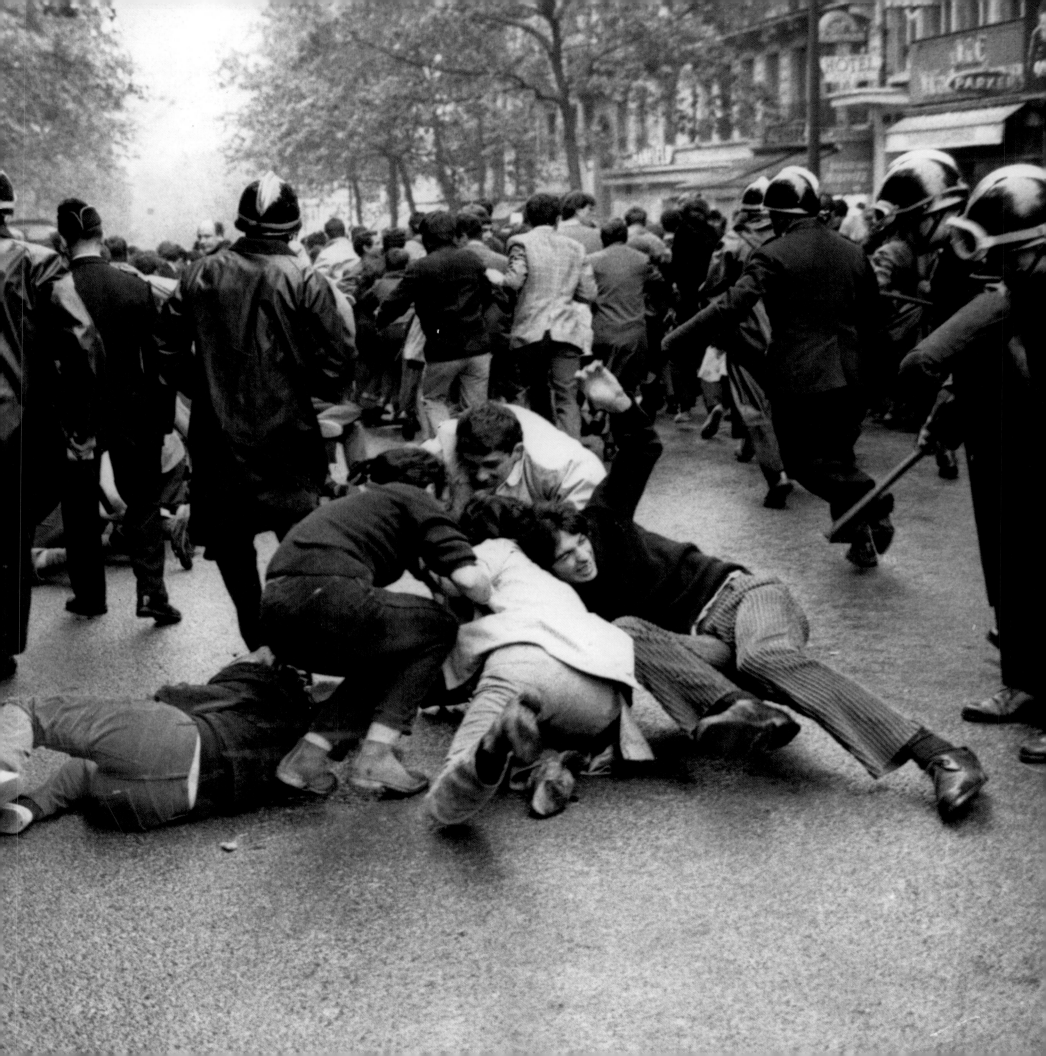

and cultural dissatisfaction in France. Italy had its own student and worker demonstrations in 1968, causing the Triennale of that year to close prematurely. The increasingly liberal communist regime in Czechoslovakia was also dealt with violently, in this case by the Soviet Union, which invaded Prague in the same year.

The effect of these events on design was dramatic, especially in Italy. The Pop revolution impacted on the development of design in that country in a number of ways. On one level, it influenced the movement known as "Radical Architecture," or "Anti-Design," which manifested itself in the work of young architects working together in groups. Among them were Superstudio (formed in 1966), Archizoom (also formed in 1966), and Gruppo 9999 (formed in 1967), all of which worked conceptually, creating architectural visions and designed artifacts that functioned outside Modernism, and which embraced irony, popular culture, and stylistic revivalism. The *Sanremo* floor lamp of 1968, for example, created by Archizoom—a group that included the young architect Andrea Branzi—was designed to resemble a palm tree. On another level, a young generation of designers worked with a number of manufacturing companies to create Pop-inspired objects that moved into the marketplace. Piero Gatti, Cesare Paolini, and Franco Teodoro, who first worked together in 1965, designed the *Sacco* for Zanotta (fig. 10), which was launched in 1969. With its unstable shape and informality, this beanbag chair epitomized the values of Pop and stood for the lifestyle of a generation who had rejected the idealism of the Modernists. Gaetano Pesce's *Up-1* chair (fig. 11), a polyurethane seating object covered in stretch fabric, which was manufactured by C&B Italia in 1969, similarly circumvented the universal, static values of Modernism by expanding from a flat object to a three-dimensional doughnut shape when released from its packaging. The element of "play" that defined these objects distanced them from their more serious predecessors and anticipated the Postmodernist movement in architecture and design, which was just around the corner.[8]

Even Italian product design was influenced by the new *Zeitgeist*. The architect–designer Ettore Sottsass—a member of the generation of Italian architects whose number also included Vico Magistretti, Marco Zanuso, and Achille and Pier Giacomo Castiglioni, among others—had begun to practice at the end of the Second World War. Never wholly embracing the fully fledged Modernism of his contemporaries, Sottsass had worked on mainstream interior and design projects while simultaneously undertaking personal experiments, creating ceramics and furniture (fig. 12) that looked to Eastern traditions and to American popular culture for inspiration. In the late 1950s, Olivetti had taken him on board as a consultant and he had worked on their

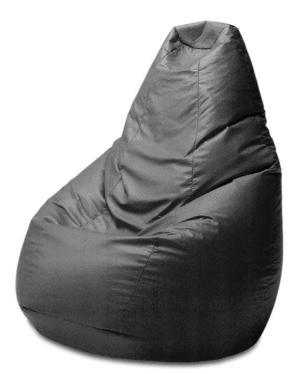

10 ←
Piero Gatti
Italian (b. 1940)
Cesare Paolini
Italian (b. 1937)
Franco Teodoro
Italian (b. 1939)
Sacco Beanbag Chair, 1969
Leather
Mfr: Zanotta S.p.A.
31½ × 26¾ × 31½ in.
(80 × 68 × 80 cm)

11 ↓
Gaetano Pesce
Italian (b. 1939)
Up-1 Chair, 1969
Injected polyurethane and stretch fabric
Mfr: originally C&B Italia; now B&B Italia S.p.A.
39⅜ × 39⅜ × 26⅜ in.
(100 × 100 × 67 cm)

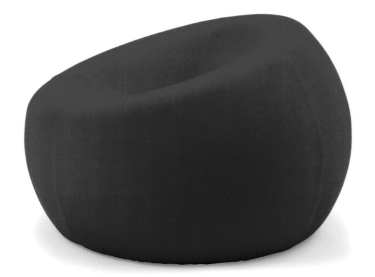

12 →
Ettore Sottsass, Jr.
Italian, born Austria (1917–2007)
Carlton Bookcase, 1981
Wood and plastic
Mfr: Memphis
75 × 78 × 13 in.
(190.5 × 198 × 33 cm)

13 ↓
Ettore Sottsass, Jr.
Italian, born Austria (1917–2007)
Valentine Typewriter, 1969
ABS plastic and metal
Mfr: Olivetti
4⅝ × 13½ × 14 in.
(11.8 × 34.3 × 35.3 cm)

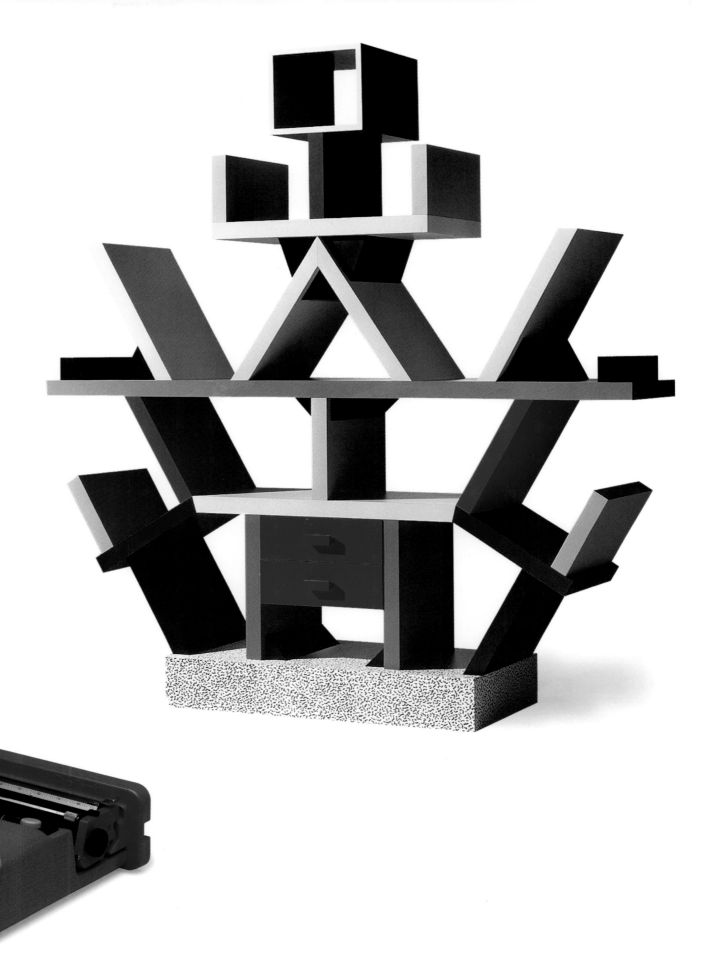

14
US President Richard M. Nixon
and Israeli Prime Minister
Golda Meir at the Oil Crisis
Summit of 1973, which changed
the course of world history.

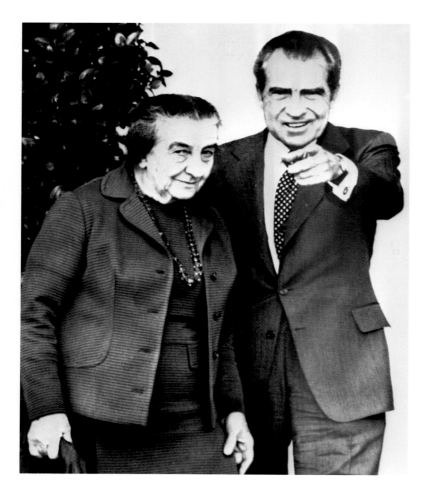

first computer, the *Elea 9003*, as well as creating a number of typewriters for the company in the early 1960s. In 1969, Olivetti launched the Sottsass-designed *Valentine* typewriter (fig. 13), a bright-red, plastic-bodied, portable machine marketed as a mobile object that could be used anywhere at any time. The product marked the first incursion of Postmodernist values into an object of this kind and pointed toward the widespread rejection of Modernism that was to occur in the next two decades.

From Modernism to Postmodernism

The 1970s were difficult years for design in Europe, inasmuch as one set of values, which had been in place for half a century, was being scrutinized, while its replacement had not yet been fully formulated. As a decade, it was a turbulent one. The oil crisis (fig. 14), created after a short Arab–Israeli war and a decision by OPEC to raise the price of oil, had a dramatic effect on the European economy. The production of plastic goods in particular was badly affected. A number of new developments, the impact of which was not fully felt until later, had their roots in the 1970s. The fight against pollution, for example, was initiated at that time, and, in Britain, the pressure group Greenpeace was formed. Terrorism also reared its ugly head, with the killings of eleven Israelis at Munich's 1972 Olympic Games and the murder of Italy's prime minister, Aldo Moro, in 1978. In Britain, coalminers' strikes were just part of an era of general social unrest; mainland Europe experienced a similar period of instability. In Britain, too, the Pop youth movements of the 1960s were replaced by Punk. While this subculture was most evident in the dress styles and body ornaments of its followers, its anarchic attitudes also affected a radical edge of design.

Generally speaking, the sense of optimism that had still existed in the 1960s was less in evidence. Many turned away from industrial manufacture toward a revival of traditional craft skills; stylistically, a new interest in the past inspired a "retro" movement, which saw the revival of Art Nouveau and Art Deco designs. Above all, the expansion of mass communications and international trade meant the beginning of the end of national identities and the growth of globalism. Design was particularly susceptible to this tendency, and designers began to move around the world in search of employment. Japan became a force to be reckoned with, not just technologically and economically but also in terms of design, as it began to emulate and then "leapfrog" developments in Europe. Japanese automobiles and electronic goods began to flood the international marketplace, including that of Europe.

15 ←
Gijs Bakker
Dutch (b. 1942)
Stovepipe Necklace and
Bracelet, 1967
Aluminum
Mfr: Gijs Bakker
Necklace: 4³/₄ × 8¹/₂ × 7⁷/₈ in.
(12 × 21.5 × 20 cm)
Bracelet: 2¹/₄ × 6³/₄ in.
(5.5 × 17 cm) (height × diameter)

16 ↙
Bruno Gregori
Italian (b. 1954)
Collage model for cover
illustration of *Alchimia Never
Ending Italian Design* (detail),
1985
Graphite, gouache, paper, and
colored pencil on board
39¹/₄ × 27¹/₂ in. (99.7 × 70 cm)
(height × width)

17 ↓
Marco Zanuso
Italian (1916–2001)
BA2000 Scales, 1970
ABS plastic
Mfr: Terraillon Corporation
7 × 6 × 3¹/₂ in.
(17.8 × 15.2 × 8.9 cm)

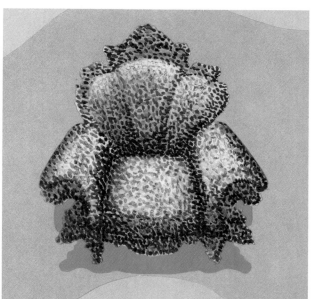

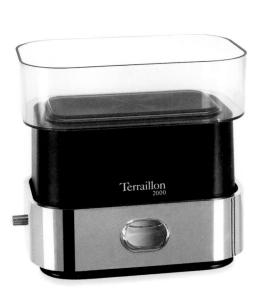

Where European design was concerned, Italy was still pre-eminent in the 1970s. Sophisticated furniture items and products continued to flow from the assembly lines of its leading manufacturers, Cassina, Artemide, FLOS, and others. Italian designers became international "superstars" and were invited to work in other countries. Marco Zanuso, for example, worked with the French kitchen-scale company Terraillon, creating a stylish set of scales that was launched on to the market in 1970 (fig. 17). Such products had a definite "Euro" quality to them, in the sense that they were stylish, elegant, simple in form, and aesthetically self-conscious, at least as seen from outside Europe, from the US and Japan in particular. Alongside this slick, stylish face of European design, however, a Pop-inspired, "alternative" face was still developing. In The Netherlands, for example, a country that up to this point had only really been known for its neo-Modernist graphic design, a group of jewelry and furniture makers began to develop a highly conceptual approach to design. Gijs Bakker, later to become a leading figure in the Droog Design group, which came to the fore in the 1990s, was already active in the 1970s, creating innovative designs that combined craft methods with abstract concepts. A necklace and bracelet made of stovepipe (fig. 15), created in 1967, indicated the direction in which Bakker was to travel.

The eclecticism within European design of the 1970s was a marker not only of a loss of direction now that the guiding principles of Modernism had ceased to show the way forward, but also of an experimentation that was to underpin the new flowering of design creativity in Europe in the 1980s and 1990s. One indication of the existence of that potential was the work that emerged at the very end of the decade, produced by the members of the Milan-based Studio Alchymia group. In the late 1970s, Alessandro Guerriero brought together a group of well-established "anti-designers"—Sottsass, Branzi, and Alessandro Mendini among them—with some younger designers to develop bodies of work for exhibitions. Named, ironically, *BauHaus 1* and *BauHaus 2*, the exhibits he created brought to the surface many of the preoccupations that had existed in the 1970s but that had not been fully visible to the public eye. Building on the anti-design work of the late 1960s, Branzi, Mendini, and Sottsass, in particular, created prototype designs for exhibition purposes that highlighted the world after Modernism, within which irony, play, decoration, and references to the past and to contemporary popular culture became the driving forces behind design thinking and practice. Mendini's *Proust* chair of 1978 (illustrated in fig. 16) exemplified all those preoccupations, playing with the idea of the mass replication of fine-art imagery and the "kitsch" that resulted from that process.

18 ←
Nathalie du Pasquier
French (b. 1957)
Gabon Textile, 1982
Cotton
Mfr: Rainbow
55 × 159 in. (140 × 404 cm)
(width × length)

19 ↙
Daniel Weil
British, born Argentina (b. 1953)
Radio in a Bag, 1981
Transistor radio components
and PVC
Mfr: APEX
11³⁄₈ × 8¹⁄₄ × 1¹⁄₄ in.
(29 × 20.7 × 3 cm)

While Studio Alchymia served to bring these interests to the surface within the closed world of the Italian art and design community, the next development in that country, instigated by Sottsass, brought them to the notice of the whole world. Memphis was the name of a spin-off group that Sottsass formed because he was frustrated by the innate pessimism of the Alchymia experiment. So named because it combined the birthplace of Elvis Presley with the home of the ancient gods of Egypt, Memphis brought together a young team of designers based in Milan and attached to Sottsass in various ways—Michele De Lucchi, George Sowden (fig. 20), Nathalie du Pasquier (fig. 18), Martine Bedin, Marco Zanini, Matheo Thun, and Aldo Cibic among them—with some European design stars, including the Austrian Hans Hollein and the Spaniard Javier Mariscal (fig. 22), as well as some other international key players. These included the Americans Michael Graves and Peter Shire, the British designer Daniel Weil (fig. 19), and the Japanese designers Arata Isozaki and Shiro Kuramata. The message was that the "New Design" was international in nature and that the movement away from Modernism was recognized as a global event. Importantly, however, the energy behind that statement was rooted in Italy and in a designer who had been working in an Italian context since 1945. Memphis held a series of annual exhibitions in Milan between 1981 and 1987. In the first few years at least, they took over from the Triennales as the key destination for design pilgrims from all over the world.

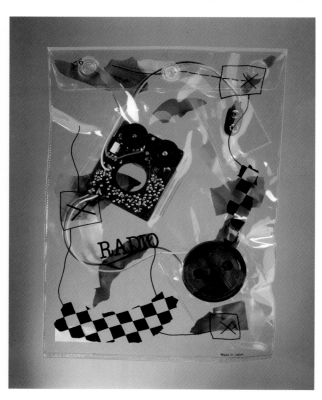

Memphis represented an important turning point in the story of European design between 1945 and 1985. It brought to a head the anxieties about Modernism being the appropriate driving force in a world in which, increasingly, it was mass consumption, rather than the logic of industrial mass production, that was underpinning social, economic, and cultural change. Increasingly, industrial production had to be flexible to meet the needs and desires of the marketplace. The Swiss watch company Swatch (fig. 21) was alert to this shift in emphasis and geared its production to a sequence of batches, so that it could change the aesthetic of its products on a regular basis to suit the changing tastes of niche markets. This was a lesson learned from Japan, where flexible mass production, rather than American-style Fordism, had enabled that country to gear its products to different taste cultures.

The 1980s also saw two more important European countries—Spain and France—develop and actively promote their modern design movements, the former as part of its new, post-fascist identity, and the latter as part of President Georges Pompidou's attempt to renew the image of France in both

20 ↙
George J. Sowden
British (b. 1942)
Luxor Cabinet, 1982
Wood and plastic
Mfr: Memphis
78¾ × 39⅜ × 23⅝ in.
(200 × 100 × 60 cm)

21 →
Swatch Ltd.
Swiss (founded 1983)
Four Classic Watches from the
first Swatch collection, 1983

22 ↓
Javier Mariscal
Spanish (b. 1950)
Hilton Trolley, 1981
Steel and glass
Mfr: Memphis
31½ × 55⅛ × 17¾ in.
(80 × 140 × 45 cm)

a European and a global context. Both countries had the advantage of making their efforts within a Postmodernist context, so they were able to draw on the experiences of other countries in the development of their own design cultures. Spain, for example, drew heavily on Italy's post-1945 experience. The world within which the new Spanish designers—including Mariscal, Oscar Tusquets, Josep Llusca, and Jorge Pensi—emerged was essentially a pluralistic one that tolerated the coexistence of late Modernism with Postmodernism. The French designers, most notably Starck, whose interior for the Café Costes in Paris (fig. 23) was reproduced internationally, but also Jean-Michel Wilmotte, Garouste & Bonetti, and others, were also able to work across a range of contemporary styles. The last group of designer "superstars" to emerge in the 1970s and 1980s was from Britain, a country that boasted the most extensive network of educational design institutions in Europe; it was also the home of "street style," a sophisticated youth subculture, which, following the Pop revolution of two decades earlier, had developed its own lifestyle accompaniments and was a stimulus for design innovation. Ron Arad (fig. 24), an Israeli living in London, and Jasper Morrison (fig. 25), a product of the English art school system, both emerged at this time. Both men developed their own individual, quite different, philosophies of design and quickly became international figures of repute.

By the mid-1980s, Europe was a much more cohesive place than ever before. Designers moved across national boundaries and worked with companies in different European countries with ease. The strict national identities of the immediate post-war years were less in evidence, but it was clear that the journey that had been taken since 1945 still underpinned the progress that was being made and the successes that were being achieved. After 1985, the rampant globalism that was already in evidence intensified, and it became increasingly hard to talk about things being "Italian" or "German" or "English." They had simply become, especially to outside eyes, "European." At the same time, however, the traits that had characterized the different national design programs of the post-1945 period still provided the bedrock upon which new developments were built. Europe itself was more united than it had ever been. The Polish Solidarity Party was beginning to show that Communism was at its end in Europe and that liberal democracy had won the day. Within that *Zeitgeist*, design had an important part to play— in terms, that is, of keeping the wheels of the economy oiled, helping to create national and transnational identities, and, above all, making the "good life" more accessible than ever before.

23 ↓
Philippe Starck
French (b. 1949)
Costes Chair, 1982
Plywood, steel, and leather
Mfr: Driade S.p.A.
19 × 21 × 31½ in.
(48 × 53 × 80 cm)

24 →
Ron Arad
British, born Israel (b. 1951)
Rover Chair, 1981
Steel and leather
Mfr: One Off Ltd.
27 × 36 × 37 in.
(68.6 × 91.4 × 94 cm)

25 ↘
Jasper Morrison
British (b. 1959)
Wing-nut Chair, 1984
Wood and metal
Mfr: Jasper Morrison
31½ × 15¾ × 15¾ in.
(80 × 40 × 40 cm)

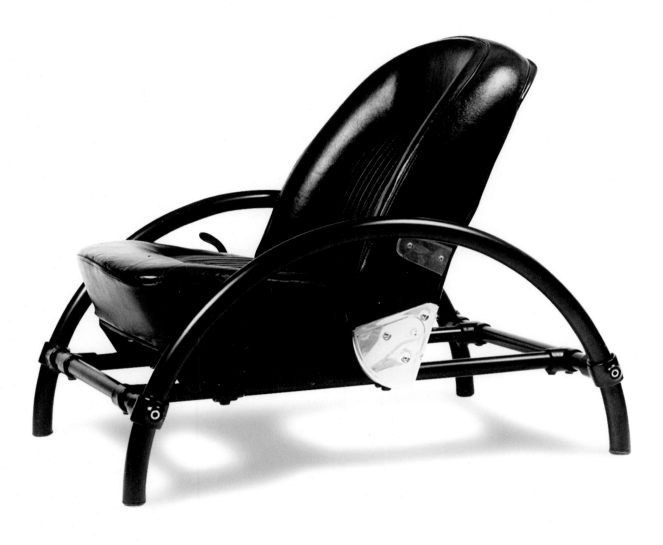

Notes

1 See M. Gringrod, *The Re-building of Italy: Politics and Economics 1945–1955*, London and New York (Greenwood Press) 1955.

2 E.N. Rogers, "Editorial," *Domus*, January 1946, p. 3.

3 For more detail see P. Sparke, *Italian Design: 1870 to the Present*, London (Thames & Hudson) 1988.

4 See D. McFadden, *Scandinavian Modern Design 1880–1980*, New York (Harry N. Abrams) 1982.

5 See H. Lindinger (intro.), *Hochschule für Gestaltung Ulm*, Berlin (Ernst & Sohn) 1987.

6 See P. Sparke, *Did Britain Make It? British Design in Context, 1946–1986*, London (Design Council) 1986.

7 P. Sparke, *Design by Choice*, London (Academy Books) 1981, p. 94.

8 See E. Ambasz, ed., *Italy: The New Domestic Landscape: Achievements and Problems of Italian Design*, New York (Museum of Modern Art) 1972.

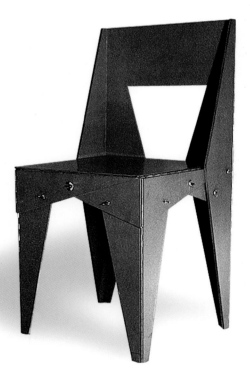

The Context of
European Design
Since 1985

Catherine McDermott

ooking back to the Europe of 1985, it is difficult to imagine that everything that had seemed fixed, from the political boundaries of the Cold War to the way we communicated, was about to experience a period of revolutionary change. Design was no exception, and, in just over two decades, design processes, production, and priorities responded to a very different world. It was the mid-1980s that witnessed the discovery of a hole in the earth's ozone layer, an environmental crisis highlighted in 1986 by the Chernobyl nuclear catastrophe in the Ukraine, then part of the Soviet Union. The following decade experienced the appalling tragedy of armed conflict in Europe, the first since the Second World War, when Croatia and Slovenia broke away from Yugoslavia and the alliance with Serbia (1991). Internationally, European servicemen and -women also fought in the Gulf War (1990; fig. 26); following the destruction of the New York World Trade Center (2001), they remain part of the ongoing conflict in Afghanistan (2002) and Iraq (2003).

The late twentieth century radically transformed our understanding both of Europe and of being European, most profoundly in the extraordinary downfall of the old Soviet Union. This epic event would end the global East–West divide, transforming the lives of millions of European citizens. It would also redraw the European map and expand the European Union (EU) to include twenty-seven countries. The subsequent emergence of the world's largest single market, serving an estimated 490 million EU consumers, had a direct impact on design, enabling the rise of a new and much stronger European design culture.

It is worth pointing out that, in 1985, the international understanding of "European design," at least the kind illustrated in mainstream publications and exhibitions, meant design only from Western Europe. It was Western European designers, across all disciplines, who achieved some of the most creative and original work of the late twentieth century, from the conceptual installations of Droog Design in The Netherlands to the revival by John Galliano and Vivienne Westwood of couture and the modernity of Jasper Morrison furniture. The ambition for the twenty-first century is that designers from across the whole of the new Europe will shape international trends and design, and the indications are that they will.

In order to understand these West–East European dividing lines for design, we have to return to the controversial Yalta agreement signed in 1945 by the Allied leaders, Winston Churchill, Joseph Stalin, and Franklin D. Roosevelt. Yalta created the Soviet bloc, and the decades of repression engendered by its formation were marked by a potent and feared symbol, the Berlin Wall, which divided the German capital into East and West zones. The Wall was the visible sign of the fifty-year divide in European culture and design. For nearly half a century, the axis of power it created between the Soviet Union and the Western powers controlled and shaped patterns of consumption. It brought into sharp contrast the differences between planned economies and the free market, and it inevitably had a profound impact on the visual appearance of European designs. This polarization in European design of the 1980s can be highlighted in the contrast between two automobiles of roughly the same date: the functional and basic *440 Spartak* from the Communist Czech company Skoda, and the Audi *Quattro* from West Germany, with its advanced engineering and comfort.

New European borders

Our understanding of Europe, and of European design, has changed quite dramatically in the last few decades. In 1985, however, it would have been impossible to imagine how quickly the Berlin Wall would be pulled down (fig. 27) or the speed with which the Soviet Union, built from the nineteenth-century Russian Empire, would devolve into fifteen separate countries. It would have been equally impossible to believe that the end of the Cold War would signal the rise and rise of capitalism and consumerism in Europe, creating a world in which Muscovites celebrate luxury brands, drive to their local IKEA, and embrace designer culture.

Of profound importance to design was the fact that this new map of Europe was decided not by the autocrats of 1945 but by states that defended their cultural traditions, and ethnic groups who kept alive the importance of difference. The emergence of new nations had one immediate impact on designers, in the urgent requirement for currency, banknotes, and postage stamps. Notable in terms of design was the paper money for Estonia by the graphic designer Vladimir Taiger, celebrating such much-loved national, and previously repressed, figures as the Estonian poet Lydia Koidula. Such initiatives also gave voice to a movement that has revitalized European design in the twenty-first century: the important rise of European regional design identities. These emerging new centers include the creativity of Flemish design in Belgium, Catalan culture in Spain, and the growing influence of Scottish and Welsh designers, such as Timorous Beasties and Dai Rees respectively, in the UK.

Design also played a role in the struggle for political change after 1985. The Polish independence movement, for example, is still defined through two

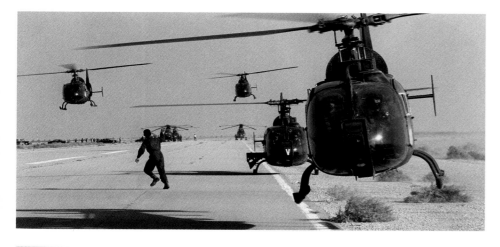

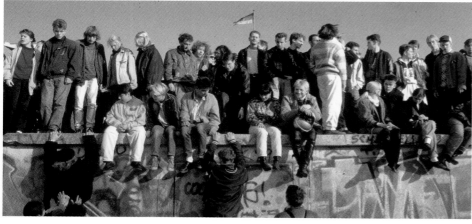

French armed forces in Yanbu,
Saudi Arabia, during the Gulf
War. Yanbu, a key strategic site
for world oil transportation, is
the location of the East–West
Pipeline, which was closed in
August 1990 after the Iraqi
invasion of Kuwait.

27 ↑
The Berlin Wall, which
separated East and West
Berlin for twenty-eight years,
was finally opened on
November 9, 1989. The
following day, it was the site
of universal celebrations.

landmark graphic images. The first is the striking red logo for Solidarność, the independent trade union of Gdańsk headed by Lech Wałęsa, designed by Polish artist Jerzy Janiszewski. The second, from 1992, a collage poster of Gary Cooper from the Hollywood Western *High Noon* by Tomasz Sarnecki, effectively rallied international support for Poland. Freedom in design was also a fundamental element of the Prague Isametová Revoluce, or Velvet Revolution (1989), a dissidence movement famously led by Václav Havel, a dramatist whose 1960s' band Plastic People of the Universe remains a rare example of Soviet bloc Pop culture.

As president of the Czech Republic, Havel did much to restore Prague's profile as a European design capital. His inspiration focused the attention of former Communist manufacturing industries on design and helped reconcile the old East–West divide. One revealing example of change came from the Czech company Techo, formerly a state-owned wood-processing company manufacturing office furniture for the Soviet Union. Relaunched in 1992, Techo commissioned leading European designers to design high-profile Czech interiors in drab government buildings. Techo also created innovative spaces in which young Czech creatives could experiment, including the Factory 2001 project, which offered its manufacturing works as installation space. The Czech government also famously supported, with prestigious commissions, political émigré designers who had left after 1968, including Bořek Šípek, Eva Jiricna, and Jan Kaplicky. Finally, Havel's government invested in the work of a new generation of designer–makers who were beginning to make their mark, including ceramics by Maxim Velcovsky and Daniel Pirsc, and commercial glass by Studio Olgoj Chorchoj, founded in 1990 by Michal Froněk and Jan Němeček.

Innovative design in other Eastern European countries has also emerged, albeit more slowly. Hungary's tradition of Modernism, famously represented in America by Tibor Kalman, continues with such new designers as Balázs Tanitó. In 2007, the Slovenian government's installation at London's *100% Design* exhibition continued to mark the growing confidence of Eastern European design culture.

Not all the new countries of the old Soviet bloc focused on design as a strategy to achieve a successful, broad-based economy. In the twenty-first century, Russian design is struggling to come to terms with a past in which its best-known design was the Kalashnikov sub-machinegun, and its once famous manufacturing center in Rostov is now dilapidated and under-resourced. There are signs of change in those sectors of the economy—graphics, packaging, and interior design—that connect more immediately

with the consumer. More successful is the emergence of Russian fashion designers, such as Helen Yarmak and her fur coats for Hollywood movie stars, and Tatiana Parfionova and her luxury couture.

The rise of the European Union

The other transforming event for European design was the expanding power and confidence of the EU. Its history goes back fifty years to the Treaty of Rome (1957), an agreement that famously established the European Community, with six original signatories: Belgium, France, Germany, Italy, Luxembourg, and The Netherlands. Over the next two decades, the EU began to grow, with the inclusion of Austria, Denmark, Finland, Greece, Ireland, Portugal, Spain, Sweden, and the United Kingdom. The most radical expansion, however, came in 2004, when eight countries of Central and Eastern Europe joined: the Czech Republic, Estonia, Latvia, Lithuania, Hungary, Poland, Slovenia, and Slovakia. There are now twenty-seven member states, with Croatia, the Former Yugoslav Republic of Macedonia, and Turkey as potential candidates for future accession.

The EU has become the largest free-trade area in the world, with, for most citizens, a single currency, the euro. The EU's impact on design, through a series of legislative changes, has led to the economic success of European design services and products in the global marketplace. These changes have operated in different spheres. Primarily, they have allowed the freedom of movement of goods, services, and peoples within the EU. Equally importantly, by dismantling the existing monopoly markets for telecommunications and energy, the EU has dramatically expanded people's choice of goods and services. The EU, often criticized as bureaucratic and slow, has established an exciting vision for the future of European design.

That future also includes proposals for design education, framed within the EU's Bologna Declaration (1999). State design education in Europe has a long history of nearly two hundred years, enjoying a high profile and a particularly strong reputation for postgraduate training. Staff, students, and alumni of some of these institutions—for example, the Design Academy Eindhoven in The Netherlands—have not only had an impact on design education but have also shaped international design directions. Other high-profile European design schools include the Domus Academy in Milan; the Royal College of Art (fig. 28) and the University of the Arts in London; ECAL (the University of Art and Design Lausanne); and the Vienna Academy. For the present, these remain national design schools, but there are signs that student and staff profiles are moving toward the Bologna objectives. This

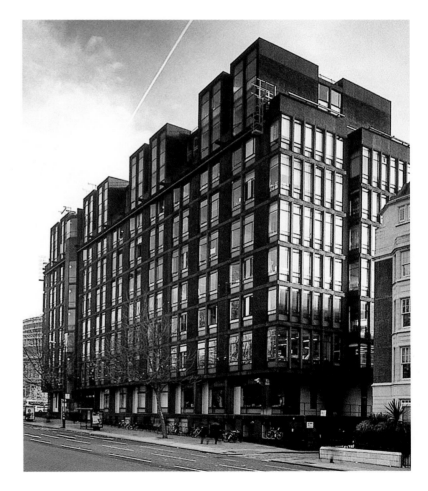

28
The Darwin Building at the Royal College of Art, London, designed by H.T. Cadbury-Brown, with Hugh Casson and Robert Goodden. Named after Robin Darwin, principal and rector from 1948 to 1971, the building forms part of a group of museums and universities, known as "Albertopolis," developed after the Great Exhibition of 1851.

EU vision aims to break down the structural barriers of education, in terms of the curriculum, and to use more permeable European borders to enable staff and students to work together. The scale of the movement of people within the EU is huge. For the UK, this migration has resulted in the largest recorded immigration of people from a single country: after Poland joined the EU in May 2004, British government figures reported that 73,545 Poles had signed the UK register of migrant workers. In 2007, it was estimated that more than 15 million Europeans were working or studying in another EU country across all sectors, including design. These complex population shifts have inevitably impacted on European design. One micro-example comes from the "British" design partnership of El Último Grito (fig. 29). In 2007, the practice comprised Roberto Feo and Rosario Hurtado, brought up in Madrid, educated at the Royal College of Art, living in London, and working in their Berlin studio for international manufacturers. Such flexibility in creative practice offers a new European model for the design profession that transcends language and cultural boundaries.

European design culture after 1985

Design is an excellent antenna for the cultural changes taking place in society, and European design is no exception. Since the mid-1980s, the media coverage of design has seen a dramatic increase across television programs,

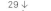

29 ↓
El Último Grito
British, also resides Germany
(Roberto Feo, b. 1964; Rosario
Hurtado, Spanish, b. 1966)
Mico Chair/Playtoy, 2006
Fiberglass
Mfr: Magis S.p.A.
15¾ × 25½ × 27½ in.
(40 × 65 × 70 cm)

30 →
Clockwise, from top left:
Blueprint Magazine (December
2007); *Icon* Magazine (June
2003); *Frame* Magazine
(September/October 1998);
*Wallpaper** Magazine (May 2005)

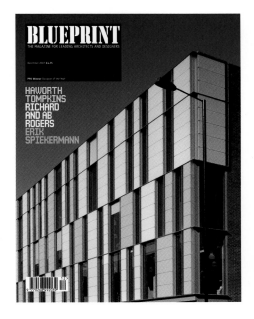

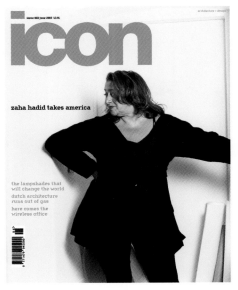

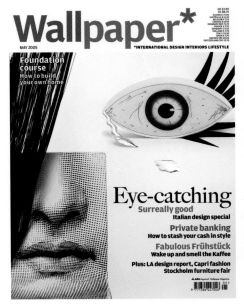

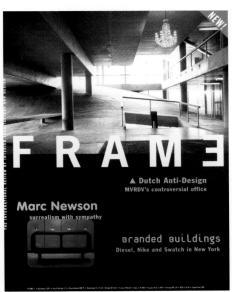

newspaper columns, published books, magazines, and websites. The trend was started with design magazines, such as the UK's *Blueprint* (1983), followed by *Wallpaper** magazine (1996), and the currently fashionable *Icon* magazine (2003; fig. 30). Their design and content are a way of reading each decade's design priorities. The 1980s famously centred on design as an expression of individual, not shared, cultural identity, a *Zeitgeist* summed up by British Prime Minister Margaret Thatcher's notorious claim that "there is no such thing as society." The period from the 1990s, however, moved toward more reflection on the context and purpose of design within society. Three iconic European design objects help to illustrate the shifts within design over twenty years. The first, *Juicy Salif* (1989), a lemon-squeezer by French designer Philippe Starck for the Italian company Alessi, is a self-conscious object of display. By way of contrast, the *Wind-Up Radio* (1995) by British inventor Trevor Baylis was designed to communicate Aids health information to African regions with limited electricity. The *Rag* chair (1991; fig. 257) by Dutch Droog designer Tejo Remy suggests environmental awareness, offering the option for the user to recycle his or her own discarded clothes, but within the context of an expensive limited-edition piece.

Postmodernism and Europe

In the 1980s, such contrasts within design culture were not confined to Europe but were international in scope, framed by the cultural paradigm of Postmodernism. Design, along with many other disciplines, was struggling to come to terms with the radical cultural change that followed the aftermath of the Second World War. After the war, not only Europe but also many other parts of the world lost confidence in forms of cultural stability now associated with the past. The French philosopher Jean-François Lyotard, in his defining work *The Postmodern Condition* (1979), famously called these shared certainties the "grand narratives," including the works of Karl Marx in economics, or those of Albert Einstein in physics. In terms of design, twentieth-century European masters of visual culture also dominated these grand narratives. It was European Modernist designers, for example, who essentially created the design language of the modern age and influenced all areas of international creative practice from the 1920s onward, including the architect Le Corbusier (Swiss/French), the furniture designer Marcel Breuer (Hungarian), Eva Zeisel in ceramics (Hungarian), Aino Aalto in glassware (Finnish), and Jan Tschichold in typography (German). The key agenda underpinning their work was to create mass-produced, affordable products for the widest market. Postmodernism expressed the shift from design for

society to design for consumerism. European designers were quick to reflect these new priorities, with a series of projects that established a visual style for new Postmodernist design. Defining examples include Alessi's *Kettle with a Singing Whistle* (c. 1985) by German designer Richard Sapper, and from Starck a series of seminal international collaborations with the hotelier Ian Schrager. The first of these hotels, the Royalton (1988), with its theatrical foyers and bars, created for its guests the experience of Postmodernism.

Europe not only developed a visual language for Postmodernist design; during the 1980s, its designers were also pioneering theoretical work on the methodologies and intellectual framing of practice. The initial moves to establish Postmodernism as a critical design position against formal Modernism had come from America. The first was Robert Venturi's *Complexity and Contradiction in Architecture* (1966), which introduced the innovative concept of "the messy vitality of the city"; the second was a bestseller by the American architectural historian Charles Jencks, *The Language of Post-Modern Architecture* (1977). Developments in Postmodernist theory, however, were rooted in work not from America but from France, and in the theories of such philosophers as Lyotard, Roland Barthes, Michel Foucault, and Jean Baudrillard. The most influential of these in terms of design was Barthes; his book *Mythologies* (1957) extracted the meaning, or, in his words, the "mythologies," of design images and form. Barthes changed the way in which a new generation of European designers and design critics would see design— as cultural signs to be formally analyzed. Perhaps even more significantly, his work signalled a wider shift in European design, from purely problem-solving activities to a larger context of intellectual ideas.

Postmodernism was to lead to a renewed emphasis on interdisciplinary practice, bringing the methodologies of anthropology, philosophy, and sociology to both design and design education. Over the last two decades, this convergence of practice has been taken up enthusiastically by designers and continues to define the most successful examples of twenty-first-century European design. Postmodernism also made the traditional dividing lines between European art and design less distinct, thereby changing the processes and conventions of commissioning, exhibiting, and selling work. In the UK, these new directions are reflected in the work of a design company called Established & Sons, whose CEO is Alasdhair Willis, the husband of fashion designer Stella McCartney. Established & Sons (fig. 31) commissions limited-edition work that moves design toward the meeting point with art, a trend now widely referred to as Designart, the impact of which on design is just beginning to be felt.

Global local design

Globalization has been another key influence on European design since the mid-1980s—the growing feeling that, wherever we travel, there is an increasing sameness of experience, expressed through the impact of such American global brands as McDonalds, Starbucks, and Gap. This process of globalization, however, is not one-way; there are also global European brands, such as IKEA and Nokia, alongside luxury fashion brands, such as Burberry (UK), Hermès and Louis Vuitton (France), and Prada and Gucci (Italy). Confidence in the enduring appeal of a certain kind of European chic has ensured for these labels an international profile in the shopping malls and boutiques of Singapore, Dubai, Rodeo Drive in Los Angeles, and the Bund in Shanghai (figs. 32, 33). The idea that Europe sets retail trends is widely acknowledged in the interiors of such innovators as Prada and Viktor & Rolf, the Dutch duo of Viktor Horsting and Rolf Snoeren. Horsting and Snoeren's influential Surrealist shops from 2006 in Milan and New York offered the consumer an alternative retail experience, including "upside down" interiors, with wooden floors for the ceilings and chandeliers sprouting from the floor.

In the context of future trends, Europe also leads the more recent development in which cities, not countries, now arguably define international design cultures and economies. The biggest and most important European example of this is London, a city at the center of not only a national but also a global economy transformed by creativity (fig. 34). Other European capital cities focus on single areas, such as Milan for design, Paris for fashion, or Barcelona, Berlin, Reykjavik, Stockholm, and Prague for social and cultural variety.

In spite of this, European countries, or cities, do not yet see themselves as part of a shared design culture but rather as separate entities with individual languages, educational systems, design media, and governmental promotional agencies. They share parallel strands of European experience set alongside fiercely competitive national design identities. Within the design professions, there is still an understanding of what British or Scandinavian design values might be and of their changing success in the marketplace. In the 1980s, such shifts saw the move away from Scandinavia, Italy, and France to the new design centers of Spain, Britain, and The Netherlands.

Although Spain enjoys a rich architectural and design heritage, from Antoní Gaudi to Salvador Dalí, its post-war contribution to design was virtually non-existent. In 1975, however, the death of Spain's leader, General Francisco Franco, ended a thirty-six-year dictatorship and began a creative regeneration across Spain. A new generation of designers in Spanish fashion

31 ← ←
The *Pinch Chair*, designed in 2005 by Mark Holmes for Established & Sons, on display at the Milan Salone Internazionale del Mobile (see p. 42) of 2006.

32 ←
Burberry, a British luxury brand famous for its distinctive check fabric, opened its flaghip store in Beijing, China, in 2005.

33 ↙
Maison Hermès, the corporate headquarters of Hermès Japan, was completed by Renzo Piano in 1998. It caters to the enduring Japanese demand for European luxury brands.

34 ↓
The Design Museum, London, an international museum of contemporary design founded in 1989. The building was converted from a banana warehouse to resemble a Modernist structure.

 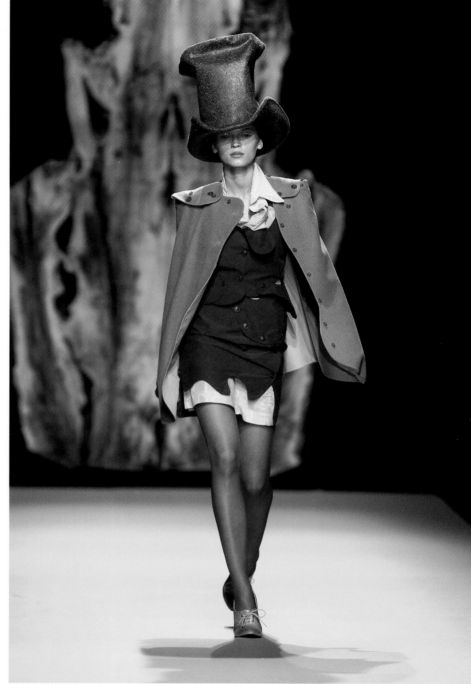

35 ↑ ↗
Vivienne Westwood
British (b. 1941)
Wake up Cave Girl! Collection
Outfits, 2007–08
Above, left: Wool, cotton, rayon,
viscose, polyester, cashmere,
and leather
Above, right: Cotton, polyamide,
polyester, viscose, and leather
Mfr: Vivienne Westwood

36 →
Thomas Heatherwick
British (b. 1970)
Bleigiessen Sculpture, 2006
Glass and steel
Mfr: Heatherwick Studio
1181 in. (3000 cm) (height)

attracted much attention, from Adolfo Dominguez and his high-end, softly tailored clothes to such global brands as Mango and Zara, famous for the speed at which they deliver catwalk trends to the high street, typically offering 11,000 new garments each year. Spain's cultural transformation was driven by a series of international events, starting in 1992, when Barcelona hosted the Olympic Games. It was Barcelona that defined Spain's growing design reputation in the 1980s, with the Catalan designer Javier Mariscal. Spain continues to inspire design, with a reputation for commissioning innovative building projects by architects of international standing. The most famous of these projects, Frank Gehry's Guggenheim Museum for Bilbao, was such a success that the term "the Bilbao effect" has come to stand for aspirational urban regeneration projects across the world.

British designers also attracted international attention in the 1980s, not for the country's traditional success in manufacturing but for the original vision of its unique youth culture, a continuing theme since the "Swinging Sixties." In the 1980s, however, a new generation of designers responded with such originality to Punk culture that their impact continues to influence design. This first wave of designers, including Vivienne Westwood, Ron Arad, and Peter Saville, are now established as international figures. These British designers took the anarchic approach of Punk to offer a vision of how people might experience design rather differently. In the case of Westwood, she portrayed a unique concept of how clothes might express a way of living in the late twentieth century (fig. 35). This first group of innovators was followed in the 1990s by an equally talented second generation of British designers, who went on to build an international profile: Alexander McQueen and Galliano in Paris, Jonathan Ive for Apple, and Jasper Morrison in product design. A third generation, including El Último Grito, Gitta Gschwendtner, BarberOsgerby, and Thomas Heatherwick (fig. 36), has confirmed London's reputation for creative practice.

In terms of products and furniture, however, most design commentators would agree that Europe's most original design contribution of the late twentieth century came from The Netherlands. Indeed, many would argue that one of the most influential designers of the twenty-first century is the Dutchman Marcel Wanders, who established his career in the 1990s with the conceptual work of the design group Droog Design. Droog should be compared to the Milan-based Memphis group in the way it changed design thinking and practice. Unlike Memphis, which was a loose association of international practitioners, Droog (fig. 37) developed from a single source, the most influential postgraduate design school in Europe: the Design

37 ↑ →
The *Simply Droog: 10 + 1 Years
of Avant-Garde Design from
The Netherlands* exhibition,
Munich, 2004.

Academy Eindhoven in The Netherlands (fig. 38). Established in 1947 as AIVE (Akademie Industriële Vormgeving), Eindhoven remains small, with around sixty postgraduate students each year, but its alumni include some of the world's best-known designers, such as Hella Jongerius (fig. 41), Jurgen Bey, Tord Boontje, Job Smeets, and Richard Hutten. Promotion is the key to the Eindhoven strategy, with graduate work presented at the Milan Salone Internazionale del Mobile (Milan Furniture Fair) each year (fig. 39). In 2005, for example, the New York design store Moss invited Eindhoven graduate Maarten Baas to hold a one-man exhibition featuring his burned furniture. Dutch design continues to lead innovative practice.

In the 1980s, the design reputations of more established European countries also shifted. Scandinavian designers in Finland, Norway, and Sweden no longer led innovation, although the strength of their heritage brands remained strong. The Finnish textile company Marimekko, for example, relaunched Maija Isola's bold floral fabrics of the 1960s. The enduring popularity of iconic Finnish brands Iittala and Artek was also given a contemporary twist by a younger generation of designers. In 2005, Iittala worked with young designers Aleksi Perälä and Camilla Kropp, while for the Milan Furniture Fair of 2007, Artek commissioned an innovative building made out of paper tubes from Japanese architect Shigeru Ban, under Tom Dixon's art direction.

Scandinavian design also retained its enduring status as one of the most popular design styles for the contemporary home, an aesthetic unchanged for fifty years and a style captured in twenty-first-century property brochures all over the world. A photograph in *Ideal Home* from 1951, of the sitting room of two rising stars of British design, Robin and Lucienne Day, shows the look. Natural wooden floors and loosely woven curtains and rugs, combined with carefully selected designer objects and ethnic souvenirs, including a wire Eames chair, a Finn Juhl wooden bowl, and architect-designed lighting by John Reid, still suggest an almost contemporary interior.

In the twenty-first century, the fact that Scandinavia remains the defining influence on the international home is due to IKEA. IKEA is a lifestyle phenomenon, the most popular furniture store in the world and unique in the sector as a European brand successful across America (first store opened in 1985), China (1998; fig. 40), and Russia (2000). The American publishing company Forbes documented the statistics of this success in 2004. They named IKEA's founder, Ingvar Kamprad, as one of the richest men in the world, and the company's turnover as $16.4 billion per annum, with more than 250 international stores and rising. IKEA's roots were much more

38 ↑
The Design Academy Eindhoven. A former Philips light bulb factory, its white color has earned it the name "De Witte" (White Lady).

39 ←↙
Two advertisements for *Tales from Eindhoven*, an exhibition of eight Eindhoven-based designers and collectives held at the Milan Furniture Fair of 2007.

modest. It was founded in 1947 by Kamprad in his hometown of Almhult in rural southern Sweden. Very quickly, however, his first European stores defined the IKEA style: flat-pack furniture using natural wood and strong colors, with a strong Scandinavian identity derived from existing classics, at low prices. These early stores also defined the winning IKEA retail experience, inviting consumers to buy from large warehouse structures with limited sales staff but with a high-profile catalog and website. IKEA is not the only successful global Scandinavian brand; the Finnish company Nokia is a world leader in mobile telephones and communications, and the company's emphasis on the use of design, in user interfaces and casings, has made Nokia mobile telephones the world's most popular handsets, ahead of those of such competitors as Samsung, Motorola, and Sony. Until the 1990s, however, innovative work from a younger generation of Scandinavian designers was scarce. The Scandinavian design practice Snowcrash changed this perception with an installation at the Milan Furniture Fair of 1999, which moved from nature to explore shipbuilding and transport materials, creating a new image of what Scandinavian design could be (fig. 42).

Italian design continues to be a driving force, but it offers a more complex reading of European design. First, some of the designers who built the reputation of Italian design from the 1960s onward have enjoyed remarkably long careers, a generation that includes Gaetano Pesce, whose *Ghost* chair of

40 ←
An IKEA store opens in Chengdu, China, in 2006. The Chengdu branch was the fourth to open in the country, following stores in Beijing, Shanghai, and Guangzhou.

41 ↓
Hella Jongerius
Dutch (b. 1963)
Polder Sofa, 2005
Polyester, wool, horn, mother-of-pearl, shell, and bamboo
Mfr: Vitra AG
39¼ × 130¾ × 30¾ in.
(99.7 × 332 × 78 cm)

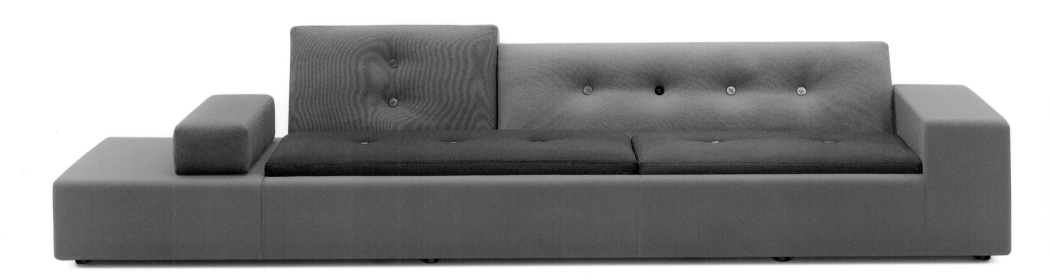

42 ↓
Front Design
Swedish (Sofia Lagerkvist, Anna
Lindgren, Katja Sävström, and
Charlotte von der Lancken)
Rat Wallpaper, 2003
Paper
Mfr: Front Design and rats
393¾ × 21⅝ in. (1000 × 55 cm)
(length × width)

43 → ↘
The Milan Furniture Fair, which
takes place in various locations
across the city, is one of the
most important trade events on
the design calendar. In 2007, it
attracted more than 270,000
international visitors.

44 → →
Martino Gamper
Italian (b.1971)
Back Issue Chair, 2006
Existing wood chairs
Mfr: Martino Gamper
19¾ × 19¾ × 26⅜ in.
(50 × 50 × 67 cm)

2007 represents an unbroken line of four decades of experimentation with expressive sculptural forms. Milan also remains the capital of design, and the Milan Furniture Fair (fig. 43) remains the key event for identifying new industry and style directions (fig. 44). Held every spring, the fair has expanded over the last decade to include the Zona Tortona, an industrial area in the south-west of the city, and its industry status remains unsurpassed.

What has changed is that, since the 1980s, the "Italian-ness" of Italian design has been marked by the increasing internationalization of companies and designers. Although Italian design manufacturers appear to dominate the design world, consider the example of the furniture retailer Poltrona Frau, which owns Cappellini, Cassina, Alias, Gufram, and Gebrüder Thonet Vienna. Its designers are not Italian but European, ranging from Arad to Morrison, BarberOsgerby, and Wanders.

Such changes reflect parallel shifts in other sectors that have traditionally defined national design, such as the couture houses of Paris. In the 1990s, French fashion turned to British fashion designers, such as McQueen, Galliano, and McCartney, to increase profitability. French design is another key element within the bigger European picture, dominated from 1985 by the presence of the massive figure of Starck, now the most famous designer brand-name in the world. The formidable output of his French studio from the mid-1980s, which still continues, has assured his position as the most famous European designer of his generation. Stepping out of Starck's shadow, however, is a high-profile second generation of French designers, including Patrick Jouin and the Bouroullec brothers, Ronan and Erwan. The reality of European national design identities would become even more complex in the twenty-first century.

European design in the twenty-first century: new technologies and sustainable development

At the start of the twenty-first century, issues bigger than national identities now dominate both European and international design. First and foremost of these is the modern environmental crisis of global warming (figs. 45, 46). Secondly, 85 percent of the world's energy is consumed by 25 percent of the world's population, and increasingly this unfair distribution of resources is being challenged. Thirdly, governments and societies are changing patterns of consumption and producing high levels of waste. Design's potential to tackle these issues is becoming more widely recognized and increasingly placed at the center of the solution.

Over the last forty years, some of the most influential commentators on such environmental issues have come from America. Writers in the US

critiquing the problem of consumption range from Vance Packard to Rachel Carson, Richard Buckminster Fuller, and Naomi Klein. The first important European voices emerged in the 1980s; seminal in this regard was a book by the British economist E.F. Schumacher, *Small is Beautiful* (1971), about manageable economies of scale. Other European publications that have helped to shape the debate include Victor Papanek's *Design for the Real World* (1971), published in the UK by Penguin Books, translated into twenty-three languages, and still one of the world's most widely read books on design. Although Papanek was American, he spent most of the 1980s working and teaching in Europe, for such clients as Volvo, and Salford University in England. The central arguments in *Design for the Real World* still resonate in European design today, none more strongly than Papanek's belief that the designer should have an ethical position and a sense of social responsibility above the potential to increase profit.

Papanek argued that design should be sensitive to local resources and cultural practice. In doing so, he anticipated the emergence in the 1990s of Appropriate Technology. He offered the modern template for sustainable growth through supporting the local economy and using locally sourced materials to sustain a diverse skills-base in the community. Papanek's legacy for European environmental thinking is the leap from "Green" as a personal lifestyle choice to the more complex actions of governance. His views about design are no longer at the margins but have been integrated into the mainstream as a holistic approach to global resources, people, economics, and trade, under the term "sustainability," a word adopted internationally from a United Nations publication, *Our Common Future in Europe* (1985). Contemporary design practice has also progressed from a single environmental issue to a situation in which each stage of the design life-cycle is researched in painstaking detail under new professional activities called Design for Disassembly (DfA) and Design for Recycling (DfC).

The most important of the European initiatives concerning sustainability has been a series of EC legislative sustainable policies, which directly impact on design. The EC Waste Electrical and Electronic Equipment (WEEE) Directive, for example, requires manufacturers to design goods so that they can be recycled, and retailers to take responsibility for the disposal of such items, including televisions, refrigerators, and computers. These changes in legislation should also be seen alongside a growing European interest in sustainable futures, particularly in Northern Europe. Since the 1980s, this interest has led to a variety of outcomes, including the bestselling *The Green Consumer Guide* (1989) by two British consultants, John Elkington and

45 ↑↑
Tony Blair, former prime minister of the UK, at the close of the G8 Summit of 2005 held in Gleneagles, Scotland. Climate change was one of the main items on the summit's agenda.

46 ↑
Icebergs in Disko Bay, Jakobshavn, Greenland. As a consequence of global warming, the Jakobshavn glacier is shrinking at a rapidly increasing rate and contributing to rising sea levels.

Julia Hailes, which sold 1 million copies worldwide and spent forty-four weeks on UK bestseller lists. Europe has also seen a steady increase in popular support for Green issues, alongside individual and radical voices, such as the British scientist James Lovelock and his books on climate catastrophe, *Gaia: A New Look at Life on Earth* (1979) and *Revenge of Gaia* (2006). Other powerful voices supporting the environment have included that of UK retailer Dame Anita Roddick, whose chain The Body Shop was an early pioneer of recycled paper and refillable containers for beauty products.

European designers also started to respond to this growing need for change. In the 1980s, recycling emerged as a new-wave British design theme around graphics, fashion, and furniture. Arad, for example, who went on to open the influential One Off showroom in London, launched his career with a range of chairs made partly from old leather car seats. Other designers experimented with the same aesthetic, including Tom Dixon and his ongoing experiments with scrap metal, but it must be said that recycling in these contexts remained an aesthetic rather than a sustainable solution. By the 1990s, all this started to change, and European designers began to engage with recycled materials (recyclates). Early pioneers included the UK designer Jane Atfield. Atfield's *RPC-2* chair (1995) was one of the first designs to use recycled material made by Smile Plastics, which compressed discarded plastic bottles, vending cups, yogurt pots, banknotes, and toothbrushes to form distinctive colored sheets.

In the twenty-first century, recycling continues as a strong European design theme in the work of Jurgen Bey of the Dutch design group Droog Design, who creates outdoor garden furniture from compressed garden waste, which at the end of its life can be broken down and returned to the compost heap. More importantly, sustainability has shifted from a personal ideology to a research and development process at the center of economic success. European design companies are looking at local and global responsibilities, and social design is slowly moving up the agenda. Philips, for example, is pioneering such projects as the Philips Innovation Campus in Bangalore, India, to enable communities to access technology.

The multimedia fusion of mobile telephones, computers, and television has transformed the world at an incredible speed. We live in a technologically driven era, and it is no surprise that another great issue facing twenty-first-century design is technology. From 1985, the two component parts of the IT industries—computers and telecommunications—revolutionized both the process and the production of late twentieth-century design. In less than ten years, new technologies had displaced and dismantled existing design processes across a whole range of creative disciplines. In Europe, the initial impact of this new technology was more significant in northern than in southern countries; but in spite of these geographical differences, the speed and extent of change amounted to a revolution. Product design, for example, was profoundly changed by the widespread introduction of CAD (computer-aided design). CAD offered product designers access to software expensively developed a decade earlier for the aerospace and automobile industries, and its impact on design was radical.

The first CAD "desks," as they were termed, started to appear in UK product design practices, such as Hollington Associates, from 1985. Until this point, the industry norm was to use trained draftsmen, working in formal studios, to visualize design concepts, drawing up by hand the detailed plans of products and the machines required to manufacture them. It is hard to remember that, as late as the early 1990s, the designers at such well-known European design companies as Philips in The Netherlands, Cassina in Italy, and Nokia in Finland used Rotring pens and traditional sloping drawing boards. Computer-aided design, however, was not simply a change in studio practice; it also offered the potential for standardized production in the global market and the ability to get products into retail stores faster and more cheaply. In the twenty-first century, virtually all European consumer goods are now produced using a CAD system at the visualization and rapid prototyping stages. In the 1980s, CAD capabilities developed from simple two-dimensional drawings to programs ranging across freeform surface modelling, with the output of data straight to manufacturing facilities or rapid prototyping for industrial modules. Typically today, a product might be designed and developed in London, manufactured in China, and shipped direct to America.

Each of the design disciplines responded at different levels to the potential of CAD, from machine pattern-cutting for the fashion industry to new levels of visual analysis for interior design, including fly-through techniques and easier access to working drawings with detailed structural specifications. Nowhere was the impact of computers felt more keenly than in the graphic design and printing industries, which had formerly involved a series of specialized tasks, such as font design, layout, and typesetting. Technology now combined these into streamlined processes, described by a new 1990s term, "desktop publishing," and centered around the use of software to design typeset-quality documents for commercial printing. Driven by technology, new professions have also emerged; digital or screen designers are now the most powerful element of the customer experience (fig. 47).

At the same time, technology was also transforming the visual appearance of design. Advances in microprocessing meant that the basic operations of a computer were now contained in a single chip, liberating form from function. European designers were quick to explore the potential of new interfaces between the person and the machine. Bang & Olufsen hi-fi systems, for example, combined advanced sound engineering with retro Modernist dials. Virtually unique in the industry, in the way it researches customer use and accessible screen layout, is Apple. Although it is an American company, its design guru, the British-born Jonathan Ive, has undoubtedly brought European influences to Apple's global success. Europe also contributed to world technology with the creation in the early 1990s of the World Wide Web by British designer Tim Berners-Lee. In 2004, Berners-Lee was awarded the inaugural Millennium Technology Prize to honor his innovative use of hyperlinks to navigate between different hypertext documents, or websites, created using HTML (Hypertext Mark-up Language); it is estimated that there are now 10 billion website "hits" every day. While the pages in a book are fixed, the text on a website is flexible and allows form and content to be separated in new ways. It was American programmers who began to develop more complex websites, creating such programs as Adobe Flash Player and changing the way designers communicate and practice.

The next stage in web technology has been termed "Web 2.0" and was developed in response to the global crash of dot.com businesses in 2001. Web 2.0 marks the emergence of a second generation of websites and web-based technologies that allow users to be more involved in the creation and sharing of content, for example through "blogs" (web logs) and social networking sites. Such social networks now involve more than 100 million users and are hugely profitable businesses that demonstrate the transforming social power of technological change. The majority are American sites, including Facebook, MySpace, YouTube, and Bebo (founded by a British entrepreneur based in California, Michael Birch). The impact of these American networks on the European market, with its linguistic and cultural differences, has highlighted the different design approaches to content. Such US sites as MySpace have been forced to launch localized versions in Britain and France, while European competitors, such as the Barcelona-based MyStrands, or MTVFlux, have used the interactive potential of Web 2.0 to combine social networking with music and video.

This diversity is a useful reminder that inquisitive humans also drive technology, and in this regard Europeans have proved themselves highly receptive. The UK, for example, boasts the world's highest market penetration for mobile telephones, at 100 percent, and Europe leads research into the complex landscape of mobile telephone use. Nokia is exploring the concept of "geolocation," which factors in social patterns of use: text messages sent to a young professional at 8 am on a Monday morning, for example, would be very different from those sent at the end of the working week on a Friday evening.

While the full impact of these emerging technologies on European design has still to be felt, other fields making their mark include those of nanotechnology, biotechnology, smart materials, virtual reality, and biomimicry. Nanotechnology is an umbrella term that covers a wide range of scientific activities carried out at very small, even molecular, scales, the outcomes of which will affect every sphere of our lives. Research and development in this area is best seen as a global endeavor, rather like advances in medicine or surgery. Nonetheless, European research is making significant contributions. The electronics giant Philips is conducting research projects into applications of technologies at the nano scale, including high-resolution printed displays, while chemists at Italy's University of Bologna have constructed a molecular motor of nanometer size that does not consume energy. These new technologies are also blurring the practice boundaries for scientists, designers, and makers, and opening up possibilities that promise to shape the design agenda of the future.

47
Daniel Brown
British (b. 1977)
Flower Series, 1999
Digital animation

European Design
Since 1985:
Art or Industry?

R. Craig Miller

n order to undertake a critical assessment of European design since the mid-1980s, it is essential to refer back to a larger historical context, always juxtaposing the present with the past. Indeed, one may begin by asking a fundamental question: what is the position of the designers under consideration in the larger Modern Movement? For unlike the decades between the world wars, this era in Europe has experienced few cataclysmic social, political, aesthetic, or technological upheavals that would radically affect design (that is, until the global economic crisis that ensued in the fall of 2008). Rather, it has been an uncertain, transitional time leading into a new century, not unlike the previous *fin de siècle*. There have been no predominant aesthetic movements led by towering figures but instead a myriad of manners, often quite eclectic in nature. Therefore, this has been, in many respects, an era of evolution rather than revolution.[1] Indeed, one may argue that designers are now living in a post-industrial culture and are faced, in no small part, with the formidable challenge of having to invent a groundbreaking conceptual and aesthetic basis for a design field transitioning into a new millennium.[2] Europe has, however, clearly remained the major center for innovations in design internationally. Thus the critical decades in question may be seen historically not only as a coda for the twentieth century but also as an important segue into a new polyglot century.

Some note should be made, however briefly, of a number of forces—influenced by the complexity of events during this period—that have shaped contemporary European design, for better or worse.

Political, economic, and social changes: globalization

Certainly one of the most pervasive forces has been globalization, in both a positive and a negative sense. With the incremental expansion of the European Union (EU), design became much more international, with a number of factors contributing to a lessening of a sense of national design identities.[3] For example, manufacturers in the mid-1980s began to hire foreign designers, with such countries as Italy and Spain leading the way.[4] Consequently, companies and designers increasingly began to create more of an international visual language for global markets. With the passage of the Bologna Declaration in 1999, students were free to attend virtually any educational institution throughout Europe. English more and more became the language for graduate schools as well as for international business. A number of design schools emerged as international centers: the Domus

Academy in Milan and the Royal College of Art in London during the 1980s and 1990s, and later the Design Academy Eindhoven in The Netherlands and ECAL (the University of Art and Design Lausanne) in Switzerland.

There was one curious anomaly in this global game. Given its enormous economic and military might as a superpower, the influence of the United States on European design, unlike in previous decades, decreased dramatically during this period, as was also the case with Japan.

Globalization has, however, generated a number of significant problems; and Europe has not been immune to international economic forces. In recent decades, it has lost a considerable amount of its manufacturing base; as a consequence, the role of a number of important corporations in the design field has been reduced. Major design companies, such as Orrefors, Royal Copenhagen, and Baccarat, which have design traditions that stretch back over several centuries and highly skilled teams of artisans, have struggled to define a new mission to survive in a global market against cheaper Asian imports. Likewise, major manufacturers, such as Olivetti, have gone through crises as a result of being bought up by international conglomerates for their brand-names or trademarks and have virtually ceased to exist as European businesses.[5] Smaller, but venerable, design companies, such as Venini, have gone through numerous owners and have struggled to maintain their artistic identity. Indeed, entire industries, such as the electronics companies, have been severely crippled all across Europe over the last decade.[6] For, in reality, as in other industrialized societies, fewer objects were actually being made in Europe; and, increasingly, countries had to rely on their technological or intellectual might—their "design power"—to stay competitive.[7]

Technological changes

Given the post-Industrial Revolution era in which we live, technology in recent years has not been the driving force in design that it once was. Perhaps the one notable exception is the computer and its many hi-tech offshoots, which have changed not only the method of design but also manufacturing. Designers have adapted in divergent ways. In the 1990s, Ron Arad transformed himself from a studio artist into an industrial designer. Tord Boontje, on the other hand, has used the computer to achieve handmade and very decorative effects.

Some new methods of manufacturing have been developed during this period. Blow, vacuum, and rotation molding, as well as rapid prototyping, have presented new possibilities to designers.

In terms of materials, a new generation of "plastics," including polypropylene and polycarbonate, has appeared. Designers have also used a variety of "sprayed" finishes, such as resin or rubber; and, although not new, such materials as carbon fiber and titanium have increasingly been employed.

With the passage of stringent EU guidelines, sustainable (or universal) design has become an important issue. The greatest effect of these regulations on the design field, however, has perhaps been more in terms of the materials chosen and the methods of manufacturing, rather than any major aesthetic impact.

Changes in the methods of manufacturing

Designers have continued to employ a variety of methods of construction, often simultaneously, in creating their designs. There are, however, three primary means of production in Europe today: industrial production by large manufacturers; limited production by influential design galleries or venerable design companies, where designers are creating objects made by exceptional artisans;[8] and studio production, with designers making largely handmade objects in their ateliers.[9] A number of European designers have also increasingly sought to dissolve the lines between art, design, and craft, as a new definition of craft emerged.

Changes in design leadership: Italy's new position

Italy has continued to be the "design capital" of Europe but in a different manner: today, it is the Italian system that is stronger than Italian design.[10] During this period, the Salone in Milan very much remained the most influential design fair in Europe, where major new designs were introduced and young designers were discovered. However, Italy was no longer producing the seminal European designers, given the shadows of such leaders as Achille Castiglioni and Ettore Sottsass.[11] Rather, it was the Italian manufacturing base that kept Italy at the forefront of contemporary design, for many of the Italian companies had a tremendous technological edge over their European counterparts.

Another contributing factor is that a number of the most innovative Italian companies continue to be run by "renaissance princes," who believe in pushing the boundaries of design and in fostering a remarkable collaboration between the designer and industry.[12] Indeed, they take great pride in discovering and building the careers of emerging talent:[13] one has only to cite such examples as Alberto Alessi Anghini at Alessi, Ernesto Gismondi at Artemide, Giulio Cappellini at Cappellini, Enrico Astori at Driade, Claudio Luti at Kartell, and Eugenio Perazza at Magis. These are the individuals and companies that have shaped European design in no small part during this era.[14]

Changes in the public perception of design

In recent decades, there has also been a greater awareness of the important role that design plays in European culture, as well as a more prominent role for the designer in that society. A number of factors have been involved here.

One of the most troubling developments, resulting from the fact that we are living in a global information age, has been the power of the media in driving European design. A host of new publications—*Blueprint* (1983), *Frame* (1997), *Icon* (2003), and *Wallpaper** (1996)—appeared during this period, showcasing for the general public the latest developments in design. But the media can become a double-edged sword. One is reminded of the old adage: "There's nothing that beats the combination of ability and publicity."[15] The media can make the careers of young designers, such as Ora Ito in Paris; and it can also take its toll on major designers, such as Marc Newson. Young designers can now find themselves under increasing pressure to find a "gimmick" that will attract instant media attention, instead of giving themselves sufficient time to learn their trade properly and grow as artists.[16] Equally disturbing is the fact that design movements are often regarded as being *au courant* for only five or seven years, a phenomenon driven by a media that is constantly searching for what is new or fashionable.

Furthermore, the counterbalance provided by art museums has been diminished; during certain years, it has been noticeably absent.[17] Historically, these institutions have been instrumental in setting standards for the field, providing a more scholarly perspective on current events and helping to educate the general public.

While the architect–designer has traditionally played a major role in contemporary design, it was only in the mid-1980s that the designer *per se* really emerged in Europe as a professional.[18] The 1980s were also marked by a growing awareness among the public and governments in Europe of the importance of design.[19] This was spurred, in no small part, by the emergence of the "superstar" designer. Philippe Starck was perhaps the first designer of this era to achieve a "rock star" status. Having worked initially in the fashion industry with Pierre Cardin, Starck created a hip public persona for himself, with his blue jeans, black leather jacket, and motorcycles. His image appeared throughout his own publications, and the highly stylized manner

in which his designs were photographed evoked the sexually charged fashion ads of such designers as Calvin Klein. Indeed, Starck was also one of the first designers to understand the growing globalization of design. From the very beginning of his career in the 1980s, Starck's goal was to work for international companies; ultimately, he succeeded in creating a highly individualized style that became a recognizable brand-name. Thus Starck was quite instrumental in fostering the whole idea of a "European design," in which designers could transform themselves into international figures working in many countries. In many respects, therefore, he has proved to be the "800-pound gorilla" of his generation.

Starck is a prodigious talent. Like the late American architect Philip Johnson, he has an uncanny ability to anticipate the next trend in design. But there has been a reckless aspect to his tumultuous and immensely influential career; and, as we shall see, these ups and downs became symbolic of the accomplishments—as well as the problems—of European design in general during this era. Moreover, with his superstar status, Starck has become the quixotic role model for many younger designers in the last few decades, as can be seen in the careers of such individuals as Marc Newson and Matali Crasset.

Changes in our perceptions of major conceptual movements: the Modernist tradition and the Postmodernist tradition

Penny Sparke has clearly outlined in her essay that there were two major conceptual movements in European design after the Second World War: a Modernist tradition and a Postmodernist tradition. Perhaps one of the most important goals of *European Design* is to place the multifarious developments in contemporary European design into some kind of straightforward historical framework, joining the present to the immediate past. Thus, looking back, it was widely believed that the Postmodernist movement came to an end with the dissolution in the early 1980s of such Italian design groups as Studio Alchymia and Memphis. In reality, two aspects of Postmodernism—Decorative design and Expressive design— continued well into the 1990s. But in the mid-1980s, there was clearly a powerful Modernist reaction, which took three directions: Geometric Minimal design, Biomorphic design, and Neo-Pop design. Postmodernism was not, however, just a style but presented a new conceptual basis for design, one that sought to change life and society fundamentally. Ironically, both Alchymia and Memphis would ultimately prove to have deep roots; and it was Postmodernism's ideas regarding design and culture that would be

revived in the mid-1990s. This Postmodernist resurgence led to three new movements—Conceptual design, Neo-Dada/Surreal design, and a Neo-Decorative design—that are now driving European design in new directions. The following schematic framework outlines, in a rather concise manner, these major actions and reactions in European design during the last few decades:

Postmodernism
Decorative design • Expressive design

Modernism
Geometric Minimal design • Biomorphic design • Neo-Pop design

Postmodernism
Conceptual design • Neo-Dada/Surreal design • Neo-Decorative design

The eight movements outlined above are not meant to be rigid, black-and-white divisions but rather suggestions as to how one might begin to impart a sense of structure to a complex story that is still evolving—preliminary answers, if you will, to the questions of "who," "what," "where," "when," and the more elusive "why" European design came to be what it is today. Thus there will be many shades of grey in the analysis that follows; and designers will appear in multiple sections, to reflect the development of their careers. Even within the larger eight sections, there will be sub-movements that will help to elucidate the nuanced differences in each designer's individual response to prevailing conceptual or aesthetic ideas.[20] It is altogether a remarkable story, one that demonstrates not only the ever more powerful role that design plays in European culture but also Europe's unabated leadership in contemporary international design.

Decorative Design

Concept

In reaction to a Modernist resurgence in the mid-1980s, an ongoing Decorative movement sought to continue a historicizing or decorative tradition in design. This Decorative manner is thus a late manifestation of Postmodernism—an afterglow of Alchymia and Memphis, if you will—but one that is more stylistic than strongly conceptual in nature.

The Decorative mode sought, first of all, to open up the parameters of the entire field of design. But it was also one of the first manifestations of globalization in design: manufacturers hired international designers; national boundaries were being dissolved; and designers began to be fêted as superstars or brands in their own right, self-consciously creating public personas for themselves and making highly individualized objects that became identifiable to the public.

There were four subcategories within the larger Decorative design movement: traditional Decorative design; Baroque Decorative design; industrial Decorative design; and vernacular Decorative design. These variations demonstrate the richness and diversity that existed within this aesthetic approach.

Style

Designers working in the Decorative tradition were often preoccupied with either the traditional *objet de luxe* or, conversely, vernacular forms. Thus they self-consciously approached their work as either "high" or "low" art and used a broad range of media, from the luxurious to the industrial or even the vernacular. There was a notable revival of interest in pattern, ornament, and rich color, while the objects themselves ranged from the handmade and limited-edition to the mass-produced.

Time and Place

The Decorative design movement was at its height from the mid-1980s to the 1990s and was international in its influence.

48 ↑
Bořek Šípek
Czech (b. 1949), resided
The Netherlands
Novotny Vase, 1992
Glass
Mfr: Ajeto
20⅛ in. (51 cm) (height)

49 →
Philippe Starck
French (b. 1949)
J. Serie Lang Armchair, 1987
Aluminum, steel, and leather
Mfr: Driade S.p.A.
33⅞ × 23⅝ × 26 in.
(86 × 60 × 66 cm)

By the mid-1980s, with the dissolution of such design groups as Alchymia and Memphis, Postmodernism was widely perceived as being somewhat *passé*. In reality, a number of vibrant variants continued well into the 1990s, including a strong Decorative design tradition. While both Alchymia and Memphis were based on a highly theoretical framework, this Decorative movement was perhaps a little less orthodox and more of a stylistic mode, albeit a multifarious one. There were at least four manifestations within this larger Decorative design movement that were influential in many countries across Europe: a traditional Decorative design; a Baroque Decorative design; an industrial Decorative design; and a vernacular Decorative design. In many respects, Philippe Starck and Bořek Šípek would ultimately prove to be the most significant individual designers, albeit in very different ways; but neither of them would exert the commanding leadership role of an Alessandro Mendini or Ettore Sottsass, which perhaps accounts for the polyglot character of this movement.

Traditional Decorative design

Starck began to produce designs of note in the early 1980s,[21] but his mature work dates from the middle of that decade. Indeed, given his enormous international reputation today, it is important to note that, in the mid-1980s, Starck was still very much a *Wunderkind* in the making. Like many young designers before and since, he was in the process of creating a style and persona for himself.

In these early years, Starck was concerned with overtly historicizing forms; and his vocabulary drew on traditional French decorative arts. Indeed, his importance in this period was as a chair designer.[22] Starck was designing sophisticated upholstered forms using rich woods and leather, often with metal frames; but there was a simplicity to this work. His designs were far more restrained in terms of form, color, materials, and detailing than those of Memphis, for Starck was adapting his historical forms for limited production. Accordingly, he was using simple technology and construction in his early designs; he was not designing deluxe, handmade objects that would require the skills of the finest Parisian artisans, nor was he working through such chic galleries as Galerie Neotu in Paris. Rather, Starck, from the beginning, was working for manufacturers, although, at that time, Baleri Italia and Driade were relatively small firms. Moreover, there did not seem to be any particularly strong conceptual or intellectual underpinning to Starck's work, in contrast to that of more senior Postmodernist designers such as Robert Venturi or Alessandro Mendini.

As noted earlier, Starck also began to develop his "rock star" status at this time and ultimately became the first European designer of this era to be regarded as a "superstar." The fashionable, trend-setting public persona Starck created for himself would make him the "darling" or "bad boy" of the press. His publications were filled with provocative images of himself, and his designs were photographed in a highly stylized manner that sets his work apart from other designers of his generation (fig. 50). Starck, in short, created a controversial (and newsworthy) image for himself.

Finally, Starck was determined to make his mark in virtually every design medium. He received a great deal of attention for his highly theatrical interiors (cafés, boutique hotels, restaurants, *etc.*)

Philippe Starck
French (b. 1949)
Pratfall Lounge Chair, 1982–85
Steel and leather
Mfr: Driade S.p.A.
31½ × 20⅞ × 18⅞ in.
(80 × 53 × 48 cm)

The *Pratfall* chair is typical of
Starck's prodigious early work
as a designer of seating. There
is a simplicity and richness in
his use of traditional forms
made of wood and leather with
metal frames.

52 ↘

Philippe Starck
French (b. 1949)
J. Serie Lang Armchair, 1987
Aluminum, steel, and leather
Mfr: Driade S.p.A.
33⅞ × 23⅝ × 26 in.
(86 × 60 × 66 cm)

The *J. Serie Lang* chair is a
more complex and sculptural
design than the *Pratfall* lounge
chair (fig. 51). Here, Starck is
playing with a sophisticated
upholstered form dramatically
balanced on a single rear leg.

53 ↗↗

Sylvain Dubuisson
French (b. 1946)
L'Aube et le temps qu'elle dure
Side Chair, 1987
Aluminum and leather
Mfr: Sylvain Dubuisson
31⅞ × 13 × 16⅝ in.
(81 × 33 × 42 cm)

In contrast to the bravura
often seen in Starck's work
(figs. 51, 52), there is a quiet,
elemental elegance to
Dubuisson's designs. This
side chair is the essence of
simplicity in terms of form but
requires the most extraordinary
craftsmanship to construct.

and, later, for his architecture. Thus Starck at this time became an exemplar of the Decorative design movement, which was perhaps most prevalent in France, with its long decorative tradition.

The primary focus of French traditional Decorative designers was on the *objet de luxe*, drawing on historicizing forms, luxury materials, and traditional craftsmanship. The careers of Starck, Sylvain Dubuisson, and Olivier Gagnère are perhaps most indicative of the multifarious design profession in France.

Starck is a professional designer, and two chair designs are indicative of the early phase of his prolific career. Both pieces draw on traditional eighteenth-century *bergère* forms, but Starck's interpretations are remarkably original.[23] The back of the commodious *Pratfall* chair (1982–85;

fig. 51) has a bentwood frame of rich mahogany; it also has a painted tubular steel frame with three legs, which would become a trademark of Starck's work. The only truly traditional motif is the upholstered leather seat. The *J. Serie Lang* armchair (1987; figs. 49, 52) is a more petite but original design. Starck has created a sleek, continuous upholstered form, extending from the "front legs" to the back panel. Again, he balances the composition on a single, sculptural, rear leg of aluminum. The detailing of the proportions and upholstery is masterly.

Dubuisson is an architect–designer whose designs are even more luxurious, recalling the work of such French Art Deco and Moderne masters as Jacques-Emile Ruhlmann and Pierre Chareau. The *L'Aube et le temps qu'elle dure* side chair (1987; fig. 53) appears at first glance to be a simple metal form, but closer examination reveals an aluminum frame with the most refined composition of curves culminating in a subtle, curved crest rail. The whole is then upholstered in a thin layer of leather. Dubuisson's *1989* desk (1989; fig. 54) is an even more complex play of curved and tapered forms, covered in parchment with a leather inset, an update of a traditional French bureau.[24] Both designs require the most exceptional craftsmanship and are quintessential examples of the *objet de luxe*.

Gagnère is a decorator–designer. His elegant *Feutre* table (1988; fig. 55), with its chiseled wood surface, refined proportions, and decorative detailing, draws on the sensuous work of Jean-Michel Frank.

This kind of traditional Decorative design was quite pervasive during the late 1980s, and two other design studios are worthy of note: Martin Szekely and Berghof, Landes, Rang. Szekely's *Presse-Papier* case piece (1986; fig. 56) is an update of a Louis XVI

writing cabinet; it is a witty, elegant play of graceful curves made of MDF, an industrial material.[25] Berghof, Landes, Rang was one of the few German design firms to successfully embrace an overt kind of Postmodernism. Its designs, such as the *Frankfurt Series: F1* cabinet (1986; fig. 57), are highly architectonic and superbly crafted from the finest woods, marble, ivory, and gold leaf.

A similar luxurious and refined approach can be seen in a selection of smaller decorative *objets*. Gagnère's *Arita* fruit bowl (1992; fig. 58) is an elegant composition of geometric forms embellished with lush color and decorative motifs. Anna Gili's exuberant *Canneto* vase (1998; fig. 59) recalls the colorful stripes of post-Second World War Venetian glass. Black-and-white stripes with gilded highlights are the primary design motifs used by Gagnère in his chic *Galerie Royale Black*

54
Sylvain Dubuisson
French (b. 1946)
1989 Desk, 1989
Parchment and leather
Mfr: édition Fourniture
28⅝ × 59¼ × 32½ in.
(72.5 × 150.5 × 82.5 cm)

This desk, like many of
Dubuisson's furniture designs,
is a masterful play of sculptural
curves utilizing sumptuous
materials and requiring the skills
of the finest French artisans.

55 ↓
Olivier Gagnère
French (b. 1952)
Feutre Table, 1988
Oak, felt, and iron
Mfr: Galerie Maeght
29½ × 53 × 29½ in.
(75 × 135 × 75 cm)

Gagnère's work consciously harkens back to French Art Deco and Moderne designs. Here, a simple rectangular form has been transformed into an elegant *objet* through the designer's discerning choice of materials, finishes, and detailing.

56 →
Martin Szekely
French (b. 1956)
Presse-Papier Cabinet, 1986
MDF
Mfr: Galerie Neotu
55⅛ × 22⅛ × 14¼ in.
(140 × 56 × 36 cm)

Szekely's work represents yet another distinctive approach by Postmodernist designers working within the French decorative tradition: he simplifies and refines traditional forms but executes them in quasi-industrial materials. In this instance, Szekely has produced a striking writing cabinet made of MDF.

57 → →
Berghof, Landes, Rang
German (Norbert Berghof, b. 1949; Michael Landes, b. 1948; Wolfgang Rang, b. 1949)
Frankfurt Series: F1 Cabinet, 1986
Wood, marble, ivory, and gold leaf
Mfr: Draenert Studio GmbH
89⅝ × 29½ × 15¾ in.
(230 × 75 × 40 cm)

Given the strong Neo-classical tradition in German design, it is rather ironic that Postmodernism did not have a greater resonance in Germany during the 1980s. Such firms as Berghof, Landes, Rang, however, did produce highly architectural designs that utilized elegant materials and exceptional craftsmanship.

58 →
Olivier Gagnère
French (b. 1952)
Arita Fruit Bowl, 1992
Porcelain
Mfr: Galerie Maeght
8¾ × 9½ in. (22 × 24 cm)
(height × diameter)

Inspired by the bold designs
of Memphis, Gagnère produced
an elegant series of ceramics
during the 1980s and 1990s
that was more overtly
historicizing and decorative
in its effects. With its interplay
of crisp geometric forms and
decorative motifs, the colorful
Arita bowl is one of his most
assured designs.

59 → →
Anna Gili
Italian (b. 1960)
Canneto Vase, 1998
Glass
Mfr: Salviati
9⅞ × 5⅛ in. (25 × 13 cm)
(height × diameter)

Drawing on the mid-century
work of such Italian designers
as Gio Ponti, the *Canneto* vase
is a tripartite composition
of vivid Venetian stripes
contrasted with a matte
horizontal band.

60 ↙ ↙
Olivier Gagnère
French (b. 1952)
Galerie Royale Black Tulip
Dinnerware, 1997
Porcelain
Mfr: Bernardaud
Largest: 15 in. (38.1 cm)
(diameter)

Bernardaud was one of several
venerable design companies
that gave new life to the
French decorative tradition. It
commissioned such designers
as Gagnère to create elegant
dinner services that used
historical forms and motifs
in original manners.

61 ←
Prospero Rasulo
Italian (b. 1953)
Narciso Urn, 1988
Porcelain and bronze
Mfr: Fine Factory
Lid: 14 × 16½ × 4 in.
(35.5 × 42 × 10.1 cm)
(height × width × diameter)
Urn: 12 × 9 in. (30.5 × 23 cm)
(height × diameter)

In his design for the *Narciso*
urn, Rasulo has juxtaposed
a traditional ceramic vessel
with a bold bipartite metal
finial. The dramatic contrast
of materials—white porcelain
and matte bronze—enhances
the subtle but monumental
composition.

Tulip dinnerware (1997; fig. 60).[26] Prospero Rasulo's *Narciso* urn (1988; fig. 61) is a dramatic composition that contrasts a traditional, white-porcelain urn with a flamboyant bronze finial.

Two designs in silver illustrate parallel trends in metalwork. Dubuisson's *L'Elliptique* dishwarmer (1987; fig. 63) is not so much a utilitarian object as a sublime composition of elliptical and tapered forms decorated with a pattern of holes. Nestor Perkal's *Buis* fruit bowl (1987; fig. 62) is a bipartite juxtaposition of a centerpiece on a raised base, which has been embellished with floral motifs and a punctuated pattern of holes.

When considering glass, perhaps the most imposing figure is Yoichi Ohira, a Japanese designer who works in Venice. For centuries, the Japanese have had a custom of subtly extending traditional forms and techniques with nuanced brilliance, an evolutionary versus revolutionary approach to design. In Ohira's case, he has simply chosen to immerse himself in the long tradition of Italian glassmaking to impart a poetic quality to his work.

Ohira's early work, from the 1970s and early 1980s, was a play on reinterpreting overtly historicizing Venetian glass forms. By the early 1990s, however, Ohira had found his mature style, which is illustrated in three examples of his work (1996–2000; figs. 64–66). Ohira's design approach is tripartite. First, he appropriates a series of traditional forms—for example, bottles with small necks, bowls, or vases.[27] Next, he selects his materials. Ohira's choices are very important: they allow him not only to create a color palette that can vary from monochromatic to brilliant hues but also to decorate his vessels with bold geometric or biomorphic patterns. Lastly, Ohira uses a multitude of glassmaking techniques to further embellish his pieces.[28] Other signature characteristics include his juxtaposition of opaque

62 →
Nestor Perkal
French, born Argentina (b. 1951)
Buis Fruit Bowl, 1987
Silver plate
Mfr: Algorithme
11 × 11¾ in. (28 × 30 cm)
(height × diameter)

For this centerpiece, Perkal has employed a traditional cup form and embellished it with a subtle pattern of leaves and holes. The result is a harmonious composition using sheets of silver-plated metal and two-dimensional ornament.

63 ↓
Sylvain Dubuisson
French (b. 1946)
L'Elliptique Dishwarmer, 1987
Silver-plated brass
Mfr: Algorithme
3⅝ × 11⅞ × 8¼ in.
(9 × 30 × 21 cm)

Dubuisson's mastery of monumental form is aptly illustrated in this diminutive piece of silver, an oval surface supported on wing-like pylons.

Yoichi Ohira
Japanese (b. 1946), resides Italy
A Mosaici (Cerchi) Vase, 1996
Glass canes and murrines
Mfr: Anfora di Renzo Ferro
7½ in. (19 cm) (height)

65 → →
Yoichi Ohira
Japanese (b. 1946), resides Italy
Autunno Damigiana Vase, 1998
Glass canes, murrines, and
powder inserts
Mfr: Anfora di Renzo Ferro
6½ in. (16.5 cm) (height)

66 ↘↘
Yoichi Ohira
Japanese (b. 1946), resides Italy
Pioggia d' Inverno Vase, 2000
Glass canes
Mfr: Anfora di Renzo Ferro
6⅞ × 5⅜ in. (17.5 × 13.7 cm)
(height × width)

These three glass vases
illustrate Ohira's seamless
amalgamation of Japanese and
Italian traditions. On the one
hand, the Japanese designer
is working within a formal
historical vocabulary; on the
other, he has also mastered an
astonishing array of Italian
glassmaking techniques, which
he uses to create original and
virtuoso surface effects.

and translucent glass to create "windows" in his vessels, his preference for powders to create more fluid compositions, and the contrast between matte and polished surfaces. Indeed, Ohira is one of the most sophisticated glass artists working in the Italian tradition; and his designs constitute some of the most luxurious objects made in Europe over the last two decades.

A comparison of two vases by major Postmodernist designers—Michele De Lucchi and Bořek Šípek—perhaps best illustrates the contrasting stylistic approaches that have been taken within the larger Decorative design movement. De Lucchi's *Bianco* vase (1990; fig. 67) is a monumental baluster form with a double base. An iconic example of traditional Decorative design, its power comes from its simplicity of shape and elegant proportions.[29] Šípek's *Novotny* vase (1992; figs. 48, 68), on the other hand, harks back to the exuberant Bohemian glass tradition through its complex composition, cut-glass handles and leaves, and rich color—a sumptuous Baroque design.

Baroque Decorative design

Indeed, of all the Decorative designers of this period, Šípek is perhaps the most original; in many respects, he is also the most radical Postmodernist after Ettore Sottsass.[30] Šípek is thus the most important leader of a group of designers whose work constitutes a kind of Baroque Decorative design. Šípek had the ability to work in almost every design medium; and in the 1980s and early 1990s, he produced an astounding array of new forms.[31]

In contrast to Starck's designs, there is a strong conceptual approach behind Šípek's work. His aim is to create highly sensuous objects, as opposed to anonymous, functional designs, that

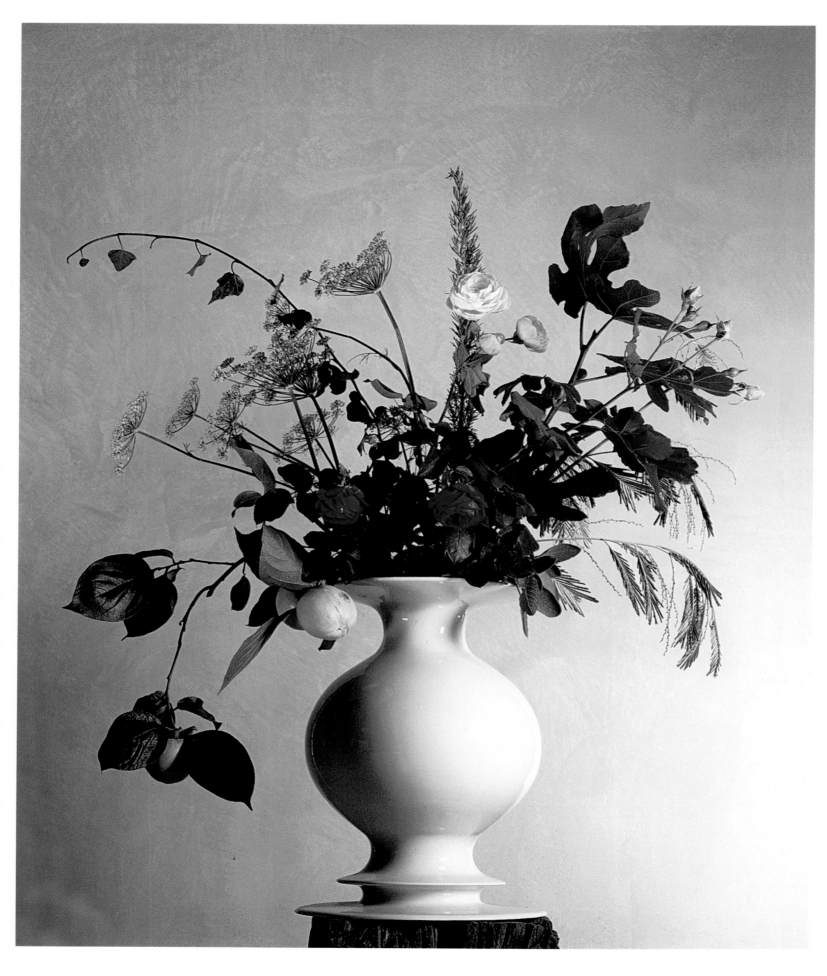

Michele De Lucchi
Italian (b. 1951)
Bianco Vase, 1990
Ceramic
Mfr: Produzione Privata
16⅝ × 11⅞ in. (42 × 30 cm)
(height × diameter)

De Lucchi's *Bianco* vase is a
symbolic expression of Italian
Postmodernism. The designer
has magically transformed a
Neo-classical urn or baluster
shape into an imposing vase
with a remarkable purity of
form, material, and proportion.

68 →
Bořek Šípek
Czech (b. 1949), resided
The Netherlands
Novotny Vase, 1992
Glass
Mfr: Ajeto
20⅛ in. (51 cm) (height)

In contrast to De Lucchi's
Bianco vessel (fig. 67), Šípek's
Novotny vase is a monumental
but exuberant design that
revels in its Baroque excess
of color, form, and decoration.

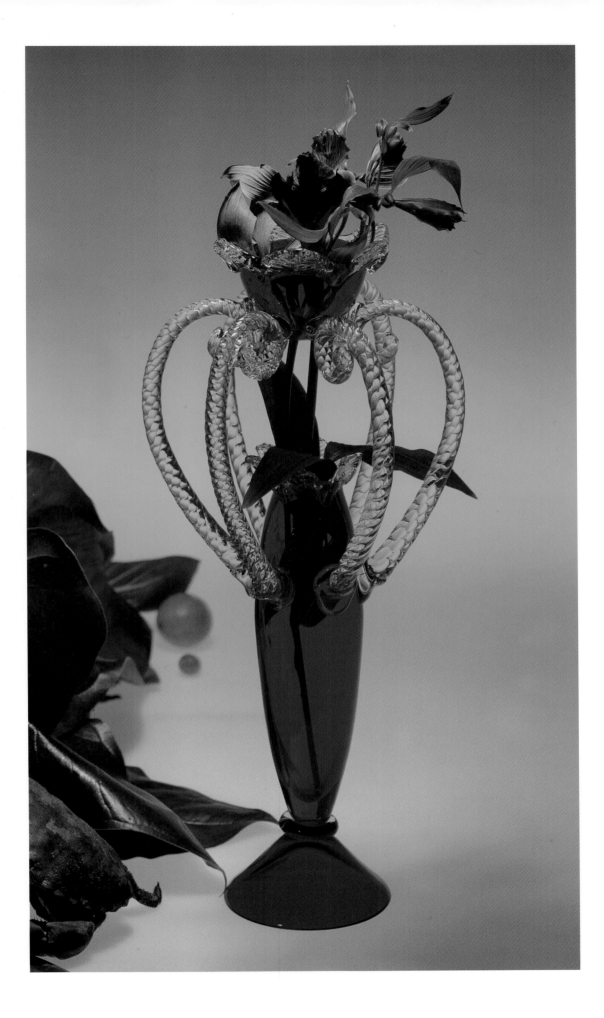

have a strong mythical or emotive quality. Šípek also believes that history provides an anchor against the changing technology of our society, hence his desire to capture a "magic" or "aura" in his objects. In addition, Šípek is seeking to create a new relationship between craft and decorative design, as can be seen in his choice of traditional— and, on occasion, even folk—motifs, colors, and techniques. He also gives his objects unusual names to further increase their emotive power. In terms of production, Šípek's work varies from limited-production items for such manufacturers as Driade in Italy (where price is a consideration) to exclusive pieces done for such galleries as Steltman in Amsterdam (an arrangement that offers greater freedom, since cost is less of a constraint).

Thus Šípek's work constitutes perhaps the most cogent representation of Baroque Decorative design. His *Luigi 1* chandelier (1989; fig. 70) is an apt example in glass and shows his continued experiments with complex and undulating compositions. The fixture is a swirling mass of colorful "branches" and lights, embellished with disks and leaves.

In his furniture designs, Šípek is seeking to reinvent a number of historical forms.[32] Characteristically, he favors a rich palette of materials, revels in complex detailing, and often creates a tension in his designs between curved and straight lines. This approach may be seen in the *Prosim Sni* chaise (1987; fig. 69), a new interpretation of a Recamier couch. Šípek juxtaposes a number of highly sculptural forms for the backrest, back panel, and wooden footrest. Likewise, being Czech by birth, he is fascinated by the tradition of Thonet bentwood chairs and often incorporates variations in his seating designs. The *Leonora* armchair (1991; fig. 71) is a play on a Thonet chair but is quite exuberant, with its

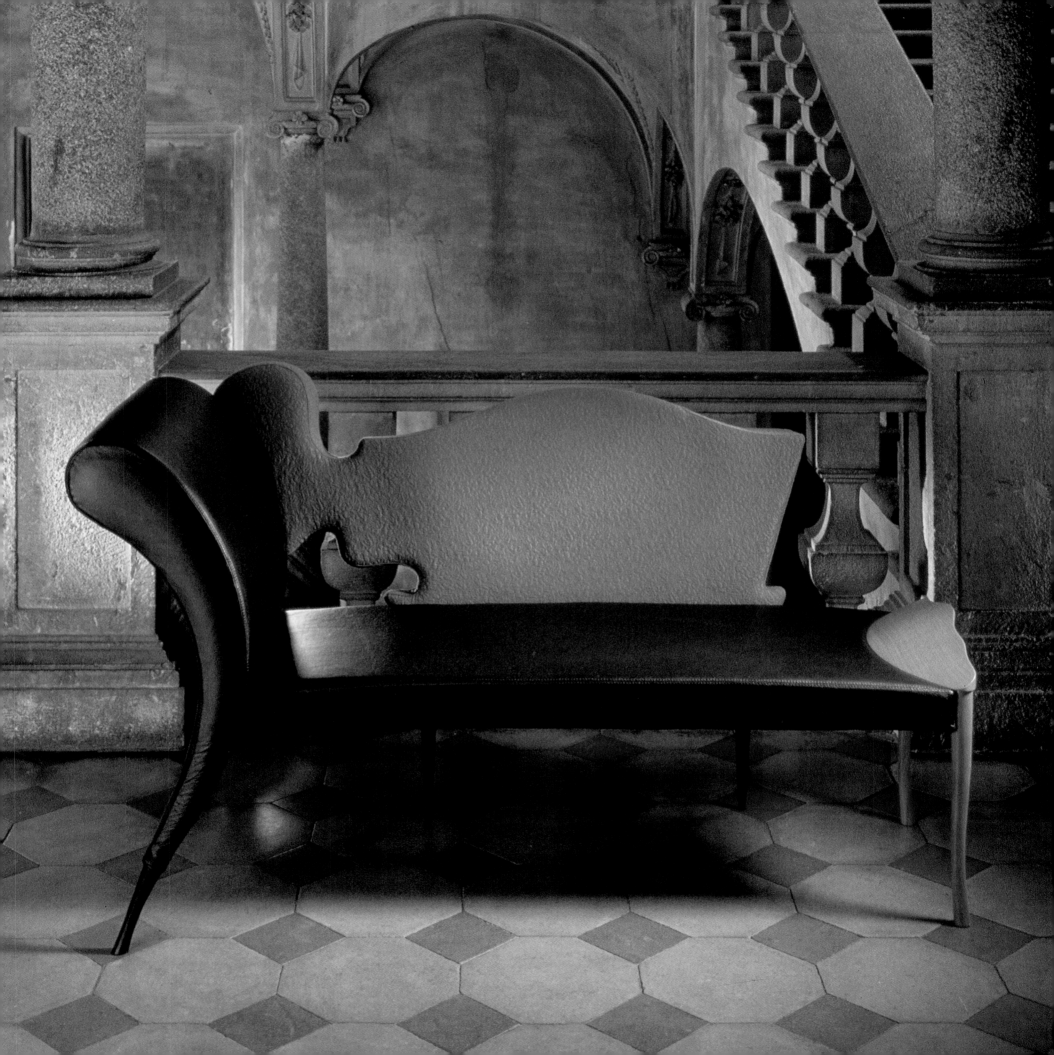

69 ←
Bořek Šípek
Czech (b.1949), resided
The Netherlands
Prosim Sni Chaise, 1987
Wood, leather, fabric, and steel
Mfr: Driade S.p.A.
39⅜ × 68½ × 33⅛ in.
(100 × 174 × 84 cm)

Such Postmodernist designers
as Šípek often like to reinterpret
historical forms—in this
instance, a Recamier couch—
in remarkable new ways. Here,
Šípek has combined highly
sculptural forms with a rich
palette of materials and colors.

70 ↖
Bořek Šípek
Czech (b.1949), resided
The Netherlands
Luigi 1 Chandelier, 1989
Brass and glass
Mfr: Driade S.p.A.
23⅝ × 19¾ × 31½ in.
(60 × 50 × 80 cm)

Šípek's Baroque aesthetic
extends into every medium.
For the *Luigi 1* chandelier, the
Czech/Dutch designer has
created an undulating and
intertwining mass of colorful
forms that draws on a rich
Bohemian glass tradition.

71 ←
Bořek Šípek
Czech (b.1949), resided
The Netherlands
Leonora Armchair, 1991
Wood and leather
Mfr: Driade S.p.A.
31½ × 20½ × 19½ in.
(80 × 52 × 49.5 cm)

The *Leonora* chair is a play on
a bentwood café chair: the rear
legs have been transformed
into sculptural side panels
with highly decorative black
cut-outs.

72 ↘
Bořek Šípek
Czech (b.1949), resided
The Netherlands
Steltman Side Chair, 1994
Plywood, wood, and leather
Mfr: Steltman Gallery
35½ in. (90 cm) (height)

Like the *Leonora* chair (fig. 71),
the *Steltman* side chair is a
new interpretation of a classic
Thonet bentwood chair. Šípek
has used a bipartite composition
much favored by designers of
this period, juxtaposing a two-
legged seating element with an
ornamental curved back panel.

elaborate side panels inspired by Czech folk art.[33] In the *Steltman* side chair (1994; fig. 72), Šípek breaks the form into two parts: a seat with two front legs, and a continuous curved back panel with decorative cut-outs.[34] Both designs depart from the conventional chair form of four legs, seat, back, and armrests.

Šípek's fascination with over-the-top Baroque forms was shared by a number of other designers during these decades, and Baroque Decorative design found itself in vogue in such cities as London and Paris. Garouste & Bonetti were among the most fashionable French decorators of this period, their work often bordering on the bizarre and exotic. The *Belgravia* commode (1990; fig. 73) is one of their more elegant (and restrained) designs, an elliptical wood form embellished with undulating iron decoration.[35] André Dubreuil is a

French designer who worked in London for a number of years, and his *Paris* side chair (1988; fig. 74) is a reinterpretation of an Empire form. This gutsy three-legged version is made of iron, and the leopard-like spots were achieved with the aid of a blowtorch.[36] The fascination with a Baroque Decorative design may even be seen in Scandinavia. Mats Theselius, for example, in his *Fatolji* armchair (1994; fig. 75), contrasted restrained forms with a rough palette of materials—in this case an iron frame, rawhide upholstery, and a wooden armrest.[37]

It was perhaps in his designs for glass, ceramics, and metalwork that Šípek was at his most imaginative and Baroque. Šípek reinvented traditional designs with startling originality, often employing interlocking forms with undulating elements at junctures. Indeed, Šípek and Ohira

André Dubreuil
French (b.1951)
Paris Side Chair, 1988
Iron
Mfr: A.D. Decorative Arts
33½ × 25⅞ × 31½ in.
(85 × 65.5 × 80 cm)

In the years since 1985, many Postmodernist designers have shown a great interest in three-legged chairs. Dubreuil's *Paris* chair is one of the more lyrical examples from this period: an iron chair with leopard-like spots.

75 →
Mats Theselius
Swedish (b.1956)
Fatolji Armchair, 1994
Iron, rawhide, and wood
Mfr: Källemo
27⅝ × 23⅝ × 24½ in.
(70 × 60 × 62 cm)

Theselius was one of the few Swedish designers to openly embrace Postmodernism; given his Scandinavian origins, however, his work is often more restrained than that of his European counterparts. The *Fatolji* chair is a subtle variation on a classic club chair, but it is the unorthodox choice of materials that imbues the design with a certain vigor.

respectively represent two great traditions in Western glass: "cut glass" (as seen in Eastern Europe) and "blown glass" (as seen in Italy and Scandinavia). They also illustrate two different design approaches: the architect–designer, who is often more inventive in terms of form, scale, and combinations of materials; and the glass designer, who works with more conventional forms but often has a greater mastery of material and technique.

In terms of their highly sculptural and irregular forms and cut-glass decoration, Šípek's *Enrico I–V* goblets and tumbler (1989; fig. 76) are a precursor to the *Novotny* vase seen earlier (figs. 48, 68). The *Brigitte* goblets (1990; fig. 77) are even more Baroque, with their swirling bowls and leaf-like garlands of glass. Šípek's *Simon* candelabra (1988; fig. 78) is an ambiguous form: it can serve as a candle holder, with its undulating branches

with double bobeches; and it can also function as a vase for sprays of flowers.[38]

In other Šípek designs, overt historical references are more discernable. The *Albertine* dinnerware (1988; fig. 79) features some of Šípek's most sculptural and irregular forms, and the blue-and-white floral decoration makes a conscious reference to Dutch Delft porcelain.[39] The serving pieces and cutlery designed for Driade (1992; fig. 80) are startling in their juxtaposition of attenuated and massive forms made of silver and rosewood. The handles are sensuous and undulating, to encourage touching and handling; Šípek also designed large wooden boxes covered in colorful folk patterns to hold the pieces. But it is in such designs as the *Brabante* vase (1992; fig. 81) that Šípek is at his most imaginative in achieving a breathtaking synthesis of Baroque form and decoration.[40]

78
Bořek Šípek
Czech (b. 1949), resided
The Netherlands
Simon Candelabra, 1988
Silver plate
Mfr: Driade S.p.A.
18⅛ × 13¾ × 15¼ in.
(45.8 × 35 × 38.5 cm)

Šípek's extraordinary
imagination is also evident
in his designs for metalwork.
With its goblet-like central
element and mass of
swirling branches, the *Simon*
candelabra is an astonishing
Baroque composition.

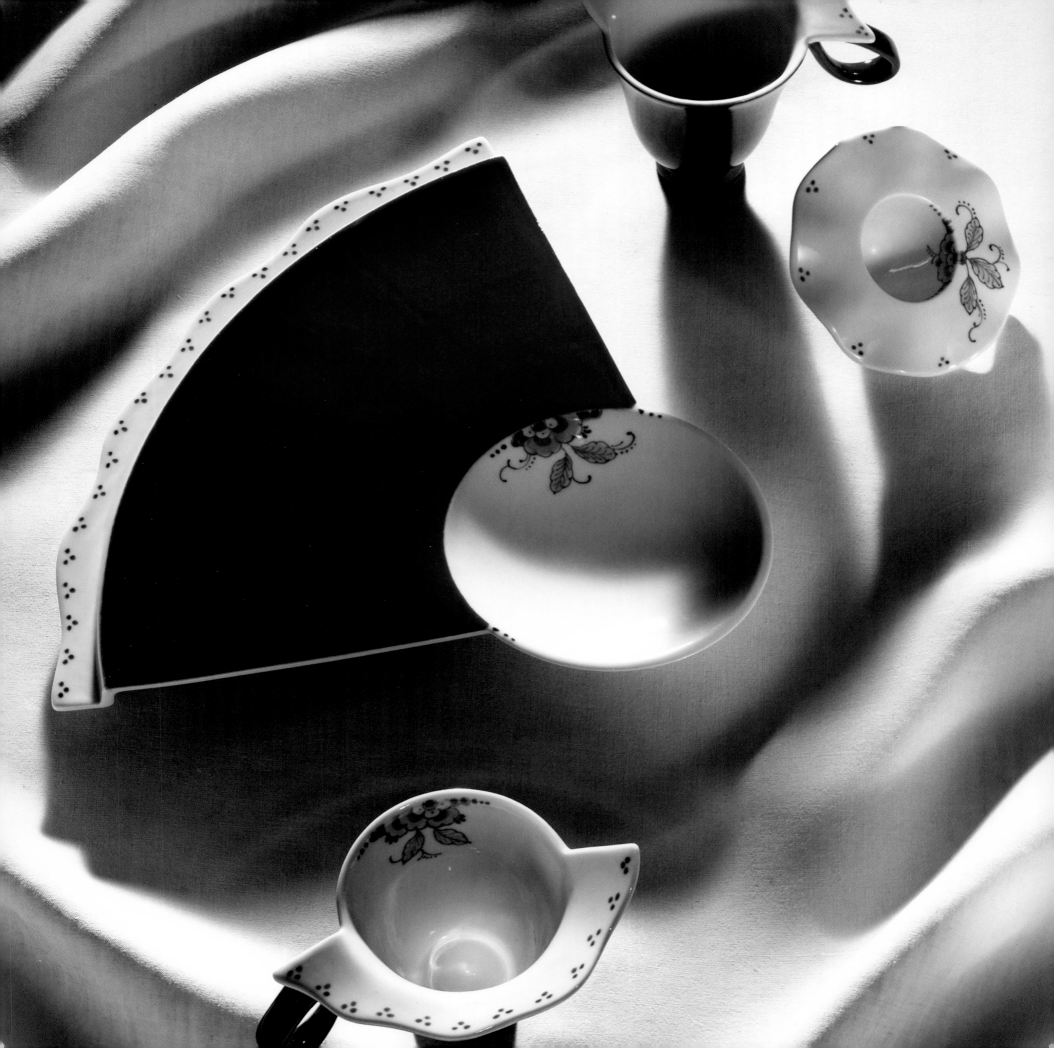

Bořek Šípek
Czech (b. 1949), resided
The Netherlands
Albertine Dinnerware, 1988
Porcelain
Mfr: Driade S.p.A.
Largest: 1 × 13½ × 10¾ in.
(2.5 × 34.2 × 27 cm)

With the *Albertine* series,
Šípek invented a new kind of
dinnerware. The highly sculptural
forms are embellished with
sumptuous blue-and-white
glazes as well as an array of
floral patterns, harkening back
to Dutch Delft porcelain.

Bořek Šípek
Czech (b. 1949), resided
The Netherlands
Clockwise from bottom left:
Arovet Soup Ladles with Block;
Ange Serving Spoon and Fork
with Block; *Aricia* Salad Spoon
and Fork with Block; *Ares*
Carving Knife and Fork with
Block, 1992
Silver plate and rosewood
Mfr: Driade S.p.A.
Largest:
Block: 21 × 13½ × 14 in.
(53.3 × 34.5 × 35.5 cm)
Spoon and Fork: 13 in.
(33 cm) (length)

When given the task of
designing a series of silver
serving pieces, Šípek created
a range of sensuous forms.
Such elegant pieces demanded
traditional wooden "knife boxes,"
which Šípek, with characteristic
élan, embellished with colorful
Czech folk patterns.

Bořek Šípek
Czech (b. 1949), resided
The Netherlands
Brabante Vase, 1992
Porcelain and rosewood
Mfr: Driade S.p.A.
10⅝ × 15¼ in. (27 × 40 cm)
(height × diameter)

The *Brabante* vase is one of
Šípek's most unorthodox—yet
creative—designs. Here, the
designer has dramatically
contrasted a highly decorated
ceramic form with a rosewood
collar, forcefully illustrating his
edict that form most certainly
does not follow function.

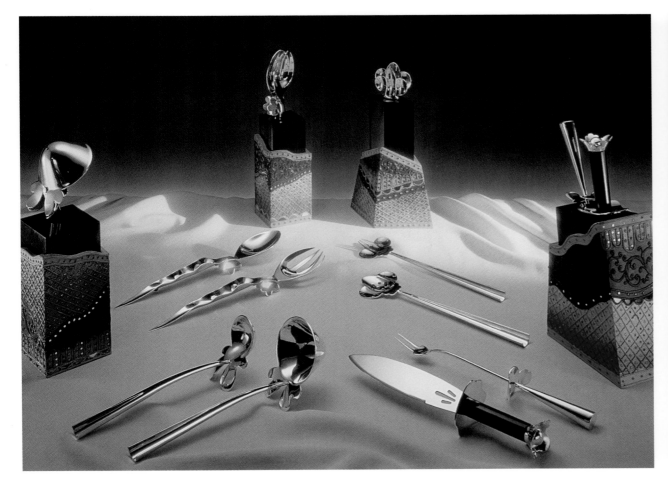

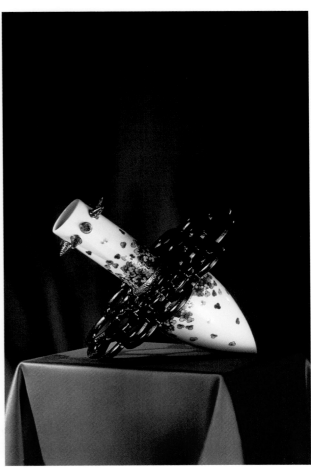

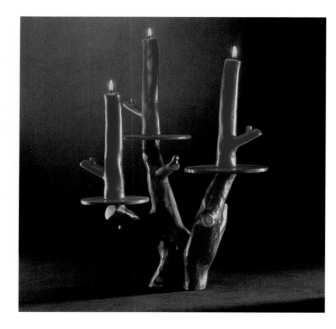

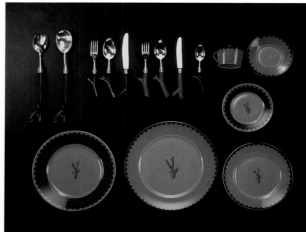

Although very different in sensibility, other European designers were also caught up in this Baroque aesthetic, including, as we have seen, Garouste & Bonetti. They were capable of producing equally quixotic designs, as in their *Trapanis* series (1989; figs. 82, 83) made of *pâte de verre*, a material (and technique) favored by French *fin-de-siècle* designers.[41]

Industrial Decorative design

Such was the vogue for Postmodernist design in the late 1980s that a number of Italian manufacturers began to approach specific designers, including Starck and De Lucchi, about creating products that could be mass-produced using industrial materials.[42] Two companies, Kartell[43] and Alessi,[44] were among the leaders in this industrial Decorative design movement.

Thus, by the late 1980s, one may detect a marked transformation in Starck's career, as he became a superstar. As noted earlier, he was one of the first designers to understand the globalization of design. Starck began to work for a series of international companies[45] and to create a highly individualized style that would soon become identifiable to the public as an iconic brand.

Starck began to use inexpensive, industrial materials: plastics, tubular metal, and stainless steel. The inherent bright colors of plastics became an important part of his aesthetic. He also began to shift his focus from *objets de luxe* to *objets ordinaires*: café chairs, tables, stools, and product designs that could be mass-produced. Increasingly, Starck chose exotic names for his products and began to develop signature shapes, such as the "horn" and "floating amoeba," which would reappear in a variety of objects and materials. This body of work—from the late

1980s to the early 1990s—constitutes some of Starck's most original and enduring designs. But with this increasing interest in creating industrial products, there would be, by the mid-1990s, almost a blurring of the lines between Modernism and Postmodernism, with a number of famous designers, including Starck, now running big offices churning out largely commercial industrial designs, often seemingly of little aesthetic merit.

Starck's initial designs for Kartell, however, were remarkable amalgamations of simplified Postmodernist forms using industrial materials. The *Dr. Glob* armchair (1988; figs. 50, 84) is one of *the* iconic café chairs of the late twentieth century. Through its bipartite composition, Starck created a new chair form: the front element combines the legs with the seat in a sculptural "plastic" unit, while the rear metal frame consists of two attenuated stiles and a crest rail. The *Miss Balu* table (1988; fig. 85) has a classic baluster pedestal.[46] Both designs marked a major change in color and finish in plastics, the polypropylene being more elegant and softer.[47]

In the 1990s, Starck produced an equally arresting series of forms for Alessi. Such designs as the *Max le Chinois* colander (1990; fig. 86) and the *Hot Bertaa* kettle (1990; fig. 87) are more like powerful sculptural compositions than everyday kitchen utensils.

There is a marked contrast between the work and philosophy of De Lucchi and that of Starck. De Lucchi started out as an architect but became a designer after meeting Sottsass.[48] De Lucchi sees himself as a "Renaissance artist" who defies neat categorization: as well as being a designer, he is a photographer, painter, sculptor, and architect. There is a pronounced interplay in his work between the creative artistic spirit and a remarkable technical expertise. Thus, following

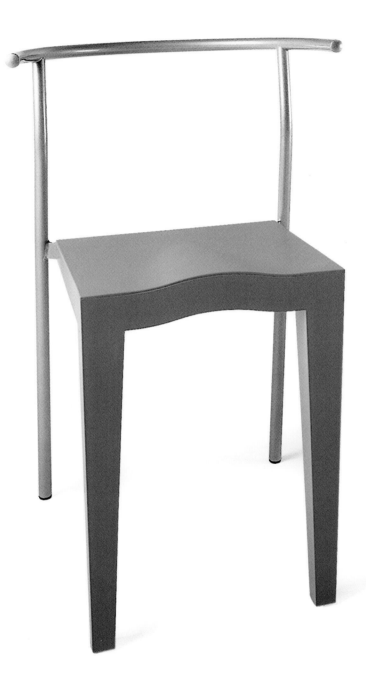

82 ←←
Garouste & Bonetti
French (Elizabeth Garouste,
b. 1949; Mattia Bonetti,
Swiss, b. 1952)
Trapanis Candelabra, 1989
Pâte de verre
Mfr: Daum
9⅞ in. (25 cm) (height)

83 ↙↙
Garouste & Bonetti
French (Elizabeth Garouste,
b. 1949; Mattia Bonetti,
Swiss, b. 1952)
Trapanis Dinnerware and
Cutlery, 1989
Pâte de verre and steel
Mfr: Daum
Largest: 13¾ in. (35 cm)
(diameter)

Like Bernardaud (fig. 60), Daum
also sought to give new life to
the French decorative tradition
by commissioning such
fashionable designers as
Garouste & Bonetti to produce
new products. For the *Trapanis*
series, the Parisian designers
used a rich color palette, a
whimsical branch motif, and
a traditional glassmaking
technique, *pâte de verre*, to
create a striking dinner service.

84 ←
Philippe Starck
French (b. 1949)
Dr. Glob Armchair, 1988
Steel and polypropylene
Mfr: Kartell S.p.A.
28¾ × 19 × 18¾ in.
(73 × 48 × 47 cm)

The *Dr. Glob* chair is one of
the iconic designs of the late
twentieth century. In creating
this piece, Starck not only
devised a new bipartite form
for seating but also established
the café chair as one of the
signature furniture types of
this period.

85 ↓
Philippe Starck
French (b. 1949)
Miss Balu Table, 1988
Polypropylene
Mfr: Kartell S.p.A.
Largest: 28¾ × 35½ in.
(73 × 90 cm) (height × diameter)

With the *Miss Balu* table,
Starck reasserted his belief
that plastics could be used
to create elegant forms with
seductive colors and finishes.

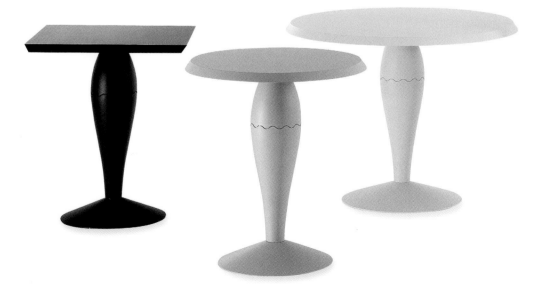

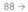

86 ↓
Philippe Starck
French (b.1949)
Max le Chinois Colander, 1990
Steel and brass
Mfr: Alessi S.p.A.
11³⁄₈ in. (29 cm) (height)

87 ↘
Philippe Starck
French (b.1949)
Hot Bertaa Kettle, 1990
Aluminum and plastic
Mfr: Alessi S.p.A.
9⁷⁄₈ in. (25 cm) (height)

Alessi was one of the first European manufacturers to realize the enormous influence of the star designer and, in turn, transform itself into an international company. Starck created some of his most important work for the Italian firm, and such pieces as the *Max le Chinois* colander and *Hot Bertaa* kettle became iconic forms—more than just functional, everyday objects—for a newly design-conscious public.

88 →
Michele De Lucchi
Italian (b.1951)
Alberto Nason
Italian (b.1972)
Fata Lamp, 2001
Glass and metal
Mfr: Produzione Privita
19³⁄₄ × 10¹⁄₄ in. (50 × 26 cm)
(height × diameter)

De Lucchi is equally adept at creating both mass-produced pieces as well as handmade, limited-edition *objets*. The *Fata* lamp is an example of the latter. Here, De Lucchi grapples with archetypal forms and the poetic qualities of his materials.

89 ↘↘
Philippe Starck
French (b.1949)
Miss Sissi Lamp, 1990
Plastic
Mfr: FLOS S.p.A.
11 × 5 × 5¹⁄₂ in.
(28 × 12.7 × 14.2 cm)

The *Miss Sissi* lamp illustrates Starck's remarkable ingenuity as a designer. In this instance, he has effortlessly transformed an archetypal form—a small table lamp—into a smart industrial product.

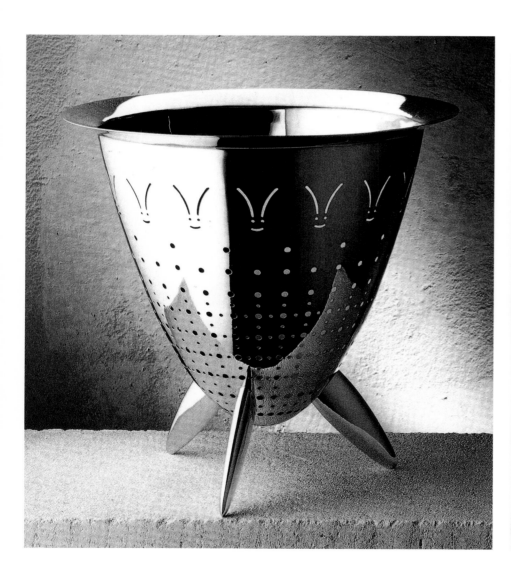

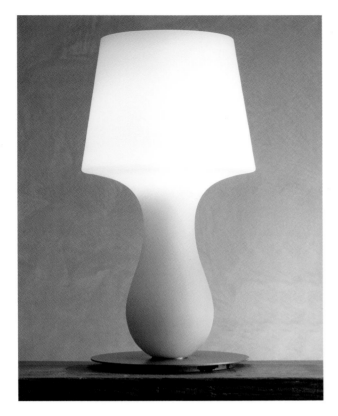

Two lighting designs by Starck and De Lucchi perhaps best illustrate the differences in their design approaches. With the *Fata* lamp (2001, designed with Alberto Nason; fig. 88), De Lucchi has again taken an archetypal form—a classic lamp with a base and shade—and reinterpreted it in a new manner.[49] The shaft and shade are now a single piece of glass with a metal base, a limited-edition design requiring considerable handcraftsmanship. But this design also clearly shows the poetic qualities that De Lucchi finds in materials; glass is contrasted with metal, both of which De Lucchi sees as metaphors—glass as perfection and metal as rough.[50] For the *Miss Sissi* lamp (1990; fig. 89), Starck has taken an antithetical approach. He has reinterpreted a small bedside lamp but has chosen plastic as the material so that the light can be mass-produced in a variety of colors: simple yet fantastic.[51]

De Lucchi's product designs from the 1990s also stand in contrast to Starck's extraordinarily prolific, but at times almost commercial, designs.

For decades, Olivetti prided itself on hiring major designers to transform everyday desktop machines into small works of art. De Lucchi was very conscious of that artistic tradition and, in many respects, was Sottsass's successor as the Postmodernist designer at Olivetti before its demise as a major Italian design company.[52] He was also clearly influenced by the elegant, mid-twentieth-century sculptural designs of Marcello Nizzoli. Indeed, it could be argued that De Lucchi has been more successful as a designer of fax machines and printers than he has as a designer of computers, as the former allow a greater sculptural freedom. De Lucchi believes that there should be a quietness about his forms, since technology itself is so aggressive.[53] Photographs of the *OFX 1000* fax machine (1994; fig. 90) show prototypes made of leaves and vegetables, demonstrating De Lucchi's wit and imagination in his desire to humanize office equipment; these initial ideas were then translated into the highly sculptural detailing of the final design's plastic

Sottsass's example of being equally adept at creating both mass-produced and limited-edition objects, De Lucchi has continued to be a model for the next generation of Postmodernist designers: he is able to work for industry as well as produce designs that are more works of art. De Lucchi's best work as a designer is perhaps at a small scale: vases, lighting, and product design. His work as a product designer, in particular, demonstrates his remarkable creativity: in such designs as the *Groviglio* lamp (2001), he combines components in a Dada-like manner to create a sculptural shape; with the Olivetti products, he invents expressive forms for electronic components; and with such designs as the *Fata* lamp (2001), he sculpts a shape from a material.

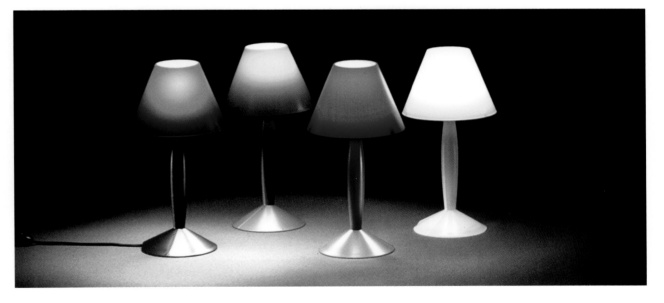

90 →
Michele De Lucchi
Italian (b. 1951)
OFX 1000 Fax Machine, 1994
Plastic and metal
Mfr: Olivetti
7⁷⁄₈ × 13 × 12¼ in.
(20 × 33 × 31 cm)

91 ↘↘
Michele De Lucchi
Italian (b. 1951)
Artjet 20 Printer, 1998
Plastic and metal
Mfr: Olivetti
6¾ × 12⁵⁄₈ × 5½ in.
(17 × 32 × 14 cm)

Building on the earlier work of Ettore Sottsass, De Lucchi created some of the most memorable Postmodernist industrial designs of this period for the Italian manufacturer Olivetti. The *OFX 1000* fax machine and the *Artjet 20* printer clearly demonstrate his consummate skill in transforming everyday office equipment into small works of art.

and metal casing.[54] Likewise, the *Artjet 20* printer (1998; fig. 91) is notable for its elegant composition of simple, curved, asymmetrical forms. In their own distinctive way, both Starck and De Lucchi illustrate how Postmodernist designers can work within an industrial design tradition but with a strongly decorative slant.

Vernacular Decorative design

The vernacular Decorative design manner represents the fourth and final sub-movement within the larger Decorative design tradition. It was, in many respects, the flip side of the coin, drawing its inspiration from "low" art versus "high" art.[55] The designers who were part of this movement were preoccupied primarily with reusing vernacular forms or found materials. Javier Mariscal and Piet Hein Eek were among

the most important of its leaders, and they were followed by a younger generation that included such designers as Satyendra Pakhalé.

In the late 1980s, Mariscal was an important symbol of a new vitality in Spanish design, which saw Barcelona emerge, for a period, as a significant international design center.[56] Mariscal was briefly associated with Memphis; later, he became a model for a new kind of designer in Spain, one who looked at design from an artistic perspective, in contrast to the industrial approach of other influential Spanish designers, such as Jorge Pensi. Thus Mariscal's designs are more cultural statements than functional objects, for he consciously blurs the lines between art and design. Mariscal was initially trained as a cartoonist and for much of his career worked in various areas of graphic design, although his

œuvre encompasses many different design media. In many respects, there are two diametrically opposed aspects to his work: a fascination with cartoon-like/two-dimensional forms and a preference for more sculptural, biomorphic forms. There is also a decidedly pop/kitsch aspect to his work, as well as a sense of humor and irreverence.

The Dutch designer Piet Hein Eek takes a much more serious approach to design, and there is a strong philosophical basis to his work: for him, design is a work of art that can change not only lives but also society.[57] Eek's primary work is about reinterpreting archetypal/elementary forms generally made of one material, with a strong emphasis on the process and inherent craftsmanship.[58] He favors planar materials, likes to show the imperfections in his objects, and openly expresses how his pieces are made.[59] But

92 →
Javier Mariscal
Spanish (b. 1950)
Alessandra Armchair, 1995
Polyurethane, leather, and
beech
Mfr: Moroso S.p.A.
44⅛ x 39 × 37 in.
(112 × 99 × 94 cm)

The *Alessandra* chair is a
mature—and powerful—
design. Here, Mariscal is
playing with the interaction
between large biomorphic
forms and a variety of two-
dimensional amoeba patterns.

93 ↓
Javier Mariscal
Spanish (b. 1950)
Biscuter Chair, 1986
Fiberglass, iron, and fabric
Mfr: AKABA S.A.
21⅝ × 22½ × 29½ in.
(55 × 57 × 75 cm)

Mariscal's work not only
symbolizes the re-emergence
of Spain as an important design
center during these decades
but also reflects an important
aspect of Postmodernism: a
fascination with the vernacular.
The *Biscuter* chair, one of
Mariscal's early designs, is a
witty and irreverent *objet*—a
child's scooter transformed into
a playful piece of sculpture.

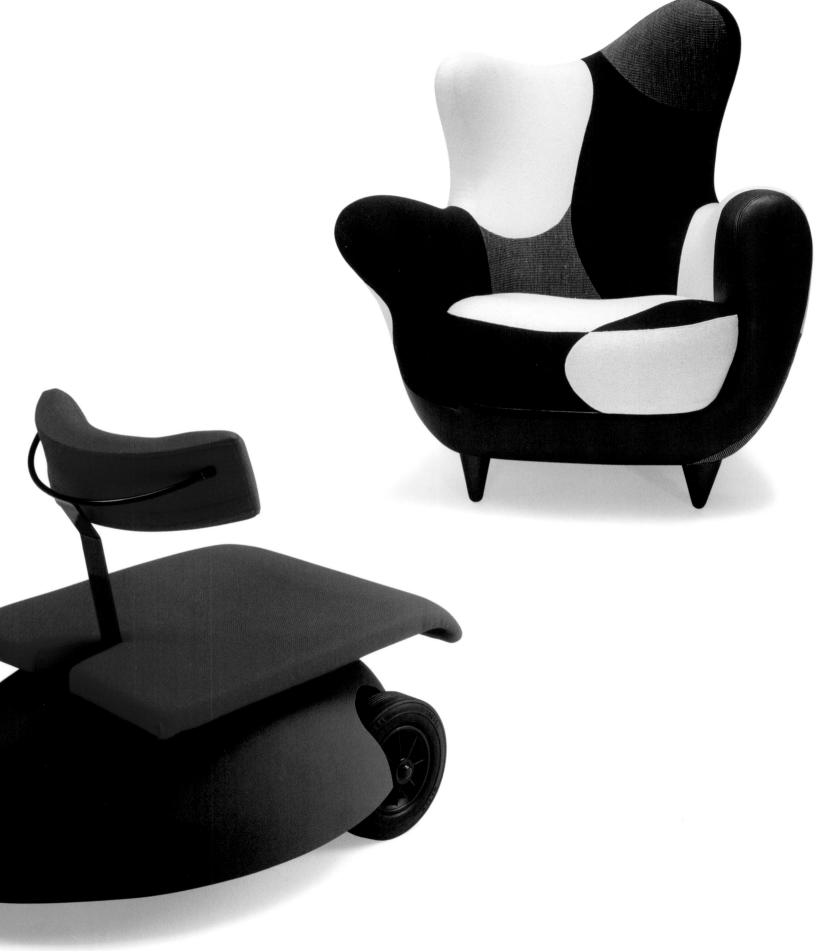

Eek also wants to capture a certain poetic quality in his work. As we shall see later with other Dutch designers, Eek is concerned with exploring new ideas of craft.

The different approaches within vernacular Decorative design are readily apparent when one begins to look at the work of Mariscal and Eek. Mariscal's *Biscuter* chair (1986; fig. 93) is an unconventional form: with its wheels, shell-like base, and brightly upholstered seat pads, it recalls a child's scooter.[60] A decade later, with his *Alessandra* lounge chair (1995; fig. 92), Mariscal was working with a more conventional form, though still in a whimsical manner. Here, one clearly sees the juxtaposition of the rather massive, asymmetrical, and biomorphic form of the chair against the two-dimensional amoeba patterning of the upholstery.[61] There is also a subtle play in the fabrics chosen, not only in the interrelationships between the black, white, and gray hues but also in the contrasting textures of the various textiles.

At first glance, Eek's *Scrap Wood* cupboard (1990; fig. 96) appears to be a simple wooden cabinet with three drawers below and a two-door storage unit above. Reacting against the machine-like perfection of industrial design, Eek set out to make an imperfect object out of waste/found materials. The cabinet is meticulously crafted from recycled pieces of wood, which provide a subtle palette of color and texture. The design is also notable for its beautiful proportions and extraordinary detailing, especially in the interiors. With Eek's *Steel Plate Dresser with Veneer* (1991; fig. 94), the historical allusions are perhaps a little more overt: the form recalls country Neo-classical chests. Eek is also playing on such veneered furniture; in this case, however, the piece is constructed of sheets of steel that are then veneered in teak.[62]

94 ←
Piet Hein Eek
Dutch (b. 1967)
Steel Plate Dresser with Veneer, 1991
Steel and teak
Mfr: Piet Hein Eek
39⅜ × 39⅜ × 19¾ in.
(100 × 100 × 50 cm)

The historical or Postmodernist allusions are perhaps a little more overt in Eek's *Steel Plate Dresser with Veneer* case piece, though they are tempered by his strong Dutch sensibility.

95 ↓
Satyendra Pakhalé
Indian (b. 1967), resides The Netherlands
Bell Metal Horse Chair, 2000
Bell metal
Mfr: Atelier Satyendra Pakhalé
21⅝ × 33⅜ × 37⅞ in.
(55 × 84.7 × 96 cm)

Pakhalé's work represents yet another approach to dealing with the vernacular, fusing Indian and European design concepts. The *Bell Metal Horse* chair is an archaic form made of a version of bronze traditionally employed by Indian craftsmen.

Satyendra Pakhalé, who was born in India but now works in Amsterdam, represents yet another approach by a younger generation. He was initially trained in Switzerland as an industrial designer but subsequently rediscovered, and began to reinterpret, ancient Indian artisan traditions. The Dutch design environment has perhaps provided Pakhalé with the perfect surroundings in which to find a new amalgamation of these two different aesthetics, for he is very interested in working with both high- and low-tech design techniques in order to add a human touch to industrial processes.[63]

The *Bell Metal Horse* chair (2000; fig. 95) very much characterizes Pakhalé's design approach, which involves working with two elements: a symbolic or archaic form and an arresting material, in this case bell metal, a form of bronze traditionally used by Indian craftsmen.[64] He has also used a lost wax-casting process—an ancient technique—for the fabrication of the chair.

96
Piet Hein Eek
Dutch (b. 1967)
Scrap Wood Cupboard, 1990
Pinewood, scrap wood, plywood, and steel
Mfr: Piet Hein Eek
85⅛ × 39⅜ × 20½ in.
(216 × 100 × 52 cm)

In contrast to the wit and élan of Mariscal's work, there is a certain Dutch spiritualism to Eek's aesthetic designs. On the surface, such pieces as the *Scrap Wood* cupboard appear to comment slyly on the vernacular and everyday; but there is a deep philosophical underpinning to Eek's work, through which he explores the fundamental relationship between design and our culture.

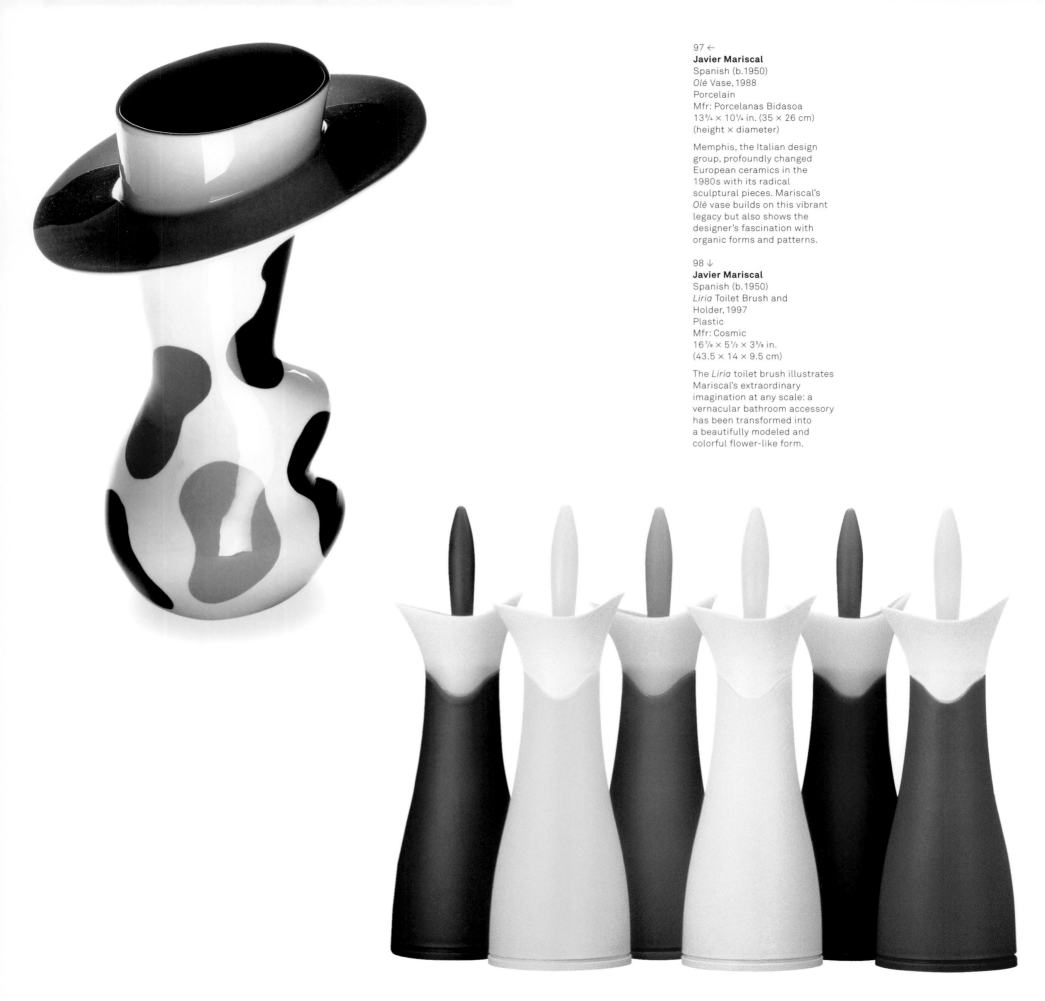

Javier Mariscal
Spanish (b.1950)
Olé Vase, 1988
Porcelain
Mfr: Porcelanas Bidasoa
13¾ × 10¼ in. (35 × 26 cm)
(height × diameter)

Memphis, the Italian design
group, profoundly changed
European ceramics in the
1980s with its radical
sculptural pieces. Mariscal's
Olé vase builds on this vibrant
legacy but also shows the
designer's fascination with
organic forms and patterns.

98 ↓
Javier Mariscal
Spanish (b.1950)
Liria Toilet Brush and
Holder, 1997
Plastic
Mfr: Cosmic
16⅞ × 5½ × 3⅝ in.
(43.5 × 14 × 9.5 cm)

The *Liria* toilet brush illustrates
Mariscal's extraordinary
imagination at any scale: a
vernacular bathroom accessory
has been transformed into
a beautifully modeled and
colorful flower-like form.

The fascination with a vernacular Decorative design approach also extends to smaller pieces. Mariscal's *Olé* vase (1988; fig. 97) is a play on biomorphic forms and patterns, with a Saturn-like ring around the lip of the vessel. It is also an unconventional but very powerful form, recalling Sottsass's early ceramic designs for Memphis. With his *Liria* toilet bush and holder (1997; fig. 98), Mariscal has reinterpreted a calla lily and imparted a poetic quality to a plastic bathroom accessory. Mariscal's design also utilizes his characteristic motif of a flat back panel with a more sculptural form to the front; the top is especially beautiful in its plasticity. Likewise, Pakhalé has looked to traditional Indian fiber baskets for his *STL* and *Akasma* containers (2002; figs. 99, 100), but has employed new materials—resin and glass, respectively—to give the objects a new context.[65]

Together, all these designers demonstrate that there was a rich and diverse Decorative mode—which was part of a larger Postmodernist movement—that shaped European design from the late 1980s onward. But there was also another, parallel aspect of Postmodernism active during this period, one that was decidedly more expressionist in nature.

99 ↗
Satyendra Pakhalé
Indian (b. 1967), resides
The Netherlands
STL Basket, 2002
Resin
Mfr: Atelier Satyendra Pakhalé
6³⁄₈ × 10¹⁄₄ in. (16 × 26 cm)
(height × diameter)

100 →
Satyendra Pakhalé
Indian (b. 1967), resides
The Netherlands
Akasma Basket, 2002
Glass
Mfr: RSVP – Curvet Ambienti
S.p.A.
Largest: 5¹⁄₂ × 20¹⁄₂ in.
(14.5 × 52 cm)
(height × diameter)

The STL and Akasma baskets are apt examples of Pakhalé's unique approach to working within a vernacular aesthetic. Using resin and bent glass as his materials, Pakhalé has metamorphosed traditional Indian forms into contemporary objects.

Expressive Design

Concept

This movement was yet another reaction to the Modernist resurgence of the mid-1980s. It focused on creating an expressive aesthetic in which design is thought of more as sculpture or a work of art—the antithesis of industrial design. To this end, form clearly took precedence over function; and, as such, it was a highly intuitive, rather than rationalist, movement.

There are three subcategories within this aesthetic: punk Expressive design; sophisticated Expressive design; and technological Expressive design. These categories span two generations of designers and evolved over some two decades.

Style

With Expressive design, the primary emphasis is on the form of an object; the movement's idiosyncratic shapes range from the highly angular to the fluid and undulating. Perhaps not surprisingly for such an unconventional design approach, a greater emphasis is placed on furniture and lighting than on other design media. The materials used are varied and include industrial and found substances, as well as more traditional ones used in unconventional ways. Objects are often richly colored and textured, such characteristics deriving either from the inherent qualities of the materials used or from the method of construction. Moreover, designers working within the Expressive design mode redefined the concept of handcraftsmanship in a multitude of ways.

Time and Place

The Expressive design movement coalesced in the mid-1980s and continues to the present. Many of its most influential advocates have chosen to work in the United Kingdom.

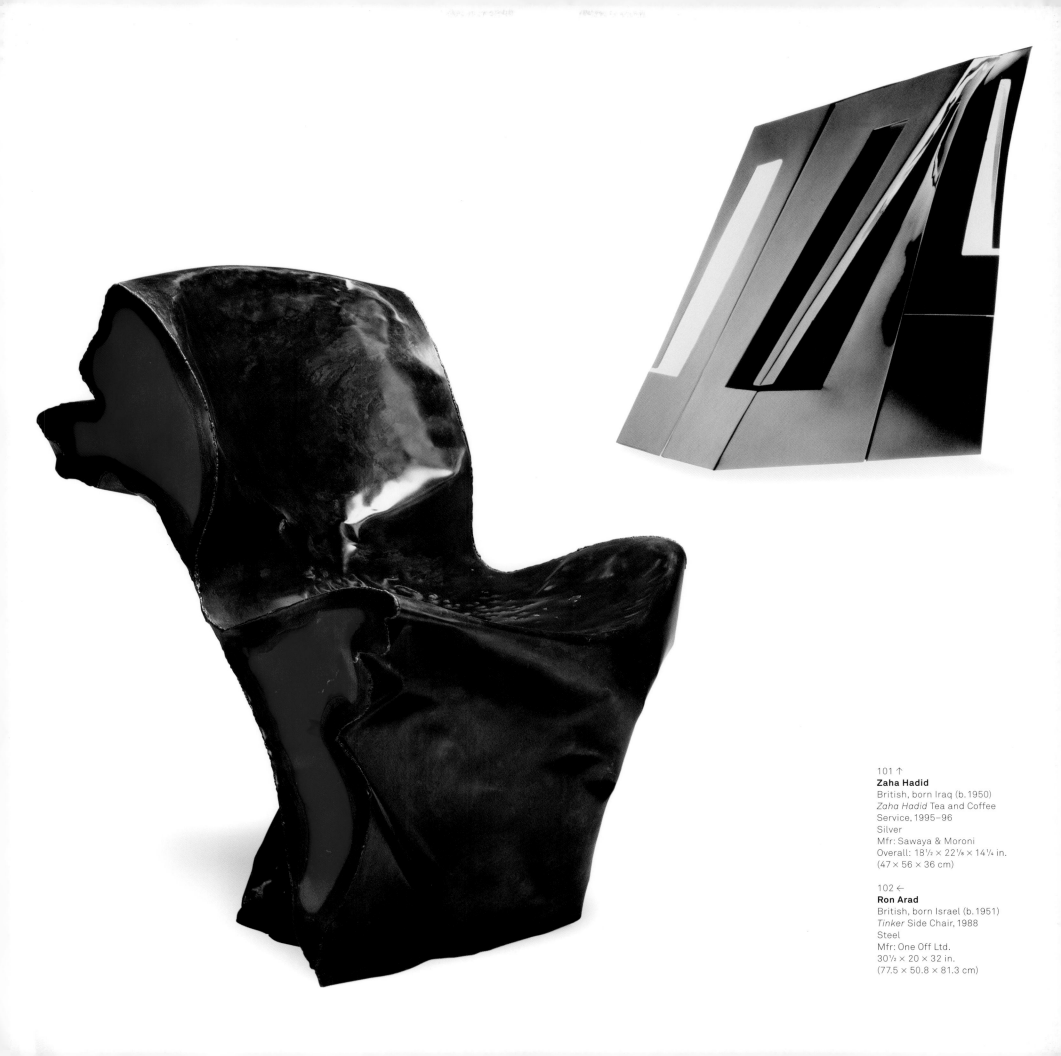

101 ↑
Zaha Hadid
British, born Iraq (b. 1950)
Zaha Hadid Tea and Coffee
Service, 1995–96
Silver
Mfr: Sawaya & Moroni
Overall: 18½ × 22⅛ × 14¼ in.
(47 × 56 × 36 cm)

102 ←
Ron Arad
British, born Israel (b. 1951)
Tinker Side Chair, 1988
Steel
Mfr: One Off Ltd.
30½ × 20 × 32 in.
(77.5 × 50.8 × 81.3 cm)

103
Ron Arad
British, born Israel (b. 1951)
Looploop Chair (detail), 1992
Steel
Mfr: One Off Ltd.
45¾ × 27⅝ × 16⅛ in.
(116 × 70 × 41 cm)

One of the most important repercussions of the larger Postmodernist movement was that it dramatically opened up the parameters of how designers might look at the applied arts conceptually. Expressive designers are a good case in point, for this was a manner that was not so widespread but one that most certainly had a significant impact on contemporary European design during this period. This movement looked at design primarily as art, largely from a sculptural perspective. The shape of the objects is highly plastic, ranging from the decidedly angular to the fluid and undulating, where form takes precedence over function (or comfort). Unorthodox materials are often used in a strongly intuitive manner, whereby colors, textures, and finishes are accentuated. There is also a strong aspect of handcraftsmanship relying on studio production.

The Expressive design movement encompassed two generations of artists, and there were three manifestations: a punk Expressive design, a sophisticated Expressive design, and a technological Expressive design. The most influential leaders were Ron Arad and Zaha Hadid, two divergent forces who have shaped and expanded this movement over the last two decades.

Punk Expressive design

Punk Expressive design was largely an English movement that was influential in the late 1980s and early 1990s. The work tended to be very gutsy, raw, and rough, for the designers involved were rebelling against a prevailing "high style" Modernism, not to mention the social and cultural climate of Margaret Thatcher's Conservative government. Indeed, this movement was the antithesis of industrial design. As there was almost no support from manufacturers at that time for this kind of experimental work, it was initially being handmade by designers in small studios with a few assistants. It was only later, when these designers began to receive critical attention, that they were able to expand to larger-scale studios with more sophisticated methods of production. Thus, in its formative years, punk Expressive design was about using "simple industrial" materials; furthermore, the emphasis was on the "making," for this was a period before the decisive impact of the computer.

Ron Arad is not only one of the major designers of this era, but he was also instrumental in shaping the early phase of punk Expressive design. His most important work has been as a furniture designer; but like a number of his contemporaries, his approach can be a little unorthodox. He was initially trained as an artist and only later as an architect. Thus a primary concern of his design work has been the relationship between art, architecture, and design.[66] It is possible to identify three phases to Arad's career to date: his studio period (c. 1985 to c. 1993), an industrial period (c. 1993 to the present), and a late limited-edition period (c. 1997 to the present).[67]

In his early studio period, Arad created limited-edition *objets*.[68] He did not, however, consider himself a craftsman; rather, he saw himself as a designer driven by the materials and technology that he had at hand. The early work was made by Arad and his assistants in his studio and sold in his London shop, One Off. Many of Arad's initial pieces were made in steel because he found it a forgiving material.[69] Arad employed two types of steel: tempered, for two-dimensional forms, and

mild, for more sculptural, three-dimensional pieces. The early designs were often quite rough, with a hammered surface and exposed welds that clearly show how the objects were made. Arad applied a variety of finishes to his steel: blackened, painted, and, later, stainless. As his technical skills improved, he would eventually polish out the welds and use chrome plating to achieve elegant stainless-steel surfaces. There is, however, a wonderful, inherent sense of movement to Arad's designs, whether seen as two-dimensional profiles or as three-dimensional continuous forms.

Three English chairs perhaps best illustrate the variety of forms and materials employed during this early punk Expressive movement.[70] They are all limited-edition pieces initially made in the designer's studio. Arad's *Tinker* side chair (1988; figs. 102, 104) is a flowing, highly sculptural form made of metal, Arad's favorite material in his early work.[71] It has a very rough quality to the surface, as hammering and welds are important parts of the aesthetic impact of the design. Arad has used red as an accent on the edges of the chair, almost as if it has been sliced open. The form of Danny Lane's *Etruscan* side chair (1988; fig. 105) is quite different from Arad's design and equally unorthodox; but Lane's work is also about a material, in this case glass, which he often combines with metal as a connector. In his work, Lane is trying to capture the mystical or spiritual quality of glass, what he calls the "glassness of glass."[72] There is also a rough and fast aspect to his designs. Thus, for the seat and back panels of the *Etruscan* chair, he has used planar shards of glass, which are held together with meticulously crafted bars of steel. The cantilevered form of Tom Dixon's *S* side chair (1988; fig. 106) is perhaps not as radical, since in many respects it is an imaginative amalgamation

104 →
Ron Arad
British, born Israel (b. 1951)
Tinker Side Chair, 1988
Steel
Mfr: One Off Ltd.
30½ × 20 × 32 in.
(77.5 × 50.8 × 81.2 cm)

One of the earliest manifestations of Expressive design was a punk movement led by a group of English designers. With its highly sculptural form made of hand-hammered and welded steel, Arad's *Tinker* chair is an iconic example of this movement's work in metal—a design that revels in its raw, gutsy power.

105 ↘
Danny Lane
American (b. 1955), resides United Kingdom
Etruscan Side Chair, 1988
Glass and steel
Mfr: Danny Lane
35 × 18½ × 22½ in.
(89 × 47 × 57 cm)

Lane became a compelling force in the punk Expressive movement by creating a series of bold designs using glass, his favorite material. The *Etruscan* chair is made of two planar shards of glass held together by sensuous and highly crafted metal elements.

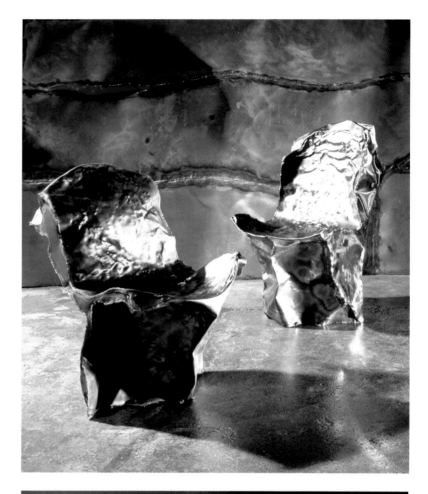

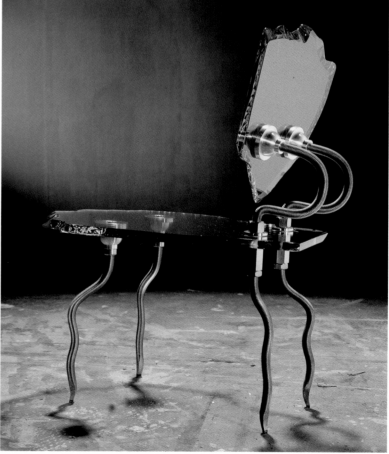

106
Tom Dixon
British, born Tunisia (b.1959)
S Chair, 1988
Steel and rush
Mfr: originally Space; now
Cappellini S.p.A.
40⅛ × 19¾ × 16⅝ in.
(102 × 50 × 42 cm)

While Dixon's *S* chair is a play
on continuous cantilevered
seating forms, there is a slightly
brutalist aspect to the design:
a rough steel frame covered
in a decidedly textured rush.

of two Verner Panton designs (his *S* chair of
1966 and the *Panton* chair of 1959–60). There is,
however, a rawness to the piece, with its steel
frame and rough, rush upholstery.[73]

Two other chairs show how this radical
movement was interpreted in other European
countries. Niels Hvass is a Danish designer, and
the form of his *Willow* chair (1994, designed with
Anne Fabricius Møller; fig. 107) recalls Frank
Gehry's early *Easy Edges* series (1972) made of
cardboard. Hvass's chair, however, is constructed
of bundles of willow sticks held together with
steel reinforcing bars: Hvass wanted a material
that would give people a sense of color, smell,
and noise when they sat on it.[74] In Central Europe,
a parallel movement called New German Design
attracted considerable attention for a brief period

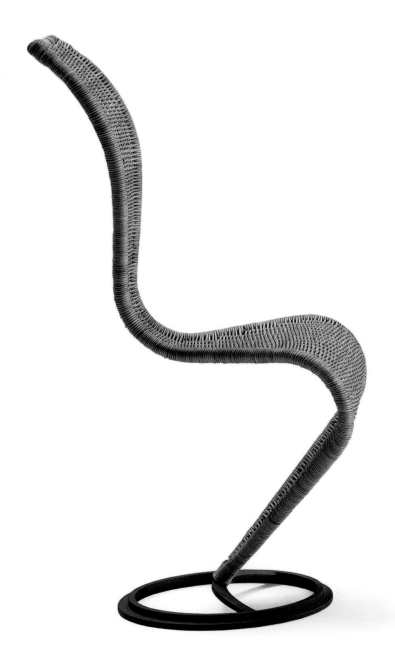

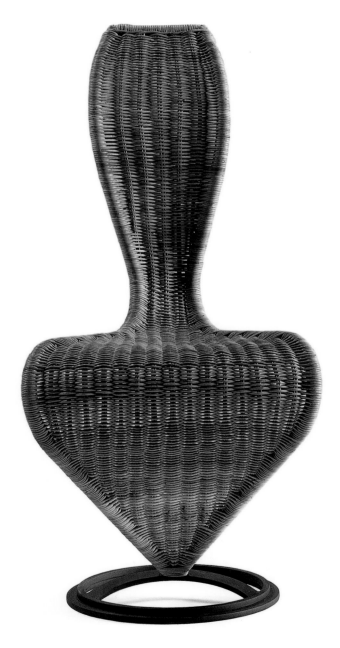

in the 1980s before ultimately dissipating.[75] Bär + Knell is one of the few German design groups from this movement that have continued to thrive. Its *Confetti* chair (1994; fig. 108) is "green," in that it has been constructed using recycled materials, including melted plastic bottles; the design is also notable for its bright colors and abstract expressionist quality. The form and technique, however, are based on those employed by Gaetano Pesce for his expressionist resin chairs (such as the *Pratt* chair of 1983).

This punk Expressive movement was not as readily adaptable to other media, such as ceramics, metalwork, or product design. Two designs by Danny Lane in glass are notable exceptions to this rule, and Lane's Expressionist use of glass stands in marked contrast to the work of Ohira and Šípek seen earlier. In the *Gingerino Glass* goblets (1991; fig. 109), shards of broken glass and bottles have been recycled and stacked.[76] Lane's *Crab* bowl (1999; fig. 110) is a large slab of glass that has been heated and slumped over a mold to produce a highly sculptural form; the air bubbles and broken edges give the bowl a decidedly punk quality.

Lighting was one other design medium that attracted the Expressive designers. The fixtures they produced tended to be highly sculptural and non-traditional in form, for many of the designers were fascinated with the quality of light as it passes through industrial materials. Three of the lighting designs are more punk in nature, while a fourth signals a transition into a more sophisticated Expressive design. Ólafur Thórdarson's choice of resin as the material for his *UL 1* table lamp (1999–2000; fig. 111) comes out of his work with Pesce. Resin allows the highly sculptural light to be more opaque at the bottom and translucent at the top. The fixture has an eerie

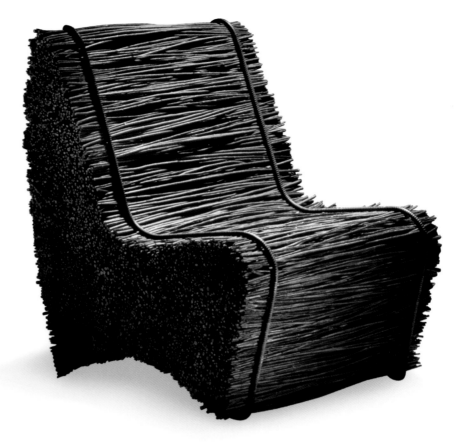

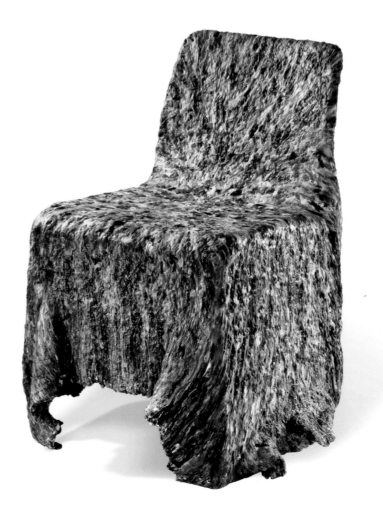

107 ←
Niels Hvass
Danish (b. 1958)
Anne Fabricius Møller
Danish (b. 1959)
Willow Chair, 1994
Willow and steel
Mfr: Niels Hvass
34⅝ × 24½ × 36¼ in.
(88 × 62 × 92 cm)

Although largely an English movement, punk Expressive design found advocates in other European countries, including Denmark. Hvass's *Willow* chair—bundles of willow sticks held together by steel bars—is an apt example of designers creating unconventional forms handmade from unorthodox materials.

108 ↙
Bär + Knell Design
German (Beata Bär, b. 1962; Gerhard Bär, b. 1959; Hartmut Knell, b. 1966)
Confetti Chair, 1994
Plastic
Mfr: Bär + Knell Design with DKR (Deutsche Gesellschaft für Kunstoff-Recycling mbH)
29¾ × 21⅞ × 23⅝ in.
(75.5 × 55.5 × 59 cm)

German designers have often been leaders in the Green movement in Europe. In terms of form, Bär + Knell has clearly been influenced by the resin chairs of Gaetano Pesce. For its *Confetti* chair, however, the design group has used melted plastic bottles, which create an almost abstract expressionist dappled surface.

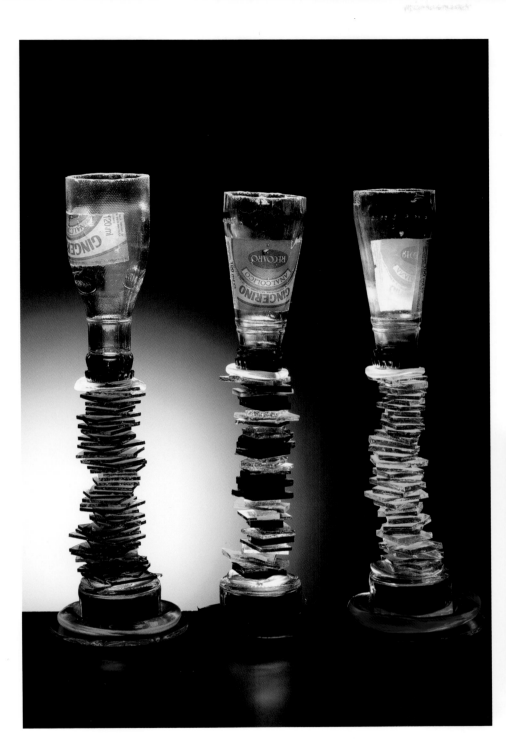

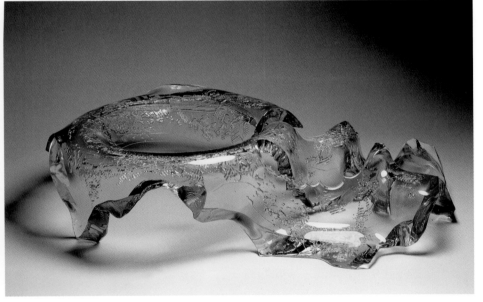

109 ←
Danny Lane
American (b. 1955), resides
United Kingdom
Gingerino Glass Goblet, 1991
Glass, lead, and silicone
Mfr: Danny Lane
9⅞ in. (25 cm) (height)

110 ↓
Danny Lane
American (b. 1955), resides
United Kingdom
Crab Bowl, 1999
Glass
Mfr: Danny Lane
7⅛ × 28⅜ × 15¾ in.
(18 × 72 × 40 cm)

Lane's designs for tableware
are as unconventional as his
furniture designs (fig. 105). The
Gingerino goblets are made of
shards of recycled glass, while
the *Crab* bowl is fashioned from
a large slab of slumped glass;
both designs celebrate a raw,
visceral power.

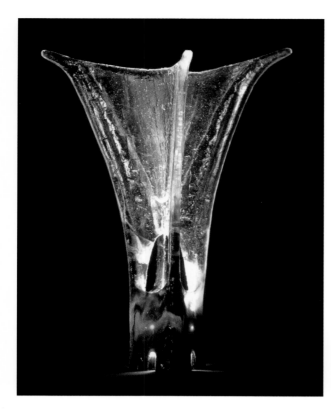

glow when illuminated, and its vase-like form casts strong shadow-patterns on the ceiling. Stefan Lindfors is another Scandinavian designer who broke with the Modernist design tradition in the 1980s. There is a strange mixture of the expressionist and zoomorphic in his best work.[77] Lindfors's *Scaragoo* table lamp (1988; fig. 112), with its concrete base and its insect-like metal lighting fixture, is a wonderfully eccentric form. Arad's ethereal *Armadillo* floor lamp (1987; fig. 114) has a concrete base and steel frame; the "shade" is made of aluminum honeycomb panels, which become a slightly surreal translucent membrane when illuminated.[78] All three designs are dramatic demonstrations of lighting as sculpture. In contrast, Zaha Hadid's massive *Vortexx* chandelier (2005, designed with Patrik Schumacher; fig. 113)

is a metaphor for powerful lines of force in space. It is an extremely sophisticated, swirling sculptural form made of fiberglass coated with car paint. The chandelier employs a complex LED lighting system, which changes color (from pink, to yellow, or to blue) and intensity as it cycles through its program.

Sophisticated Expressive design

As the first generation of Expressive designers matured and received more critical attention, they began to create more sophisticated designs. In this new work, there was a greater emphasis on expressive form than on material and construction. Objects now had a more refined sense of craftsmanship, material, and finish, for designers were increasingly using sophisticated workshops or even factories, where the pieces

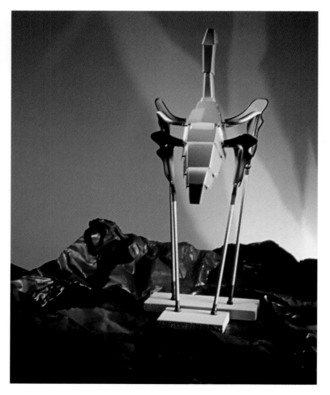

were made by other people. There was also a shift to a larger scale in a number of the designs. The two major leaders of this new direction were Arad and Hadid, the latter being one of the few women in this period to be regarded as a major designer.

Hadid took a decidedly different approach to design than her contemporaries: Arad, Lane, and Dixon. From the beginning, she was an architect–designer, creating objects made by manufacturers in limited production; much of her work has been made by Sawaya & Moroni in Italy. From almost the start of her career, Hadid was designing furniture for her interiors, such as the residence at 24 Cathcart Road in London, as her unconventional spaces obviously required furnishings that were equally radical. It is only recently that the significance of her work as a designer—rather than architect—has been recognized.[79]

Unlike contemporary designs by Arad or Lane, Hadid's early seating designs are largely upholstered. They are massive in scale and become major elements in defining her spaces. Furthermore, like the work of such highly individualistic architects as Frank Lloyd Wright, Hadid's designs are very architectonic and are meant to augment the dynamic spatial qualities she is trying to achieve in her interiors. Hadid thus occupies a rather unique position in the Expressive design movement, for her unconventional work—with its many shades of gray—often defies the perceived divisions between Modernism and Postmodernism.

By the late 1980s and early 1990s, there was a noticeable shift in Arad's work. He was still making objects in his studio but now with considerably more sophisticated means and materials. The differences between Hadid and Arad's design approaches become apparent when one contrasts their work.

111 ←
Ólafur Thórdarson
Icelandic (b. 1963), resides
United States and Iceland
UL1 Light, 1999–2000
Resin
Mfr: Dingaling Studio
24 × 13 × 13 in.
(61 × 33 × 33 cm)

Lighting has proved to be an
attractive medium for a number
of designers in the Expressive
movement. Early in his career,
Thórdarson worked for Gaetano
Pesce; the Italian designer's
influence may be discerned
in Thórdarson's *UL1* lamp, a
highly sculptural form made
of colorful resins.

112 ↙
Stefan Lindfors
Finnish (b. 1962)
Scaragoo Lamp, 1988
Aluminum, steel, plastic, and
concrete
Mfr: Ingo Maurer GmbH
31½ in. (80 cm) (height)

Like Hvass (fig. 107), Lindfors
was a Scandinavian designer
attracted to the Expressive
design movement. His *Scaragoo*
lamp is a wonderfully eccentric—
and almost menacing—design,
an insect-like form that seems
to be walking across the table
toward its user.

113 ↓
Zaha Hadid
British, born Iraq (b. 1950)
Patrik Schumacher
German (b. 1961), resides
United Kingdom
Vortexx Chandelier, 2005
Fiberglass, acrylic, and LED
lighting
Mfr: Sawaya & Moroni
65¾ × 78¾ in. (167 × 200 cm)
(height × width)

114 →
Ron Arad
British, born Israel (b. 1951)
Armadillo Light, 1987
Aluminum, steel, and concrete
Mfr: One Off Ltd.
84½ × 33 in. (214.5 × 84 cm)
(height × width)

A comparison of Arad's *Armadillo*
floor lamp from the 1980s with
Hadid's *Vortexx* chandelier (fig. 113)
from the 2000s illustrates the
differences between two distinctive
Expressive design modes. Arad's
design—a gutsy, handmade form
of raw industrial materials—is
very much a part of the punk
movement. Hadid's design, on
the other hand, is a sophisticated
and sleek piece of sculpture that
utilizes the latest high-tech lighting
systems to dramatic effect.

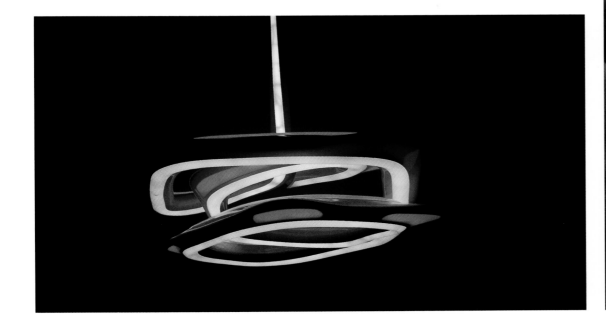

Hadid's *Sperm* coffee table (1985, designed with Nan Lee, Brenda MacKneson, Brett Steele, and Michael Wolfson; fig. 115) is one of her best early designs.[80] As provocative as its name, the table features an undulating lead base that supports a massive shard-like plane of glass. Her *Moraine* sofa (2000; fig. 117) is part of a series of large-scale, highly sculptural forms called *Z-Scape*, made by Sawaya & Moroni.[81] Hadid's earlier designs for built-in sofas in the mid-1980s often featured bipartite back and seating panels, which are slightly awkward in their juxtaposition; in the *Z-Scape* pieces, such panels have been eliminated in favour of monolithic forms. Given their massive scale, these designs appear to be more like architectural fragments in a space than functional seating. It is also interesting to note that Hadid—given her reputation as an avant-garde architect—has not used new materials or technology in her furniture; these are handmade objects using quite traditional materials and craftsmanship.[82] The *Z-Scape* series also included table forms; by the mid-2000s, Hadid had designed a number of massive tables, such as *Aqua* table (2005) for Established & Sons. These designs, with their emphasis on highly sculptural bases and planar tops, clearly reflect the influence of the mid-century work of Isamu Noguchi.

Two pairs of objects by Arad show his maturation over the same period. *This Mortal Coil* bookcase (1993; fig. 116) is a massive, nautilus-like spiral of steel bolted together with ribs.[83] The "continuous ribbon" is one of a number of forms in Arad's vocabulary that would be used for a variety of furniture designs. Indeed, as Arad began to make the transition from being a studio artist to an industrial designer, he would often take a form developed in one material and adapt it for use in another; *This Mortal Coil*, for example, would later

115
Zaha Hadid
British, born Iraq (b. 1950)
Nan Lee
American (b. 1958)
Brenda MacKneson
Canadian (b. 1960)
Brett Steele
American (b. 1958)
Michael Wolfson
American (b. 1950)
Sperm Table, 1985
Lead and glass
Mfr: Edra S.p.A.
13¾ × 33⅛ × 81⅛ in.
(35 × 84 × 206 cm)

Hadid's early furniture designs were often conceived as extensions of her dramatic architectural interiors. Her *Sperm* coffee table is a massive composition juxtaposing a large, irregular plane of glass with a powerful, undulating lead base.

116 ←
Ron Arad
British, born Israel (b. 1951)
This Mortal Coil Bookshelf, 1993
Steel
Mfr: Ron Arad Studio
87 × 86⅝ × 13 in.
(221 × 220.5 × 33.1 cm)

As Arad matured as a designer, his work became not only larger in scale but also more sophisticated in terms of its craftsmanship. *This Mortal Coil* bookcase is an apt example of this development and also illustrates Arad's interest in the "continuous ribbon" form that would become a recurring motif in his work.

117 ↓
Zaha Hadid
British, born Iraq (b. 1950)
Moraine Sofa, 2000
Fabric
Mfr: Sawaya & Moroni
29½ × 133⅛ × 47¼ in.
(75 × 338 × 120 cm)

Hadid's work as an Expressive designer—when compared to that of her contemporaries—is distinctive for its use of upholstered forms. Such designs as the *Moraine* sofa are also unusual in terms of their massive scale, whereby they function almost like monolithic architectural fragments in defining environments.

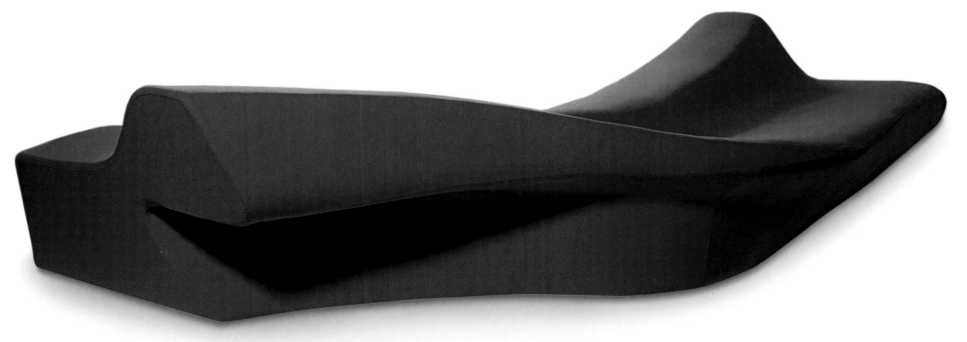

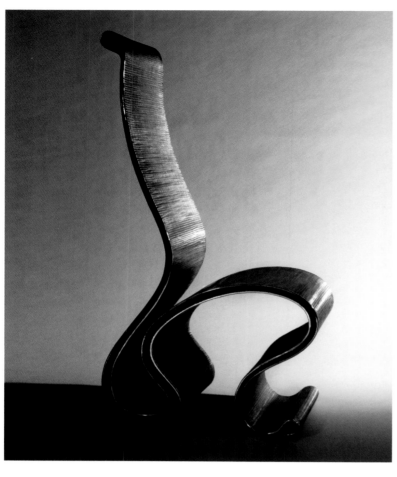

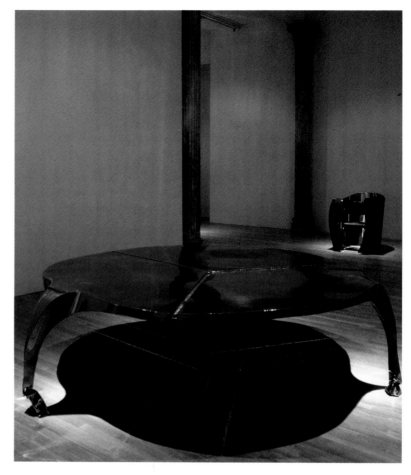

118 ← ←
Ron Arad
British, born Israel (b. 1951)
Looploop Chair, 1992
Steel
Mfr: One Off Ltd.
45³/₄ × 27⁵/₈ × 16¹/₈ in.
(116 × 70 × 41 cm)

The *Looploop* chair is an iconic design from Arad's mid-career: an elegant, serpentine form with a sumptuous surface requiring the most sophisticated craftsmanship.

119 ←
Ron Arad
British, born Israel (b. 1951)
Three Thirds of a Table, 1989
Steel and Plexiglas
Mfr: One Off Ltd.
30 × 39⁵/₈ × 72¹/₈ in.
(76.2 × 100.5 × 183 cm)

While chairs constitute some of Arad's most accomplished furniture designs, he was also able to create new interpretations of the table. *Three Thirds of a Table* is distinctive for the manner in which Arad negates its enormous mass through the use of acrylic seams and large reflective surfaces made of stainless steel.

120 ←
Ron Arad
British, born Israel (b. 1951)
The Little Heavy Lounge Chair, 1989
Steel
Mfr: One Off Ltd.
30 × 27¹/₂ × 25¹/₂ in.
(76 × 70 × 65 cm)

The continuous sculptural form is yet another recurring motif in Arad's work, from his earliest designs (figs. 102, 104) right up to the present. With its shimmering and flawless stainless steel surface, the *Little Heavy* chair is one of the most elegant interpretations of this form.

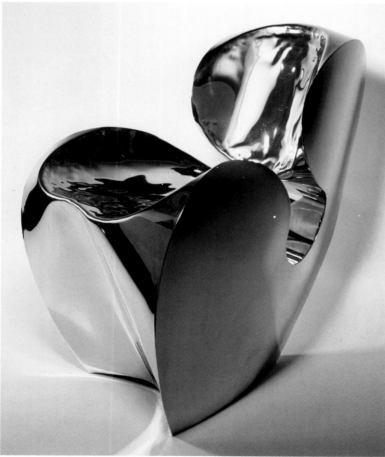

become the plastic *Bookworm* shelving (1994; figs. 202, 203) made by Kartell. Arad's *Looploop* chair (1992; figs. 103, 118) is one of his most elegant designs, with its undulating ribbon form and sensuous surface.[84] The steel outer edge is graduated in size and serves as a rigid frame to support the continuous seating panel made from industrial mesh.

Two other designs illustrate Arad's ability to work in stainless steel with an extraordinary dexterity. There is a tongue-in-cheek quality to the design of *Three Thirds of a Table* (1989; fig. 119), which features three massive wedges of steel magically held together by thin strips of translucent acrylic. Arad is fascinated by the reflectivity of large steel surfaces; and he adds a slightly whimsical note with the crumpled legs, which appear to be collapsing from the weight of the table. Arad's interest in continuous sculptural chair forms is illustrated by *The Little Heavy* chair (1989; fig. 120).[85] Compared to the earlier *Tinker* design (1988; figs. 102, 104), the surface is much more refined; the welds have been polished away to achieve a shimmering, stainless steel form.

Even in its more sophisticated mode, this kind of Expressive design has not often been applied to smaller design media. The *Zaha Hadid* tea and coffee service (1995–96; figs. 101, 121) is an exception, and its acutely angular forms stand in marked contrast to Arad's work. The four pieces of the set, made of precious silver by hand, interlock to make a crystalline form. The detailing of the handles is exceptional, and the bases of the tapered forms magically seem to float.

121
Zaha Hadid
British, born Iraq (b. 1950)
Zaha Hadid Tea and Coffee
Service, 1995–96
Silver
Mfr: Sawaya & Moroni
Overall: 18½ × 22⅛ × 14¼ in.
(47 × 56 × 36 cm)

Hadid's tea and coffee service for Sawaya & Moroni is perhaps the ultimate illustration of the Expressive precept that form is more important than function. The acute forms are simply dazzling, whether interlocked (fig. 101) or standing individually as crystalline silver shards.

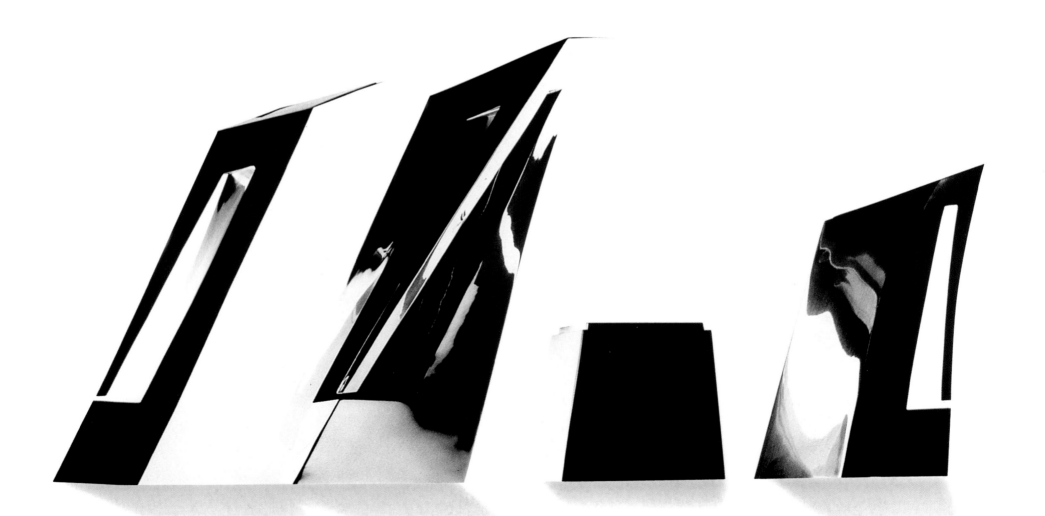

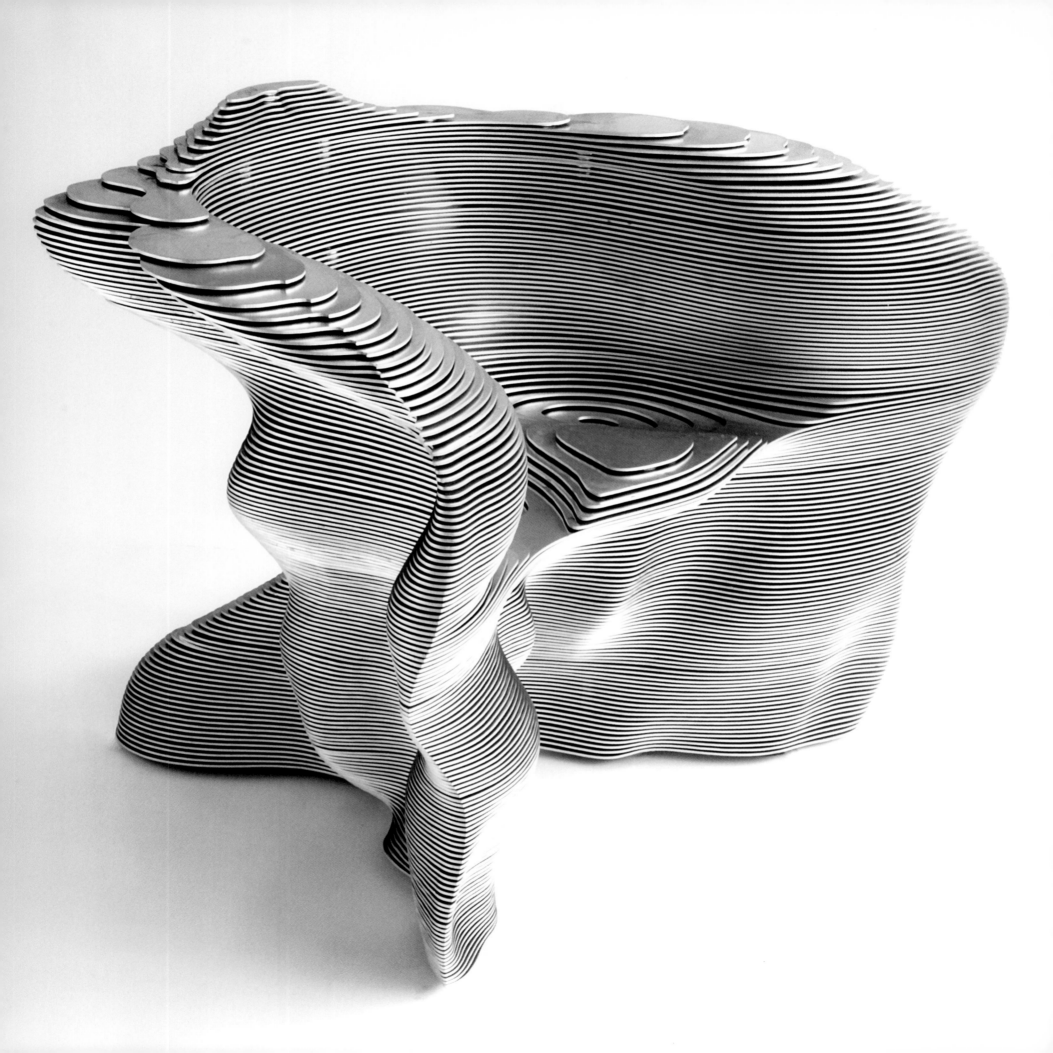

Technological Expressive design

Interest in an Expressive design approach has also been embraced by a second generation, which has produced a remarkable body of work in the 2000s. Once again, the work is all about the material and how it is made; the big difference is that these younger designers are now using the computer, new materials, and innovative technology to make their products, often in a factory rather than a studio setting. However, much of this work is still very limited-edition in terms of production.

Mathias Bengtsson is one of the most important members of this generation of Expressive designers.[86] His aesthetic is derived from a diametrical interaction between, on the one hand, machines and technology, and, on the other, handcraftsmanship. Many of his Expressionist forms are notable for the extraordinary play of light on or through their surfaces.

The concept of laminating together planar sheets of material to achieve highly sculptural forms goes back to Gehry's *Easy Edges* cardboard chairs of 1972, noted earlier. In his *03 Slice* chair (1999; fig. 122; see also p. 2), Bengtsson has taken this idea to the next level by using the computer to determine the exact shape of each layer of material, which is then cut by a laser. The chair itself can be made of plywood, aluminum, or cardboard; and the sheets of material can be stacked either vertically or horizontally. Carbon fiber is still a relatively new material in the design field, and it has most often been used in more of a handcrafted manner. However, for his *C8 Spun Carbon* chaise longue (2002; fig. 123), Bengtsson devised a computer program with which he was

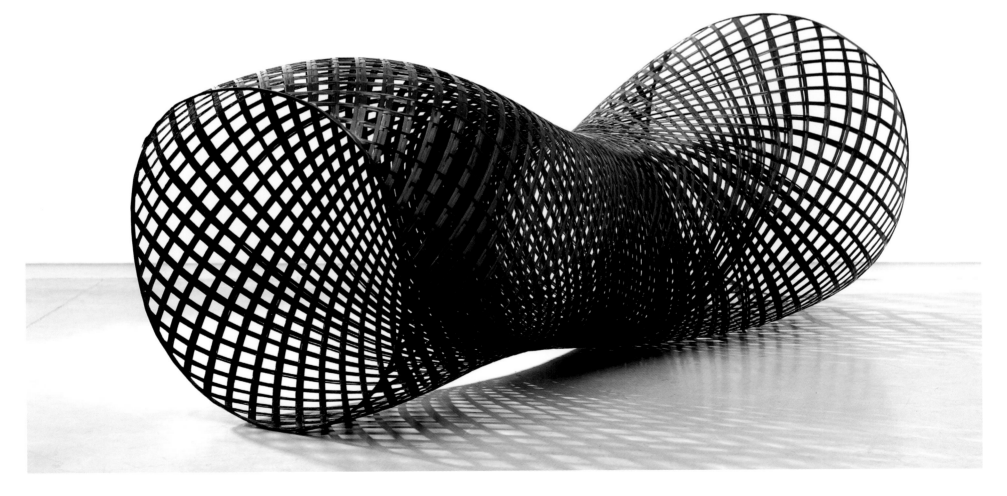

124
Patrick Jouin
French (b. 1967)
C2 Solid Side Chair, 2004
Resin
Mfr: Materialise.MGX
30¼ × 15¾ × 21¼ in.
(76.8 × 40 × 53.9 cm)

For his *C2 Solid* chair, Jouin
used stereolithography at
a greatly enlarged scale to
create a skeletal-like form
of remarkable complexity
and elegance.

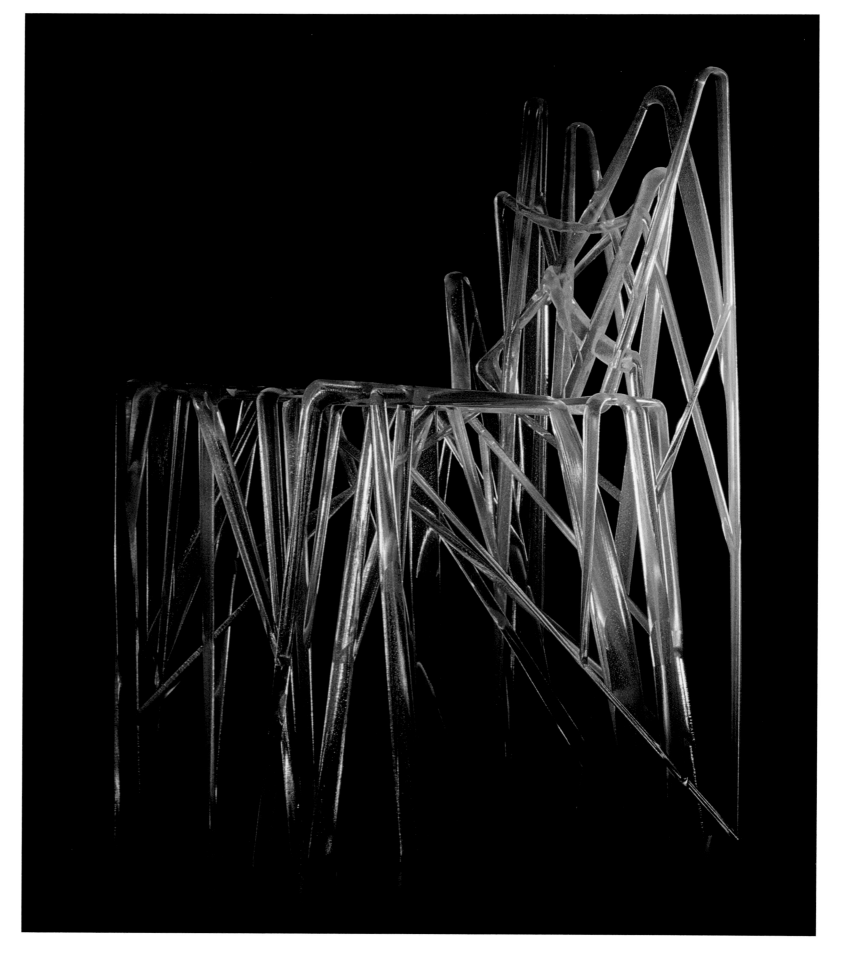

able to instruct high-tech machinery, normally used in the aircraft industry, to spin a form out of carbon fiber.[87] Again, the design is more of a sculptural object than a functional piece of furniture; it is also a more three-dimensional variation of Marc Newson's wicker chaise longue made in 1990 for Idée.

Patrick Jouin's *C2 Solid* side chair (2004; fig. 124) is one of his most radical designs to date. Working with the Materialise.MGX company, Jouin has employed stereolithography—normally used for the rapid prototyping of small models or prototypes in an office—to make a full-size chair, a remarkable technical and aesthetic feat.[88]

Likewise, Joris Laarman's *Bone* lounge chair (2005–06; fig. 125) dramatically pushes the boundaries of furniture design. The overall shell form recalls *La Chaise* (1948), designed by the Americans Charles and Ray Eames; but it is the structural base of translucent resin that is of interest. Laarman has adapted research conducted by doctors on how the mass and shape of bones evolve according to functional requirements; for the lower frame of the chair, he has used a digital tool from the automobile industry to replicate the way bones form.[89]

Three other seating designs show how the technological Expressive design aesthetic has been adapted and applied to various materials and manners by the second generation of designers. In his prototypal design for the *Silver Stream* lounge chair (1998; fig. 126), Aleksej Iskos has bent and cut a sheet of aluminum to create a dramatic cantilevered form. Bertjan Pot's *Random* lounge chair (2003; fig. 127) was also initially handmade in the designer's own studio, unlike

125
Joris Laarman
Dutch (b. 1979)
Bone Lounge Chair, 2005–06
Polyurethane and resin
Mfr: Joris Laarman
30³⁄₈ × 40¹⁄₂ × 58¹⁄₄ in.
(77 × 103 × 148 cm)

Laarman's *Bone* lounge chair is a bipartite form consisting of a contoured shell supported by a highly articulated base that recalls bone formations. The designer uses technology borrowed from the automobile industry to create such powerful sculptural forms.

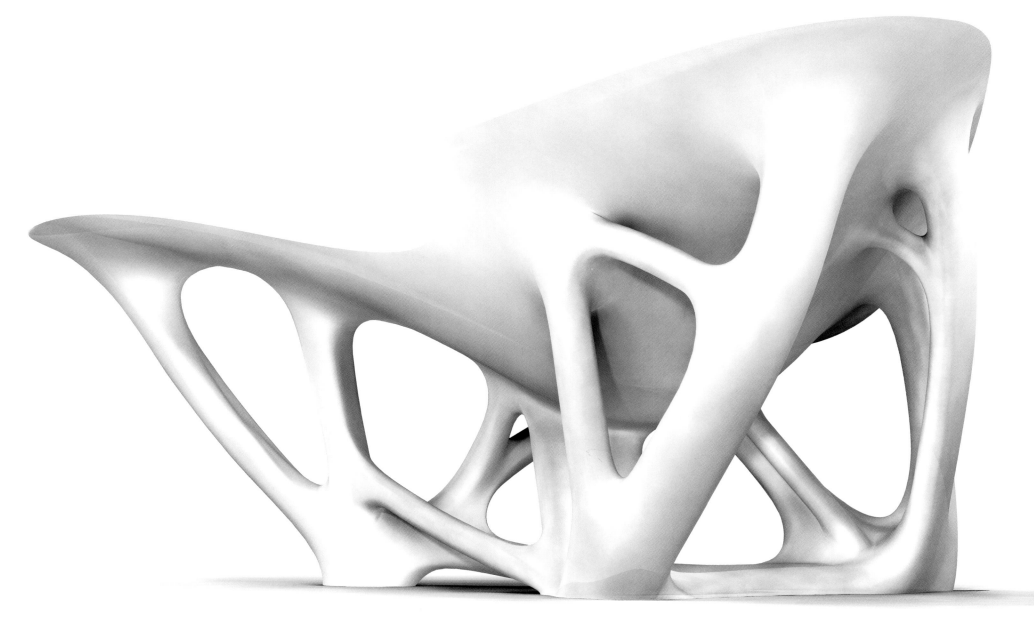

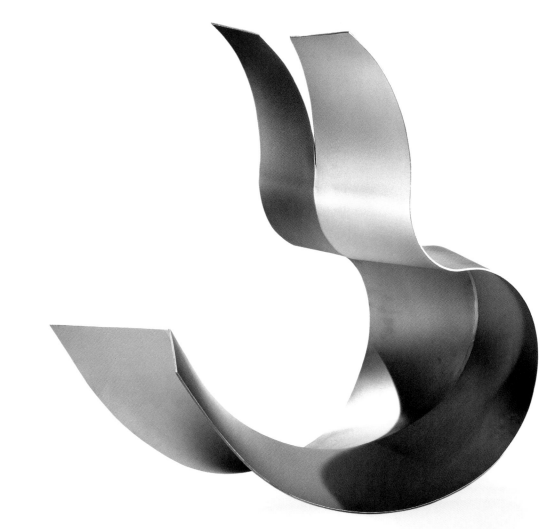

126 →
Aleksej Iskos
Danish, born Ukraine (b. 1965)
Silver Stream Lounge Chair, 1998
Aluminum
Mfr: Aleksej Iskos
20⅛ × 11⅞ × 59⅛ in.
(51 × 30 × 150 cm)

For his *Silver Stream*
prototype, Iskos has updated
the continuous cantilevered
chair form. Sheets of aluminum
have been cut and bent to
create a sleek, elegant profile.

127 ↓
Bertjan Pot
Dutch (b. 1975)
Random Lounge Chair, 2003
Carbon fiber
Mfr: originally Bertjan Pot;
now Goods
28 × 17 × 37 in.
(71.1 × 43.2 × 94 cm)

Like Bengtsson (fig. 123), Pot
uses carbon fiber for some of
his designs, but in a decidedly
different manner. Pot's *Random*
lounge chair was initially
handmade by wrapping
hundreds of strands of carbon
fiber around a mold; when dry,
the strands form a rigid, web-
like structure.

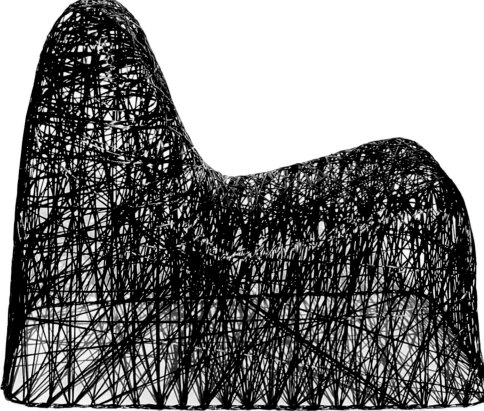

128
Studio I.T.O. Design
Italian (Setsu Ito, Japanese,
b.1964; Shinobu Ito, Japanese,
b.1966)
AU Lounge Chair, 2003
Fabric and leather
Mfr: Edra S.p.A.
Largest: 29⅞ × 57½ × 51 in.
(76 × 146 × 130 cm)

Building on the work of Hadid
(fig. 117), Studio I.T.O. Design
has produced some highly
sculptural upholstered pieces.
The colorful *AU* lounge
chair consists of two large
interlocking forms that
can be arranged in various
configurations to dramatically
change the spatial quality of
any environment.

Bengtsson's *C8 Spun Carbon* chaise longue
(fig. 123). To create the chair, Pot dipped strips of
carbon fiber into resin and then wrapped them
around a large mold, much like a large ball of yarn.
Once the piece had dried, it was then coated with
a layer of epoxy, the final result being a rigid,
sensuous, mesh-like sculpture.[90] Studio I.T.O.'s
AU lounge chairs (2003; fig. 128), on the other hand,
recall Hadid's work for major manufacturers.[91]
They are large, interlocking sculptural forms made
of molded polyurethane foam, upholstered in a
colorful stretch-fabric and leather.

The Expressive design movement has remained
a small but vital force in European design for
more than two decades. It is a varied manner that
still holds a great appeal for many designers—
both aesthetically and technically—owing to the
remarkable freedom that it affords.

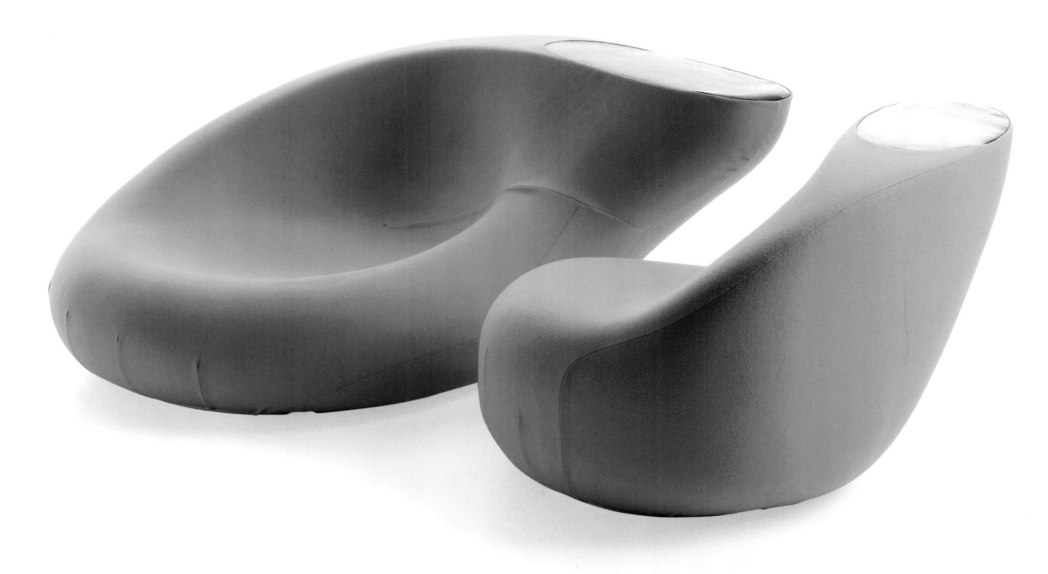

Modernist Tradition

Geometric Minimal Design

Concept

In reaction to Postmodernism, this movement sought to reinvigorate a Modernist tradition that had become synonymous with spare and refined forms, a tradition that often employed a vocabulary of simple geometric shapes with great élan. The movement's designers were primarily concerned with industrial technology and materials, for their works were usually designed to be mass-produced. There were few, if any, pronounced generational differences within this movement, one that has been immensely influential and has attracted the largest number of designers working during the period 1985 to the present. These designers, however, were not creating radical, revolutionary objects, as was the case with their precursors working between the two world wars; instead, they created a new kind of Modernism, one that sought to capture the essence of form.

Within the Geometric Minimal movement, there were four subcategories. Perhaps the most important of these was the one in which major designers sought to create powerful archetypal models. In the three other manners, designers were concerned primarily with design for design's sake. The work produced alternated between mass-produced everyday and limited-edition luxury interpretations by an older generation of designers, together with new variations on these modes by a second generation.

Style

With Geometric Minimal designers, there is a fundamental relationship between form, material, and method of construction. Characteristically, they employ a vocabulary of geometric minimalist shapes. While they are capable of producing designs in a broad range of media, utilizing a variety of materials, these designers tend to work most often with a limited palette of materials. This minimalist approach is also evident in the way that any sense of decoration is inevitably inherent to the material and method of construction: there is never any sense of superfluous ornament or pattern. But there can be marked contrasts in this design approach: color palettes can span from bright to muted hues; objects can range from inexpensive to more luxurious, limited-edition pieces; and construction can vary from the mass-produced to limited-edition.

Time and Place

The Geometric Minimal resurgence coalesced in the mid-1980s, forming a powerful movement that swept across Western Europe with almost lightening speed. Its influence extends to the present; and this mode has had a particularly strong impact in Scandinavia, although there have been manifestations in virtually every European country.

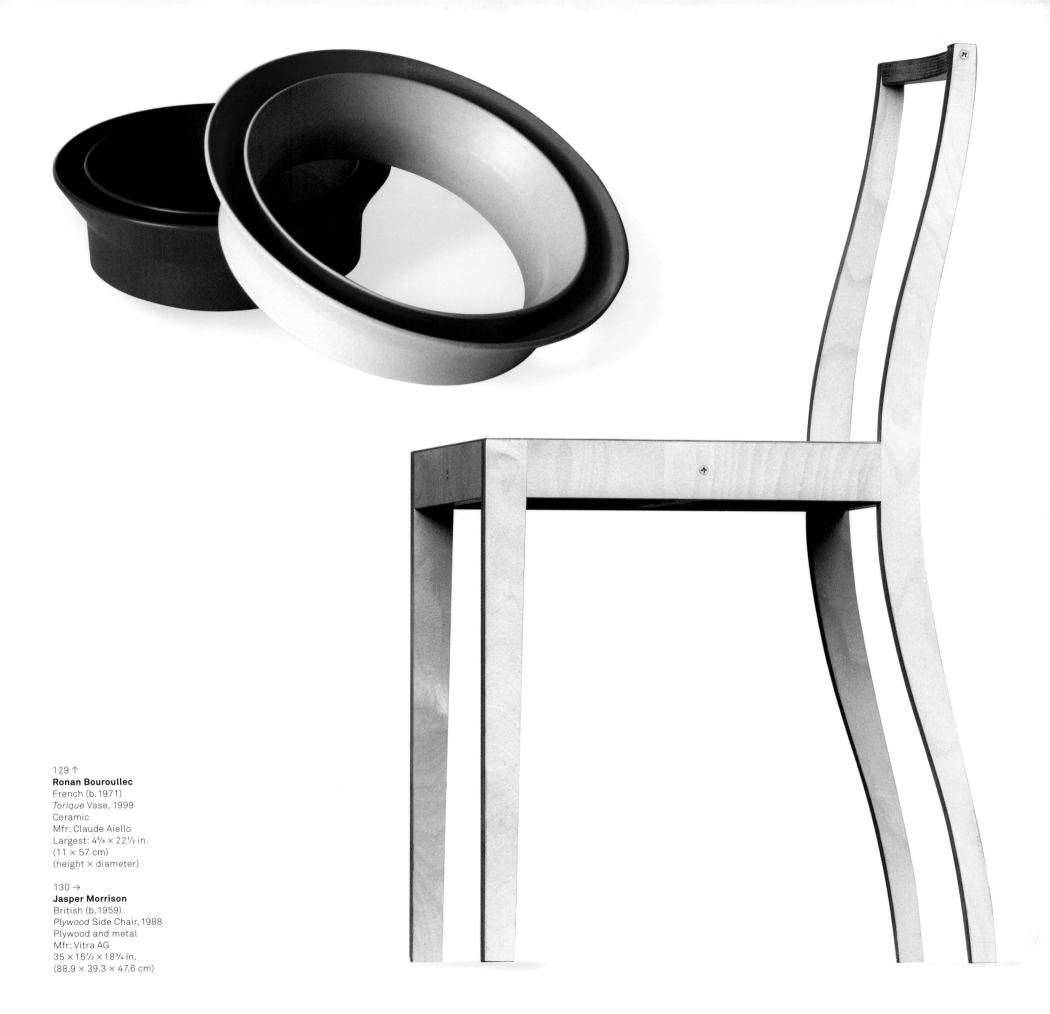

129 ↑
Ronan Bouroullec
French (b.1971)
Torique Vase, 1999
Ceramic
Mfr: Claude Aiello
Largest: 4⅜ × 22½ in.
(11 × 57 cm)
(height × diameter)

130 →
Jasper Morrison
British (b.1959)
Plywood Side Chair, 1988
Plywood and metal
Mfr: Vitra AG
35 × 15½ × 18¾ in.
(88.9 × 39.3 × 47.6 cm)

n the post-Second World War era, Modernism dominated Western design to a remarkable extent. It is hard, a quarter century later, to imagine the fierce—and often very divisive—polemics that ensued when its authority was challenged by the Postmodernists in the 1970s and 1980s. By the mid-1980s, there was, in fact, a counter-reaction by a new generation of Modernist designers, who sought to reassert their leadership position. There were two major stylistic manifestations of this Modernist resurgence: one was concerned with Geometric Minimal forms and another with Biomorphic design. There was also a third manner, a Neo-Pop revival, which briefly captured the attention of a number of designers.

Certainly the most pervasive movement in this Modernist resurgence was the one concerned with a Geometric Minimal style. Its two most influential leaders were Jasper Morrison and Maarten Van Severen, who defined a new conceptual basis for the movement that, to a remarkable degree, recaptured the theoretical purity of Modernism in the 1920s. Their focus on the archetypal form required a demanding intellectual and aesthetic rigor; but the seeming simplicity of their work allowed it to be readily copied, particularly in Scandinavia, where post-war Modernism had never completely died out.

There were other aspects of this Geometric Minimal movement that were less theoretical in nature and more concerned with "design for design's sake." Thus a certain dichotomy existed, with designers creating mass-produced everyday objects or limited-edition luxury interpretations. Although we are still very close to the moment, one may also sense a nascent questioning of this Modernist mandate by a second generation of designers, led by such figures as Ronan and Erwan Bouroullec and Konstantin Grcic. So, while Modernism is often perceived as a rather monolithic movement, the Modernist fascination with Geometric Minimal design was, in reality, a nuanced development.

Archetypal designs

It was Jasper Morrison and the late Maarten Van Severen who laid a solid theoretical basis for this Geometric Minimal movement. They simply came at it, initially at least, from different perspectives: the former as a designer, the latter more as an artist.

Morrison, while the equal of Philippe Starck in terms of sheer talent, is his polar opposite: he is a "designer's designer."[92] While he certainly is part of the Modernist tradition, Morrison has developed a unique interpretation. He is not primarily concerned with new materials or technology.[93] Nor does he believe that designs have to be radically new, hence his interest in interpreting archetypal forms in an innovative manner, so that design does not lose its history.[94] Morrison has been able to pursue this intuitive and subtle design approach because he is an artist of the first rank. This approach, however, has led to the emergence of a host of less assured followers—not unlike what happened to the architect Ludwig Mies van der Rohe in the 1950s—who have popularized Morrison's concept of interpreting archetypal forms, but who often do little more than update or reinterpret Modernist designs of the post-Second World War period, often at the level of pastiche.[95] Morrison also believes that objects should be quietly comfortable with themselves. Characteristically, he is seeking to achieve an unassuming balance in his work through the combined use of straight and curved lines; Morrison's formal vocabulary can thus vary from the geometric to the "softly biomorphic." He has also spoken of the qualities that he values in a

design: to be graceful, economical, and well conceived.[96] Fundamentally, then, Morrison's goal is to make design a part of our everyday lives and not let it become some elitist discipline. Moreover, Morrison does not like to think of himself as part of any movement—even Minimalism—and there is not a deep intellectual basis to his work. It is what it is. Indeed, his interest in having the average consumer appreciate his work fuels his preoccupation with using archetypal forms to evoke indirectly from the user that sense of the familiar.[97]

Maarten Van Severen was an artist of immense talent, whose career lasted some twenty years; remarkably, in spite of a difficult personal life, he was able to maintain an extraordinary level of creativity almost to the end. Van Severen's design process was a long, complicated affair, since his goal was always to capture the essence of an object—to produce the quintessential (or archetypal) chair or table. He sought to create, as one critic noted, a kind of "poetic sensual minimalism."[98] Van Severen used his love of materials as a means of finding these elemental forms, removing as much matter as possible to get to the minimum.[99] Van Severen loved the touch and feel of materials, especially wood and aluminum. There was also the added factor that this production could be done (and controlled) directly in his studio, versus using an outside factory.[100] The constant and ascetic refinement of proportions and details became other themes in his work, requiring the most exceptional craftsmanship. Van Severen was also quite prolific, in the sense that he would take simple forms and continue to refine them with subtle modifications and variations. He was, in short, the ultimate perfectionist.

There were three phases to Van Severen's career. From 1986 to 1996, his work was largely made by hand in his studio, Maarten Van Severen Meubelen. In late 1999, he allowed his designs to be adapted for limited production by Top-Mouton, a Belgian company.[101] Occasionally, he created special pieces for such galleries as Galerie kreo in Paris. From about 1994 to 1999, with his fame growing, he made the transition to being an industrial designer, creating work for such large-scale manufacturers as Vitra.[102] Van Severen was faced with two challenges at this point in time: he was no longer able to exercise the same kind of

132 →
Jasper Morrison
British (b.1959)
Plywood Side Chair, 1988
Plywood and metal
Mfr: Vitra AG
35 × 15½ × 18¾ in.
(88.9 × 39.3 × 47.6 cm)

Morrison's *Plywood* chair is one of *the* iconic examples of Geometric Minimal design. It is the rectangular wooden side chair reduced to the absolute minimum in terms of form and material, a reaffirmation of Mies van der Rohe's creed that less can indeed be more.

133 → →
Maarten Van Severen
Belgian (1956–2005)
No. 2 Side Chair, 1992
Aluminum and beech
Mfr: originally Maarten Van Severen Meubelen; now Top-Mouton
32⅜ × 14⅞ × 22⅛ in.
(82 × 38 × 56.2 cm)

Van Severen's *No. 2* chair, like Morrison's *Plywood* side chair (figs. 130, 132), is an emblematic minimal design. It is a particularly subtle creation, down to the most minute detail, utilizing Van Severen's favorite materials, wood and aluminum; it may also be seen as a harbinger of the designer's extraordinary work over succeeding decades.

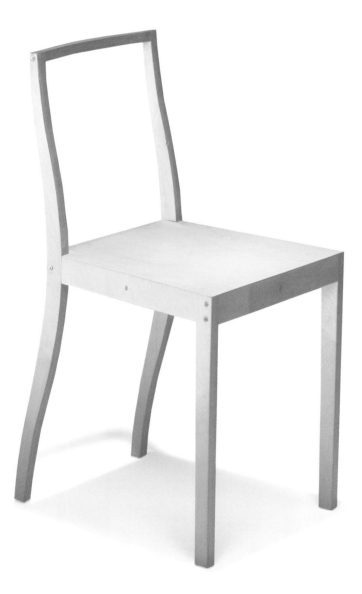

control over the details and proportions of his pieces that he had had in his studio, and the problems in his personal life began to affect the quality of his late work.[103] So, looking at his production as an industrial designer, it is his early designs that will perhaps prove to be his most enduring accomplishments. Without question, however, Van Severen was one of the seminal designers of this period; and his career stands as a cogent counterpart to that of Ron Arad.[104]

Thus, in many respects, Morrison and Van Severen laid the foundations for the Geometric Minimal movement. Both designers were searching for pure archetypal forms in terms of seating, tables, and storage units, a process which led to a series of spare, attenuated designs—some of the most important work of this era. While Van Severen concentrated mainly on furniture, Morrison worked in a wide range of media and materials. Their designs range from limited-edition pieces to mass-produced objects. A comparison of their work is most revealing, highlighting both similarities and differences.

The chair was certainly the quintessential form for both designers. Morrison's *Plywood* side chair (1988; figs. 130, 132) is perhaps his first mature industrial design. It is the rectangular wooden chair reduced to its minimum. Morrison has not used the technological might of Vitra; rather, he has employed simple sawn sections of plywood for the frame, which have been meticulously joined together by metal screws, the only embellishment. The chair achieves its beauty from the elegant balance of straight and curved lines. Van Severen's *No. 2* side chair (1992; fig. 133) is also deceptive in its simplicity. The front legs of the aluminum frame are rectangular, while the rear legs are round. Even the top of the beech seating panel has a subtle curve.[105] These early designs show Morrison and Van Severen at their purest, as they were just beginning their careers.

Two later chairs show the transition in their work when they began to design for industrial manufacturers. Morrison's *Air* side chair (1999; fig. 134) is an elemental rectangular café chair. The polypropylene piece was designed to be made in an industrial mold by the thousands for Magis. Its impact comes from the simple form and captivating colors.[106] Van Severen's *No. 3* side chair (1998; fig. 135) is the epitome of the minimal office chair.[107] At first glance, with its four legs and

134 →
Jasper Morrison
British (b. 1959)
Air Side Chair, 1999
Polypropylene
Mfr: Magis S.p.A.
30½ × 19½ × 20 in.
(77.4 × 48.6 × 50.8 cm)

Morrison had the uncanny ability to adapt his spare style to true industrial production and yet retain a strong aesthetic quality in his designs. The *Air* chair, made of polypropylene, is the quintessential minimal café chair.

135 → →
Maarten Van Severen
Belgian (1956–2005)
No. 3 Side Chair, 1998
Polyurethane, steel, and aluminum
Mfr: Vitra AG
30 × 20¾ × 15 in.
(76.2 × 52.7 × 38.1 cm)

Being artists of the first rank, both Van Severen and Morrison sought to invent new interpretations of archetypal furniture forms. With the *No. 3* chair, Van Severen succeeded brilliantly in creating an iconic minimal office chair.

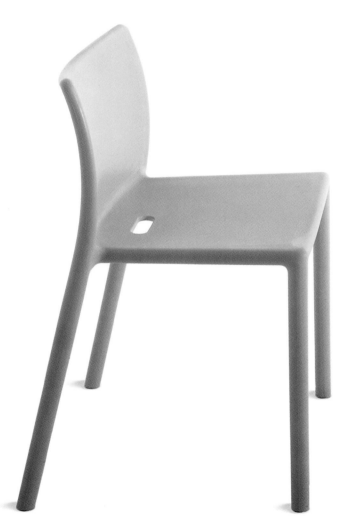

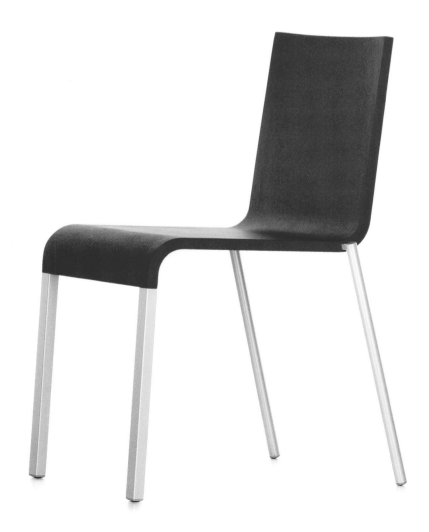

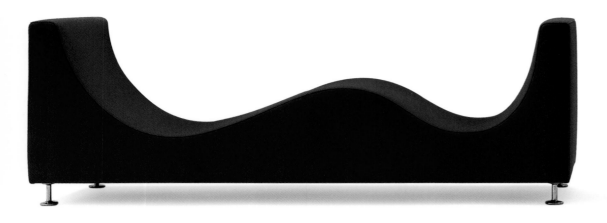

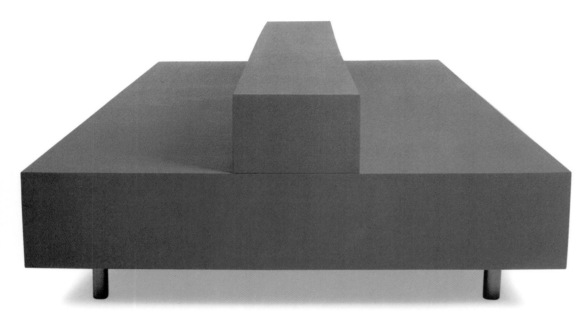

Jasper Morrison
British (b. 1959)
Air Table, 2000
Polypropylene
Mfr: Magis S.p.A.
27 × 25¼ × 25¼ in.
(68.6 × 64.1 × 64.1 cm)

While designing the *Air* café chair for Magis (fig. 134), Morrison also created a series of small tables that could be used in bars and bistros. The elemental forms were ideally suited to mass production in polypropylene and were produced in a variety of colorful hues.

139 →
Maarten Van Severen
Belgian (1956–2005)
T88A Table, 1988
Aluminum
Mfr: Top-Mouton
Largest: 28⅝ × 157½ × 39⅜ in.
(72.5 × 400 × 100 cm)

The Parsons table is perhaps one of the most elemental of furniture forms. Van Severen's variation is notable for its elongated proportions and effortless perfection, both of which require the most sophisticated engineering and detailing.

136 ↑↑
Jasper Morrison
British (b. 1959)
3 Sofa Deluxe, 1991
Aluminum and fabric
Mfr: Cappellini S.p.A.
28⅜ × 78¾ × 27⅝ in.
(72 × 200 × 70 cm)

137 ↑
Maarten Van Severen
Belgian (1956–2005)
Blue Bench Sofa, 1997
Polyurethane and metal
Mfr: Edra S.p.A.
15¾ × 78 × 43¼ in.
(40 × 198 × 109.8 cm)

Many designers think of a traditional sofa as a large upholstered mass with numerous cushions for maximum comfort. Morrison and Van Severen, however, saw it as a reductive exercise to create the sparest of forms in brilliant hues.

continuous seating panel, it appears to be a variation of the *No. 2* side chair (fig. 133); but Van Severen has in fact used the technological capabilities of Vitra, whereby the seating panel now has steel springs inside a polyurethane foam shell, which provides some elasticity.

Both designers also addressed the issue of large-scale seating with two sofa designs. There were a number of designs by Morrison in the *3 Sofa Deluxe* series (1991; fig. 136) for Cappellini, but perhaps the best of these is an asymmetrical day bed. Morrison's design once again juxtaposes a simple curve against straight lines to achieve a monumental form floating on aluminum legs. Van Severen's *Blue Bench* sofa (1997; fig. 137), with its bipartite composition of a rectangular mass with a bolster, is a variation on Mies's classic chaise of 1930. Here, Van Severen has used large blocks of coated polyurethane foam on recessed metal legs; this design also marks his first bold use of color, the blue version perhaps being the most dramatic.[108]

Both Morrison and Van Severen also produced brilliant solutions for a variety of tables and storage units. Morrison's *Air* table (2000; fig. 138) is part of the earlier café series (fig. 134). Also constructed out of polypropylene in a variety of colors, it was made available in two versions: square and oval. With his *Universal* storage system design of 1990 (fig. 140), Morrison redefined the wooden modular storage unit using the simplest of means; this becomes especially apparent when one compares it to other cabinets later in this section.[109] In his attempts to redefine the entire furniture field, Van Severen explored other forms with equal rigor. The *T88A* table (1988; fig. 139) is one of Van Severen's earliest mature designs. The form is the most basic of shapes, a simple rectangle with four legs, produced in both aluminum and a variety of woods; a great deal

of complex and "hidden" engineering was required to achieve such minimal proportions and perfect detailing. In their simplicity, Van Severen's bookcases recall the minimal metal sculptures of Donald Judd.[110] The *CK94* unit (1994; fig. 141) is again a marvel of engineering. The frame is made of intricately designed honeycomb aluminum panels that have been screwed together; the use of a translucent polycarbonate back panel magically eliminates any sense of weight or mass in such a large case piece.[111]

Mass-produced everyday interpretations

Such was the force of Morrison's and Van Severen's examples that their work was immensely influential, in both an overt and an osmotic manner; it was also adapted in a myriad of creative ways by

a number of designers for mass-produced everyday objects. The Bouroullec brothers and Konstantin Grcic were among the most influential proponents of this design approach; and in many respects they may be seen as paradigms of a younger generation.

In France, the Bouroullec brothers are widely perceived as being the new wave after Starck.[112] They have received a tremendous amount of international press, although they are still only in their thirties and, to date, have not actually produced that much work. There are two aspects to their production. Most of their work (approximately 90 percent) is designed to be mass-produced, and they have been fortunate enough to be hired by such companies as Cappellini, Magis, and Vitra, giving them a high profile. Occasionally, they also like to undertake

Jasper Morrison
British (b. 1959)
Universal Storage System, 1990
Plywood and aluminum
Mfr: Cappellini S.p.A.
Largest: 20½ × 58¼ × 15¾ in.
(52.5 × 148 × 40 cm)

With their architectonic metal frames and colorful wooden panels, Charles and Ray Eames's *ESU* storage units are a mid-century Modernist icon. In contrast, the spareness of Morrison's design approach is readily apparent in his *Universal* storage units. Here, the geometric cabinets have been reduced to the simplest of metal bases and natural plywood finishes.

limited-edition projects for such galleries as Galerie kreo in Paris.

Despite their age, the Bouroullec brothers are keenly aware that design is undergoing a moment of great transition into a new century; and they are still in the formative stages of trying to forge a new conceptual basis for European design.[113] The brothers sense that Europe is increasingly losing its manufacturing base and is becoming an intellectual center where brands take precedence. They are also remarkable for their age to the extent that they understand how to work effectively and creatively within an existing industrial design system, while at the same time being able to push it in new directions.[114] Lastly, the Bouroullec brothers are unusual in their interest in creating environments or over-scaled pieces, where the

user has the opportunity to create "self-defining space"; they see such pieces as bigger than furniture but smaller than architecture.[115]

In Europe, Konstantin Grcic is now seen as perhaps the new wave after Morrison. He was born almost a decade earlier than the Bouroullec brothers and may well prove to be a true European designer with no nationality, having led a fairly nomadic life.[116] While most of his major work is seemingly simple, Grcic, under the influence of Morrison, has in many respects reprised the old saying that "still waters run deep." For upon close examination, his career is replete with complexities and connections. Furthermore, unlike Starck, who in the 1990s appeared to anticipate with great acumen every shift in fashion, Grcic seems to be driven by a more fundamental

141
Maarten Van Severen
Belgian (1956–2005)
CK94 Bookcase, 1994
Aluminum and polycarbonate
Mfr: originally Maarten Van
Severen Meubelen; now
Top-Mouton
92½ × 49 × 13¾ in.
(235 × 125 × 35 cm)

The *CK94* bookcase is one of
Van Severen's most ethereal
designs. The monumental scale
of such a large case piece is
defied by the juxtaposition of
a shimmering aluminum frame
against a frosted back panel,
creating an effect not unlike
the magical translucency of
shoji screens.

142 ↓
Erwan Bouroullec
French (b.1976)
Ronan Bouroullec
French (b.1971)
Cloud Shelving System, 2004
Polyethylene
Mfr: Cappellini S.p.A.
One Unit: 41⅜ × 73⅝ × 16 in.
(105 × 187 × 40.5 cm)

The Bouroullec brothers like
to create pieces that blur the
line between furniture and
architecture. The *Cloud* shelving
system is an apt example:
a monumental but airy and
lightweight room-divider that
can be assembled in a variety
of configurations, engaging the
user in an interactive manner.

143 →
Antonio Citterio
Italian (b.1950)
Glen Oliver Low
German (b.1959)
Mobil Storage System, 1994
Aluminum and plastic
Mfr: Kartell S.p.A.
Largest: 30¾ × 38¼ × 18¾ in.
(78 × 97 × 47.5 cm)

Citterio has become one of the
most successful and assured
Italian industrial designers of
this era. He has been influenced,
in particular, by the mid-century
designs of Charles and Ray
Eames, which he reinterprets in
an original manner using new
materials and technologies.
Citterio's *Mobil* storage system
is an elegant variation on the
Eameses' *ESU* units, while his
Famiglia AC2 chair (fig. 144)
draws on a number of their
designs for office seating
manufactured by Herman Miller.

cause: to help redefine European design in a new century.[117] He is, in short, a designer of promise to be followed carefully.

There have been two major influences on Grcic's work. He first studied with John Makepiece, from whom he learned the tradition of the craftsman/designer.[118] Grcic then attended the Royal College of Art in London, where, under Morrison's influence, he absorbed the model of being a true industrial designer.[119] Thus Makepiece was about making, Morrison about designing. Over the years, Grcic has sought to fuse these two traditions, both conceptually and aesthetically. Like Morrison's work, Grcic's early designs are about exploring archetypal forms. This work is largely about material and finding a manufacturer who will allow Grcic to experiment with industrial processes to achieve a new synthesis of matter, technology, and form. Grcic is also unusual in that he is acutely aware of the history of design, and he is clearly able not only to place his work in that continuum but also to perceive how he is breaking new ground—a rare sensibility.

There were, of course, many other designers in Europe who embraced a somewhat analogous design approach. These designers, encompassing two generations, were concerned primarily with creating mass-produced industrial objects. They often employed new technology and used inexpensive industrial materials. Their forms span a broad range of media and tend to be spare and light, with color and material being the principal aesthetic components.

A number of these designers focused on creating new interpretations of key archetypal furniture forms. Like Ron Arad, the Bouroullec brothers have designed large shelving systems that are almost environmental in scale. Their *Cloud* shelves (2004; fig. 142) are massive forms made of lightweight polyethylene that interlock in various configurations. With their round openings, however, they are more like pieces of sculpture

144 →
Antonio Citterio
Italian (b. 1950)
Famiglia AC2 Office Chair, 1990
Aluminum, steel, and fabric
Mfr: Vitra AG
35⅛ × 27¼ × 27 in.
(89.6 × 69.2 × 69.2 cm)

145 ↘
Jorge Pensi
Spanish, born Argentina
(b. 1946)
Toledo Stacking Chair, 1988
Aluminum
Mfr: Amat SA
29⅞ × 21⅝ × 21¼ in.
(76 × 55 × 54 cm)

Pensi, one of Spain's foremost
Modernist industrial designers,
was fascinated with the idea of
developing a new interpretation
of the aluminum café chair.
The *Toledo* chair consists of a
combination of cast and tubular
elements; the result is a minimal
but remarkably graceful design.

or room-dividers than functional bookcases. In his work as an industrial designer, Antonio Citterio often looked to American Modernist designs of the 1950s and 1960s for inspiration. In his *Mobil* storage system (1994, designed with Glen Oliver Low; fig. 143), Citterio tackled the issue of creating a new series of modular storage units. His combination of a metal frame with colorful plastic drawers is an update of Charles and Ray Eames's *ESU* units (1950).[120] Indeed, the *Mobil* units provide a striking contrast with Morrison's *Universal* system of 1990 (fig. 140). Citterio also addressed the issue of the office chair in his *Famiglia AC2* chair (1990; fig. 144); again, one can see the influence of the Eameses in the overall form, the checkered upholstery, and especially the detailing of the five-prong base.[121] Jorge Pensi's *Toledo* stacking chair (1988; fig. 145), on the other hand, is an update of a café chair and illustrates his fascination with aluminum. In its use of cast and tubular elements, the chair is also indicative of Pensi's industrial aesthetic and his desire to create straightforward designs, pieces that are "simple but not too much."[122]

Other designers addressed the problem of creating new interpretations of more generic everyday chairs and tables. Such design teams as Komplot and BarberOsgerby often favored a more minimal color palette in their work. At first glance, Komplot's *Non* side chair (2000; fig. 146) appears to be an archetype of a simple rectangular stacking chair, as its name implies. There is, however, a steel structure inside the pliable rubber frame, which was originally available in black or red. Likewise, BarberOsgerby's *Pilot* table (1999; fig. 147), made of molded plywood, is the simplest of forms: a "mini-engineering exercise."[123] The subtle bends and curves impart to such a minimal design not only an elegance but also an added strength.

146 →
Komplot
Danish (Boris Berlin, Russian,
b. 1953; Poul Christiansen,
b. 1947)
Non Side Chair, 2000
Rubber
Mfr: Källemo
30 × 17 × 15½ in.
(76.2 × 43.2 × 39.4 cm)

For many Modernist designers,
the material is often the genesis
of a design. This is certainly
the case with Komplot's *Non*
chair, which uses rubber—often
thought of as a utilitarian
material—with great élan to
create a refined reinterpretation
of a rectangular wooden chair.

147 ↘
BarberOsgerby
British (Edward Barber, b. 1969;
Jay Osgerby, b. 1969)
Pilot Table, 1999
Plywood
Mfr: Cappellini S.p.A.
26 × 15¾ × 15¾ in.
(65 × 40 × 40 cm)

Since the 1930s, Modernist
designers have been fascinated
with the aesthetic possibilities
of bending and molding plywood.
BarberOsgerby's elegant *Pilot*
table, which uses the minimum
of material and the most subtle
detailing, is a nuanced update
of that rich tradition.

Such designers as Christian Flindt and Grcic, in contrast, delight in using bold colors in their designs. Following the model of such earlier designers as Verner Panton, Flindt aspires to be an industrial designer and has not embraced the traditional Danish aesthetic of wood and handcraftsmanship. His *Parts of a Rainbow* stackable chairs (2004; fig. 148) are prototypes made of Repsol glass, a form of satin acrylic. The design is unusual in that the chairs stack sideways rather than vertically, and the "hollow" translucent shapes magically capture and reflect light. Grcic's *Diana* table series (2002; fig. 149) comprises simple geometric forms made of steel, which has been laser-cut and bent. The crisp forms interact together in a lyrical manner; but the primary aesthetic punch comes from the brilliant, fluorescent-paint finishes, another instance of a designer judiciously using the interplay of color and light.

Albeit in different ways, all of these artists are working as true industrial designers, creating objects that could be mass-produced for the average consumer. It is Modernism at its purest and best.

Limited-edition luxury interpretations

While one of the central tenets of Modernism was to produce good, inexpensive design for the masses, in reality, earlier Modernist designers, such as Ludwig Mies van der Rohe and Florence ("Shu") Knoll, had consistently designed objects that were quite luxurious and required the finest materials and craftsmanship. This aspect of Modernism continued during this *fin-de-siècle* period.

The designers who pursued this aspect of Modernism were preoccupied with more elegant forms, proportions, and detailing, often showing the influence of such designers as Knoll and Jean-Michel Frank. They favored sumptuous

148
Christian Flindt
Danish (b.1972)
Parts of a Rainbow Stackable
Chair, 2004
Repsol glass
Mfr: Christian Flindt
34⅝ × 22 × 16⅝ in.
(88 × 56 × 42 cm)

A bold and colorful new
interpretation of the stackable
chair, Flindt's *Parts of a Rainbow*
prototype is an unusual
design in that the pieces stack
horizontally rather than
vertically. Flindt also uses the
resultant hollow forms as a
magical way to capture and
reflect light and color.

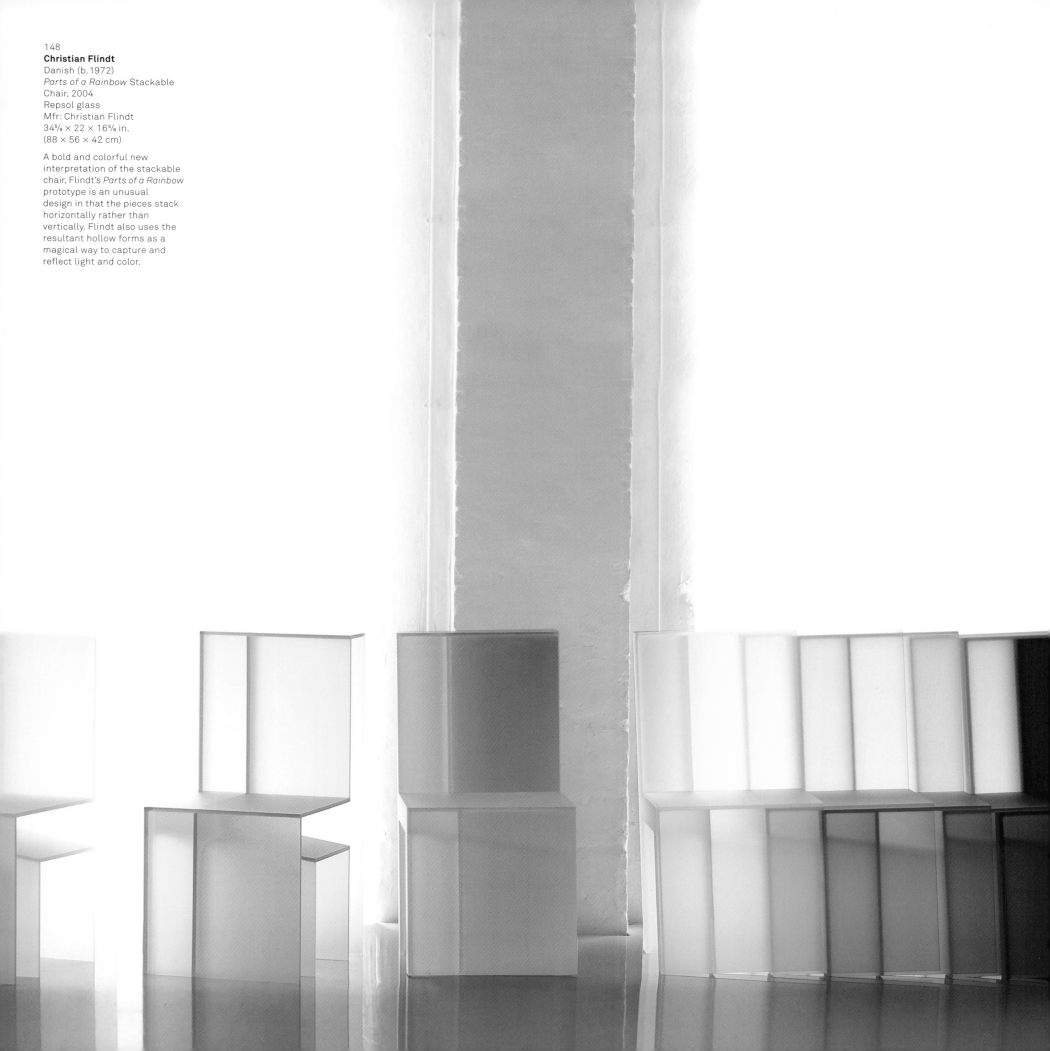

149
Konstantin Grcic
German (b. 1965)
Diana Table, 2002
Steel and glass
Mfr: ClassiCon GmbH
Largest: 10¼ × 35⅜ × 25⅛ in.
(26.1 × 89.9 × 63.7 cm)

In his early work, the starting point for Grcic was a desire to explore the aesthetic and technological qualities of a material. For the *Diana* series, he used the technology at ClassiCon to bend and laser-cut colorful sheets of steel to create an ensemble of crisp geometric tables.

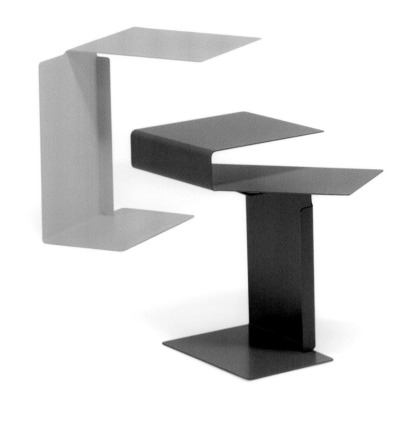

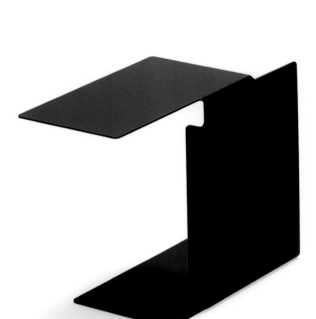

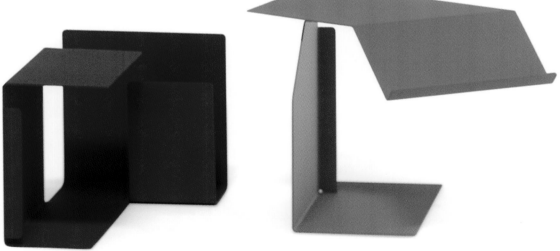

150 ↓
Antonio Citterio
Italian (b. 1950)
Charles TCH120/3 Coffee
Table, 1998
Aluminum and oak
Mfr: B&B Italia S.p.A.
10¼ × 47¼ × 47¼ in.
(26 × 120 × 120 cm)

151 →
Antonio Citterio
Italian (b. 1950)
Apta 9630 Storage Unit, 1996
Wood and steel
Mfr: B&B Italia S.p.A.
24 × 103 × 24 in.
(61 × 261.5 × 61 cm)

Citterio is equally capable of
creating both inexpensive
industrial designs and more
limited-edition luxury products.
Many of his elegant designs for
B&B, such as the *Apta 9630*
cabinet or the *Charles TCH120/3*
table, reflect the influence of
Florence Knoll in their deluxe
materials, refined proportions
and details, and unabated sense
of the luxurious.

and expensive materials and more traditional
technology and craftsmanship. Their *métier*
was the limited-edition, luxury object, although
they very much worked within a Geometric
Minimal vocabulary.

One of the most adept of these designers was
certainly Antonio Citterio, who was able to work
with equal dexterity as an industrial designer,
as was seen earlier. Much of his work, especially
for B&B Italia, has been widely imitated for a
bourgeois market that seeks designs that
are contemporary yet still somewhat traditional.
Few of Citterio's imitators, however, possess
his masterly and innate sense of elegant form,
proportion, detail, color, and material. One of the
earliest and strongest influences on his work was
Knoll, as can be seen in such designs as the

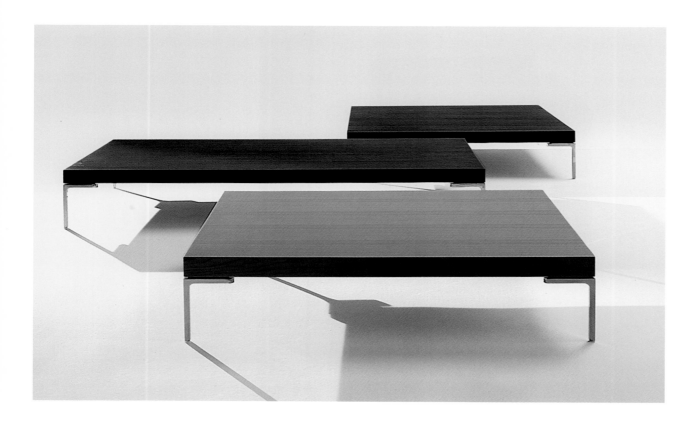

152 ↘
Antonio Citterio
Italian (b. 1950)
Compagnia Delle Filippine
Lounge Chairs, 1993
Leather, rattan, and aluminum
Mfr: B&B Italia S.p.A.
31½ × 28⅜ × 42½ in.
(80 × 72 ×108 cm)

153 ↓
Antonio Citterio
Italian (b. 1950)
Apta 9861 Sofa, 1996
Fabric and steel
Mfr: B&B Italia S.p.A.
29½ × 92 × 38½ in.
(74.9 × 233.5 × 97.8 cm)

Contrary to popular opinion, Modernist designers often look to historical figures for inspiration, especially to those designers whose work is simpatico to their own aesthetic. Jean-Michel Frank was such a figure for Citterio, and the French master's elegant Moderne style has been reinterpreted with great flair in such Citterio designs as the *Apta 9861* sofa and the *Compagnia Delle Filippine* chairs.

Apta 9630 storage unit (1996; fig. 151) and the *Charles TCH120/3* coffee table (1998; fig. 150). Here Citterio is playing with perfectly proportioned wooden pieces on a variety of metal bases, with a complex and refined detailing that is almost Miesian in its rigor. He later discovered the Moderne work of such French designers as Frank, as illustrated in such pieces as the *Apta 9861* sofa (1996; fig. 153) and the *Compagnia Delle Filippine* lounge chairs (1993; fig. 152). Sleek and low, the sofa has a grandeur appropriate for a chic 1930s drawing room; and where Frank might have used parchment or straw, Citterio has employed hand-woven rattan for his *bergère*-like lounge chairs. Thus both of these luxurious upholstered pieces rely on fastidious proportions, materials, and detailing for their visual impact.

There were, of course, a multitude of other European designers who embraced this aesthetic, though in individual manners, and perfected traditional furniture forms. Two Dutch and Swedish storage units illustrate this design approach. The *Perception* storage system (1992; fig. 154) by NPK is a simple, tripartite, geometric composition reduced to the absolute minimum.[124] It features extruded aluminum horizontals, wooden ends, and 180-degree pivoting doors. While Claesson, Koivisto, Rune works in a number of Modernist manners, the design group's *#3 Unit* storage system (2001; fig. 155) is even more elemental. The credenza is constructed solely of oak and is architectonic, especially in its subtle play of negative spaces against simple geometric masses, a recurring

theme used by a number of Modernist designers during this period.

Mass-produced versus limited-edition designs

The dichotomy between designing mass-produced everyday objects and more limited-edition luxury pieces has, in fact, given the Geometric Minimal movement a remarkable energy. In the first scenario, designers learn to deal with all of the considerable demands and compromises required when working for industry. The alternative approach, on the other hand, affords them a certain freedom and ability to experiment with new ideas, in that market forces are less pressing.[125] Indeed, if one may generalize, there is another dichotomy here between the "generic" and "iconic" forms that are often the by-products of these two respective design approaches. This is particularly evident when one looks at other design media and materials, such as metalwork, ceramics, glass, plastics, lighting, and product design. A quick overview of this work reveals an extraordinary vitality and the pervasive influence of the Geometric Minimal movement across Europe during the last few decades.

Metalwork
With regard to mass-produced metalwork, designers are creating simplified generic forms that can readily be made by machines using such industrial materials as stainless steel. Some designers, however, including Björn Dahlström, Harri Koskinen, and Citterio, are still able to impart a strong aesthetic component to their work, for example in the elemental *Dahlström 98* cookware (1998; figs. 131, 156), the rather massive *Koskinen 2000* barbecue tools (2000; fig. 157), and the sleek *Citterio 98* cutlery (1998, designed with Glen Oliver Low; fig. 158).

In marked contrast, designers making limited-edition luxury metalwork often seek to create more iconic forms. These pieces can be more complex because of the degree of inherent craftsmanship; they may also employ a richer palette of materials to create a more opulent effect.

These diametrically different design approaches are perhaps best illustrated if one compares the *Citterio 98* cutlery (fig. 158) with Van Severen's *Hybrid* cutlery (2006; fig. 159). Citterio has designed an extensive service in steel that can be mass-produced by machine. Van Severen, in characteristic manner, went through an elaborate design process over several years to rethink the whole idea of what constitutes a fork, knife, and spoon.[126] The final result is an idiosyncratic design of unique forms and materials: a titanium fork, a zirconium ceramic knife, and a lacquered wooden spoon.[127]

While perhaps not as meticulous as Van Severen, other designers have also shown an interest in creating limited-edition luxury objects.

157 ↓
Harri Koskinen
Finnish (b. 1970)
Koskinen 2000 Barbecue
Tools, 2000
Steel
Mfr: Hackman
Largest: 1¼ × 2¾ × 13¾ in.
(3 × 7 × 35 cm)
(height × width × length)

158 ↓↓
Antonio Citterio
Italian (b. 1950)
Glen Oliver Low
German (b. 1959)
Citterio 98 Cutlery, 1998
Steel
Mfr: originally Hackman;
now Iittala
Largest: 9 in. (22.8 cm) (length)

One of the central tenets of
the Modernist tradition was to
create good, inexpensive design
for the masses. Using such
industrial materials as stainless
steel, Dahlström, Koskinen, and
Citterio have transformed
everyday cookware and cutlery
into objects with a refined
minimal aesthetic.

159 ↓
Maarten Van Severen
Belgian (1956–2005)
Hybrid Cutlery, 2006
Fork: titanium
Knife: zirconium ceramic
Spoon: lacquer
Mfr: When Objects Work
Largest: 9½ in. (24 cm) (length)

The *Hybrid* cutlery was one of
Van Severen's last designs and
was put into limited-edition
production only after his death.
In marked contrast to the
mass-produced *Citterio 98*
cutlery (fig. 158), Van Severen's
design was characteristically
subjected to an arduous
design process over several
years, during which the Belgian
designer sought to create
the archetypal fork, knife,
and spoon.

156 ↑
Björn Dahlström
Swedish (b. 1957)
Dahlström 98 Cookware, 1998
Steel
Mfr: originally Hackman; now
Iittala
Largest: 2⅜ × 16⅛ × 14⅝ in.
(6.1 × 41 × 37 cm)

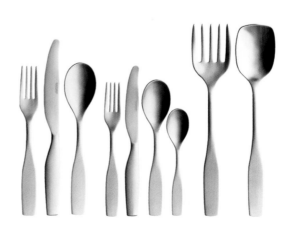

Bruno Ninaber van Eyben often works as an industrial designer; but his iconic *Cast-Iron Dish* bowls (2002; fig. 160) are monumental geometric forms made of cast iron, featuring a wonderful interplay between the sensuous surfaces and the quiet grandeur of their mass.[128] Pia Törnell is known primarily as a ceramicist who works for such companies as Röstrand, but she also creates more artistic pieces. Her *Arcus* candlestick (1995; fig. 162) achieves a monumentality similar to that found in Ninaber's work, through the stately composition of cult-like, elemental curved forms.[129] David Huycke is a true metalsmith, who creates limited-edition series of designs.[130] He often employs interlocking geometric forms, contrasting a bright silver surface with a blackened one, as illustrated in his *Bolrond 3* bowls (1995; fig. 161). As noted earlier in the work of other designers, Huycke is also playing with the negative spaces between forms.

160 ↖
Bruno Ninaber van Eyben
Dutch (b. 1950)
Cast-Iron Dish No. 5, 2002
Cast iron
Mfr: Lovink Terborg
14¾ × 29½ in. (37.5 × 75 cm)
(height × diameter)

Ninaber is equally adept at designing both mass-produced pieces and more limited-edition objects; these bowls are an example of the latter. Here, Ninaber has used cast iron, an ancient material, to impart a monumentality to a series of simple geometric forms.

161 ←←
David Huycke
Belgian (b. 1967)
Bolrond 3 Bowl, 1995
Silver
Mfr: David Huycke
5⅞ × 10⅝ in. (15 × 27 cm)
(height × diameter)

One of the central themes of this era has been the attempt by a number of designers to create a new concept of craft. In contrast to the fine arts approach of the Studio Movement, Huycke is a metalsmith who has continued to produce "functional" objects. His *Bolrond 3* bowls are sophisticated *objets* that play with the contrast between silver and blackened surfaces, as well as the negative spaces between hemispherical forms.

162 ←
Pia Törnell
Swedish (b. 1963)
Arcus Candlestick, 1995
Iron
Mfr: originally Element Design; later Rörstrand
9⅛ (23 cm) (height)

When trying to capture the sense of mass, color, and texture needed for a new design, the choice of material is often critical. For this powerful, archaic candlestick, Törnell—like Ninaber (fig. 160)—has chosen iron.

163 ←
Erwan Bouroullec
French (b. 1976)
Ronan Bouroullec
French (b. 1971)
Aio Dinnerware, 2000
Porcelain
Mfr: Habitat
Largest: 7⁷/₈ × 6⁷/₈ × 3⁵/₈ in.
(20 × 17.5 × 9 cm)
(height × width × diameter)

164 ↓
Pia Törnell
Swedish (b. 1963)
Convito Dinnerware, 2003
Porcelain
Mfr: Rörstrand
Largest: 7¹/₂ × 17³/₄ in.
(19 × 45 cm) (height × width)

Mass-produced dinnerware
often presents designers
with an opportunity to explore
new concepts of form, as can
be seen in the *Aio* and *Convito*
services. Here, the Bouroullec
brothers and Törnell have
experimented with
multipurpose modular
and stackable ceramics.

165 →
Jasper Morrison
British (b. 1959)
Column Family Big Bowl, 2000
Enameled earthenware
Mfr: Antoine Betta
3¹/₄ × 13³/₄ in. (8.1 × 35 cm)
(height × diameter)

166 ↘
Ronan Bouroullec
French (b. 1971)
Torique Vase, 1999
Ceramic
Mfr: Claude Aiello
Largest: 4³/₈ × 22¹/₂ in.
(11 × 57 cm) (height × diameter)

Collaborations between major
designers and highly skilled
artisans can often result in
ceramics that are more complex
than those produced using
industrial technology. While
seemingly simple geometric
forms, Morrison's *Column
Family* centerpiece and
Bouroullec's *Torique* vase are
intricate designs requiring
extraordinary craftsmanship
for their execution.

Ceramics

One may detect a similar dichotomy when looking
at contemporary ceramics. In designing everyday
dinnerware, the Bouroullec brothers and Törnell
have both used simple geometric forms that can
readily be made by machine, as demonstrated by
the *Aio* (2000; fig. 163) and *Convito* (2003; fig. 164)
dinner services. These examples show that both
designers are also working with the idea of modular
and stackable forms. The *Aio* dinnerware is perhaps
the more minimal design and has a decidedly
Japanese quality, particularly in the detailing of the
handles and spouts. Törnell's design is notable for
its use of multipurpose geometric elements that
can be arranged in various configurations on large
serving pieces.[131]

In marked contrast was a series of
collaborations between designers and artisans
in the French town of Vallauris.[132] Fearing the loss
of traditional crafts, the French government paired
leading designers with local craftsmen to produce
a remarkable series of handmade ceramics. Two
of the most successful designs were the *Column
Family* centerpiece (2000; fig. 165) by Jasper
Morrison and the *Torique* vases (1999; figs. 129,
166) by Ronan Bouroullec. Morrison's design has
a certain monumentality in its solid-footed mass
and simple, brilliant-white glaze. Bouroullec's
design plays with the void between two concave
walls, which is emphasized when color is
applied.[133] While such pieces are seemingly simple
in form, their execution requires exceptional
handcraftsmanship.

Glass

Glass presents an even more complex story and demonstrates that, during this period, important innovations have been made in this medium by decorative and industrial designers.[134] Annaleena Hakatie and Alfredo Häberli, for example, have produced generic serial forms that are industrially made in large quantities, in this case by the Finnish company Iittala. They most often use clear glass, although some pieces are colored. Hakatie's *Relations* vessels (1998; fig. 167) are simple cylindrical forms with a pronounced spout, building on the work of such post-war Finnish designers as Kaj Franck.[135] Their elegance lies in their perfect proportions and gossamer-like walls. Likewise, Häberli's *Essence* goblets, tumblers, and carafes (2000; fig. 168) represent one of the most refined designs for drinking vessels of this period. The goblets feature tapered bowls on identical stems;[136] the carafe recalls the graceful forms of Timo Sarpaneva, another major Finnish designer of the 1950s.[137] As is true of so much Scandinavian (and even Swiss) design of the last few decades, both Hakatie and Häberli are consciously extending Modernist traditions rather than creating radical new designs.

One may point to at least two different approaches when looking at more limited-edition luxury glass. Clarissa Berning and Harri Koskinen have produced quasi-functional objects in their designs for, respectively, the *Meniscus* bowl (2001; fig. 169) and the *Berlin Blue* centerpiece (2002; fig. 170). Both pieces are, in fact, unique, handmade forms of one material, created by using low-tech molds. A major part of their aesthetic impact comes from the inherent texture and color. Berning's circular, concave form achieves a luminosity from the soda that has been added to create swirls and bubbles in the glass. Koskinen's rectangular design has a small, asymmetrical indention (on the underside in fig. 170), but its power comes from the designer's use of an iridescent, "Yves Klein" blue glass.

Two other glass designers, Guggisberg & Baldwin and Tobias Møhl, have achieved a subtle synthesis of Scandinavian and Italian glassmaking traditions to create handmade, iconic art objects. The simplicity of their work—in terms of shape, color, and decoration—stands in marked contrast to the material and technical complexity of Yoichi Ohira's designs (1996–2000; figs. 64–66).[138]

167 ↙
Annaleena Hakatie
Finnish (b. 1965)
Relations Pitcher, 1998
Glass
Mfr: Iittala
Largest: 8 × 6¾ in. (20 × 17 cm)
(height × diameter)

Glass has proved to be one of
the most fertile design media
of this period, leading to a
number of different conceptual
approaches. With their subtle
simplicity and refined detailing,
Hakatie's *Relations* series
carafes are certainly some of
the most elegant examples of
industrial production.

168 ↓
Alfredo Häberli
Swiss, born Argentina (b. 1964)
Essence Goblet, Tumbler, and
Carafe, 2000
Glass
Mfr: Iittala
Largest: 11¾ × 2½ in. (30 × 6 cm)
(height × diameter)

Häberli's *Essence* series is a
paradigm both of industrial
production and of a design
approach that seeks not to
produce radical new ideas but
to extend a rich Modernist
legacy. An extensive range of
stemware is achieved simply
by setting a variety of tapered
bowls on identical stems, but
the formal vocabulary of the
Essence series draws on the
extraordinary glass produced
by Finnish designers in the
mid-twentieth century.

169 ←
Clarissa Berning
British, born South Africa
(b. 1967)
Meniscus Bowl, 2001
Glass
Mfr: originally Clarissa Berning;
now When Objects Work
13¾ in. (35 cm) (diameter)

170 ↙
Harri Koskinen
Finnish (b. 1970)
Berlin Blue Centerpiece, 2002
Glass
Mfr: Iittala
2 × 12 × 8 in.
(5.1 × 30.5 × 20.3 cm)

Modernist designers were
also capable of producing
ethereal glass pieces during
this period; such designs were
consequently more limited-
edition in nature and were
made using low-tech means
of production. Both Berning's
Meniscus and Koskinen's
Berlin Blue centerpieces—
simple geometric shapes of
cast glass—achieve a subtle
richness through their
inherent texture and color.

171 →
Guggisberg & Baldwin
Swiss, now resides France
(Monica Guggisberg, b. 1955;
Philip Baldwin, American, b. 1947)
Figura Alta Vase, 1999
Glass
Mfr: Venini
20½ × 7 in. (52 × 17.8 cm)
(height × diameter)

Although trained in Scandinavia,
Guggisberg and Baldwin have
readily absorbed Venetian glass
traditions and techniques by
working with such venerable
Italian companies as Venini, as
can be seen here in their elegant
Figura Alta vase.

172 ↗↗
Tobias Møhl
Danish (b. 1970)
Conch Bowl, 2001
Glass
Mfr: Tobias Møhl
7⅞ × 13¾ in. (20 × 35 cm)
(height × diameter)

Møhl, a Scandinavian
glassmaker, has carefully studied
the rich history of Italian glass.
His *Conch* bowl is an example of
the dramatic vessels that can be
realized when designers achieve
a masterful synthesis of material
and technique.

173 →→
Jasper Morrison
British (b. 1959)
Sim & Saladin Salad Bowl and
Serving Pieces, 1998
Polycarbonate
Mfr: Alessi S.p.A.
Bowl: 5⅞ × 13⅜ in. (15 × 34 cm)
(height × diameter)
Serving Pieces: 11⅞ in. (30 cm)
(length)

Modernist designers will often
willingly accept commissions
from major manufacturers when
it gives them the opportunity to
work with new materials or
technology. Morrison's *Sim &
Saladin* salad bowl and serving
pieces for Alessi are a case in
point: using polycarbonate,
Morrison has transformed a
utilitarian object into an
iridescent minimal design.

174 ↘↘
BarberOsgerby
British (Edward Barber, b. 1969;
Jay Osgerby, b. 1969)
Hangers for Levis Shirt-
Hanger, 2003
Plastic
Mfr: prototype for Levi Strauss
9⅛ × 17½ × 4⅛ in.
(23 × 44.5 × 10.4 cm)

The freedom afforded by plastics
in terms of form, detail, color, and
finish in no small part accounts
for designers' continuing interest
in this medium. In this instance,
BarberOsgerby has turned an
everyday coat-hanger into an
elegant sculptural object.

A primary goal for many designers working with plastics is to create inexpensive, everyday objects that can be mass-produced.

Two designs by Morrison and BarberOsgerby illustrate the above characteristics. Morrison's *Sim & Saladin* salad bowl and serving pieces (1998; fig. 173) consists of two identical and interlocking bowl forms made of frosted plastic; it is, however, the serving pieces that are perhaps the most elegant element, with their graceful curves and iridescent colored edges. In its design for Levi Strauss, BarberOsgerby created a sculptural shirt-hanger (2003; fig. 174) that is all of one piece and stackable. The beading around the edge adds a subtle detail and provides additional strength; the design was made in frosted plastic as well as a variety of glowing colors.[139]

Both John Pawson and the Bouroullec brothers have also used plastics but for more limited-edition, handmade objects. Pawson is a master of Minimalism in terms of form, material, and surface. His *Piatina* soap bowl (2005; fig. 175), made of matte-white lacquered acrylic resin, recalls the work of Koskinen (fig. 170) in its use of an elemental geometric form with a slight

Guggisberg & Baldwin's *Figura Alta* vase (1999; fig. 171) is a chaste, tripartite, bulbous form of one material, handblown by Venetian glassmasters. Its beauty comes from the delicate balance between its form and decoration, in this case three different engraved geometric patterns: vertical lines at the bottom, horizontal at the mid-section, and diagonal at the top. Møhl is a Danish glassmaker who actually fabricates his own work. His *Conch* bowl (2001; fig. 172) is the simplest of forms, again of one material, but employs virtuoso glass-blowing techniques for its surface decoration. Thus, glass, in particular, demonstrates the remarkable diversity of conceptual approaches that are available to designers working within this Geometric Minimal design aesthetic.

Plastics
The dichotomy between everyday and luxury objects may even be seen in such a utilitarian material as plastics. Given the inherent plasticity of the medium, the resultant shapes can vary from the minimal to more sculptural forms all of one piece. Color is also an important factor, as are translucent or iridescent surface effects.

John Pawson
British (b.1949)
Piatina Soap Bowl, 2005
Acrylic resin
Mfr: When Objects Work
7½ in. (19 cm) (diameter)

Plastics may be used for both
inexpensive, mass-produced
designs as well as more limited-
edition, handmade objects.
Pawson's *Piatina* soap bowl,
a minimal floating disk made of
acrylic resin, is an example
of the latter.

176 ↓
Erwan Bouroullec
French (b.1976)
Ronan Bouroullec
French (b.1971)
Sans Titre Vase, 1997
Plastic
Mfr: originally Ewans et Wong;
now Cappellini S.p.A.
7⅞ × 5½ in. (20 × 14 cm)
(height × diameter)

One of their early designs, the
Sans Titre vase illustrates the
remarkable and original sense
of form that has characterized
the careers of the Bouroullec
brothers and elevated them to
international status.

indention in the surface. With its paper-thin edge, though, Pawson's design eliminates any sense of mass and becomes a magically floating circular dish. The *Sans Titre* vases (1997; fig. 176) by the Bouroullec brothers are closer in appearance to a piece of futuristic sculpture than a functional vessel, especially when grouped in interlocking compositions.[140]

Lighting
Lighting is one of the most prolific fields in industrial design. Two seminal designs of this period illustrate the creative solutions that have been applied to mass-produced fixtures in metal or plastic. For the *Tolomeo* table lamp (1986, designed with Giancarlo Fassina; fig. 177), Michele De Lucchi was asked by Artemide to design a new variant of

Richard Sapper's classic *Tizio* desk lamp (1972).[141] As is so often the case with De Lucchi's work, the design is a sophisticated amalgamation of past and present. The form consciously recalls an archetypal form, an architect's desk lamp of the 1920s and 1930s; but it also employs the latest technology, in this case a complex system of cables and springs that keeps the lamp balanced.[142] As its name implies, Grcic's *Mayday* lamp (1998; fig. 178) is a witty parody of a contractor's metal emergency light. The tripartite design features a simple conical shade of translucent, white polypropylene; a colored handle/hook; and an exposed cord. It is a brilliant feat of straightforward engineering and aesthetics. It was also one of Grcic's first industrial designs and a very personal project for him, for it reflected his idea of a "mobile domestic life."[143]

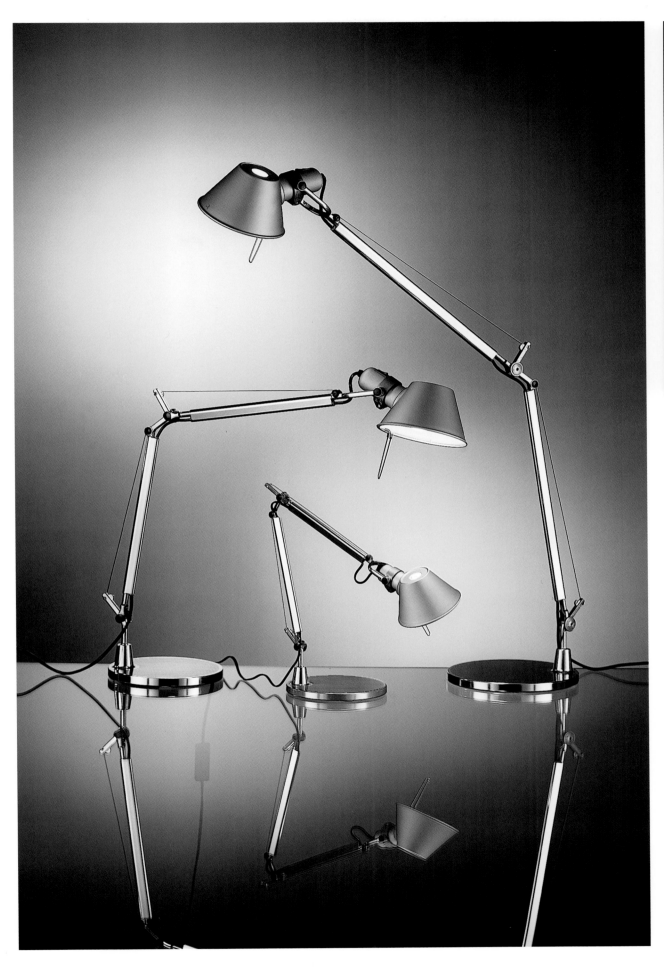

177 ←
Michele De Lucchi
Italian (b. 1951)
Giancarlo Fassina
Italian (b. 1935)
Tolomeo Table Lamp, 1986
Aluminum
Mfr: Artemide S.p.A.
Largest: 50¾ in. (129 cm)
(height)

178 ↑
Konstantin Grcic
German (b. 1965)
Mayday Lamp, 1998
Polypropylene
Mfr: FLOS S.p.A.
20⅞ × 8½ in. (53 × 21.5 cm)
(height × diameter)

The challenge to design
an iconic light is one that
few designers have met
successfully, as evidenced
by the myriad of such products
produced annually. Both
De·Lucchi and Grcic, however,
have succeeded brilliantly
with their classic *Tolomeo*
and *Mayday* lamps, which,
respectively, exploit the
possibilities of aluminum and
polypropylene to the fullest.

179 ↓
Erwan Bouroullec
French (b. 1976)
Ronan Bouroullec
French (b. 1971)
Vase TV Light, 2001
Fiberglass
Mfr: Galerie kreo
20½ × 26 × 5⅞ in.
(52 × 66 × 15 cm)

180 ↘
Arik Levy
Israeli, resides France (b. 1963)
XM3 Duo Hanging Light, 1998
Aluminum
Mfr: Ldesign
11⅞ × 4 in. (30 × 10 cm)
(length × diameter)

Many Modernist designers view lighting as an opportunity to create mass-produced industrial designs. Others, however, such as the Bouroullec brothers and Levy, are fascinated with the poetic and aesthetic qualities of light and have created haunting and unconventional *objets* for contemplation.

Two designs by the Bouroullec brothers and Arik Levy are antithetical in their approach. These lights are not functional fixtures but rather deluxe handmade *objets* that, respectively, make a social statement on our culture and a comment on humanizing technology. The Bouroullecs' *Vase TV* light (2001; fig. 179) plays on the hypnotic power of the ubiquitous television screen or our nonstop global media but morphs the fiberglass fixture into a Zen-like contemplative *objet* for flowers and a soft, glowing light. Levy's *XM3 Duo* hanging light (1998; fig. 180), a high-tech composition consisting of hanging cords and a trio of luminous honeycomb aluminum coils, is magically transformed into a poetic sculpture.[144]

Product design
Even everyday product designs have been affected by this duality. Both Morrison and Achim Heine were asked by industrial companies to create casings for products; in doing so, the designers focused less on the internal components and more on designing anonymous, stylized, and minimal exterior forms to express the function of the object. Indeed, except for differences in scale, the *Jasper Morrison* toaster (2004; fig. 182) and Heine's *D-Lux* camera (2003; fig. 181) are remarkably similar in their sleek rectangular forms, softly rounded corners, and lack of any superfluous details.[145]

Matali Crasset and Philips Design, on the other hand, were asked to create prototypal designs for products whereby the form would act as a metaphor for the function of the object. Crasset's *Soundsation* radio alarm clock (1996–98, designed with Philippe Starck; fig. 184) is a bipartite composition juxtaposing a flat panel against a conical shape that expresses the sound emanating from within.[146] The Philips Design *Shiva* notebook (1995; fig. 183)—named after the Hindu god—was envisioned as a multi-tasking communications tool. It was also a harbinger of the plethora of high-tech communications gadgets—from mobile telephones to handheld computers and portable e-mail devices—that now dominate every waking moment of a globally connected citizen.

181 ←
Achim Heine
German (b. 1955)
D-Lux Camera, 2003
Aluminum
Mfr: Leica Camera Inc.
2 × 4¾ × 1⅜ in.
(5 × 12 × 3.4 cm)

The Leica camera has long been regarded as an icon of twentieth-century German industrial design. Paying homage to that tradition, Heine's *D-Lux* version of 2003 is a masterful, yet subtle, machine, every detail of which has been refined to perfection.

182 ←
Jasper Morrison
British (b. 1959)
Jasper Morrison Toaster, 2004
Polypropylene and steel
Mfr: Rowenta
7½ × 15 × 4½ in.
(19 × 38 × 11.4 cm)

In designing everyday products, the primary task for designers is often to create new casings for generic industrial components. The *Jasper Morrison* toaster is a case in point: the designer's extraordinary sense of form, proportion, and detail has transformed a utilitarian appliance into a minimal white sculpture.

183 ↙ ↙
Philips Design
Dutch (founded 1891)
Shiva Notebook, 1995
Metal and plastic
Mfr: Prototype for Philips Design
4¾ × 1⅞ × ⅜ in.
(12 × 5 × 1 cm)

184 ↓
Matali Crasset
French (b. 1965)
Philippe Starck
French (b. 1949)
Soundsation Radio Alarm Clock, 1996–98
Plastic
Mfr: Lexon
3⅝ × 6⅜ × 4¼ in.
(9 × 16 × 11.1 cm)

Because they are rarely put into production and seldom reach a mass audience, "experimental industrial designs" are generally not that well known. Yet such designs, produced by designers who have been allowed to explore innovative concepts, constitute some of the most intriguing work in the field. The *Soundsation* radio by Crasset and Starck and the *Shiva* notebook by Philips Design are two examples of designers thinking outside of the box and envisioning bold new product designs.

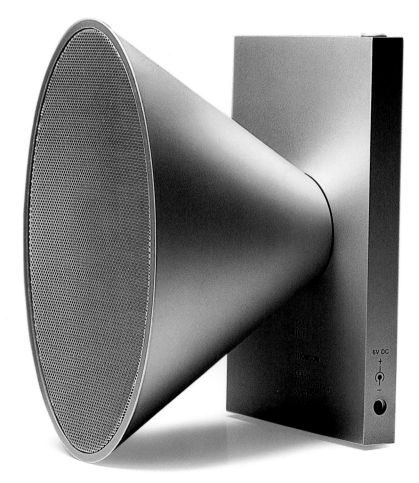

It is altogether remarkable that this fascination with Geometric Minimal design has continued unabated for almost two decades, especially given how quickly movements go in and out fashion in our global culture. But what is ultimately to be made of this Modernist resurgence? Clearly it has been the most pervasive style in almost every country in Europe during this period. Certainly it has produced major figures in both generations of designers, not to mention some of the most influential objects of the era. And yet it was a movement preoccupied, in no small part, with style—with notable exceptions, such as Morrison and Van Severen—and thus it was, perhaps, a little solipsistic in nature. Indeed, as we shall see, by the mid-1990s, a new generation of Postmodernist designers had begun to sense

an illusive quality in this Geometric Minimal movement; and a multifaceted counter-reaction ensued.

New interpretations by the second generation
It is also important to note that, although we are still very close to the moment, as mentioned earlier, there now seem to be growing indications that a second generation of significant designers is beginning to question and redefine this Geometric Minimal aesthetic. Five pieces are indicative of this new direction, in which designers are still using geometric forms but in more complex compositions; even the choice of names may indicate a shift in the movement. The *Facett* armchair (2005–06; fig. 185) by the Bouroullec brothers perhaps marks the beginning of a subtle change of direction for these extraordinarily

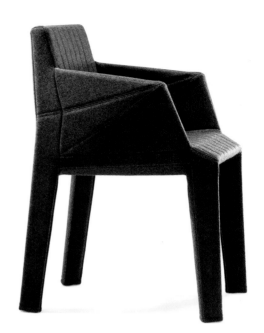

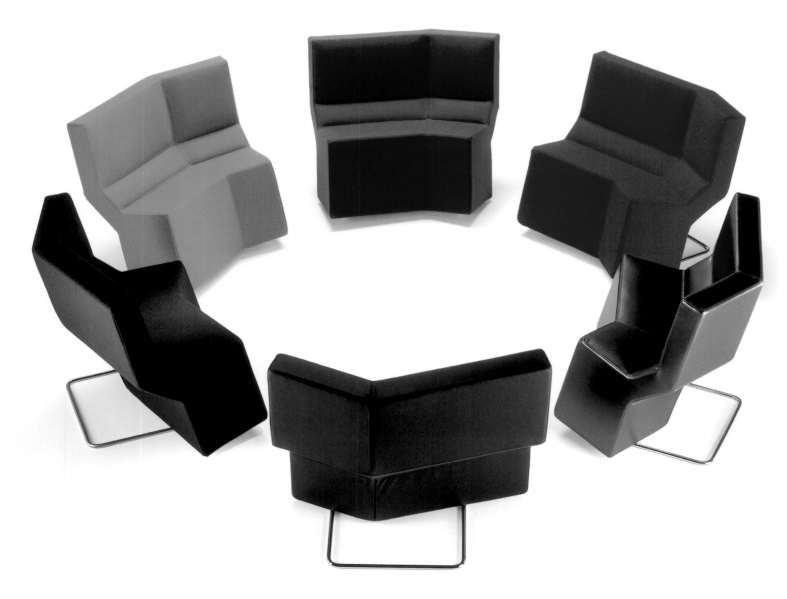

185 ←
Erwan Bouroullec
French (b. 1976)
Ronan Bouroullec
French (b. 1971)
Facett Armchair, 2005–06
Polyurethane
Mfr: Ligne Roset
32 × 24 × 20½ in.
(81 × 61 × 52.71 cm)

186 ↙
Konstantin Grcic
German (b. 1965)
Chaos Side Chair, 2000
Steel and fabric
Mfr: ClassiCon GmbH
29¼ × 35½ × 20½ in.
(74.1 × 90.17 × 52.71 cm)

187 →
Konstantin Grcic
German (b. 1965)
Mars Side Chair, 2003
Fabric
Mfr: ClassiCon GmbH
29 × 18 × 21 in.
(75 × 47 × 54 cm)

As they mature as artists,
the Bouroullec brothers and
Grcic appear to be among a
handful of cutting-edge
designers questioning the
status quo in Modernism
and decisively pushing the
movement in new directions.
Their recent furniture
designs—which show an
interest in upholstered forms
and shapes that are more
complex in their geometry—
are therefore somewhat
unorthodox but possess a
remarkable sense of energy.

talented designers.[147] However, it is Grcic, with
his *Chaos* seating unit (2000; fig. 186), *Diana* side
tables (2002; fig. 149), *Mars* side chair (2003;
fig. 187), and the *Miura* stool (2005), who seems
to be moving in a more decisive manner, pushing
the Geometric Minimal aesthetic in a new
direction and positioning himself as a force to be
reckoned with.[148] As Morrison has noted: "He's at
the forefront of the search for a new language of
design, in fact he's way ahead of everyone else."[149]
But there are yet two other manifestations of the
Modernist resurgence that must be dealt with in
order to fully explicate this complex story of
fin-de-siècle design.

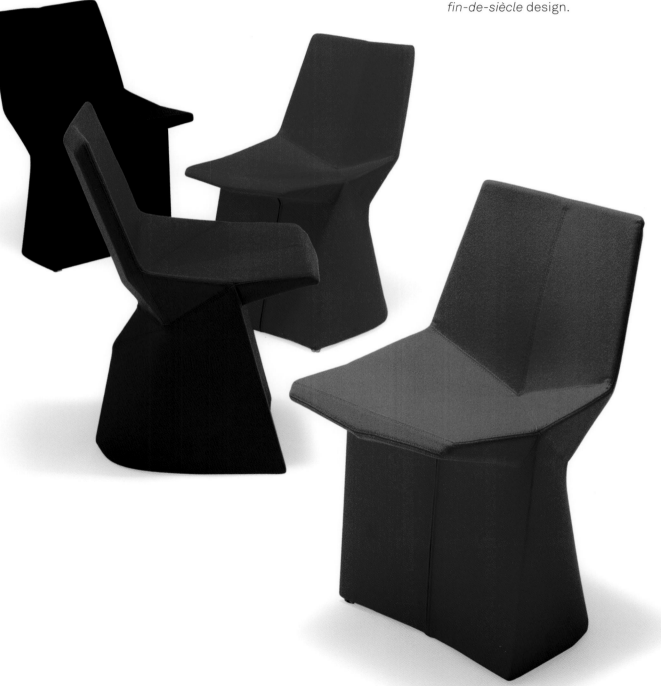

Biomorphic Design

Concept

Modernist designers working in the immediate post-Second World War period often alternated between two aesthetics: one favoring simple geometric forms and another employing soft, undulating shapes. Thus, with the Modernist resurgence that occurred in the mid-1980s, it is not surprising that there was a new wave of designers who would also be drawn to forms based on those found in the natural world. There were also a number of conceptual parallels between these two aspects of Modernism in the late twentieth century. Both were preoccupied with design for design's sake, although the work of the Biomorphic designers was driven in no small part by their interest in industrial technology and materials. There was, however, no particularly strong conceptual or cultural philosophy driving the movement, nor were there any pronounced generational differences among the designers working within this tradition. Unlike their precursors earlier in the twentieth century, the later Biomorphic designers were not preoccupied with creating radical or revolutionary objects.

As with the Geometric Minimal design movement, there were two subcategories within this manner: designers concerned with producing mass-produced everyday objects and, conversely, those interested in limited-edition luxury pieces. A number of designers were equally adept at creating products in both manners.

Style

Designers working in this tradition are fascinated by the soft, flowing forms derived from those found in nature. Their work includes a broad range of media, materials, colors (from the bright to the muted), and construction methods (from the handcrafted and limited-edition to the mass-produced). Any sense of decoration is inherent to the material and method of construction; objects have no applied ornament or pattern, though their undulating forms often allow Biomorphic designers to play with sensuous surface effects. These designers also tend to work with a limited palette of materials, which, like the chosen methods of manufacture, are closely related to the form of an object.

Time and Place

The Biomorphic movement began in the mid-1980s and extends to the present. It has had a particularly strong impact in Scandinavia.

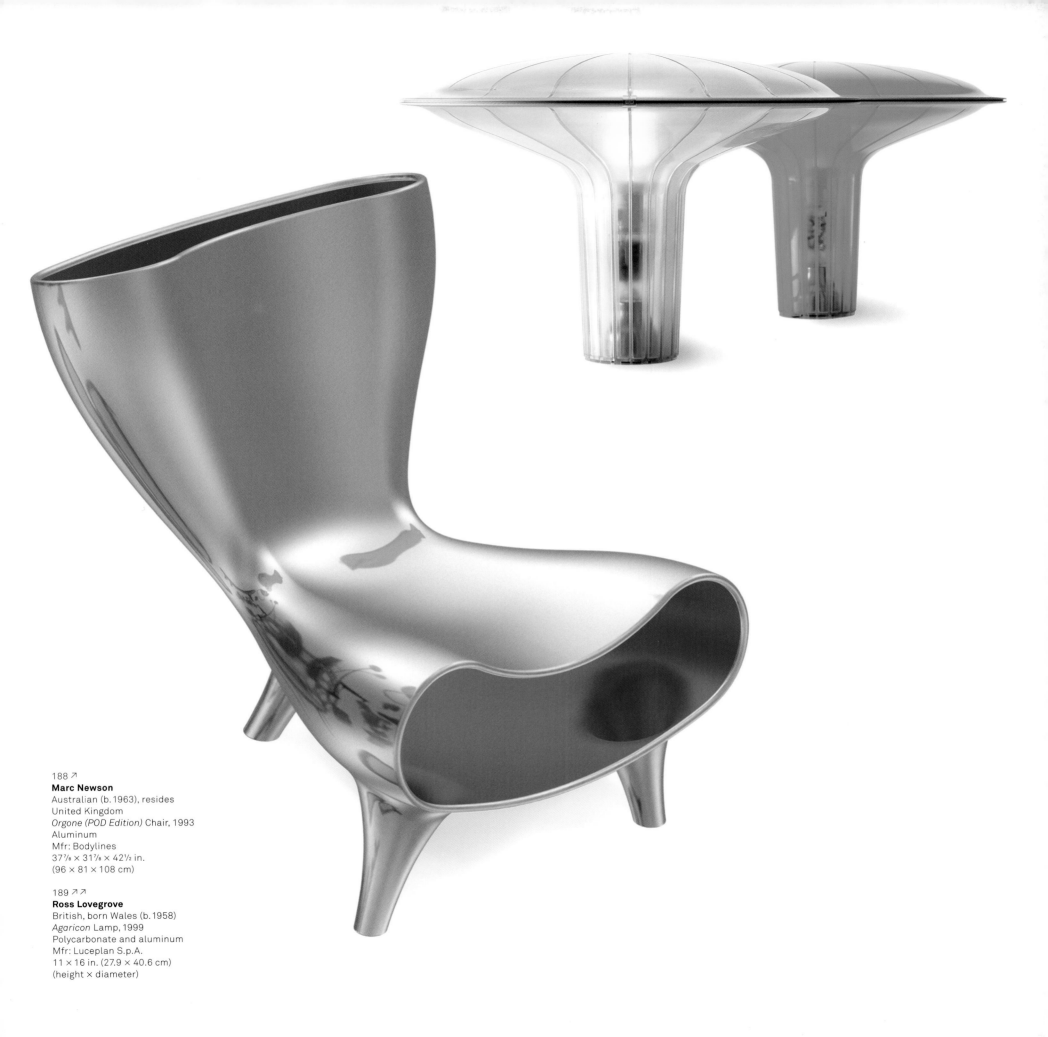

188 ↗
Marc Newson
Australian (b. 1963), resides
United Kingdom
Orgone (POD Edition) Chair, 1993
Aluminum
Mfr: Bodylines
37⅞ × 31⅞ × 42½ in.
(96 × 81 × 108 cm)

189 ↗↗
Ross Lovegrove
British, born Wales (b. 1958)
Agaricon Lamp, 1999
Polycarbonate and aluminum
Mfr: Luceplan S.p.A.
11 × 16 in. (27.9 × 40.6 cm)
(height × diameter)

The second important aspect of Modernism in the post-1985 period centered on designers who were preoccupied with biomorphic forms, a tradition that has roots stretching back to the early twentieth century. Modernist designers, including Alvar Aalto, Bruno Mathsson, and even Marcel Breuer, became fascinated with biomorphic forms in the 1930s; this interest was maintained into the post-war period by such important figures as Eero Saarinen and Arne Jacobsen.

The late twentieth-century manifestation of Biomorphic design, however, had little in the way of a strong conceptual basis; this was a movement that was primarily about "design for design's sake." Unlike their precursors, the new generation of Biomorphic designers—with such notable exceptions as Marc Newson and Ron Arad—was not creating radical new designs. As with the Geometric Minimal movement, there were two aspects to this Biomorphic revival: designers who were making limited-edition luxury objects and those who were creating mass-produced everyday pieces.

Limited-edition luxury objects

The dichotomy between limited-edition luxury objects and mass-produced everyday objects that we saw in the Geometric Minimal mode was much less pronounced in this new Biomorphic movement. Nonetheless, some major designers, including Marc Newson and Ron Arad, produced very significant work in the former category, examples of which have become iconic designs of the era.

Like Konstantin Grcic, Newson is a striking representative of the "new European" designer; he began his career in Australia and Japan and only later moved permanently to Europe, where he resides primarily in London. Following Starck's model, he consciously sought to project himself in the media as a superstar. He was initially, perhaps, the most creative of the Biomorphic designers of his generation; but his most enduring work, at least to date, may prove to be his designs from the late 1980s and 1990s.

Newson's work is driven by his interest in new technologies and materials, aluminum being one of his favorites, much like steel is for Arad. One of Newson's primary goals has been to invent new forms to expand the Modernist vocabulary, hence his fascination with such biomorphic and futuristic shapes as the orgone; the "black hole"; "hollow" (negative) forms; and three-legged pieces. Newson's early work was largely handmade. He then began to collaborate with manufacturers and galleries, but his designs still required considerable hand-finishing. It was only later, as with Arad and Van Severen, that he became a true industrial designer of mass-produced objects. Newson's palette tends toward bright colors; and he pays great attention to the details in his work, in part reflecting his early training as a jewelry designer. Perhaps his most important aesthetic achievement is the idea of "hollow" forms (with "negative" spaces), where the interior space is equal to the exterior form.

The *Lockheed* chaise longue (1986; figs. 190, 191) is one of Newson's earliest mature designs and is now considered an icon of the era; the chaise form clearly shows the influence of Postmodernism in the mid-1980s.[150] The piece was handmade by the designer in a limited edition and consisted of a fiberglass carcass to which Newson riveted

191
Marc Newson
Australian (b. 1963), resides
United Kingdom
Lockheed Chaise Longue, 1986
Aluminum and fiberglass
Mfr: POD
31½ × 23⅝ × 71 in.
(80 × 60 × 180 cm)

The *Lockheed* chaise is one of
Newson's masterpieces, created
when he was only twenty-four
years old—a remarkable feat.
It was designed in the mid-
1980s during the heyday of
Postmodernism and is thus a
curious melange of past and
present. Newson has used a
traditional chaise longue form
but has made it very much his
own, employing sensuous
biomorphic modeling and a
luxurious, riveted aluminum skin.

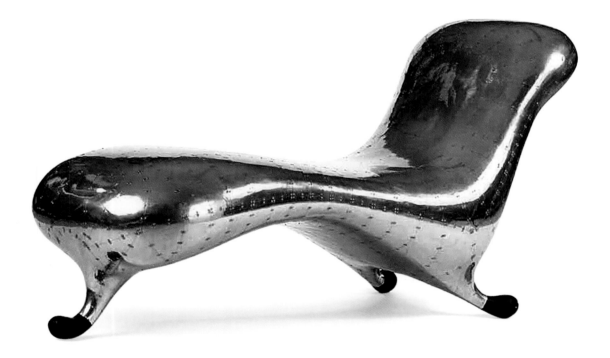

aluminum panels. The beauty of the design lies
in the perfect synergy between the three-legged
undulating form and the sensuous patterning of
the aluminum panels and rivets.

Two years later, Newson created the *Embryo*
lounge chair (1988; fig. 192). This design also
features an undulating sculptural mass with
three legs, but it is in the detailing of the legs that
Newson begins to play with the concept of hollow
forms and negative space. Also crucial to the
design is the treatment of the surface, in this
instance upholstery made of black or fluorescent
neoprene, which is used for surfers' wetsuits.[151]
The detailing of the stitching is meticulous,
especially the bold zipper on the back of the chair.

It is, however, the *Orgone (POD Edition)* chair
(1993; figs. 188, 193) that is clearly one of Newson's
most seminal designs. Again, Newson has used a
highly sculptural form, handmade out of polished
aluminum; but the interior or negative space has
now become as important as the exterior shell,
especially when it is highlighted in color. This new
concept for a chair is perhaps Newson's most
important contribution as a furniture designer.

Arad's early work as an Expressionist designer,
producing handmade pieces in his London studio,
has been outlined above (see pp. 91–101). As
his reputation grew, there were three important
shifts in his career. First, Arad began to use other
companies or galleries, such as Ronchetti in Italy
or the Gallery Mourmans in The Netherlands and
Belgium, to make what were now more limited-
edition luxury designs. Secondly, he realized that
the computer was radically changing how designs
were not only created but also manufactured; Arad
has noted that he was afraid that the computer
would pass him by, hence his desire to conquer
this new technology.[152] Lastly, he also began the
process of transforming himself into a true
industrial designer.[153]

192 →
Marc Newson
Australian (b. 1963), resides
United Kingdom
Embryo Lounge Chair, 1988
Steel, polyurethane, and
neoprene
Mfr: Idée Co.
31½ × 33 × 35 in.
(80 × 84 × 89 cm)

In such designs as the
Embryo lounge, one begins to
see the motifs that recur in
Newson's most important
chairs: three-legged biomorphic
forms, "negative" spaces, and
meticulously detailed surfaces.

193 ↘
Marc Newson
Australian (b. 1963), resides
United Kingdom
Orgone (POD Edition) Chair, 1993
Aluminum
Mfr: Bodylines
31⅞ × 42½ × 37⅞ in.
(81 × 108 × 96 cm)

The *Orgone* chair illustrates the
extent to which the choice of
material—in this instance
aluminum—acts as a driving
force in Newson's work. But it
also clearly demonstrates that
Modernist icons cannot always
be mass-produced: this very
sculptural piece has to be
handmade, requiring the most
painstaking craftsmanship.

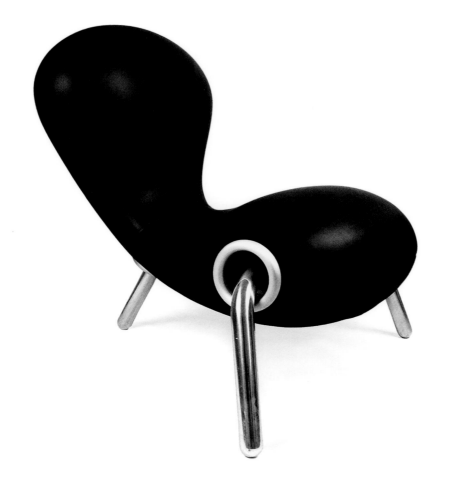

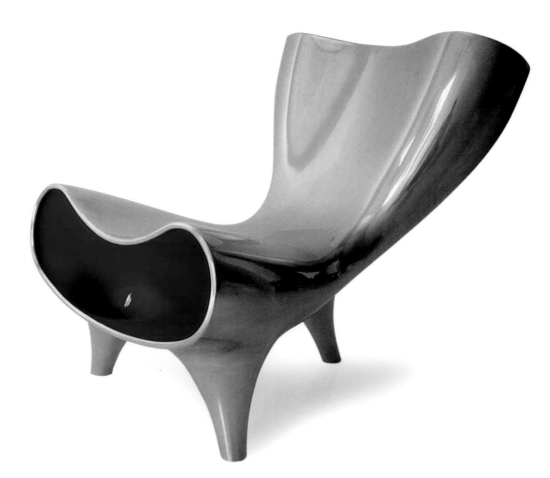

Indeed, in his later career, Arad has worked simultaneously—and with equal dexterity—as a designer producing both limited-edition luxury pieces and mass-produced everyday designs. He has, in short, transformed himself from a Postmodernist to more of a Modernist designer; thus stylistically, his late work belongs in the Biomorphic design movement.[154] Looking at both aspects of his later work, it is possible to identify common underlying characteristics. Arad's designs had always been about the material and the making of the object. In order to reinvent himself and remain creative, he simply began to use a new array of materials—carbon fiber, Corian, aluminum, and resin—and new construction methods— vacuum molds, poured resin, stereolithography, and rotation molding.

The *Oh Void 2* lounge chair (2002; fig. 194) is perhaps closest in form to Arad's continuous sculptural chairs made of steel, such as *The Little Heavy* (1989; fig. 120). In the case of *Oh Void 2*, the chair is made of hundreds of laminations of carbon fiber, which are then cored out (like an apple). The result is a beautiful interplay between the continuous curved form and the negative or hollow spaces, not unlike Newson's designs a decade earlier.

The *B.O.O.P.* coffee table (1998; fig. 195) is part of a series that included a range of large furniture forms and vases.[155] The pieces are made of sheets of aluminum that are pressed against a form in a vacuum mold, a technique developed for the aerospace and auto industries. The sheets are then welded together, and the seams polished out to achieve almost mirror-like biomorphic forms.[156] This table illustrates, once again, the creative interplay that occurs in Arad's designs when he is working with new forms, materials, and technologies.

The *Hot Ingo* light (2001; fig. 196) shows Arad using another new technology: stereolithography,

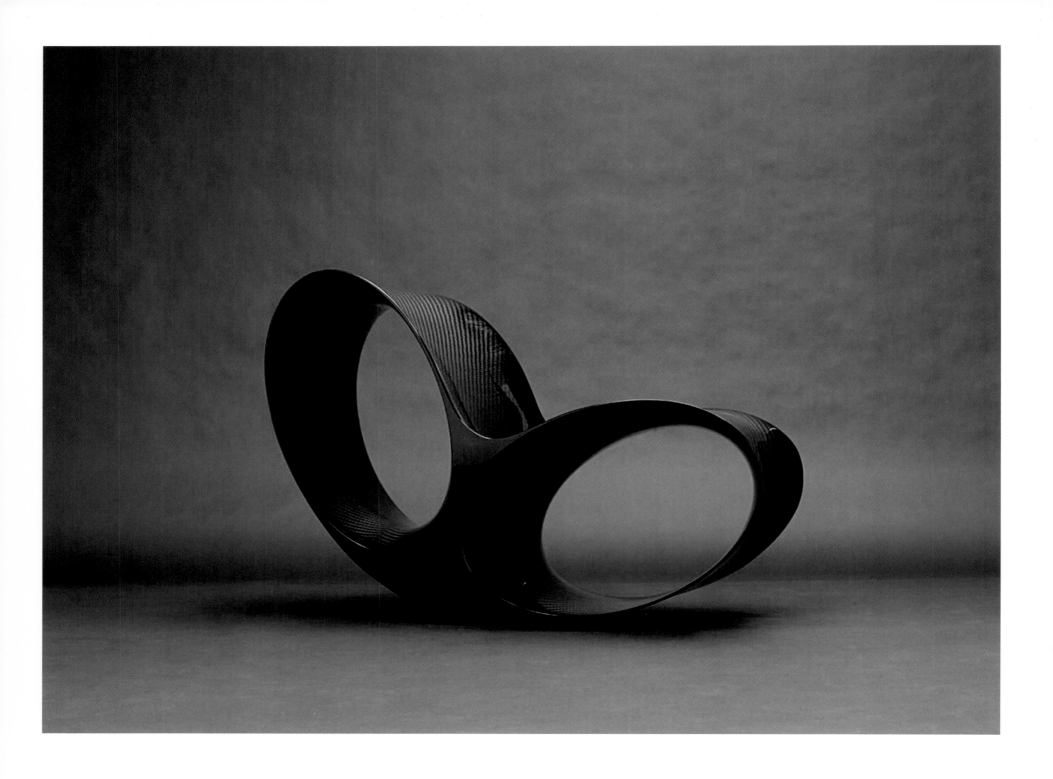

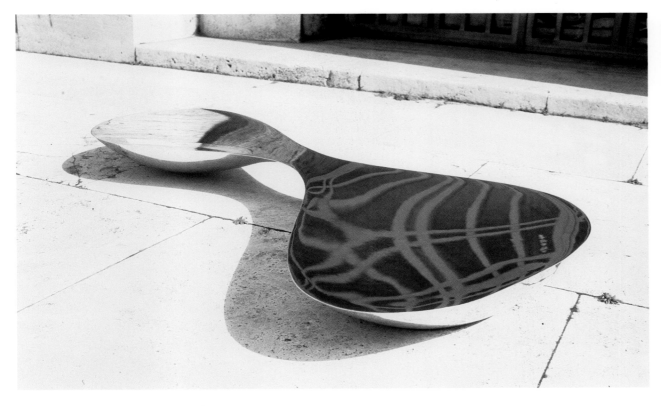

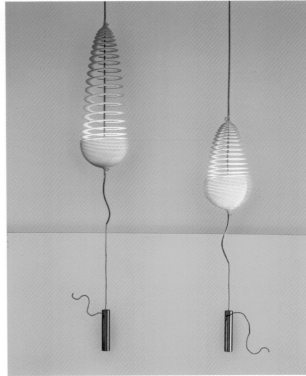

194 ←
Ron Arad
British, born Israel (b. 1951)
Oh Void 2 Lounge Chair, 2002
Carbon fiber
Mfr: Gallery Mourmans
30¼ × 43 × 23⅝ in.
(76.7 × 109.2 × 59.9 cm)

Being a major designer, Arad
was sensitive to the shifts that
occurred in European design
in the 1990s. Thus his work
evolved as he moved from an
Expressionist aesthetic to one
more closely aligned with a
Biomorphic mode, in which
he used industrial materials
and technology in a variety of
manners. The *Oh Void 2* chair, a
highly sculptural piece made of
carbon fiber, clearly illustrates
this nuanced evolution.

195 ↑
Ron Arad
British, born Israel (b. 1951)
B.O.O.P. Low Table, 1998
Aluminum
Mfr: Gallery Mourmans
10¼ × 74¾ × 37⅜ in.
(26 × 190 × 95 cm)

196 ↗
Ron Arad
British, born Israel (b. 1951)
Hot Ingo Light, 2001
Polyamide, steel, and halogen
bulb
Mfr: Gallery Mourmans
Fully extended: 70¾ in.
(180 cm) (length)

Arad's collaboration with the
Gallery Mourmans has allowed
him to continue to design
largely handmade objects,
using the latest technology
to explore how materials can
be used in new manners. The
B.O.O.P. coffee table and *Hot
Ingo* light are two examples of
this creative partnership.

used for rapid prototyping, as was seen earlier
with Jouin's *C2 Solid* side chair (2004; fig. 124).[157]
The tapered helix or coil-like shape (much like
the *Slinky* toy) perhaps most clearly illustrates
the change that has occurred in Arad's formal
vocabulary, especially when the light is compared
to his earlier designs, such as the *Armadillo* floor
lamp (1987; fig. 114).

This limited-edition luxury work by Newson
and Arad represents an important aspect of their
careers: they have been able to experiment with
new forms, materials, and technologies, without
cost being a major factor. They were, in a sense,
producing deluxe "works of art," to be sold through
international galleries to a limited clientele. Other
designers have also worked within this mode,
using different media.

197 ↓
Giorgio Vigna
Italian (b. 1955)
Fior d'Acqua Vase/Necklace, 2000
Glass and silver
Mfr: Venini
20¾ in. (53 cm) (height)

198 ↘
Ann Wåhlström
Swedish (b. 1957)
Soap Bubble Vase, 1999
Glass
Mfr: Kosta Boda
Largest: 39⅜ in. (100 cm)
(height)

Some of the most important
Modernist designs are luxurious
objects handmade in limited
editions. This is particularly true
in the field of glass, where such
designers as Vigna and
Wåhlström use the highly
skilled artisans at Venini and
Kosta Boda, both venerable
glass houses, to create elegant
biomorphic vases. These pieces
are more *objets d'art* than
functional wares.

Glass

In the designs of Giorgio Vigna and Ann Wahlström,
one can see again the interplay between Italian
and Scandinavian glass traditions. Vigna's work is
concerned primarily with nature. His vases tend to
be simple, assuring forms made of transparent or
iridescent glass to symbolize water; they also often
feature sprays of flower-like forms made of metal
and glass. The rope-like metal band on the neck of
the *Fior d'Acqua* vase/necklace (2000; fig. 197) can
be worn as a necklace, reflecting Vigna's important
work as a jewelry designer. Wahlström's *Soap
Bubble* vases (1999; fig. 198), by contrast, are large,
imposing, gourd-like forms. There is nothing radical
here in terms of form or craftsmanship; rather, the
designs are quiet, virtuoso displays of form, color,
and technique, which capture the soft, fluid quality
of glass after it becomes hard.[158]

199 ↓
Doriana Mandrelli Fuksas
Italian (b. after 1946)
Massimiliano Fuksas
Italian (b. 1944)
E-Li-Li Vase, 2005
Steel
Mfr: Alessi S.p.A.
11⅞ × 9⅞ × 3⅛ in.
(30 × 25 × 8.2 cm)

The calla lily and similar floral
forms have often served as an
inspiration for designers, as can
readily be seen in the Fuksases'
E-Li-Li design. Here, a sheet of
polished steel has been magically
metamorphosed into a vase.

200 ↘↘
William Sawaya
Italian, born Lebanon (b. 1948)
Le Diable en Tête Pitcher, 1992
Silver
Mfr: Sawaya & Moroni
10½ × 9½ × 6 in.
(26.6 × 24.1 × 15.2 cm)

At first glance, Sawaya's *Le Diable
en Tête* pitcher appears to be
the essence of simplicity. It is,
in fact, a complex interplay of
form, material, and surface—
a sensuous Biomorphic design
requiring the finest craftsmanship.

Metalwork

Doriana Mandrelli Fuksas's *E-Li-Li* vase (2005,
designed with Massimiliano Fuksas; fig. 199)
possesses a machine-like quality. It is a simple
sheet of steel that has been bent into an
abstract flower form.[159] *Le Diable en Tête* pitcher
(1992; fig. 200) is one of William Sawaya's most
elegant designs, a bipartite form contrasting
a soft tapered pitcher with a calla lily-like
handle. The hand-hammered silver surface
imparts a sensuous and shimmering quality
to the carafe.

Mass-produced everyday objects

While circumscribed, the fascination with
a limited-edition luxury aesthetic was quite
important to the larger Biomorphic design
movement. At the same time, such designers

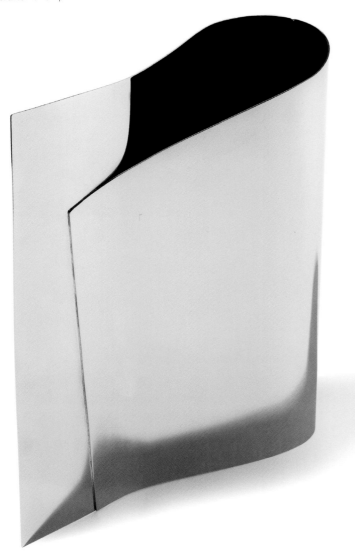

as Newson, Arad, and Ross Lovegrove were also producing mass-produced everyday objects.

The conceptual basis for this work closely followed parameters established half a century earlier. A primary criterion for designers was a strong relationship between form, material, and the method of manufacture. Likewise, there was a pronounced absence of any kind of ornament or pattern, for any sense of decoration would be inherent to the materials and methods of construction employed. Designers also tended to work with a limited palette of materials. Perhaps the one notable innovation here was an interest in sensuous or shimmering surface effects, which could be accentuated on soft, flowing forms.

Four of Arad's industrial designs perhaps best illustrate this alternative approach within the Biomorphic design movement. In these examples, Arad is working as a true industrial designer, creating a straightforward form derived directly from the material and industrial process. The *Fantastic Plastic Elastic* (*FPE*) stacking chair (1997; fig. 201) and *Bookworm* shelving (1994; figs. 202, 203)— designed for Kartell—were both inexpensive, two-dimensional forms utlizing plastic. The *Bookworm* recalls Arad's ribbon forms, such as *This Mortal Coil* bookcase (1993; fig. 116); but it is a far less complicated design, which can be arranged by the user on the wall in any configuration. It was also one of the first designs by Arad that was a commercial success. The *FPE* chair is the essence of simplicity: it is a single sheet of plastic inserted into an extruded aluminum frame. Two other Arad designs employ more three-dimensional forms. The *Tom Vac* armchair (1997; fig. 204) consists of two parts: a ribbed polypropylene shell and a simple steel base, not unlike the plastic chairs designed by the Eameses in the late 1940s and 1950s.[160] The *Little Albert* armchair (2000; fig. 205)—a continuous, one-piece chair made of polyurethane using rotation molding—is another example of Arad achieving a unity between form, material, and method of manufacture.

Unlike Newson or Arad, Ross Lovegrove has worked almost exclusively as an industrial designer producing mass-produced everyday objects; and his designs are indicative of another important direction in the Biomorphic design movement. Lovegrove, in fact, represents an influential school of designers, which includes such significant figures as James Dyson, who see good engineering as the basis of industrial design, a potent idea that has long roots in the nineteenth century.[161] Lovegrove's formal vocabulary is limited almost entirely to biomorphic shapes. In particular, he likes to work with various kinds of plastics, since they naturally lend themselves to fluid, organic shapes. Lovegrove also likes to use translucent plastics, the intriguing surfaces of which permit the inner components in products to be visible; in recent years, this has proved to be an important look in industrial design.[162]

An interest in designing mass-produced everyday objects has proved to be the most pervasive and influential aspect of the larger Biomorphic design movement. It may be seen at a variety of scales, from large-size environmental pieces to generic café chairs and tables, as well as in a wide range of media, including glass, ceramics, metalwork, and product design.

201 ←←
Ron Arad
British, born Israel (b. 1951)
Fantastic Plastic Elastic
Stacking Chair, 1997
Plastic and aluminum
Mfr: Kartell S.p.A.
31½ × 16⅛ × 20¾ in.
(80 × 41.9 × 52.7 cm)

202 ↙
Ron Arad
British, born Israel (b. 1951)
Bookworm Shelving, 1994
PVC
Mfr: Kartell S.p.A.
Largest: 7½ × 322⅞ × 8 in.
(19 × 820 × 20.3 cm)

As Arad matured as an artist in
the 1990s, he became in many
respects a chameleon-like
figure in his remarkable ability
to tackle design from a variety
of conceptual approaches. Two
pieces, the *Fantastic Plastic
Elastic* chair and the *Bookworm*
shelving, show him working as
a true industrial designer, using
two-dimensional ribbons of
plastic to create inexpensive
everyday objects

203 →
Ron Arad
British, born Israel (b. 1951)
Bookworm Shelving (detail), 1994
PVC
Mfr: Kartell S.p.A.
Largest: 7½ × 322⅞ × 8 in.
(19 × 820 × 20.3 cm)

204 →
Ron Arad
British, born Israel (b. 1951)
Tom Vac Armchair, 1997
Polypropylene and steel
Mfr: Vitra AG
29⅞ × 26½ × 24⅞ in.
(76 × 67.5 × 63 cm)

For the *Tom Vac* chair, Arad has reinterpreted one of the icons of Modernist design: a three-dimensional, molded-plastic shell on a metal base. Indeed, during the 1990s, he created a number of variations of this form, from inexpensive, mass-produced versions to limited-edition collectors' pieces.

205 ↘
Ron Arad
British, born Israel (b. 1951)
Little Albert Armchair, 2000
Polyurethane
Mfr: Moroso S.p.A.
27 × 29⅛ × 24½ in.
(70 × 74 × 62 cm)

Like many Modernist designers, Arad would occasionally reinterpret a standard form using different materials, proving once again that form does not always follow function. The *Little Albert* is a case in point: an upholstered version was transformed with great aplomb into a one-piece sculptural chair made of polyurethane.

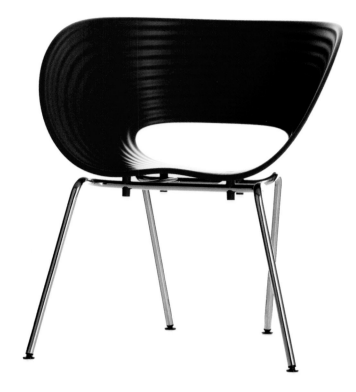

In contrast to their massive *Cloud* stacking units (2004; fig. 142), the Bouroullec brothers' *Algue* screen (2004; fig. 206) is made from small pieces of "plastic seaweed" that snap together. When assembled, they become a glimmering fishnet-like room-divider, especially when layered in a variety of colors.

Three further designs illustrate two of the quintessential furniture forms of this era: the café chair and table.[163] Lovegrove's *Go* armchair (1998; fig. 209, 210) has a nautical, skeletal frame made of metal, while Sawaya's polypropylene *Calla* stacking chair (2001; fig. 207) is almost futuristic in its fluid, naturalistic form. Newson's *Mini Event Horizon* table (1993; fig. 208) updates Eero Saarinen's *Pedestal* side tables (1955–57); Newson's prototypal design emphasizes both the metal base and, with the use of color, the hollow, negative space in the pill-like top.

Designers' fascination with biomorphic, botanical, and even zoomorphic shapes is particularly evident when one looks at the myriad of everyday objects made for the average consumer. Nine pairs of objects—representing various aspects of tableware and product design—show artists working in a range of media.

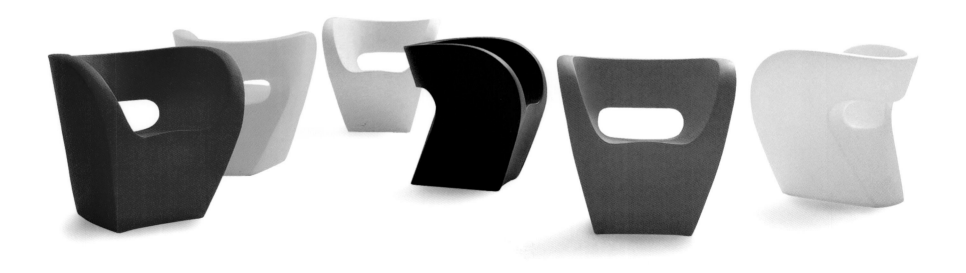

206
Erwan Bouroullec
French (b. 1976)
Ronan Bouroullec
French (b. 1971)
Algue Screen, 2004
Plastic
Mfr: Vitra AG
One unit: 12 × 8 × 2 in.
(30.4 × 20.3 × 5 cm)

The Bouroullec brothers' formal vocabulary can range from the Geometric Minimal to the Biomorphic. They are also interested in creating objects that blur the line between design and architecture. The *Algue* screen, for example, is made of small "twigs" of colorful plastic that snap together to create diaphanous scrims for enlivening interiors.

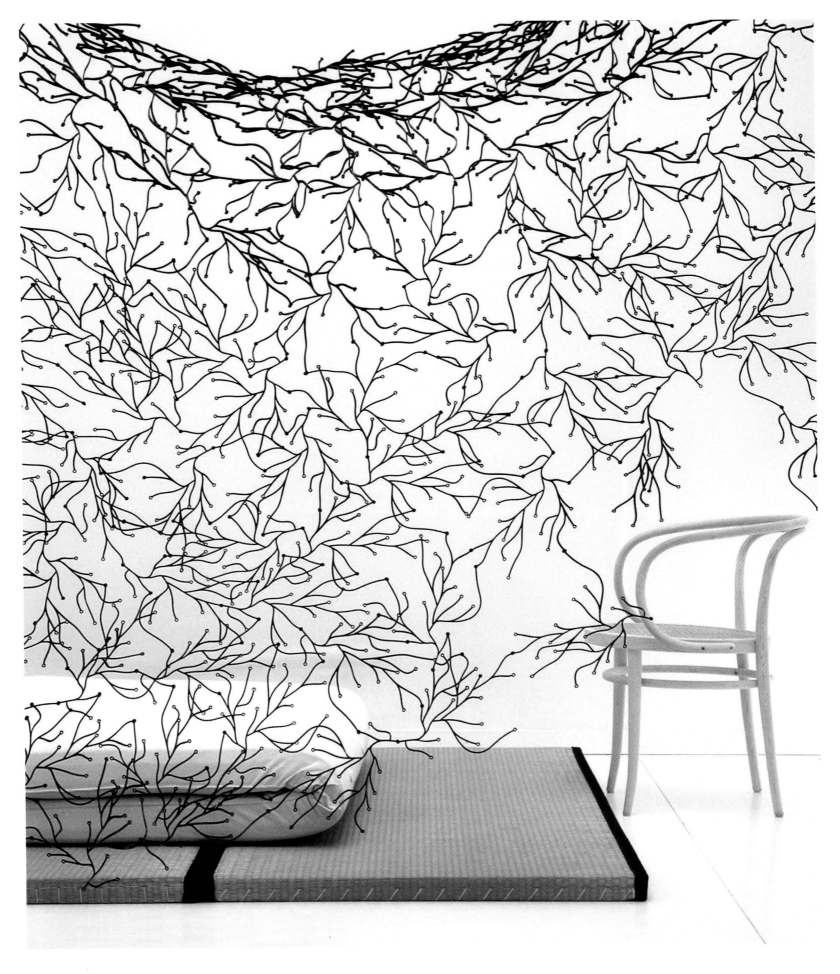

207 ↓
William Sawaya
Italian, born Lebanon (b. 1948)
Calla Stacking Chair, 2001
Polypropylene
Mfr: Heller S.r.l.
31½ × 22 × 23½ in.
(80 × 55.8 × 59.6 cm)

In terms of form and function,
Sawaya's *Calla* café chair is one
of his most successful designs.
Produced in a number of
striking colors, it is both a
beautiful undulating shape as
well as a continuous one-piece
stacking unit designed with
maximum efficiency in mind.

208 ↘↘
Marc Newson
Australian (b. 1963), resides
United Kingdom
Mini Event Horizon Table, 1993
Polyurethane and steel
Mfr: Prototype for Cappellini S.p.A.
22¾ × 19¼ × 15¾ in.
(58 × 49 × 40 cm)
(height × diameter)

While many of his designs are
envisioned as being handmade
in limited editions, Newson is
also interested in producing
prototypes for industrial
production. This is exemplified
by the *Mini Event Horizon* piece,
a small end table made of
polyurethane and steel, with
a single pedestal.

209 →
Ross Lovegrove
British, born Wales (b. 1958)
Go Armchair, 1998
Magnesium-aluminum and
polycarbonate
Mfr: Bernhardt Design USA
30½ × 22⅞ × 27 in.
(77.5 × 58.4 × 68.6 cm)

Lovegrove is a true industrial
designer, and his work is
invariably infused with a
Biomorphic aesthetic. Thus
the continuous sculptural form
of the *Go* armchair has been
characteristically stripped down
to a bare, bone-like frame.

210 →→
Ross Lovegrove
British, born Wales (b. 1958)
Go Armchair (detail), 1998
Magnesium-aluminum and
polycarbonate
Mfr: Bernhardt Design USA
30½ × 22⅞ × 27 in.
(77.5 × 58.4 × 68.6 cm)

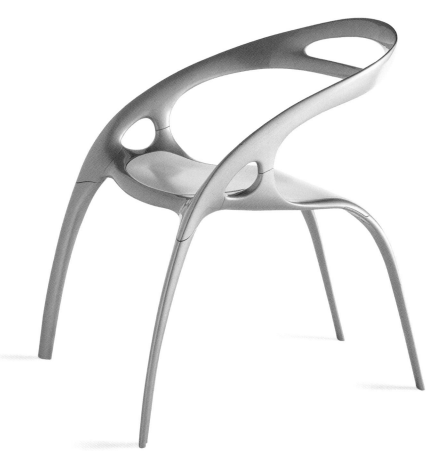

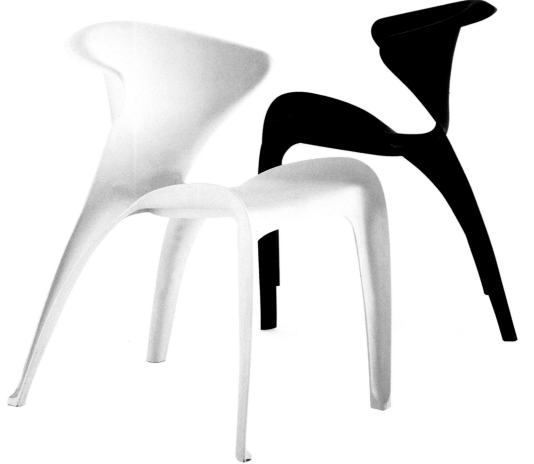

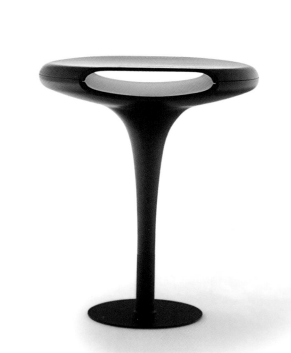

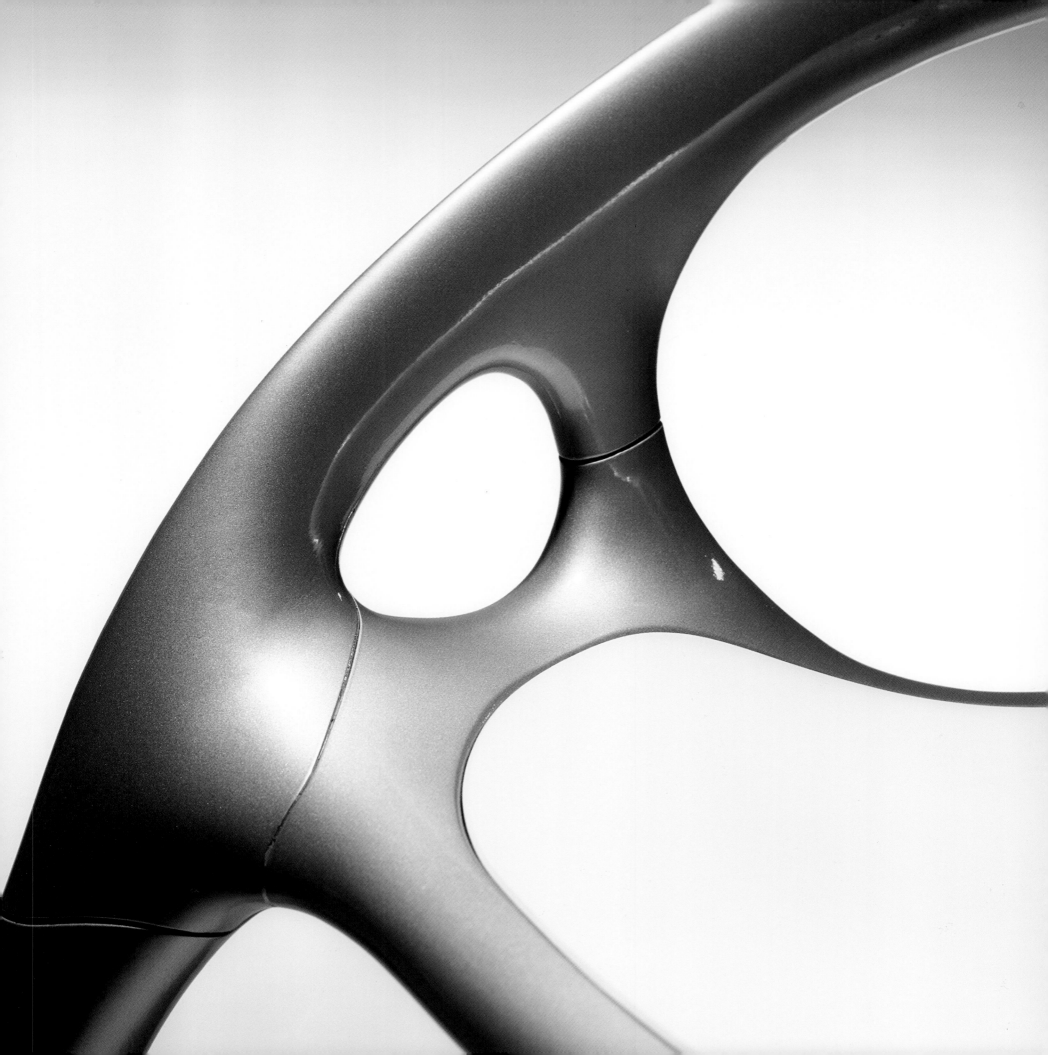

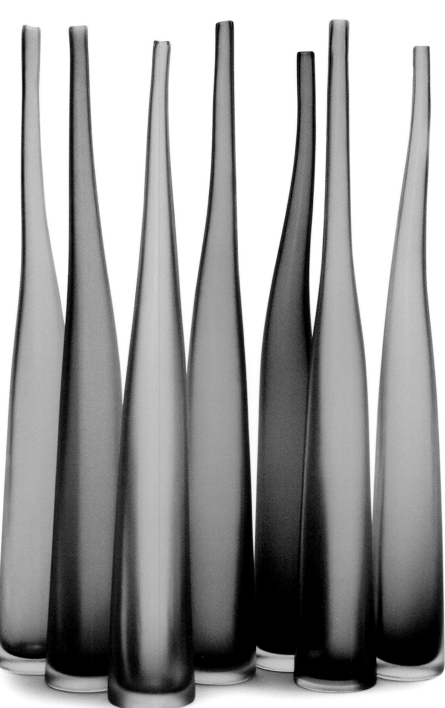

211 ↙
Laura de Santillana
Italian (b. 1955)
Bambu Vase, 1995
Glass
Mfr: Arcade
19 × 2½ in. (48.2 × 6.3 cm)
(height × width)

212 ↘
Sophie Cook
British (b. 1974)
Pod and *Teardrop* Vases,
c. 1997–2003
Porcelain
Mfr: Sophie Cook
Pod: 7 in. (18 cm) (height)
Teardrop: 15¾ in. (40 cm)
(height)

Vases are often seen as
utilitarian objects, to be used
as receptacles for flora.
Santillana and Cook, however,
have transformed them into
elegant, sculptural pieces by
clustering elongated forms in
ensembles and by playing with
the inherent colors and textures
of glass and ceramics in a
subtle but riveting manner.

213 ↘↘
Johan Verde
Norwegian (b. 1964)
Spir Dinnerware, 2002
Porcelain
Mfr: Figgjo A/S
Largest: 10¼ in. (26 cm) (height)

With the *Spir* service, Verde
has transformed everyday
dinnerware into graceful
tapered forms. Elongated
handles and abbreviated
spouts have been fused into
the attenuated vessels so as
not to interrupt the flowing
lines of the Biomorphic pieces.

214 ↗↗
Ole Jensen
Danish (b. 1958)
Ole Dinnerware, 1997
Porcelain
Mfr: Royal Copenhagen A/S
Largest: 25⅝ in. (65 cm) (length)

Jensen's dinnerware—a
robust design featuring large,
undulating serving pieces and
highly sculptural mugs and
bowls—is a refreshing and
marked departure from Royal
Copenhagen's more traditional
services.

Tableware

Both Laura de Santillana and Sophie Cook use attenuated forms for their vases, which are most elegant when grouped in clusters. Santillana's *Bambu* glass vases (1995; fig. 211), which come in a rainbow of colors, are blown in a mold and then hand-finished in the Arcade factory; this lends these semi-mass-produced pieces some individuality. Cook's *Pod* and *Teardrop* vases (c. 1997–2003; fig. 212) are porcelain ceramics handmade by the artist in her studio. Although serially produced, each piece is thus unique in terms of its exact form and color.

Likewise, Johan Verde and Ole Jensen have employed more pronounced biomorphic forms in two dinner services. Verde's *Spir* dinnerware (2002; fig. 213) features vertical forms with exaggerated

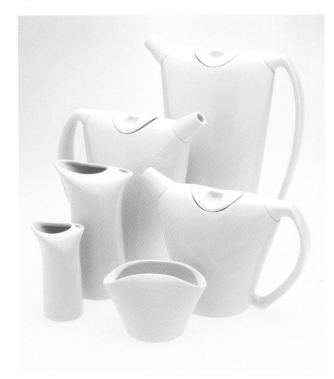

handles and spouts. The pieces are particularly powerful when grouped in clusters, where they interact in an almost organic manner, much like Eva Zeisel's famous *Hallcraft/Tomorrow's Classics* dinnerware (c. 1952). In contrast, Jensen's *Ole* dinnerware (1997; fig. 214) consists of large horizontal platters and plates that recall Alvar Aalto's *Savoy* vases (1936) in their undulating profiles. To complete the service, Jensen has added cups with exaggerated handles and bowls with sculptural feet.

Jensen's *Ole* teapot (1993; fig. 215), with its three-legged mass and sculptural handle, is almost zoomorphic; even the black stopper has a pronounced plasticity of form.[164] The form and color of Maria Berntsen's *Quack* thermos (2002; fig. 216) are more restrained, yet there is a subtle but refined elegance in the interplay between the ovoid jug and the tapered handle and spout. Indeed, there is an almost bird-like quality to the design, as implied by its name.

Stefan Lindfors and Newson are responsible for two other notable designs for tableware. The *Lindfors 98* salad bowl and serving pieces (1998; fig. 217) feature soft, biomorphic shapes, especially in the bowl, with its gently protruding feet; the contrast of a matte exterior with a polished interior adds interest to such a subtle form. The oversized and nicely profiled serving pieces are an integral part of the design. For the *Coast* series (1995; fig. 218), Newson has taken a single form—an ovoid base with tapered stem—and has varied its size for an ice bucket, tumblers, and vase. He has also mixed two materials—aluminum and glass—thereby contrasting differences in surface and translucency.

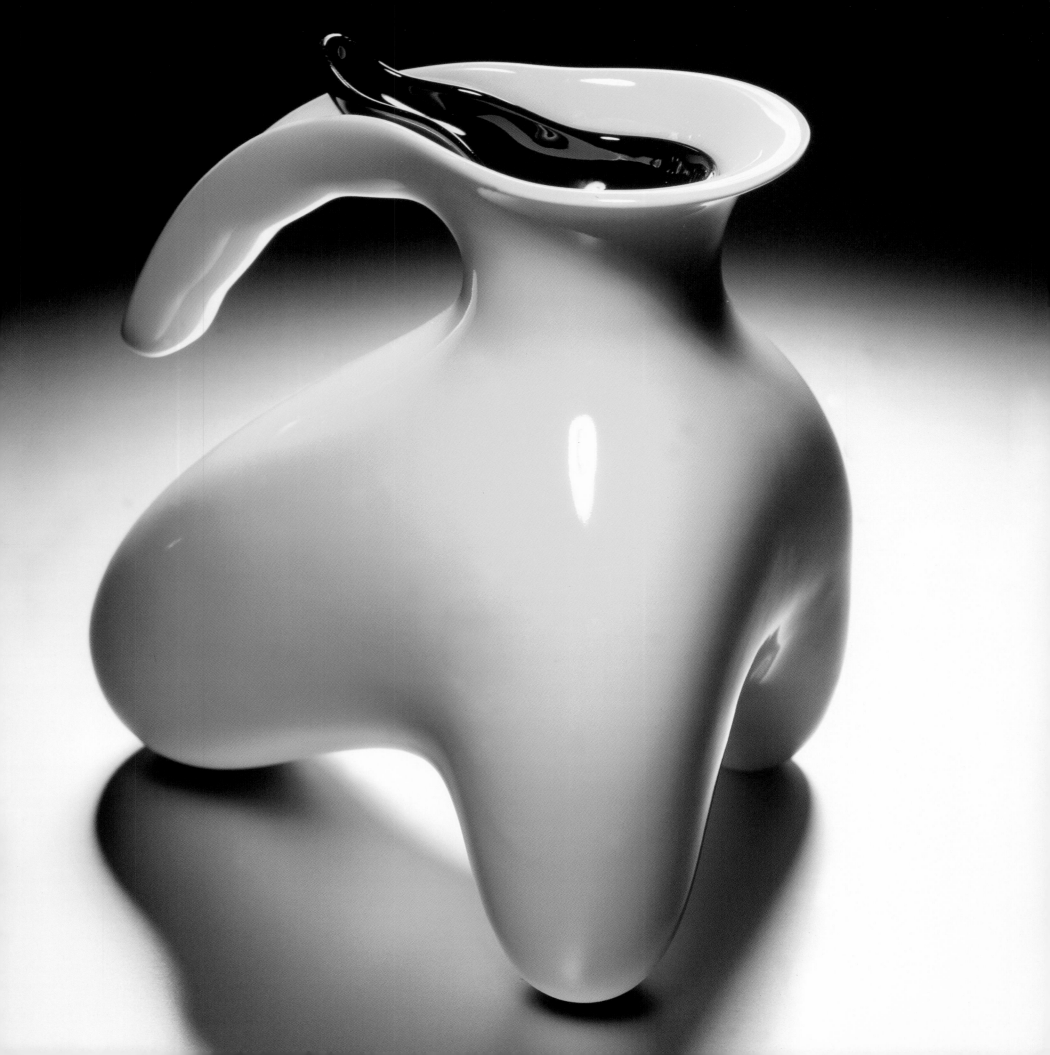

215 ←
Ole Jensen
Danish (b. 1958)
Ole Teapot, 1993
Porcelain
Mfr: originally Paustian A/S;
now Royal Copenhagen A/S
7⅞ × 5⅞ × 7½ in.
(20 × 15 × 19 cm)

The *Ole* teapot is one of
Jensen's most important
designs. A dramatic biomorphic
form of brilliant yellow
porcelain, it consciously breaks
away from Royal Copenhagen's
famed palette of blue-and-
white ceramics.

216 ↓
Maria Berntsen
Danish (b. 1961)
Quack Thermos, 2002
Plastic and zinc
Mfr: Georg Jensen
9 in. (22.8 cm) (height)

Georg Jensen is perhaps best
known for its luxurious designs
in silver. Berntsen's *Quack*
carafe—made of plastic and
zinc—is an apt example of
how a utilitarian object can
be transformed into a subtle
but extraordinarily elegant
Biomorphic composition.

217 →
Stefan Lindfors
Finnish (b. 1962)
Lindfors 98 Salad Bowl and
Serving Pieces, 1998
Stainless steel
Mfr: Hackman
Bowl: 4¼ × 14¾ in.
(11 × 37.3 cm)
(height × diameter)

Scandinavian designs are
often noted for their quiet,
understated elegance. This
is certainly true of Lindfors's
salad bowl, which subtly
contrasts matte and polished
stainless steel surfaces. The
two serving pieces—with their
gutsy sculptural shapes—
inject an unexpected jolt into
the ensemble.

218 ↘
Marc Newson
Australian (b. 1963), resides
United Kingdom
Coast Ice Bucket, Vase, and
Tumbler, 1995
Glass and aluminum
Mfr: Goto
Ice bucket: 8¾ × 10¼ in.
(22 × 26 cm) (height × diameter)
Vase: 6⅜ × 3½ in.
(16 × 9 cm) (height × diameter)
Tumbler: 5½ × 3½ in.
(14 × 9.2 cm) (height × diameter)

While Newson is perhaps
best known for his powerful
biomorphic furniture, he is
capable of designing equally
compelling tableware. The
Coast series is a deft synthesis
of form, material, and finish.

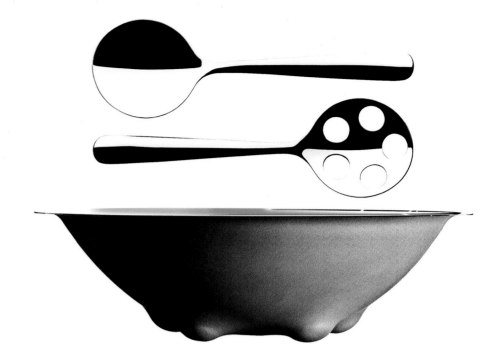

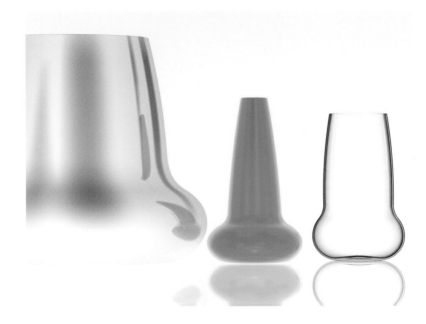

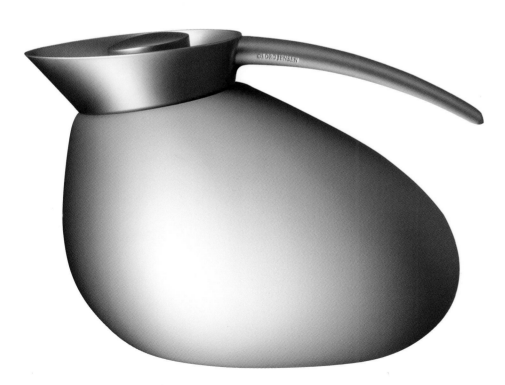

219 ↙
Stefan Lindfors
Finnish (b. 1962)
Oil Gasoline Can, 1994
Polyethylene
Mfr: prototypes for Neste Oil Oyj
Largest: 13⅝ × 8¼ × 3⅛ in.
(34.5 × 21 × 7.7 cm)

220 ↘
Ross Lovegrove
British, born Wales (b. 1958)
Ty Nant Water Bottle, 1999–2001
Polyethylene terephthalate
Mfr: Ty Nant
Largest: 12¾ in. (32.4 cm)
(height)

Plastic bottles and cans are
some of the most ubiquitous
and aesthetically innocuous
consumer products. Lovegrove
and Lindfors, however, have
succeeded brilliantly in
transforming such ordinary,
utilitarian objects into designs
worthy of praise.

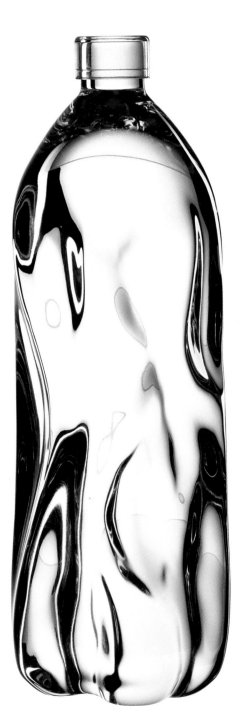

Product design

As one would expect in Modernist industrial design, there is a broad range of product designs in this Biomorphic aesthetic. Everyday bottles and cans can be transformed into exceptional objects with a designer's sensibility. Lovegrove's *Ty Nant* water bottle (1999–2001; fig. 220) is, in fact, one of his best designs.[165] While the undulating form of the bottle makes it easy to hold, the play of light and shadow between the translucent vessel and the liquid inside is nothing short of magical. Lindfors's *Oil* cans (1994; fig. 219) have a highly sculptural form, which is designed not only to help the user hold the pieces but also to generate beautiful reflections on the opaque surfaces.

The differences between Italian and Danish design are highlighted when one compares two examples of kitchen utensils: Newson's *Dish Doctor* dish rack (1997; fig. 221) and Jensen's *Washing Up* bowl and brush (1996; fig. 222). Newson's design for the Italian manufacturer

221 ←
Marc Newson
Australian (b. 1963), resides United Kingdom
Dish Doctor Dish Rack, 1997
Polyproylene
Mfr: Magis S.p.A.
3⅞ × 17⅞ × 15¼ in.
(9.9 × 45.4 × 38.6 cm)

222 ↓
Ole Jensen
Danish (b. 1958)
Washing Up Bowl and Brush, 1996
Rubber, beech, and hair
Mfr: originally Ole Jensen; now Normann Copenhagen
5½ × 12¼ × 12¼ in.
(13.9 × 31.1 × 31.1 cm)

A designer's sensibility can dramatically alter boring, everyday kitchenware. For *Dish Doctor*, Newson has used colorful polypropylene to morph a dish rack into a sexy Biomorphic sculpture for the countertop. Jensen's *Washing Up* bowl and brush, on the other hand, reflect a quiet but assured Scandinavian design aesthetic.

223 →
Jérôme Olivet
French (b. 1971)
Philippe Starck
French (b. 1949)
Moosk Radio, 1996
Polystyrene
Mfr: Alessi S.p.A.
3⅛ × 8¼ × 5⅝ in.
(8 × 21 × 14.5 cm)

Olivet, a French industrial
designer, is fascinated by
Biomorphic forms. His *Moosk*
radio—designed in collaboration
with Starck—is a beautifully
modeled and colorful form that
can be either placed on a
horizontal surface like a mini
sculpture or hung vertically.

224 ↘
Ross Lovegrove
British, born Wales (b. 1958)
Eye Digital Camera, 1992
Hydrodynamic elastomeric
materials, latex, and rubber
Mfr: Ross Lovegrove
4⅛ × 6½ in. (10.5 × 16.5 cm)
(height × width)

At first glance, it is hard to tell
that Lovegrove's *Eye* camera is
a piece of electronic equipment.
Like Olivet's *Moosk* radio
(fig. 223), it is such an elegantly
modeled form that it appears
to be a work of sculpture.

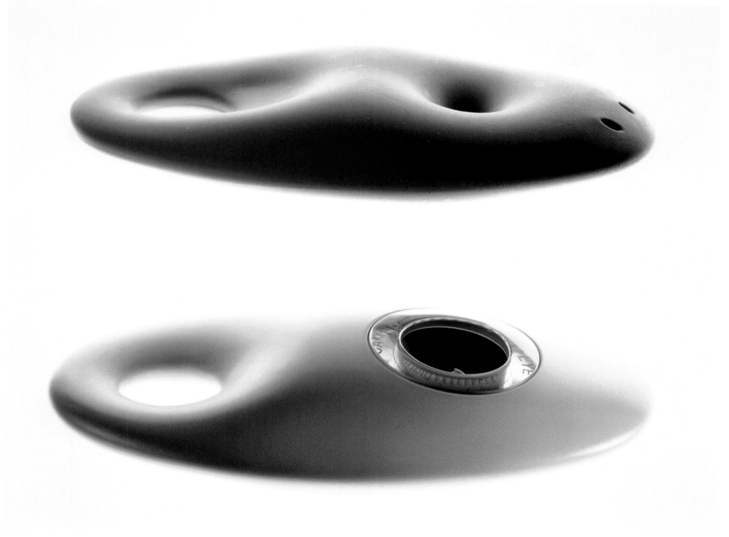

225 →
Monika Mulder
Dutch (b. 1972), resides Sweden
Vållö Watering Can, 2003
Polypropylene
Mfr: IKEA
13 in. (33 cm) (height)

IKEA is renowned worldwide
for manufacturing good,
inexpensive design. Mulder's
Vållö is one of its most
successful industrial products,
in the remarkable way that the
designer has achieved a simple
and straightforward synthesis
of form and function in an
everyday object.

226 ↘
Olavi Lindén
Finnish (b. 1946)
Top to bottom: *Universal
Convenience Cutter* Pruner,
c. 2004; *Power Gear* Hand
Pruner, 1996
Plastic and steel
Mfr: Fiskars Brands Finland Oy Ab
Pruner: 24⅞ in. (63 cm) (length)
Hand Pruner: 8¼ in. (20.8 cm)
(length)

Fiskars has achieved
international recognition for
its products through its use
of distinctive forms and a
signature orange accent color.
These characteristic motifs can
be seen in Lindén's pruners,
everyday gardening tools
magically transformed into
enticing zoomorphic shapes.

Magis is a sleek rack of molded polypropylene and, with its slightly erotic nipple-like dividers, more than a little tongue-in-cheek. Jensen's piece, on the other hand, has a marvelous down-to-earth quality in the way it contrasts a utilitarian rubber bowl with a simple wooden brush.

Some designers have even been able to radically transform electronic equipment using Biomorphic vocabularies; this becomes especially clear when their work is compared to such objects as Matali Crasset's *Soundsation* radio alarm clock (1996–98, designed with Philippe Starck; fig. 184) or Achim Heine's minimal Leica *D-Lux* camera (2003; fig. 181). Jérôme Olivet's *Moosk* radio (1996, designed with Starck; fig. 223) is a sensuous *objet*, reminiscent of a Henry Moore sculpture, to be contemplated from every perspective, whether placed on a table or hung on the wall. Likewise, Lovegrove's *Eye* digital camera (1992; fig. 224) is a sensual oval with a carefully modulated surface on both the front and the back, inviting the user to hold and caress the product.

Even mass-produced everyday gardening tools have been re-imagined. Monika Mulder's *Vållö* watering can (2003; fig. 225), an inexpensive polypropylene product for IKEA, is an extremely functional design in that it is made of one piece and is stackable; but it is also an elegant biomorphic form in the way the handle, can, and spout are fused into a continuous, flowing whole. In his pruners for Fiskars (1996–*c.* 2004; fig. 226), Olavi Lindén has imparted a zoomorphic quality to the bird-like clippers.

Lastly, in the product design field, lighting is always one of the most powerful expressions of an aesthetic. Herzog & de Meuron's flexible *Pipe* light (2002; fig. 228), with its sperm-like form made of translucent white silicon, recalls an extraterrestrial-like object. The use of "frosted plastics" to show the

inner components of an object also characterizes Lovegrove's *Agaricon* lamp (1999; figs. 189, 227). While the shape is part mushroom, the lamp also resembles a futuristic spacecraft: when one touches the metal rim, it becomes magically alive, glowing from the inside as if it were about to take off.

Although the Biomorphic design aesthetic has perhaps not been as pervasive as the Geometric Minimal movement, it has nonetheless proved to be a powerful one, especially in its highly evocative forms and sensuous use of materials. It is a design mode that speaks to the user subliminally and overtly on a multitude of levels. There was also one other Modernist movement, Neo-Pop design, which, in the 1990s, briefly gave a new vitality to European design.

227 →
Ross Lovegrove
British, born Wales (b. 1958)
Agaricon Lamp, 1999
Polycarbonate and aluminum
Mfr: Luceplan S.p.A.
11 × 16 in. (27.9 × 40.6 cm)
(height × diameter)

The *Agaricon* lamp is one of Lovegrove's most significant product designs. It has a beautiful Biomorphic form, but is also important technically in its use of translucent plastic and a sensing device for activating the lighting fixture.

228 → →
Herzog & de Meuron
Swiss (Pierre de Meuron, b. 1950; Jacques Herzog, b. 1950)
Pipe Light, 2002
Steel, silicon, and lacquer
Mfr: Artemide S.p.A.
54¼ × 8¼ in. (137.8 × 20.9 cm)
(length × diameter)

Herzog & de Meuron is perhaps best known for its architecture, but recently the firm has also turned its hand to designing industrial products. The *Pipe* light is one of its most successful designs: a lighting fixture treated as a sensuous—and slightly mysterious—piece of sculpture.

Neo-Pop Design

Concept

The Neo-Pop design movement also arose in reaction to Postmodernism. Albeit not a major or widely disseminated manner, it sought to create a Modernist interpretation of Pop design, which had been so influential during the 1960s and 1970s. This Neo-Pop movement had no strong intellectual or conceptual foundation. Rather, designers took a straightforward, light-hearted, and playful aesthetic approach to the design of objects, often blurring the line between "high" and "low" art. In contrast to their precursors at mid-century, the designers working within this movement were not concerned with innovative technology and materials, nor were they using design as a means of making a social or political statement. There were also fewer subcategories or pronounced generational differences among the designers involved with this movement than among those involved with aspects of the Modernist resurgence outlined earlier.

Style

Neo-Pop design was concerned, above all, with the playful reinterpretation of everyday objects by giving them a new frame of reference. The movement was characterized by a fascination with inflatable forms; adjustable or chameleon-like shapes; Pop icons; bright, iridescent colors; and the use of bold patterns as decorative elements. Construction ranged from the handcrafted and limited-edition to the mass-produced, though designers tended to work with a limited palette of materials. There was often a tongue-in-cheek humor, not only in the Pop references used but also in the names chosen for many of the designs.

Time and Place

The movement began in the 1990s and continued strongly into the early years of the new millennium. It had a particularly strong influence in the Nordic countries.

229 ←
Jerszy Seymour
German (b. 1968)
Pipe Dreams Watering Can, 2000
Polyethylene
Mfr: Magis S.p.A.
10⅝ × 7⅛ × 11⅜ in.
(27 × 18 × 29 cm)

230 ↓
Snowcrash
Finnish (Pasi Kolhonen, b. 1968;
Ilkka Suppanen, b. 1968)
Airbag Chair, 1997
Nylon and polyester
Mfr: Snowcrash
31½ × 35½ × 33½ in.
(80 × 90 × 85 cm)

231
Carlotta de Bevilacqua
Italian (b. 1957)
Yang Lamp, 2000
Polycarbonate, acrylic,
fluorescent lights, and
microprocessor
Mfr: Artemide S.p.A.
12¼ × 15¾ in. (31 × 40 cm)
(height × diameter)

Designers involved with the Geometric Minimal and Biomorphic movements were often inspired by both American and European Modernist designs of the 1940s and 1950s. Thus it was perhaps inevitable that designers would eventually move on in time and begin to look at the irreverent Pop designs of the 1960s and 1970s from a new perspective. The resultant Neo-Pop movement was a revival, hence the use of the term "neo."[166] Unlike Geometric Minimal or Biomorphic design, it was not a seminal or "serious" movement but, in large part, a secondary manner. Indeed, it was more of a take-off of its precursor, though lacking much of its revolutionary zeal.[167] It was, in short, a marvelous antidote: a light-hearted aesthetic approach with no particularly strong intellectual or conceptual basis, an approach that playfully dissolved the lines between "high" and "low" art. It was also very much an international development and one that exerted an influence in the 1990s and 2000s. There were two aspects to this Neo-Pop revival: one that was more overtly Pop and another that was more high-tech in nature.

Pop revival

Designers who were concerned with the more overtly Pop aspect of this movement focused on creating playful interpretations of everyday objects, often laced with a sense of humor that reflected a casual and informal lifestyle. They favored strong, simple forms, with a preference for plastics and bright colors. They were also fascinated with forms that could be used for multiple purposes. This aspect of the Neo-Pop movement spans two generations and is perhaps best exemplified by the work of Tom Dixon and Jerszy Seymour.

As noted earlier, Dixon was self-taught as a designer, so in many respects his work lacks a strong or logical conceptual basis. His early work from the 1980s formed part of the Expressive design movement (see pp. 88–107). Dixon subsequently moved in a variety of directions;[168] but among his most original late designs has been a series of Pop-inspired pieces, including the *Jack* light/stool (1997) and the *Extendable* folding screen (2003), both made of brightly colored plastic.

With Seymour, on the other hand, there is a clear and focused conceptual basis to his work, albeit one that is still developing, given his youth. Seymour is concerned with the power of the media and the superficiality that pervades much of contemporary design. Initially, his work was rather tongue-in-cheek; and his designs played on kitsch or vernacular objects, most notably in a series of everyday products for Magis made of iridescent plastics.[169]

Six designs from the late 1990s and 2000s aptly illustrate this overtly Pop design approach. The *Knitted* lights (2002; fig. 232) were designed by Bertjan Pot when he was part of the Monkey Boys—could there be a more telling name? The lights were made of colorful lengths of knitted fabric, which had been soaked in a resin, stuffed with balloons, and then allowed to harden.[170] Each hanging light is unique and pure whimsy. Claesson, Koivisto, Rune's *Dodo* chair (2003; fig. 233), available in a variety of Pop colors, is not only an uncharacteristic design for this firm but also an atypical chair form. It consists of a circular pad that sits directly on the floor and swivels, allowing the sitter to achieve a variety of positions; it is even possible to use one's laptop computer on the back panel. Dixon's *Jack* sitting, stacking,

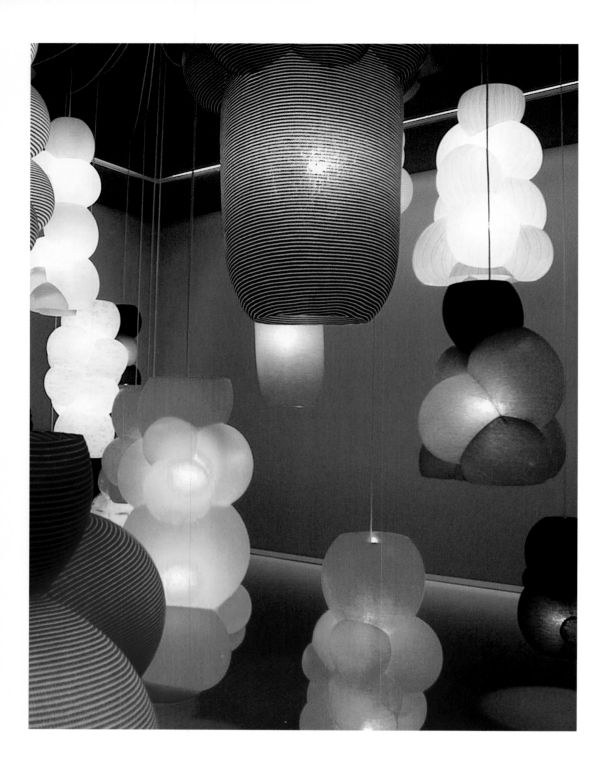

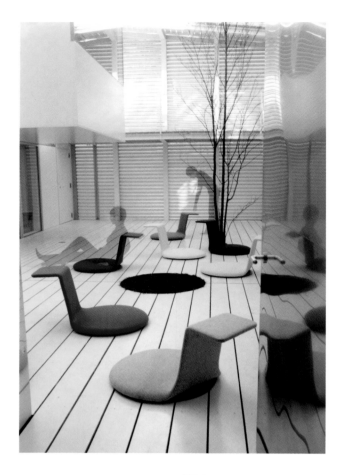

232 ←
Bertjan Pot
Dutch (b. 1975)
Knitted Light, 2002
Fiber and resin
Mfr: Bertjan Pot
Largest: 47¼ × 19¾ in.
(120 × 50 cm)
(height × diameter)

Many young, emerging
designers, such as Pot, often
have to make their work in
their own studios, employing
low-tech materials and
techniques. For the *Knitted*
lights, Pot stuffed balloons
into pieces of knitted fabric,
which had been soaked in
resin. The colorful lights are
a playful reinterpretation of
Japanese lanterns.

233 ↑
Claesson, Koivisto, Rune
Swedish (Mårten Claesson,
b. 1970; Eero Koivisto, b. 1958;
Ola Rune, b. 1963)
Dodo Floor Chair, 2003
Fabric
Mfr: E & Y
19⅞ × 28⅜ × 38¼ in.
(50.5 × 72 × 97 cm)

Claesson, Koivisto, Rune is one
of the best Modernist design
firms in Sweden. The *Dodo* chair
was designed for the Japanese
company E & Y and consists of
a swiveling circular form that
sits directly on the floor—a
Neo-Pop lollipop.

234
Tom Dixon
British, born Tunisia (b. 1959)
Jack Sitting, Stacking, Lighting
Thing, 1997
Polyethylene
Mfr: Eurolounge
23⅝ × 23⅝ in. (60 × 60 cm)
(height × width)

As seen in Andy Warhol's
treatment of a Campbell's
soup can, Pop designers often
take everyday forms, enlarge
them, and use them in a new
context; Dixon's *Jack* is a
compelling example of this
approach. The designer
has taken a jackstone and
reinterpreted it as a colorful
and glowing form that can be
used as a stool, a light, or a
stacking sculpture.

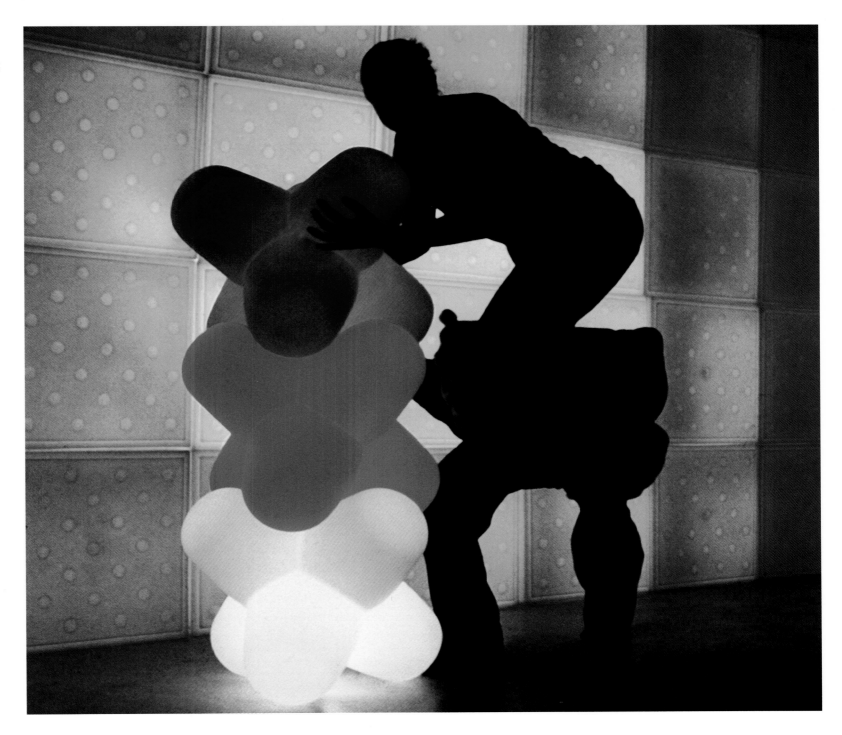

lighting thing (1997; fig. 234) is perhaps the epitome of this Pop revival aesthetic and one of the iconic designs of the era. As its name implies, it can be an arresting stool, a light, or, when stacked, a sculpture. The *Beach (BT/4)* table (2001; fig. 236) by Christophe Pillet is another unconventional shape made of fiberglass, recalling a surfboard. Its visual impact comes from the shaded lacquered surface, which is decorated with large flowers, a favorite Pop pattern often used as a decorative element. In a similar manner, Eero Koivisto used a floral motif for his *Flower* stool/table (2004; fig. 235). The piece, available in a variety of colors, is made by pouring polyurethane into a simple mold.[171] The design is particularly strong when a number of the interlocking forms are clustered together in an array of bold colors.

235 ←
Eero Koivisto
Swedish (b. 1958)
Flower Stool/Table, 2004
Polyurethane
Mfr: Offecct
17⅜ × 21¼ × 21¼ in.
(44 × 54 × 54 cm)

Koivisto, a partner in the Swedish design firm Claesson, Koivisto, Rune, often undertakes independent work. For *Flower*, he has taken a floral form and enlarged it to make a colorful end table or stool—a mini Neo-Pop sculpture for any room.

236 ↙
Christophe Pillet
French (b. 1959)
Beach (BT/4) Table, 2001
Lacquered fiberglass
Mfr: Cappellini S.p.A.
23⅝ × 21⅝ × 70⅞ in.
(60 × 55 × 180 cm)

Pop artists often used two-dimensional floral patterns in their art. Pillet has expanded on this playful tradition for his *Beach* table; made of fiberglass, like a surfboard, it has been decorated with an array of colorful flowers.

237
Jerszy Seymour
German (b. 1968)
Easy Stacking Chair, 2003
Polypropylene
Mfr: Magis S.p.A.
29½ × 23¼ × 24 in.
(75 × 59 × 61 cm)

Seymour is one of the most
talented young designers
working in Germany today,
and there is a decidedly Neo-
Pop aspect to much of his work.
With the *Easy* stacking chair,
Seymour has reinterpreted the
bland, ubiquitous plastic café
chair in a delightfully witty and
colorful manner, while also
making a sly comment on our
consumer society.

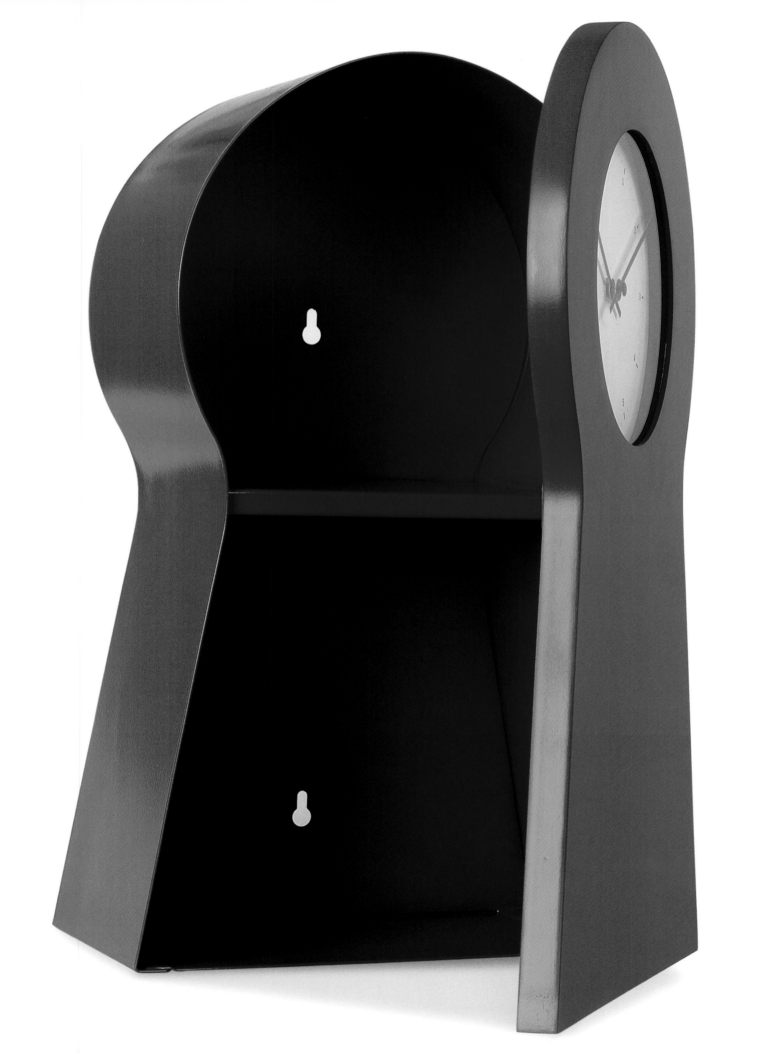

Seymour's *Easy* stacking chair (2003; fig. 237) is a play on the generic plastic café chair; but it is also a sophisticated design that revels in its gutsy massing and bold colors, a marked contrast to Jasper Morrison's refined *Air* chair (1999; fig. 134).

The Pop revival approach is also evident when looking at the design of certain storage units and bottles/vessels. Here, designers are concerned with the transformation of everyday objects into Pop icons; bright colors and humor are also an integral part of their approach. Two of Thomas Eriksson's designs from the 1990s are apt exemplars and are among the earliest expressions of this aesthetic. The *PO 9208* cabinet (1992; fig. 239) uses the familiar symbol of the Red Cross for a medicine cabinet. The *PS* clock/storage cabinet (1995; fig. 238) is a witty play on form, recalling a shelf clock as well as the void of a keyhole. Battery-powered clocks with microchips, of course, have few inner workings, so the clock case is now a "negative" space that can be used for storage. For his vivid *Pipe Dreams* watering can (2000; figs. 229, 240), Seymour has used the double spout motif to create a quirky and slightly erotic *objet*, a marked departure from Monika Mulder's

238 ← ↑
Thomas Eriksson
Swedish (b.1959)
PS Clock/Storage Cabinet, 1995
Plastic and metal
Mfr: IKEA
18½ × 11 × 6 in.
(46.9 × 27.9 × 15.2 cm)

239 ↗
Thomas Eriksson
Swedish (b.1959)
PO 9208 Cabinet, 1992
Enamelled steel
Mfr: Cappellini S.p.A.
17 × 5¾ × 17 in.
(43 × 14.5 × 43 cm)

In his designs for two storage units, Eriksson has taken iconic forms and transformed them into colorful Neo-Pop mini sculptures.

240 →
Jerszy Seymour
German (b.1968)
Pipe Dreams Watering Can, 2000
Polyethylene
Mfr: Magis S.p.A.
10⅝ × 7⅛ × 11⅜ in.
(27 × 18 × 29 cm)

Seymour's *Pipe Dreams* watering can clearly demonstrates his remarkable originality as a designer. Using the industrial technology at Magis, Seymour has created an inexpensive design for mass production in polyethylene; but he has also transformed a generic object into a double-spouted form of extraordinary beauty.

Monica Förster
Swedish (b. 1966)
Cloud Portable Meeting
Room, 2004
Nylon
Mfr: Offecct
91⅛ × 211⅛ × 155⅞ in.
(231.3 × 536.1 × 395.9 cm)

Förster is establishing a
reputation for herself as one of
the most talented young female
designers in Scandinavia.
Cloud, one of her first designs
of note, was an experiment
with inflatable forms at a large
scale; the piece may be used as
either an interior environment
or a billowy sculpture.

243 →

Snowcrash
Finnish (Teppo Asikainen,
b. 1968; Ilkka Terho, b. 1968)
Netsurfer Computer
Workstation, 1995
Steel and leather
Mfr: originally Netsurfer Ltd.;
then Snowcrash
38½ × 63⅜ × 30⅞ in.
(98 × 161 × 78 cm)

244 ↘

Snowcrash
Finnish (Pasi Kolhonen, b. 1968;
Ilkka Suppanen, b. 1968)
Airbag Chair, 1997
Nylon and polyester
Mfr: Snowcrash
31½ × 35½ × 33½ in.
(80 × 90 × 85 cm)

Through their pioneering work
made of bent and laminated
wood, such Scandinavian
designers as Alvar Aalto and
Bruno Mathsson developed
one of the most compelling
versions of Modernism; indeed,
it became so pervasive in the
Nordic countries that it almost
stifled any alternative design
approaches. It was therefore
perhaps inevitable that new
design groups, such as
Snowcrash, would rebel
and advocate a radical, high-
tech aesthetic. *Netsurfer* and
Airbag are two of Snowcrash's
most acclaimed designs. The
former was a startling new
concept for a computer
workstation, while the latter—
a radical reinterpretation of a
conventional chair—harkened
back to the heady days of
the original Pop movement
of the 1960s.

241 ↑

Maria Grazia Rosin
Italian (b. 1958)
Detergens Bottle, 2000
Glass
Mfr: Vittorio Ferro
Largest: 13⅞ in. (35 cm)
(height)

For her *Detergens* bottles,
Rosin has reinterpreted a
plastic detergent container as
a precious piece of glass, using
brilliant colors and geometric
patterns—a *tour de force* of
Venetian glassmaking.

IKEA design (2003; fig. 225). With equal agility, Maria Grazia Rosin has illustrated the inventiveness of the Italian glass tradition with her *Detergens* bottles (2000; fig. 241). Inspired by one of the most utilitarian of objects—a kitchen detergent bottle—Rosin has created deluxe glass *objets* featuring sensuous and brilliant striped and geometric patterns. The addition of real plastic spouts only adds to the merriment.

High-tech revival

A second group of designers within the Neo-Pop movement, particularly those in Scandinavia, were more concerned with high-tech forms. These designers, whose work dates largely from the 1990s, focused on playful interpretations of technological and futuristic concepts. They were

also fascinated by inflatable, adjustable, and chameleon-like forms and often used metal—rather than plastics—in their work.

One of the most compelling examples of this design approach is Monica Förster's *Cloud* portable meeting room (2004; fig. 242). The nylon "tent" comes in a duffle bag and can be inflated to create a special environment for meetings as well as a luminous sculpture for any office.

The Finnish/Swedish design group Snowcrash was one of the strongest advocates of this high-tech look.[172] Its work was, first of all, a brash rebellion against the refined, bent-plywood aesthetic of so much Scandinavian Modernist design. The group sought to achieve a new definition of efficient space by using new materials and technology and to create a new type of furniture that was

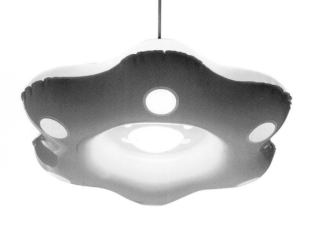

more flexible and mobile. The *Airbag* chair (1997; figs. 230, 244) and the *Netsurfer* computer workstation (1995; fig. 243) perhaps best illustrate the group's design approach. The former, essentially two large pillows held together with straps, tries to recapture the casual lifestyle exemplified by the beanbag chairs of the 1960s.[173] The latter is a bold concept for a new kind of computer workstation, with a metal frame and an adjustable chaise unit.

The high-tech aesthetic may also be seen in two lighting fixtures of the period. Snowcrash's *Glowblow* floor lamp (1996; fig. 246) has a nylon shade that inflates when the floor lamp is turned on. The lamp's design possesses a remarkable subtlety, particularly in the asymmetrical placement of the stem in relation to the base and shade. The playful aesthetic of this lamp was certainly not confined to Scandinavian design, and in the United Kingdom such groups as Inflate were creating similar Pop and inflatable pieces. Inflate's *UFO* light (1998; fig. 245) has the eerie and whimsical look of a flying saucer.

At the same time, this high-tech look was also influential in the product design field. The designers working in this area infused their industrial objects with a similar playful aesthetic quality, often employing bright colors. Forms could vary from the complex to the elemental, and the mechanics of the product were often made into an important design element. Some designers also used new technology in their objects.

Both Dyson and Artemide are companies that often produce original designs driven by innovations in engineering and technology. For the *DC11* cleaner (2003; fig. 248), James Dyson has adapted the technology developed for his revolutionary vacuum cleaners of the 1980s for a small portable unit, in which all of the components are exposed and highlighted in a brilliant yellow—a *tour de force*

of high-tech design. In a similar manner, the *Yang* light (2000; figs. 231, 247), designed by Carlotta de Bevilacqua for Artemide, has a clear, spherical case that exposes the colored fluorescent bulbs within; these bulbs can be activated via remote control and, using different hues of light, can change the mood of a room.

Designers have also sought to make other consumer products more user-friendly through their look. The Nokia *5210* mobile telephone (2001; fig. 249) has been turned into a sensuous, high-tech hand sculpture. Swatch has long been famous for its over-the-top watches embellished with bold colors and patterns, as illustrated by the *Bouquet* (1992), *Hot Stuff* (1995), and *Space People* watches (1993; fig. 252).[174]

Good design has become such an integral part of Scandinavian culture that even the most utilitarian of objects are now conceived with the greatest of care. With the *Ava* padlock (1992; fig. 251), Creadesign transformed the normal, gray, metal design into an elegant asymmetrical form highlighted with a bold color palette. Likewise, with *Startloop* (2002; fig. 250), Hareide Designmill succeeded in turning a battery charger into a piece of Pop sculpture. Both of these designs demonstrate a fundamental tenet of Modernism: that the most ordinary, everyday objects—whether a soup can or a padlock—can be transformed into something extraordinary through the magic of design.

There were, of course, real differences between the Neo-Pop revival of the 1990s and 2000s and the original movement of the 1960s and 1970s, especially if one compares the work in this section with that featured in Sparke's essay (pp. 12–29). The earlier two decades were a turbulent period in European culture; and while there was a certain irreverence about the Pop designs of that period,

245 ←
Inflate
British (Nick Crosbie, b. 1971)
UFO Light, 1998
Vinyl
Mfr: Inflate
4¾ × 17¾ in. (12 × 45 cm)
(height × diameter)

246 ↙
Snowcrash
Finnish (Vesa Hinkola, b. 1970;
Markus Nevalainen, b. 1970;
Rane Vaskivuori, b. 1967)
Glowblow Floor Lamp, 1996
Steel and nylon
Mfr: originally Netsurfer Ltd.;
then Snowcrash; now David
design
63 × 25⅝ in. (160 × 65 cm)
(height × width)

Inflatable forms were of
particular interest to Neo-Pop
designers since they inherently
implied that there was no
fixed form or even rules to
contemporary design—an
appealing mantra for such
avant-garde design groups
as Snowcrash and Inflate.

247 →
Carlotta de Bevilacqua
Italian (b. 1957)
Yang Lamp, 2000
Polycarbonate, acrylic,
fluorescent lights, and
microprocessor
Mfr: Artemide S.p.A.
12¼ × 15¾ in. (31 × 40 cm)
(height × diameter)

248 ↓
James Dyson
British (b. 1947)
DC11 Vacuum Cleaner, 2003
Plastic and metal
Mfr: Dyson Ltd.
13 × 11 × 16½ in.
(33 × 27.9 × 41.9 cm)
(height × width × length)

The fascination with a high-tech
look found particular favor with
a number of industrial designers
during this period. Dyson's mini
DC11 vacuum cleaner has all the
bravura and power of a massive
nineteenth-century engine,
while Bevilacqua's *Yang*
light magically captures the aura of
the most sophisticated space-
age technology.

there was also an underlying gravitas to the work. Designers were committed to creating radical designs that would fundamentally change their culture, and they clearly saw that innovative technology and new materials could play a major role in their work. These issues did not weigh so heavily on a later generation.

But without doubt, there were some very positive aspects to this Neo-Pop revival. It brought a jolt of irreverence and energy to the Modernist movement, a fact reinforced when one compares the pieces it produced to the more cerebral work of such designers as Jasper Morrison and Maarten Van Severen. It also provided a degree of freedom for experimentation when Modernist designers crossed over into this aesthetic. It opened up the formal vocabulary of Modernist design with the use of inflatable, adjustable, and iconic shapes; it also dissolved the lines between craftsmanship, limited production, and mass production. Most importantly, perhaps, this Neo-Pop mode helped to dissolve the rigid categories between "high" and "low" design, which had been very much a mandate of Postmodernism.

The tripartite Modernist resurgence at the end of the twentieth century—consisting of the Geometric Minimal, Biomorphic, and Neo-Pop design movements—was quite remarkable in its extraordinary richness and its wide-ranging influence across Europe. Postmodernism's roots, however, proved to be deep and strong; by the early 1990s, a rebirth was underway that would ultimately push European design in dramatic new directions.

249 ← ←
Nokia
Finnish (founded 1865)
5210 Mobile Telephone, 2001
Polyamide, thermoplastic,
and acrylic
Mfr: Nokia
3⅜ × 1⅝ × ⅞ in. (10 × 4 × 2 cm)

Nokia, a Finnish company,
has been one of the pioneers
in developing the mobile
telephone, both aesthetically
and technologically. For the
5210 model, the firm's
designers have used bright
colors and undulating, jazzy
patterns to transform the
ordinary into the extraordinary.

250 ← ←
Hareide Designmill
Norwegian (Anders Hansen,
b. 1971; Einar Hareide, b. 1959)
Startloop Battery Charger, 2002
ABS plastic
Mfr: Startloop A/S
13 × 3 × 1⅝ in. (33 × 7.4 × 4 cm)

251 ↙ ↙
Creadesign Oy
Finnish (Hannu Kähönen,
b. 1948)
Ava Padlock, 1992
ABS plastic and steel
Mfr: Abloy Oy
2⅜ × 1⅞ in. (6 × 5 cm)
(height × width)

Many Neo-Pop designers
have successfully risen to the
challenge of transforming the
most utilitarian of objects into
colorful mini-sculptures, as
illustrated by the *Ava* padlock
and *Startloop* battery charger.

252 ←
Swatch Ltd.
Swiss (founded 1983)
J.C. de Castelbajac, French
(b. 1949) (*Space People*); Swatch
Lab (*Bouquet*, *Hot Stuff*)
Pop Watches: *Bouquet*, 1992;
Hot Stuff, 1995; *Space People*,
1993
Plastic and metal
Mfr: Swatch Ltd.
Left to right:
10¼ × 1⅝ in. (26 × 4.5 cm)
(length × width)
9½ × 1⅝ in. (24 × 4 cm)
(length × width)
9⅛ × 1¼ in. (23 × 3.3 cm)
(length × width)

With their unrestrained
creativity, Swatch watches have
long been cult objects among
design aficionados. These three
exuberant models represent
some of the most compelling
examples of Neo-Pop design
from the 1990s.

Conceptual Design

Concept

In reaction to the influential and widespread tripartite Modernist resurgence that arose in the late twentieth century, a new Conceptual movement sought to revive a rational, highly conceptual approach to design. Its intellectual roots lay in the Italian avant-garde design groups of the 1970s and 1980s: both Studio Alchymia and Memphis had sought to redefine the concept of design in a radical way, so that design would be thought of as a cultural force rather than simply a means of making functional objects for industry. Accordingly, for the Conceptualists, form followed concept rather than function. This rational, theoretical approach to design tended to blur the boundaries between design, art, craft, and industry; it played with the ambiguities between "high" and "low" art, favoring, in fact, the beauty of the banal; and it reveled in the idea that objects could have multiple, layered meanings.

Given its highly theoretical nature, the Conceptual movement may be examined from four different perspectives: designers reinterpreting found objects; designers reinterpreting everyday objects; designers reinterpreting archetypal objects; and designers dissolving the lines between art and design.

Style

Given that concept was seen as more important than form, there was no uniform stylistic approach among the designers of this movement. As a result, these designers tended to blur the lines between an object as a work of design or as a work of art. Pieces were, for the most part, either handmade or issued in limited-edition series; furthermore, little interest was shown in the use of new materials or innovative technologies. Perhaps most tellingly, many Conceptual objects conveyed a dry, intellectual sense of humor.

Time and Place

With its strong philosophical and aesthetic basis, the Conceptual movement became a major force in European design during the 1990s. While it was initially a Dutch development, a broad cross-section of a second generation of Western European designers has now embraced this manner.

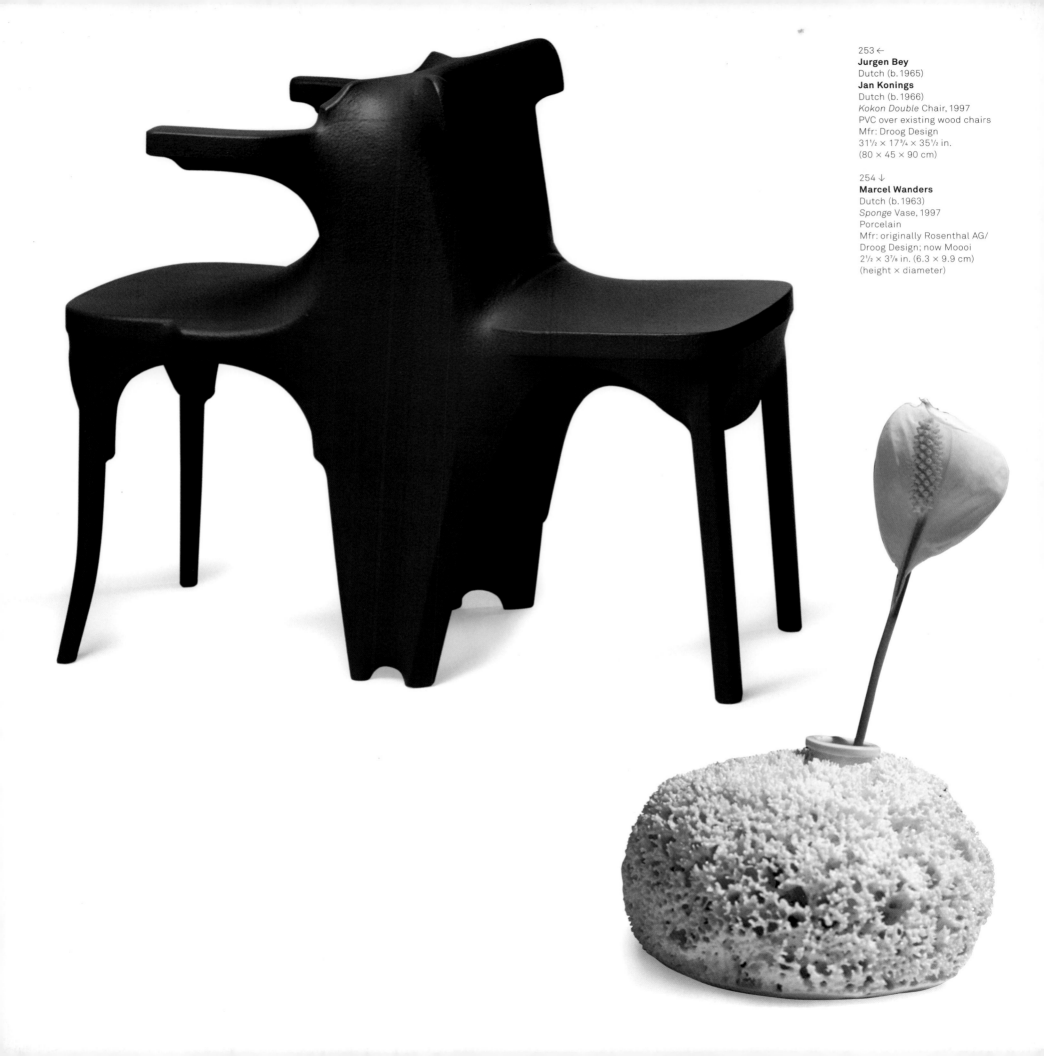

n the 1990s, The Netherlands re-emerged as a major design center and assumed a leadership role comparable to its position between the world wars.[175] A number of Dutch designers were instrumental in developing a new Conceptual design movement, which would ultimately lead to a multi-faceted resurgence of Postmodernism in the mid-1990s and 2000s. This movement was initially associated with such groups as Droog Design[176] and the design school at Eindhoven; but it would soon become an international phenomenon.

This Dutch Conceptual movement was quite antithetical to the prevailing Modernist modes in Europe. It conceived of design as primarily a cultural force, rather than as a means of producing industrial or functional objects: form would follow concept, not function. It was also very rational and theoretical in its approach but in a manner quite different from Modernism. Objects were often seen as having multiple, layered meanings. Favoring the beauty of the banal, this movement also sought to blur the lines between "high" and "low" art; and, characteristically, it often dissolved the lines between design, art, craft, and industry.

Of course, the roots of this Conceptual movement inevitably go back to such radical Italian Postmodernist design groups as Alchymia and Memphis. Alessandro Mendini had used Alchymia as a means of developing a highly theoretical approach to design. Likewise, Ettore Sottsass had used Memphis as a vehicle for challenging the very concept of design.

Given its pronounced theoretical nature, there was no single, uniform stylistic approach within the Conceptual movement, since concept was seen as more important than form. Indeed, one may point to four different aspects of this movement:

designers reinterpreting found objects; designers reinterpreting everyday objects; designers reinterpreting archetypal forms; and designers creating pieces more akin to design as art.

Reinterpreting found objects
One of the first aspects of the Conceptual movement focused on the found object, with designers taking ordinary or vernacular items and using them in new contexts. Droog Design was a strong advocate of this design approach, and it was very Dutch in its desire to use the "least" of whatever.

Tejo Remy's work is a good representation of Droog's early production. His *Milk Bottle* lamp (1991; fig. 256) uses a cluster of twelve sandblasted bottles, positioned exactly as they would be in a Dutch milk crate, to create a hanging light. It is a common form that seeks to evoke a familiar emotion in the user. Remy's *Rag* chair (1991; fig. 257) is a commentary on the conspicuous consumption of Western society. The design is made of recycled textiles strapped together with metal bands; binding pieces together to create ensembles is a recurring theme in Remy's work. His *You Can't Lay Down Your Memories* chest of drawers (1991; fig. 258) is perhaps his most monumental and arresting design. It consists of approximately twenty found drawers, for which new wooden sleeves have been made; the user then assembles the pieces into a jumbled composition held together with a large furniture-mover's belt. The brilliance of the design lies in its simplicity but also in its unsettling power.

Jurgen Bey's work is representative of Droog's production from the late 1990s. Bey is one of three Dutch designers—Hella Jongerius and Marcel Wanders being the other two—who have emerged from this Conceptual movement as international figures. Bey's designs are highly intuitive and

256 ←
Tejo Remy
Dutch (b. 1960)
Milk Bottle Lamp, 1991
Existing glass milk bottle and
steel
Mfr: Droog Design
Single bottle: 10⅝ × 3¾ in.
(26.9 × 9.3 cm)
(height × diameter)

Remy's *Milk Bottle* light was
a radical idea in 1991. It is
also a good illustration of the
conceptual work produced by
Droog Design, the influential
Dutch design consortium, which
advocated using found objects
in a new context.

257 →
Tejo Remy
Dutch (b. 1960)
Rag Chair, 1991
Existing rags and steel
Mfr: Droog Design
43¼ × 23⅝ × 23⅝ in.
(110 × 60 × 60 cm)

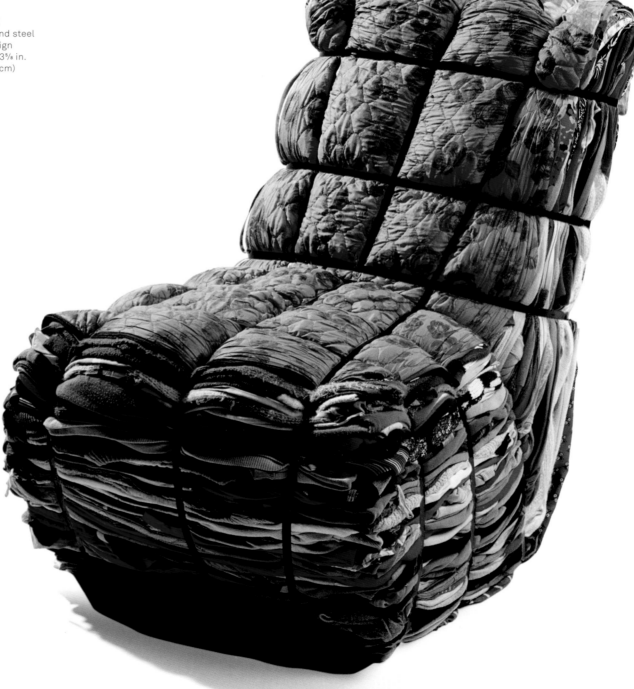

258
Tejo Remy
Dutch (b. 1960)
You Can't Lay Down Your Memories Chest of Drawers, 1991
Existing wood drawers, plywood, and fabric
Mfr: Droog Design
Approximately:
47¼ × 43⅜ × 23⅝ in.
(120 × 110 × 60 cm)

In the early 1990s, Remy was interested in creating unconventional objects by binding together clusters of unusual materials. The *Rag* chair (fig. 257) and *You Can't Lay Down Your Memories* chest, consisting of rags and drawer units respectively, are two of the most compelling examples of this design aesthetic.

259 ←
Jurgen Bey
Dutch (b. 1965)
Light Shade Shade Lamp, 1999
Two-way mirror foil and existing
chandelier
Mfr: Droog Design
32³⁄₈ × 18¹⁄₂ in. (82 × 47 cm)
(height × diameter)

Like Remy's *Milk Bottle* lamp
(fig. 256), Bey's *Light Shade
Shade* light was a shocking
design when it first appeared
in the late 1990s. Bey has
used a bourgeoisie, cut-glass
chandelier in a new and
startling context.

260 ↘
Jurgen Bey
Dutch (b. 1965)
Jan Konings
Dutch (b. 1966)
Kokon Double Chair, 1997
PVC over existing wood chairs
Mfr: Droog Design
31¹⁄₂ × 17³⁄₄ × 35¹⁄₂ in.
(80 × 45 × 90 cm)

The use of new skins or
surfaces over found objects
is a recurring theme in Bey's
œuvre. The *Kokon Double* chair
is an early and particularly
compelling example of this
design approach, where
two ordinary wooden chairs
have been covered in a PVC
resin coating.

conceptual in approach; he works with his heart
and then his mind. There are two important themes
in his œuvre: nature and the idea of skin covering
the body. Thus in Bey's pieces, one often sees
various kinds of "skins" or "surfaces" covering found
objects.[177] Bey characteristically looks for objects
that exist in our lives but that do not have a fixed
category; by giving them a new skin (or identity),
he believes that he is able to create new systems
in nature and our culture.[178] He is, as Jongerius has
noted, very much a designer's designer.[179]

Three of Bey's designs illustrate the richness
of his Conceptual design approach. In the *Light
Shade Shade* lamp (1999; fig. 259), a kitsch glass
chandelier has been given a shade made of two-way
mirrored foil. When the light is off, one sees a silver
cylinder; when it is illuminated, one sees the glowing

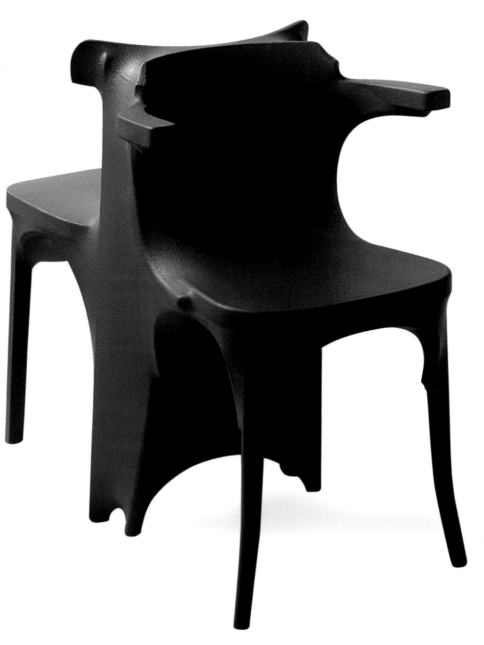

pentimento of the chandelier. In Bey's design for the *Kokon Double* chair (1997, designed with Jan Konings; figs. 253, 260), vernacular wooden chairs have been covered in an elastic PVC coating.[180] As has been noted elsewhere, "By cross-breeding and grafting, products and functions of a different nature can merge and develop into new products."[181] Likewise, Bey gathered random ceramics from friends for the *Broken Family* tea set (1999; fig. 261); by silver-plating the pieces, he gave them a unity and created a new category. Bey, like Remy, was taking found objects and giving them new meanings by using them in a new context.

Reinterpreting everyday objects

Other designers in the Conceptual movement focused on banal or everyday objects, techniques,

and materials, using them in an imaginative manner. Many of these designers' pieces date from the late 1990s, at a time when the movement had become much more international in its influence.

Hrafnkell Birgisson is an Icelandic designer who resides mostly in Germany. His *Hab'* cupboard (1998; fig. 262) is a play on a type of bourgeois, eighteenth-century cupboard (and its countless reproductions) often seen in traditional, middle-class homes.[182] Birgisson's design, however, is not a massive piece of wooden furniture; rather, it is a sheet of *trompe l'œil* poured polyurethane with straps for holding plates and utensils. The piece can be hung on the wall or rolled up if one is moving: it is nomadic furniture, if you will.

Jonas Bohlin is a rather iconic figure in Sweden, for he was one of the first Scandinavian designers

261 ↓
Jurgen Bey
Dutch (b. 1965)
Broken Family Tea Set, 1999
Silver plate over existing ceramics
Mfr: Jurgen Bey
Largest: 7⅞ × 8¾ × 4¾ in.
(20 × 22 × 12 cm)
(height × width × diameter)

In the 1990s, the work of such Dutch Conceptual designers as Bey openly challenged the fundamental tenets of Modernism. The *Broken Family* tea set is a prime example of this reaction; using silver plating, the designer has transformed odds and ends of dishes into semiprecious objects.

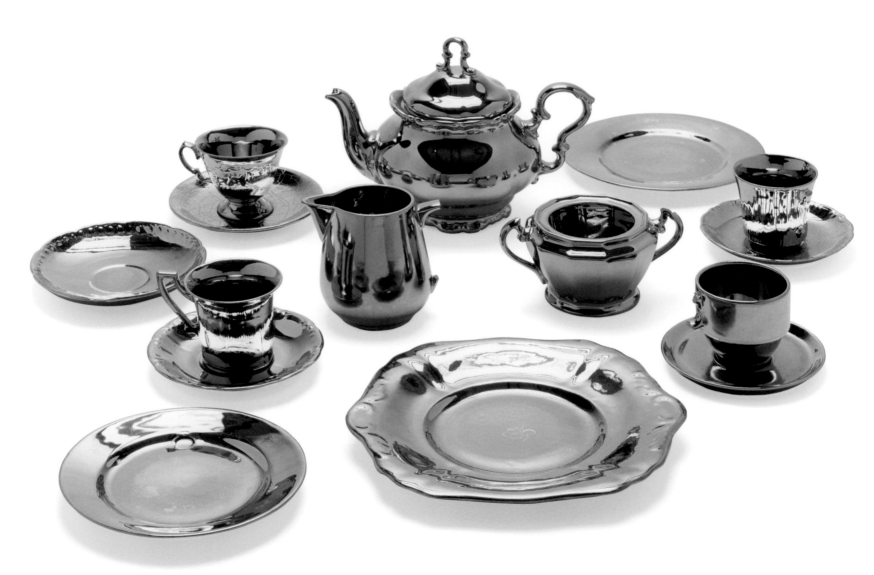

262
Hrafnkell Birgisson
Icelandic (b. 1969), resides
Iceland and Germany
Hab' Cupboard, 1998
Polyurethane
Mfr: Hrafnkell Birgisson
75 × 45 in. (190.5 × 114.3 cm)
(height × width)

The Dutch Conceptual movement
gained widespread fame in the
1990s and influenced designers
in virtually every European
country. The concept of using
everyday objects, techniques,
or materials in new contexts
was one of the movement's
most exciting ideas. Birgisson's
Hab' cupboard is a compelling
example of this design approach
in its radical reinterpretation
of a traditional wooden cabinet.

to openly break with the prevailing Modernist style.[183] There is a poetic quality to his work, and many of his designs blur the line between art and design. His *LIV* stool (1997; fig. 263) is a disconcerting object: an everyday pillow floats on a metal tripod base. Should one sit on it or merely be amused by such an unconventional juxtaposition?

Marcel Wanders is one of the most influential Dutch designers of this period, and his polyglot work can be placed in a number of categories that reflect his development as an artist: the early conceptual work for Droog Design from the early 1990s, which is largely handmade; the more minimal "industrial" work from the late 1990s onward, when he was working for such companies as Wanders Wonders, Cappellini, and Moooi; and the most recent work from the early 2000s, when he became a leader in the Neo-Decorative design movement, as we shall see shortly.

Like many of his Postmodernist contemporaries, Wanders believes that design has the power to change our lives. His early work, with its emphasis on a tradition of simplicity and intellectual clarity, also demonstrates a straightforward Dutch approach—no fat on the bones.[184] As with Droog's early collections, Wanders's initial work was highly conceptual and an attempt to bring a more human approach to design. Wanders is exploring the interactions between meaning, technology, and function in objects. He is looking for ties between the past and the future, to make cultural connections.[185] He also wants his pieces to have a greater sensibility and to look more crafted. Wanders's choice of materials is frequently quite unconventional, and he often employs textiles in new manners. There is also a lightness and translucency to much of his work; his forms can be open, and even when they are massive in scale, they are often hollow.

Perhaps most importantly, while a number of his colleagues, including Bey and Jongerius, were exploring the relationship between studio production and craft, Wanders, almost from the beginning of his career, was fascinated by the possible links between studio production and industry. Wanders wanted to explore whether unique objects could be made using industrial processes, even though at the time this was still very much a nascent idea in his work.[186] Thus there is a constant interplay in his designs between craft and industry or between low-tech and high-tech, whether one is dealing with materials or technology.

The *Knotted* chair (1996; fig. 264) is an apt example of Wanders's early design approach, in which he explored the boundaries between craftsmanship and industrial production. The chair reflects this dichotomy in that it is made of carbon fiber sheathed in a knitted casing; the piece is then dipped in resin and hung up to dry. The first examples of this design were made by hand in a collaboration between Droog Design and the Aviation and Space Laboratory of Delft University of Technology; the design was later produced by Cappellini. The *Knotted* chair is thus a powerful juxtaposition of craft and industry.

Wanders considers an earlier piece, the *Couple* vase (1991; fig. 265), to be one of his most important designs, for it would prove to be a harbinger of the duality between studio production and industry in his œuvre.[187] A highly controversial design at the time, since it openly challenged so many tenets of Dutch industrial

263 ↑
Jonas Bohlin
Swedish (b. 1953)
LIV Stool, 1997
Steel and linen
Mfr: J. Bohlin Design
23⅝ × 27⅝ × 17¾ in.
(60 × 70 × 45 cm)

Bohlin, a Swedish designer, was an early advocate of a more theoretical approach to design that broke with the strong Scandinavian Modernist aesthetic. His *LIV* stool is a particularly eye-catching piece: a billowy pillow juxtaposed with a simple metal base.

264 →
Marcel Wanders
Dutch (b. 1963)
Knotted Chair, 1996
Carbon, aramid, and epoxy
Mfr: originally Droog Design; now Cappellini S.p.A.
39⅜ × 19¾ × 23⅝ in.
(100 × 50 × 60 cm)

One of the early leaders of the Dutch Conceptual movement, Wanders has grown into a figure of international repute. The *Knotted* chair was one of his first important designs and captures the spirit and multiple layers of meaning that characterized the best work by Droog in its initial years.

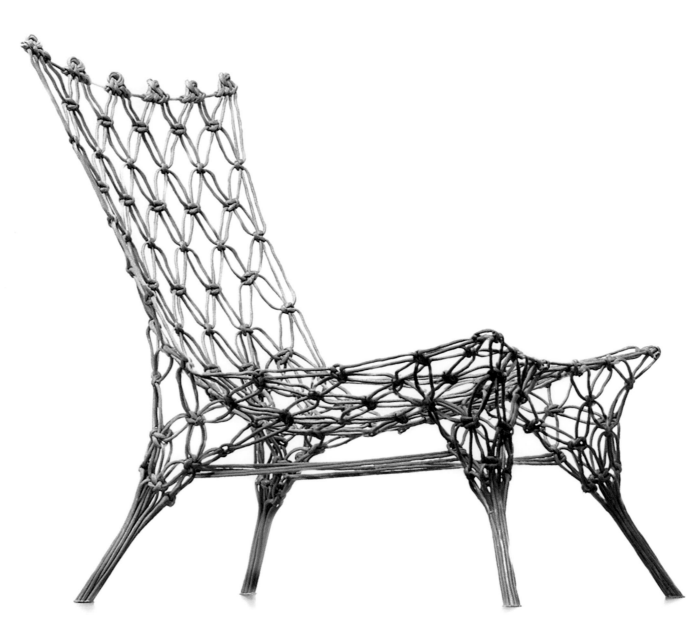

265 ↘

Marcel Wanders
Dutch (b. 1963)
Couple Vase, 1991
Existing vases, wood, bricks,
and copper
Mfr: Marcel Wanders
Approximately: 7⅞ × 5⅛ in.
(20 × 13 cm) (height × length)

Consisting of two everyday
ceramic vases standing on a pair
of generic bricks, the *Couple* vase
proved to be quite a shocking
and disconcerting design when
it first appeared in 1991.

266 ↗↗

Marcel Wanders
Dutch (b. 1963)
Egg Vase, 1997
Porcelain
Mfr: originally Rosenthal AG/
Droog Design; now Moooi
6 × 4½ × 4 in.
(15.2 × 11.4 × 10.1 cm)

267 ↘↘

Marcel Wanders
Dutch (b. 1963)
Sponge Vase, 1997
Porcelain
Mfr: originally Rosenthal AG/
Droog Design; now Moooi
2½ × 3⅞ in. (6.3 × 9.9 cm)
(height × diameter)

The *Egg* and *Sponge* vases
represent two important
experiments by Wanders.
The designer was beginning
to play with the idea of
creating handcrafted objects
in conjunction with a mass-
production manufacturer,
thereby blurring the line
between craft and industry.
This would become a central
theme in Wanders's mature work.

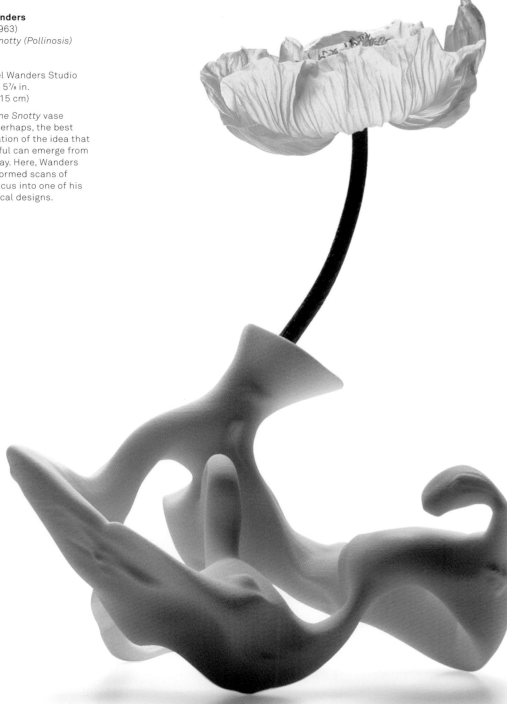

268
Marcel Wanders
Dutch (b.1963)
Airborne Snotty (Pollinosis)
Vase, 2001
Polyamide
Mfr: Marcel Wanders Studio
5⅞ × 5⅞ × 5⅞ in.
(15 × 15 × 15 cm)

The *Airborne Snotty* vase series is, perhaps, the best demonstration of the idea that the beautiful can emerge from the everyday. Here, Wanders has transformed scans of human mucus into one of his most magical designs.

design, the piece basically consists of a tableau of two traditional ceramic vases mounted on a floating masonry base made from two bricks. The design would also prove to be quite prophetic, as it would touch on numerous themes in Wanders's later work: it was highly conceptual; it was made in his studio; and it blurred the lines between found, everyday, and industrial objects. Moreover, there is a disturbing quality to the ensemble, with Wanders forcing the viewer not only to confront everyday objects in new contexts but also to ask the question of what exactly is a vase.

Two other vessel forms show a further evolution in Wanders's thinking. The *Egg* vase (1997; fig. 266) and *Sponge* vase (1997; figs. 254, 267) were two experiments with Rosenthal, the industrial ceramics company, in which Wanders was able to achieve unique objects using industrial processes. The *Egg* vase—created by stuffing eggs in a condom, dipping the piece, and then firing it—was intended to be a play on the thinness of porcelain. In reality, the vases are quite monumental, the opposite of what the designer wanted.[188] The *Sponge* vase is made using a similar dipping-and-firing technique; but here Wanders has succeeded in capturing the brittle quality and subtle detailing so characteristic of fine porcelain.

For the *Airborne Snotty (Pollinosis)* vase (2001; fig. 268), Wanders used computer technology—in an eccentric manner—again to achieve unique objects. The form is based on a three-dimensional scan of human mucus; the vase itself is made by rapid prototyping. The highly sculptural piece is one of Wanders's most sensuous and cerebral designs.[189]

Much like the International Style half a century earlier, the larger Conceptual design movement had a clear intellectual basis and a strong stylistic aesthetic that found wide favor across Europe.

269 →
Cecilie Manz
Danish (b. 1972)
HochAcht Library Ladder, 1999
Wood
Mfr: Nils Holger Moormann
93⁷⁄₈ × 20¹⁄₈ × 36³⁄₈ in.
(238 × 51 × 92 cm)

270 ↘
Uglycute
Swedish (Markus Degerman,
b. 1972; Andreas Noble, b. 1966;
Jonas Noble, b. 1970;
Fredrik Stenberg, b. 1971)
Baltic Babel Environment, 2002
Chipboard and styrofoam
Mfr: Uglycute
118 × 118 in. (300 × 300 cm)
(area)

The Conceptual design
movement also found great
favor with a second generation
of Scandinavian designers,
including Manz in Denmark and
the Uglycute group in Sweden.
Manz reinterprets everyday
forms, in this case a ladder,
while Uglycute uses everyday
materials, in this instance
chipboard and styrofoam,
to create highly unorthodox
compositions.

271 → →
Matali Crasset
French (b. 1965)
Artican Wastepaper Basket, 1999
Polymethacrylate, aluminum,
and polypropylene
Mfr: Galerie Gilles Peyroulet & Cie
24 × 16¹⁄₂ in. (60.9 × 41.9 cm)
(height × diameter)

Following the example of
Philippe Starck, Crasset has
succeeded in creating an
engaging—and sometimes
controversial—media persona.
Such designs as the *Artican*
wastepaper basket are a clear
demonstration of her remarkable
ability to seamlessly blend the
everyday with the cerebral.

272 ↘ ↘
Frank Tjepkema
Dutch, born Switzerland
(b. 1970)
Artificial Plant, 1996
Polyurethane rubber and
polypropylene
Mfr: Droog Design
19³⁄₄ × 19³⁄₄ in. (50 × 50 cm)
(width × depth)

It could be argued that
Tjepkema's *Artificial Plant* is
the archetypal Droog object: the
most banal, everyday material
has been used to create a
design with no real function
other than to stimulate our
intellectual senses.

Its appeal to a second generation was pervasive and international.

Typical of the designs of this younger generation, Cecilie Manz's work features a duality between mass-produced and more experimental pieces. The *HochAcht* library ladder (1999; fig. 269) is representative of the latter. On the one hand, it is an everyday ladder; on the other, with the modification of the second and third rungs, it is also a seat—a disquieting object in a space.

The Uglycute design group represents yet another characteristic of this second generation: their tendency to form collaboratives, after graduation from design school, as a means of producing their work and building their reputations. Uglycute's aesthetic also reflects a reaction to the sleek Modernist work of an older generation of Swedish designers. The *Baltic Babel* environment (2002; fig. 270) is handcrafted in seemingly random blocks of Styrofoam and chipboard—everyday industrial materials. It revels in its banality.

Three other objects by younger designers show how this fascination with the everyday can be adapted. As with Manz, there are two aspects to Matali Crasset's work: industrial design and conceptual design.[190] It is the latter that is perhaps the most significant; indeed, Crasset's designs are often more interesting for their ideas than for their aesthetics. The *Artican* wastepaper basket (1999; fig. 271) is a case in point. Here, Crasset has used the green plastic brushes from the brooms of Parisian sanitation workers to create a work of art that can be examined from a plethora of intellectual perspectives. In a similar manner, Frank Tjepkema has folded up sheets of rubber and plastic "grass" to make the *Artificial Plant* (1996; fig. 272), a purely conceptual piece with no use or function. The ceramicist Wieki Somers has also created a combination of handmade and serial production pieces; but it is her conceptual work that features the most potent poetic play between material and function. Somers's *High Tea* pot (2003; fig. 273) is one of the most powerful and disturbing designs of the early 2000s.[191] Inspired by Roman iconography, Somers has based the teapot's form on a pig's skull[192] and has used rat fur for the cozy.[193] The pot itself is made from bone china, adding yet another layer of meaning to the highly conceptual design.[194] Such extraordinary objects—derived from the preoccupation of two generations of international designers with everyday forms, materials, and techniques—clearly demonstrate the remarkable influence of the Conceptual movement during these decades.

Reinterpreting archetypal forms
An interest in archetypal forms has also proved to be one of the paramount intellectual concerns during this period, spanning both the Modernist and Postmodernist movements. As noted earlier, such forms were of particular interest to both Jasper Morrison and Maarten Van Severen. They were also a recurring theme in the work of such Conceptual designers as Wanders and Jongerius, though in slightly different ways.

Wanders's "industrial" work from the late 1990s is perhaps closest in feeling to that of Morrison and Van Severen, once again illustrating the fluidity and almost amorphous nature of certain design movements during this decade. In his *Big Shadows* floor lamp (1998; fig. 274), Wanders has taken the generic form of a table lamp and transformed it into a monumental illuminated totem. Likewise, when given the challenge of creating an archetypal chair for a V.I.P. (2000; fig. 276), Wanders used elemental geometric forms made of gray felt, tailored like a Savile Row suit. The monolithic mass has a calm power not unlike that of a regal throne.

273 →↘
Wieki Somers
Dutch (b. 1976)
High Tea Pot, 2003
Porcelain, fur, steel, and leather
Mfr: EKWC (Erik Jan Kwakkel
with European Ceramic
Workcentre)
9⁷/₈ × 7⁷/₈ × 18¹/₂ in.
(25 × 20 × 47 cm)

Somers's ceramics are evidence
of an extraordinary perspicacity.
In *High Tea* pot, multiple
layers of meaning are replete
with allusions to historical
iconography, the Green
movement, and the ordinary.
It is a remarkable *tour de force*
for such a young designer.

Richard Hutten's task was to design a generic plastic child's chair. His *Bronto* chair (1997; fig. 275) is a wonderful amalgamation of material, technique, and form. The piece is made of colored resins using a rotation-molding machine, which produces suitably simple forms that are hollow with soft contours. The arresting result is one of the best archetypal plastic chairs of the last two decades.

However, in the early stages of her career, it was Jongerius who explored the idea of archetypal forms from a Conceptual perspective in perhaps the most imaginative manner. Originally trained at Eindhoven in textiles, she first made her mark for Droog Design with pieces made of polyurethane and then ceramics. Over the last decade, she has grown into one of the major European designers of her generation, one who has the ability to work in multiple media with equal dexterity. Jongerius is also one of the few women—along with Zaha Hadid—to become an artist of the first rank during this period.

Like many of her Dutch contemporaries in the 1990s, Jongerius believed in the importance of concept over function—that the layered meanings in an object were a way of communicating with the user, that the design arts were equal to the fine arts, and that ideas were often more important than aesthetics.[195] It is Jongerius's design approach, however, that sets her early work apart from that of Bey and Wanders. Jongerius begins with the material, whether traditional or high-tech; she then transforms the technology normally associated with that material.[196] It is her approach to form, though, that is perhaps most distinctive. Jongerius avoids creating new forms; rather, she uses historical archetypal shapes, which she then adapts in some manner to give them a new meaning, combining the past and the present.[197] Four of her early pieces illustrate her evolution as a designer.

274
Marcel Wanders
Dutch (b. 1963)
Big Shadows Floor Lamp, 1998
Metal and cotton
Mfr: Cappellini S.p.A.
Largest: 79½ × 37½ in.
(201.9 × 95.2 cm)
(height × diameter)

Given the magnitude of his talent (and ambition), Wanders has played at various times with many of the central tenets of the Conceptual movement. The *Big Shadows* floor lamps are one of the most compelling examples of Wanders's use of an archetypal form: a generic light has been transformed into glowing sculptural masses.

275 →
Richard Hutten
Dutch (b.1967)
Bronto Child's Chair, 1997
Polyurethane
Mfr: Droog Design
33⅛ × 17⅜ × 21¼ in.
(84 × 44 × 54 cm)

The plastic café chair became one of the iconic forms of the post-1985 era. Hutten's *Bronto* chair is a sly commentary on this development; he has achieved an archetypal variation through his conceptual synthesis of form, technique, and material.

276 ↓
Marcel Wanders
Dutch (b.1963)
V.I.P. Chair, 2000
Felt
Mfr: Moooi
30⅜ × 24 × 20⅞ in.
(77.9 × 61.9 × 53 cm)

Textiles—in various manifestations—have played an important role in Wanders's work, as can be seen in his *V.I.P.* armchair. Here, the structural frame has become secondary to a taut, upholstered form.

For the *Soft Urn* vase (1993; fig. 277), Jongerius bought a traditional ceramic vase and copied it in a new material—polyurethane.[198] Thus the design was about the material. Although the form captures the feeling of being old, in reality the vase was something quite different. The piece also openly shows the imperfections in its surface.

In the late 1990s, Jongerius began to work in ceramics in a new manner. Although ceramics would become one of her most favored materials, she did not particularly like the perfection and hardness of porcelain. In the *Big White Pot* vase (1998; shown in fig. 278 with the *Red/White* vase), she sought to capture the imperfection of older ceramics and to make a hard material more soft and human.[199] This process is carried even further in the *Princess* vase (2000; fig. 279).[200] Here, Jongerius has used a Ming vase form but has drilled holes in the wall of the vessel to form a flower pattern. Red polyurethane, which has been poured into the interior, bleeds out of the holes, highlighting the decoration.[201] The *Groove and Long Neck* bottles (2000; fig. 280), with their glass tops and ceramic bottoms held together by plastic tape, are an equally compelling design. Jongerius wanted to create a new family of forms, since both glass and ceramics are made from sand, water, and heat.[202] In both the *Princess* vase and the *Groove and Long Neck* bottles, Jongerius was taking her first steps toward using decoration— whether floral patterns or typography—as an integral part of her work. Thus in less than a decade, Jongerius had conceptually redefined the field of ceramics in Europe.

Jongerius's influence was immediate and profound, especially on a second generation of designers. For his *Painting a Fresco with Giotto #3* vase (2005; figs. 255, 281), Fernando Brízio used a traditional archetypal vase form. Recalling

277 ↑
Hella Jongerius
Dutch (b. 1963)
Soft Urn Vase, 1993
Polyurethane
Mfr: Droog Design
9.5 × 8 in. (24.1 × 20.3 cm)
(height × diameter)

In many respects, Jongerius's
innovative designs have turned
the field of European ceramics
on its head. The *Soft Urn* vase
was one of her first efforts:
a traditional ceramic form
reinterpreted in polyurethane.

278 →
Hella Jongerius
Dutch (b. 1963)
Red/White Vase (left), 1998;
Big White Pot Vase, 1998
Porcelain
Mfr: Royal Tichelaar Makkum
Red/White: 16⅛ × 6⅜ in.
(41 × 16 cm) (height × diameter)
Big White Pot: 13¾ × 11⅞ in.
(35 × 30 cm) (height × diameter)

The *Big White Pot* vase
illustrates two important
developments in Jongerius's
work: the principle that
concept is more important
than function and the quest
to create a new ideal of form
(and beauty) in her vessels.

Jongerius's *Princess* vase (fig. 279), Brízio achieved a colorful decorative pattern by inserting felt-tip pens into the ceramic wall of the vessel. Ineke Hans also sought to create archetypal forms, but in a manner slightly different from that of Jongerius. In her *Black Gold Modular Porcelain* series (2002; fig. 282), she designed elemental forms using a modular set of five shapes to generate a variety of tableware pieces. She also used the imperfections from the firing as a conscious part of the aesthetic, creating a monumental but unsettling ceramic series.

Design as art

In the 1990s, a number of other European designers were also producing work antithetical to Modernism, but which shared certain similarities with the work of the Conceptualists. These figures tended to be sculptors or painters by training but chose to work as designers. They wanted their objects to be used and to be a part of everyday life;[203] or, as Robert Wettstein has noted: "design could have an artistic dimension with a more vital link to life."[204] These designers were often strongly influenced by American fine arts movements, such as the Minimal and Conceptual art of the 1970s, or by related intellectual movements in Europe.[205] Thus they were creating forms that were more works of art, ones that were handcrafted and made in limited editions. Like the Conceptualists, they were interested in creating archetypal or elemental forms; and, in many respects, these designers can be regarded as an important link to the Neo-Dada/Surreal design movement (see pp. 206–25).

279 ←
Hella Jongerius
Dutch (b. 1963)
Princess Vase, 2000
Porcelain and silicone
Mfr: Jongeriuslab
13 × 9⅞ in. (33 × 25 cm)
(height × diameter)

The *Princess* vase is an
important transitional design
in Jongerius's work. Here, she
is no longer making functional
wares and is beginning to
experiment with pattern and
color in her ceramics.

280 ↙
Hella Jongerius
Dutch (b. 1963)
Groove and Long Neck
Bottle, 2000
Porcelain, glass, and tape
Mfr: Jongeriuslab
Largest: 19⅜ × 5⅛ in.
(49 × 13 cm) (height × width)

With their plastic-tape bands,
the bottles of the *Groove and
Long Neck* series possess a
wonderfully Dutch, sly sense
of humor. At the same time,
however, Jongerius is pushing
the envelope in her use of bold
colors, typography, and a
combination of glass and
ceramics.

281 →
Fernando Brízio
Portuguese, born Angola
(b. 1968)
Painting a Fresco with Giotto #3
Vase, 2005
Faience and felt-tip pens
Mfr: Fernando Brízio
13¾ × 13 in. (35 × 33 cm)
(height × diameter)

282 ↘
Ineke Hans
Dutch (b. 1966)
Black Gold Modular Porcelain
Tulip Vase, 2002
Porcelain
Mfr: EKWC (European Ceramic
Workcentre)
7⅞ × 15¾ in. (20 × 40 cm)
(height × diameter)

Jongerius's work had a
liberating effect on the field of
European ceramics in a variety
of ways. Brízio's *Painting a
Fresco with Giotto #3* vase is a
witty use of felt-tip pens: they
serve not only as strong visual
elements in the design but also
as a means of imparting color
to the ceramic vase. Hans's
Black Gold Modular Porcelain
series, on the other hand, is a
much more serious study of
archetypal porcelain forms.

Three chair designs show the richness of the design-as-art approach in different parts of Europe. François Bauchet's *ABS 1* chair (1993; fig. 284) is an elemental form made of resin but softened with subtle curves in the legs and back. Rolf Sachs's *3 Equal Parts* chair (1995; fig. 283) is almost Judd-like in its use of three L-shaped wooden elements that can be arranged in different sculptural configurations. Wettstein's *Tristan* chaise longue (1991; fig. 285) consists of slightly eccentric geometric compositions made of multiple layers of paper glued to a wooden frame. Wettstein cherishes the imperfect look of a natural material, and his nominally functional designs achieve a sensuous texture and luminosity similar to that of a precious stone.[206]

Other designs by Pierre Charpin and Hutten are almost totemic in their scale and power. Charpin's *Tavolino da Salotto* table (1998; fig. 286) is, at first glance, a serene geometric composition. His work, however, often features two diametrically opposed forces. On the one hand, Charpin is trying to reduce a concept to the absolute minimum. On the other, not unlike Sottsass, he seeks to impart to his abstract forms a keen sense of life, whereby the meaning of the object is derived from each user's interaction with the design. Hutten's *The Cross* bench seat (1994; fig. 287) is characteristic of his

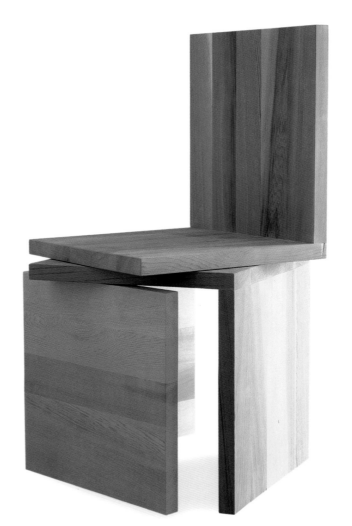

Parallel in time and approach to the Conceptualists, a number of European artists also thought of themselves as designers. Three somewhat nominal chair forms by Sachs, Bauchet, and Wettstein illustrate the richness of this unconventional design approach, in terms of form, material, and construction.

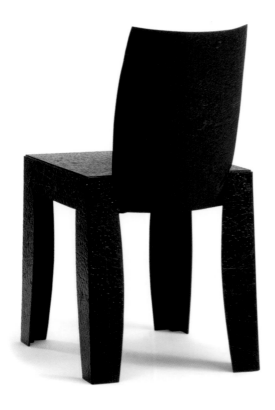

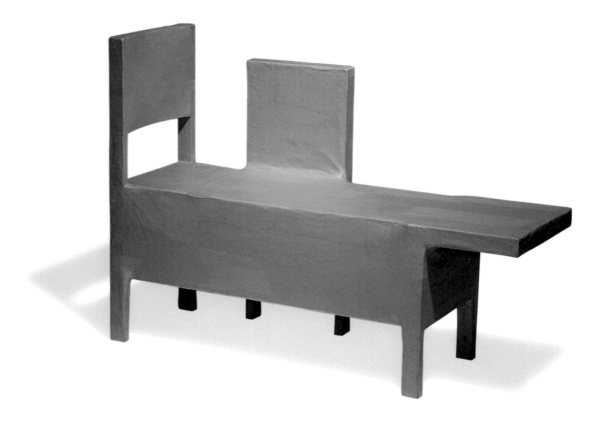

early work for Droog Design, which was more purely conceptual than such later designs as the *Bronto* chair (1997; fig. 275). The piece was designed for the *Abitare il Tempo* fair in Verona at a moment in time when the Italian fascists were enjoying a political resurgence. The iconography is rapier-like in its message: "The cross-shape," notes Hutten, "was inspired by Catholism [*sic*] in Italy, a breeding ground of corruption, fascism and misuse of power."[207] In short, such designs are no longer simply functional objects but also powerful commentaries on the state of European culture.

In the 1990s, the Conceptual design movement proved to be a mighty bulwark against such pervasive Modernist modes as Geometric Minimal design. It would also open the door to a small but influential group of Neo-Dada/Surreal designers scattered across various European countries.[208] But with the advent of a new century, many of the leaders of the Conceptual movement would evolve and would look back from a new perspective at the Decorative design of the late 1980s, in time coalescing into a Neo-Decorative design movement. Thus the remarkable creativity of European design since the mid-1980s makes for a complex (and often untidy) story of action and reaction.

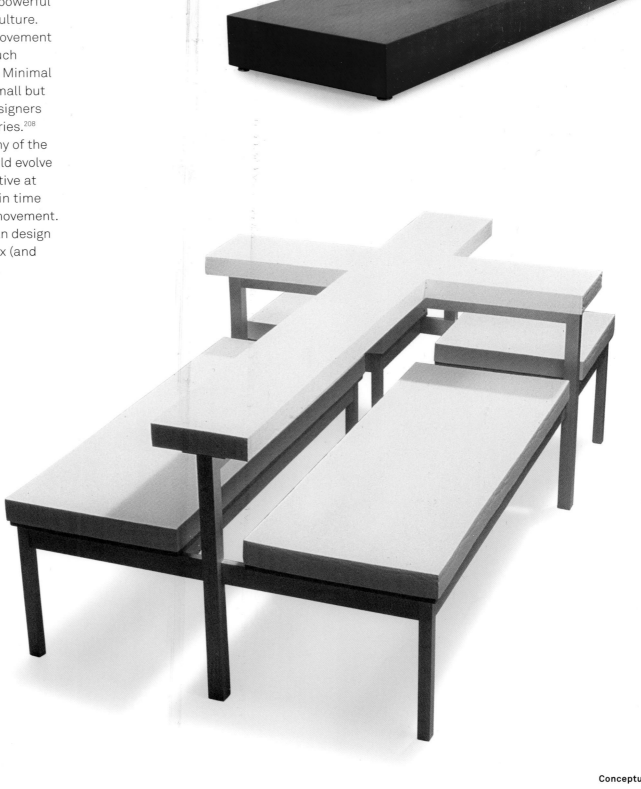

286 ↗
Pierre Charpin
French (b. 1962)
Tavolino da Salotto Table, 1998
Lacquered maplewood
Mfr: Post Design
15¾ × 43⅜ × 14¼ in.
(40 × 110 × 36 cm)

287 →
Richard Hutten
Dutch (b. 1967)
The Cross Bench Seat, 1994
Maple and polyurethane
Mfr: Droog Design
29½ × 47⅛ × 78⅞ in.
(75 × 120 × 200 cm)

A "design as art" approach may also be seen in the work of Charpin and Hutten. Their pieces are often treated as *ensembles*, through which the designers are exploring complex layered meanings. The scale, however, can vary dramatically, from the diminutive, as in Charpin's red lacquered table, to the monumental, as illustrated in Hutten's *The Cross* bench seat.

Neo-Dada/Surreal Design

Concept

In reaction to a powerful Modernist resurgence in the late twentieth century, this movement sought to revive intuitive and Dada/Surreal traditions by conceiving of design as art rather than the creation of purely functional objects. It is a mode very much in opposition to Modernist industrial design, and one that is more often aligned with developments in contemporary art rather than design itself. Designers consciously blur the boundaries between design, craft, and art—often treating objects more as metaphors. Indeed, there are strong parallels with the Conceptualist movement, although Neo-Dada/Surreal designers characteristically take a more intuitive—rather than rationalist—approach to design. The movement began with only a few practitioners among the first generation, but its influence and numbers grew significantly with the maturation of a younger generation.

There are three subcategories within the Neo-Dada/ Surreal movement: designers concerned with anthropomorphic or zoomorphic forms; designers concerned with found objects; and designers concerned with ordinary forms used in unorthodox ways.

Style

There is no one stylistic approach that characterizes this movement, as the concept underlying an object is more important than its form. Designers may approach their work from a number of perspectives: altering found objects, playing with ambiguous and unorthodox forms, or creating seemingly random, irrational assemblages. Objects tend to be restricted to one-offs or limited-edition series; and the construction processes used, as well as the materials employed, are quite often unconventional. Thus many Neo-Dada/Surreal objects have an unsettling or eerie quality about them, not to mention a sense of humor or wry irony.

Time and Place

This unorthodox design movement attracted increasing attention in the late 1990s and early 2000s. It has been particularly influential among Spanish designers, whether working in their home country or abroad.

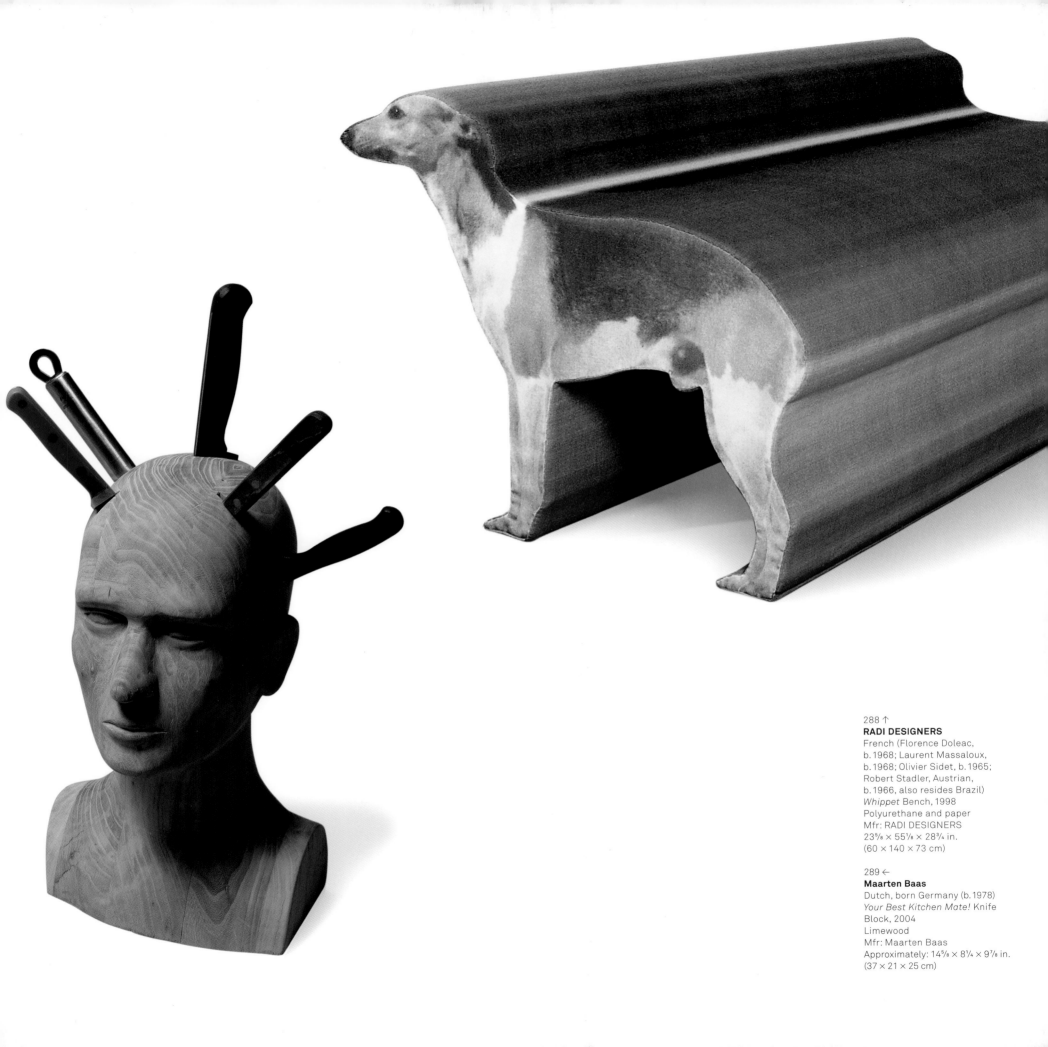

288 ↑
RADI DESIGNERS
French (Florence Doleac,
b. 1968; Laurent Massaloux,
b. 1968; Olivier Sidet, b. 1965;
Robert Stadler, Austrian,
b. 1966, also resides Brazil)
Whippet Bench, 1998
Polyurethane and paper
Mfr: RADI DESIGNERS
23⅝ × 55⅛ × 28¾ in.
(60 × 140 × 73 cm)

289 ←
Maarten Baas
Dutch, born Germany (b. 1978)
Your Best Kitchen Mate! Knife
Block, 2004
Limewood
Mfr: Maarten Baas
Approximately: 14⅝ × 8¼ × 9⅞ in.
(37 × 21 × 25 cm)

290
Cathrine Maske
Norwegian (b. 1966)
Portrett Gjennom Linse
Sculpture, 1997
Glass and silk-print photograph
Mfr: Magnor Glassverk A/S
6¾ × 6¾ in. (17 × 17 cm)
(height × width)

Dada and Surrealism are usually thought of as fine arts movements that flourished between the world wars. It is only recently that they have also been recognized as significant historical design modes of the twentieth century.[209] The once-clear theoretical and aesthetic distinctions between these two movements, however, became somewhat blurred with the Neo-Dada/Surreal resurgence that developed half a century later, hence the use of the term "neo" to describe this revival.

As noted earlier, there are unmistakable ties between the Neo-Dada/Surreal and the Conceptual design movements; but there are also important differences. Neo-Dada/Surreal designers are much more intuitive—rather than rationalist—in their design approach. They think of their designs as works of art or metaphors, as opposed to functional objects. They are more closely aligned with developments in the fine arts than with those in the design arts. Their pieces often display a sense of humor or wry irony, and there can also be an eerie or unsettling quality about the work. Indeed, many of these designers often create limited-edition pieces using unconventional materials and methods of construction.

As with Conceptual design, there is no one stylistic approach within the Neo-Dada/Surreal movement, because concept is more important than form. One may point, loosely speaking, to three aspects of this mode, which has rather amorphous boundaries: designers who are concerned with creating anthropomorphic or zoomorphic forms; designers concerned with altering found objects; and designers concerned with using ordinary forms in ambiguous or unorthodox ways. The movement began in the 1980s in a somewhat tentative manner, with a first generation of designers that included Philippe Starck and Denis Santachiara; but it expanded considerably in the 1990s, especially with the appearance of a younger generation. The various permutations of this Neo-Dada/Surreal mode are thus perhaps most evident if one looks at the work by generation.

First generation
Anthropomorphic or zoomorphic forms
One must begin with Starck, a protean designer whose work cannot be put into neat stylistic categories. This conundrum can be viewed from a number of perspectives. In the most positive sense, it can be seen as a demonstration of Starck's remarkable creativity, of his restless mind constantly exploring different avenues of design. On the other hand, it may also be seen as further evidence of Starck's uncanny ability to sense the latest and most subtle shifts in fashion and of his facile agility in embracing these trends in his work, as noted earlier. Whatever the case, his Neo-Dada/Surreal works are among his most important designs;[210] in many respects, they are unique in relation to the work of his contemporaries. Starck uses sexually charged, anthropomorphic shapes that are often variable in form; and his work is generally industrially made, rather than being handmade or limited editions.

Four Starck designs are indicative of his Neo-Dada/Surreal mode. The *Lola Mundo* chair/table (1986; fig. 291) is one of his most enticing early pieces. When closed, it is almost a Postmodernist design, with its prominent cabriole legs. When

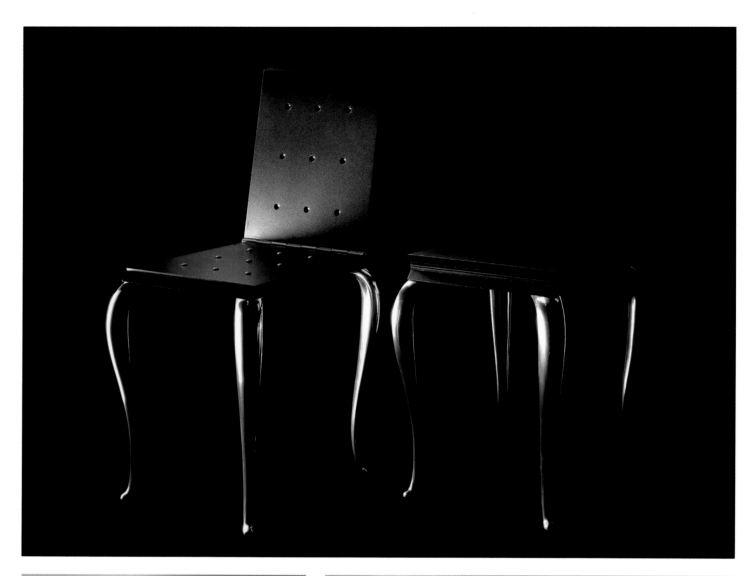

291 →
Philippe Starck
French (b. 1949)
Lola Mundo Chair/Table, 1986
Wood, aluminum, and rubber
Mfr: Driade S.p.A.
48½ × 35 × 47 in.
(123.1 × 88.9 × 119.3 cm)

In the 1980s, a number of
designers began to include
Neo-Dada/Surreal aspects
in their work, Starck being
among the most notable.
Lola Mundo is one his most
quixotic designs: it can be
seen as either a conventional
end table or a most sensuous,
if disconcerting, side chair.

292 ↘
Philippe Starck
French (b. 1949)
Luci Fair Light, 1989
Glass
Mfr: FLOS S.p.A.
6 × 5½ × 15 in.
(15.2 × 13.9 × 38 cm)

Lighting is yet another field
in which Starck has left his
unmistakable mark. Unlike
Modernist designers, who
are concerned with function,
materials, or technology,
Starck sees lighting as a
means of expressing ideas
and metaphors, none more
sexually charged than those
conveyed by the *Luci Fair*
wall sconce.

293 ↘↘
Philippe Starck
French (b. 1949)
Four Curiosities Against a Wall
Table/Vase, 1988
Glass
Mfr: Daum
23¼ × 19⅜ × 19¾ in.
(59.8 × 49.8 × 50.4 cm)

opened, it becomes a rather unnerving chair, with nine pink "nipples" on the seat. The *Luci Fair* light (1989; fig. 292) is equally unsettling. In this period, Starck began to develop a series of *leitmotifs* that he would use in various manners and materials. For *Luci Fair*, he uses a "horn" or slightly phallic shape for a wall sconce; when grouped in random clusters, the lights impart a Surreal aspect to a space. This design also marked a new direction for FLOS as a lighting company. The *Luci Fair* is innovative not because of any technological breakthrough; rather, Starck's work is about expressing potent ideas or sensations.[211] The *W.W.* stool (1990; fig. 294) is one of Starck's most quixotic pieces, a highly sculptural design that is enticing in its overt sensuality and yet a little unnerving in its unorthodox form. How exactly does one use it? This ambiguity may also be seen in Starck's *Four Curiosities Against a Wall* table/vase (1988; fig. 293). Here, Starck juxtaposes "amoebas"—another motif—of clear or colored glass against planes of clear glass. When the piece is turned on its side, the shapes magically hover in the air; when it is turned vertically, they become more like the conventional legs of a small table. The "hollow vase" amoebas can also be used as receptacles for flowers, which adds a subtle sexual undercurrent.

294
Philippe Starck
French (b. 1949)
W.W. Stool, 1990
Lacquered aluminum
Mfr: Vitra AG
38 × 22 × 21 in.
(96.5 × 55.8 × 53.34 cm)

Starck's interest in highly charged anthropomorphic forms is perhaps most vividly illustrated by two designs: the iconic *W.W.* stool for Vitra and the unsettling *Four Curiosities Against a Wall* table/vase for Daum (fig. 293).

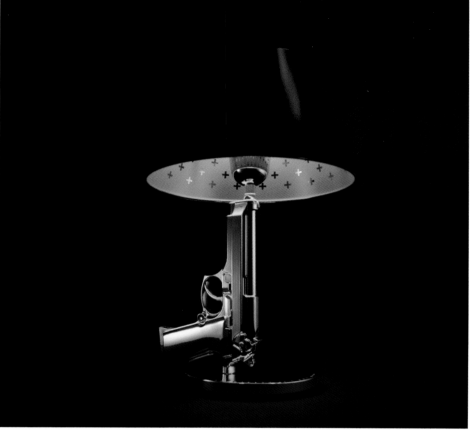

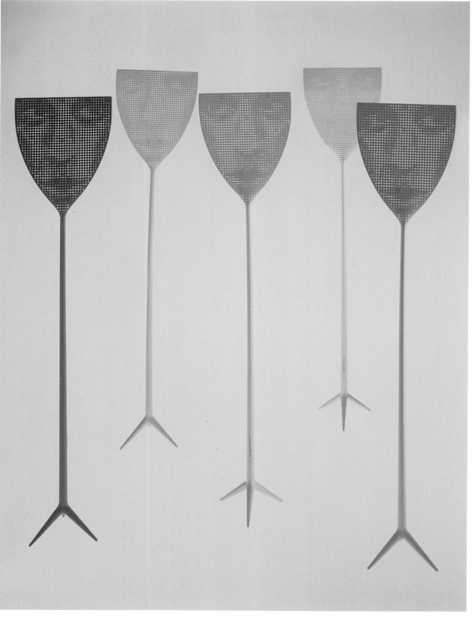

295 ↖ ↖
Philippe Starck
French (b. 1949)
Les Ministres Centerpiece, 1996
Resin and steel
Mfr: Alessi S.p.A.
5½ × 11½ in. (13.9 × 29.2 cm)
(height × diameter)

296 ←
Philippe Starck
French (b. 1949)
Dr. Skud Flyswatter, 1998
Plastic
Mfr: Alessi S.p.A.
17½ in. (44.4 cm) (length)

Starck's fascination with a
Neo-Dada/Surreal aesthetic
may also be seen in his later
work, especially in his pieces
for Alessi, a company for which
he has produced some of his
best tableware designs. In *Les
Ministres* and *Dr. Skud*, Starck,
with characteristic élan,
has transformed utilitarian
products into objects of
delight and ambiguity.

297 ↑
Philippe Starck
French (b. 1949)
Bedside Gun Lamp, 2005
Gold-plated Beretta pistol and
paper
Mfr: FLOS S.p.A.
16⅝ × 6⅜ in. (42.6 × 16 cm)
(height × diameter)

While Starck's *Bedside Gun*
lamp possesses a certain wit
and sumptuousness, it is also
a powerful comment on the
rampant violence in the global
culture of the early 2000s.

298 →
Denis Santachiara
Italian (b. 1950)
Lumiere Sofa, 1989
Aluminum and fabric
Mfr: Zerodisegno –
Quattrocchio S.r.l.
39 × 59 × 28 in.
(99 × 149.8 × 71.1 cm)

Like Starck, Santachiara was
one of the first designers of his
generation to take an interest in
a Neo-Dada/Surreal aesthetic,
as can readily be seen in many
of his designs from the last
two decades. The *Lumiere* sofa
is an early example of his work,
an unconventional form of
aluminum brought to life by a
quivering red "tongue" in its base.

Starck's more recent work also has a Surrealist aspect to it. The tripartite base of the *Les Ministres* centerpiece (1996; fig. 295) features squid-like forms that hold aloft a shimmering metal dish. The *Dr. Skud* flyswatter (1998; fig. 296) is Starck at his best: an inexpensive, mass-produced object that is beguiling in its brilliant simplicity. An attenuated base and handle support an open mesh element on which a Mona Lisa-like face glimmers or evaporates into thin air, depending on one's viewpoint. Only Starck would think to transform such a mundane object into something so magical. The *Bedside Gun* lamp (2005; fig. 297) is a more serious comment on the violence in our post-9/11 culture, tempered by a French *savoir faire*. Starck—literally "gilding the lily"—has used a gold-plated Beretta pistol for the shaft of the lamp, the base of which has been inscribed with the words "Happiness is a Hot Gun."[212]

Other European artists were also fascinated with this Neo-Dada/Surreal approach to design. Their work, though, is quite different from that of Starck. Denis Santachiara, for example, has been creating a distinctive body of work for almost two decades. His pieces often feature moving or inflatable parts, for he is fascinated by motion; he also incorporates light in his objects. Santachiara is interested in exploring technology, not in a high-tech manner but for "poetic-tech" effects.[213] His *Lumiere* sofa (1989; fig. 298) is representative of this unconventional design approach. The frame is a simple sheet of bent aluminum; but the design is animated by a moving and illuminated "red tongue" in its base, which laps at the sitter.[214] Robert Wettstein is another artist whose work cannot be put into neat categories. His *Mrs. Herz* clothes stand (1986; fig. 299) features a leather-upholstered upper torso suspended in a highly stylized anthropomorphic iron armature, a sensual but haunting design.

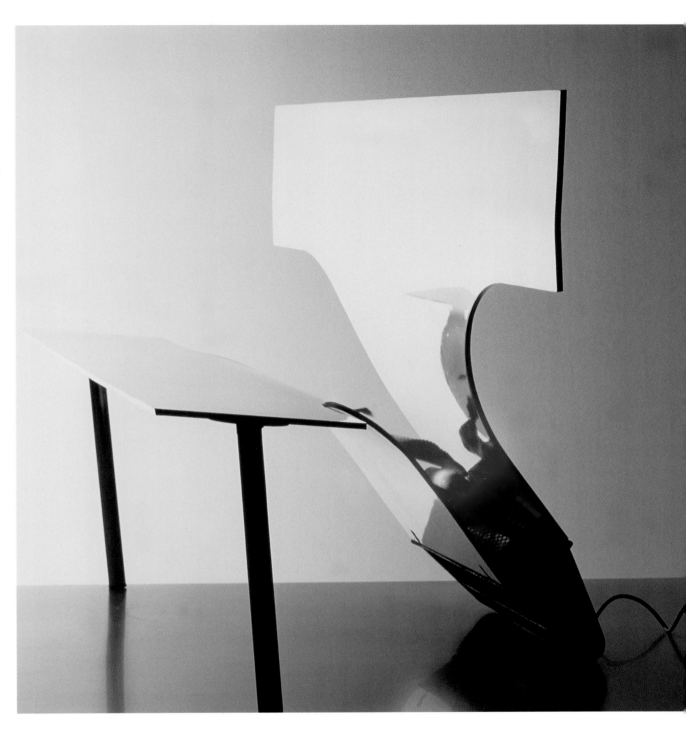

The work of this first generation of Neo-Dada/ Surreal designers continues up to the present; and lighting, in particular, has proved to be an important medium for the creation of handmade sculptural forms rather than functional fixtures. No photograph can capture the magic of Santachiara's *Cirro* hanging lamp (2002; fig. 300), a billowy cloud with flickering lights within, which imparts a Magritte-like quality to a space. In a similar manner, Nora De Rudder's work is not about creating technologically innovative lighting systems but rather about designing evocative sculptures that capture the humor, sensuality, and joy of life. De Rudder readily acknowledges that her Surreal designs are inspired by Dalí, Magritte, and even Maurer.[215] The *Wings* floor lamp (1994; fig. 302) is a quiet and ethereal early design that juxtaposes a metal base covered in papier mâché with a white goose wing, a symbol of freedom for De Rudder.[216] With *The Big Heart* hanging lamp (2002; fig. 301), a more robust and highly sensual design, De Rudder has created an iconic form out of swirls of iridescent fabric that glow and shimmer from the interior lights. Though perhaps small in size, the œuvre of this first generation of Neo- Dada/Surreal designers laid a solid foundation; in the last decade, younger designers have expanded upon this foundation with remarkable alacrity.

Second generation

The second generation of Neo-Dada/Surreal designers is quite international in scope and has embraced the aesthetic from a broader perspective. Consequently, their work involves the use of anthropomorphic or zoomorphic forms; the reinterpretation of found objects; and the treatment of ordinary forms in unorthodox ways. The last two aspects of their work reveal, in particular, the strong connections between the Conceptual and the Neo-Dada/Surreal design

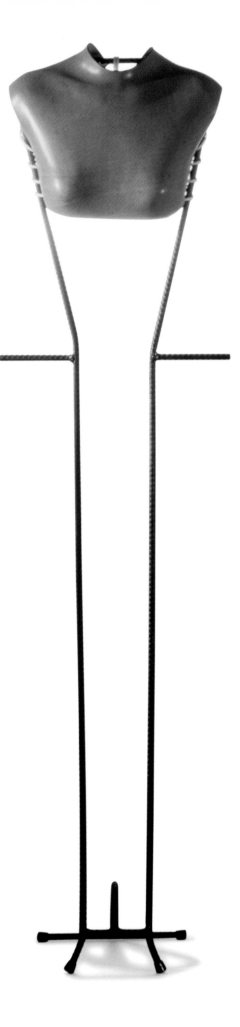

299 ←
Robert Wettstein
Swiss (b. 1960)
Mrs. Herz Clothes Stand, 1986
Iron and leather
Mfr: Anthologie Quartett
63 × 15¾ × 13¾ in.
(160 × 40 × 35 cm)

As in Scandinavia, the Modernist movement remained an influential force in Swiss design throughout much of the twentieth century. Wettstein's œuvre is a notable exception, being quite antithetical to this tradition. The evocative *Mrs. Herz* clothes stand is an apt example of his alternative design approach.

300 →
Denis Santachiara
Italian (b. 1950)
Cirro Hanging Light, 2002
Dacron
Mfr: Duepuntosette – Erreti S.r.l.
27⅝ × 39⅜ in. (70 × 100 cm)
(height × diameter)

301 ↘
Nora De Rudder
Belgian (b. 1958)
The Big Heart Hanging Light, 2002
Gold-threaded fabric
Mfr: Nora De Rudder
26¾ × 26 × 7⅞ in.
(68 × 66 × 20 cm)

302 → →
Nora De Rudder
Belgian (b. 1958)
Wings Floor Lamp, 1994
Feathers, copper, and papier mâché
Mfr: Nora De Rudder
70⅞ × 13¾ in. (180 × 35 cm)
(height × diameter)

Lighting has proved to be an important medium for Neo-Dada/Surreal designers, as can be seen in the work of Santachiara and De Rudder. These artists take such quixotic forms as a cloud, a wing, or a heart and transform them into ethereal lighting fixtures, which lend a haunting quality to interiors.

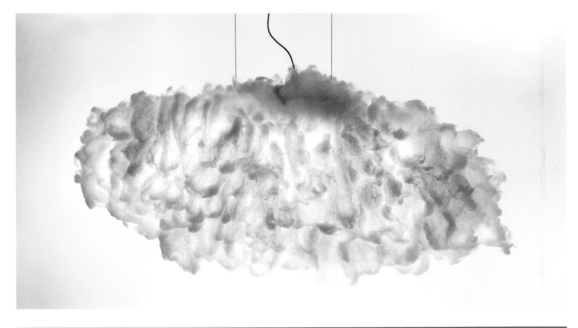

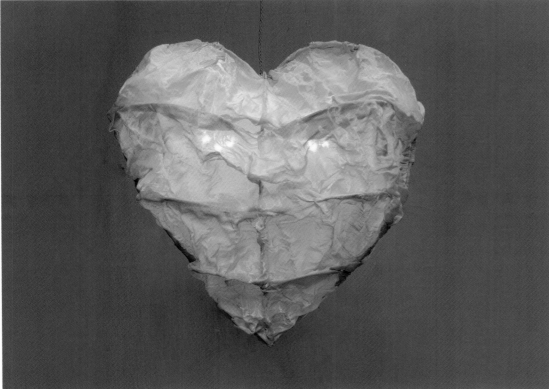

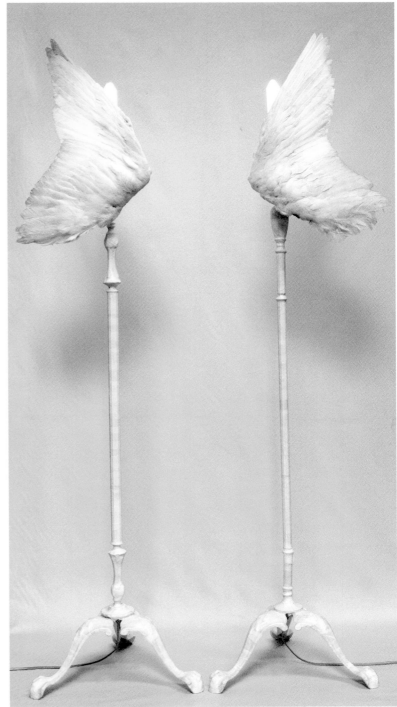

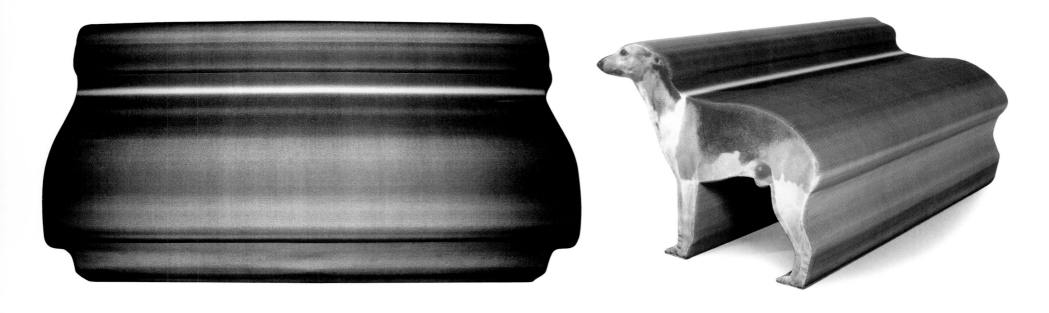

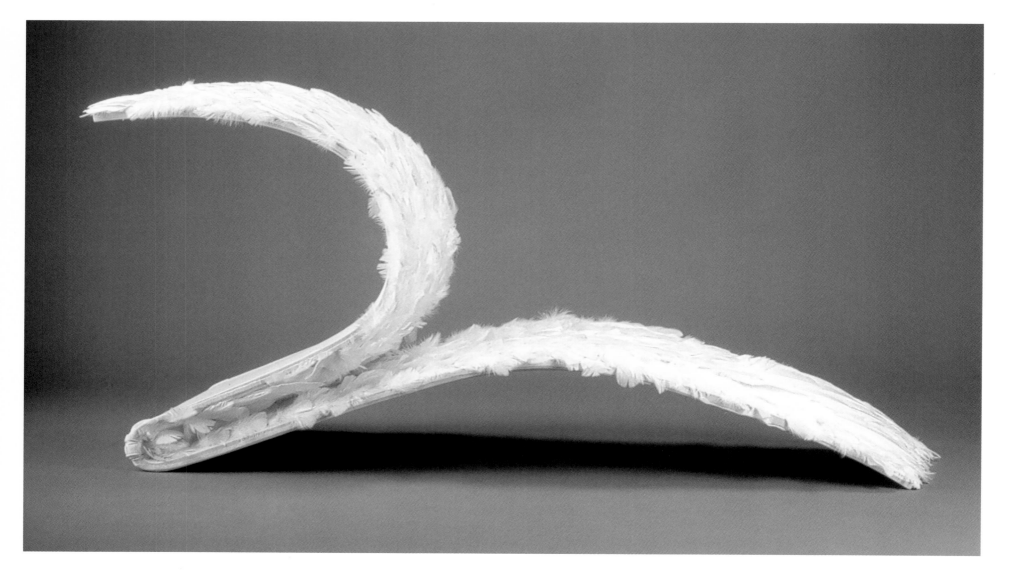

303 ←
RADI DESIGNERS
French (Florence Doleac,
b. 1968; Laurent Massaloux,
b. 1968; Olivier Sidet, b. 1965;
Robert Stadler, Austrian,
b. 1966, also resides Brazil)
Whippet Bench, 1998
Polyurethane and paper
Mfr: RADI DESIGNERS
23⅝ × 55⅛ × 28¾ in.
(60 × 140 × 73 cm)

The Neo-Dada/Surreal
aesthetic has had a strong
impact on a small but talented
group of second-generation
designers. Perhaps one of
the most well-known advocates
of this movement in France
is RADI DESIGNERS. Its
perplexing *Whippet* bench
is a quintessential Surreal
design of this period.

304 ↙
Dögg Gudmundsdóttir
Icelandic (b. 1970), resides
Denmark
Wing: Feather Lounge Chair, 1998
Feathers and plywood
Mfr: Dögg Design
23¼ × 48½ × 18½ in.
(59 × 123 × 47 cm)

Gudmundsdóttir's *Wing: Feather*
chair is a good illustration of
how readily a simple form can
be radically transformed
through the use of an unusual
material—in this case, billowing
white feathers.

305 →
El Último Grito
British, also based in Germany
(Roberto Feo, b. 1964; Rosario
Hurtado, Spanish, b. 1966)
Mico Chair/Playtoy, 2004
Polyethylene
Mfr: Magis S.p.A.
15¾ × 26⅜ in. (40 × 67 cm)
(height × width)

The *Mico* chair/playtoy is
a rare exception in the Neo-
Dada/Surreal movement: a
design that has actually been
mass-produced, in this case in
polyethylene. The truncated,
torso-like form—a colorful and
sculptural object for children (or
childlike adults)—can be used
in a variety of playful positions.

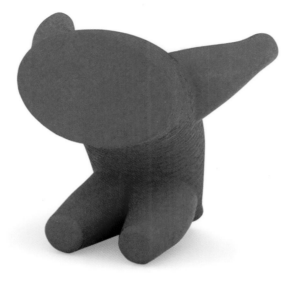

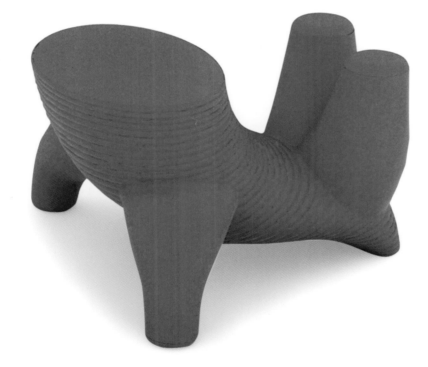

movements. The latter movement's younger
designers, however, are not bound by any hard-
and-fast rules and move freely within their
respective disciplines.

A number of this second generation have
begun to establish significant reputations for
themselves. The French group RADI DESIGNERS
initially made its name creating highly Surreal
designs in which forms or images were distorted
to produce a commentary or message.[217] The Dutch
designer Maarten Baas has a more intuitive
approach to design: he just does it.[218] Baas has
created a readily identifiable style by altering
found objects through the use of burning and by
creating idiosyncratic assemblages. It is, however,
in Spain where the Neo-Dada/Surreal design
approach has been most openly embraced. A host
of Spanish designers and groups—including El
Último Grito, Emiliana Design, Martí Guixé, and
Héctor Serrano—now work across Europe.

Anthropomorphic or zoomorphic forms
Like the first generation before them, a number
of the Neo-Dada/Surreal movement's younger
designers are fascinated by anthropomorphic or
zoomorphic forms. Their designs may be handcrafted
or may employ industrial techniques and materials;
they also often feature unorthodox surface effects.

RADI's *Whippet* bench (1998; figs. 288, 303) is
one of the iconic designs by this second generation.
There are many layers of meaning here. In terms of
form, it is a play on image and volume—consciously
blurring the lines between a graphic design and a
three-dimensional shape.[219] The design also alludes
to the use of figuration or animal forms in the history
of furniture, though it does so in a tongue-in-cheek
or Surreal manner. For RADI, a dog is man's best
friend; and yet one is forced to sit on the dog's back.[220]
It is, in short, a highly cerebral and pithy design.

Dögg Gudmundsdóttir's *Wing: Feather* lounge chair (1998; fig. 304) is equally unconventional in its use of wing forms and feathers, not unlike some of De Rudder's work (fig. 302). In *Wing: Feather*, a molded plywood shell has been covered in a quivering white surface, creating a sensuous chaise that might take flight at any moment.

El Último Grito's *Mico* chair/playtoy (2004; fig. 305; see fig. 29 for a variation) is a reversible industrial design made of polyethylene.[221] Many of the studio's Surreal designs possess a keen sense of humor and a childlike quality. While its pieces are meant to tell stories and make one think about life, they also pose the question of what is the true meaning of design.[222]

The glass designs of Cathrine Maske fall into two categories. Some of her pieces—carafes and tumblers, for example—are functional wares; but even here her approach is more that of an artist than an industrial designer, such as Alfredo Häberli (fig. 168). In these designs, Maske is playing with the color, thickness, and visual illusions of glass.[223] It is her decorative pieces, however, that perhaps constitute her most original work. For an extraordinary series of vases, Maske inserted photographs of insects, humans, or fruit between layers of glass.[224] In the *Libella* vase (2003; fig. 306), there is a powerful symbolism of the beautiful and the grotesque: the glass is meant to be elegant, while the insects introduce an element of the macabre. Maske also likes to play with the contrasts between the fragility of an insect and the solidity of glass.[225]

There is nothing subtle about Maarten Baas's *Your Best Kitchen Mate!* knife block (2004; figs. 289, 307), a rather atypical piece for this young designer. Carved from a block of wood, the design—featuring

306 ↙
Cathrine Maske
Norwegian (b. 1966)
Libella Vase, 2003
Glass and silk-print photograph
Mfr: Klart A/S
8¾ × 4¾ in. (22 × 12 cm)
(height × diameter)

307 ↓
Maarten Baas
Dutch, born Germany (b. 1978)
Your Best Kitchen Mate! Knife Block, 2004
Limewood
Mfr: Maarten Baas
Approximately: 14⅝ × 8¼ × 9⅞ in. (37 × 21 × 25 cm)

Maske and Baas are two designers whose work often pushes the envelope, especially their anthropomorphic pieces, which evoke the sublime or the macabre. The *Libella* vase and the *Your Best Kitchen Mate!* knife block, for example, are shocking but also captivating on a multitude of levels.

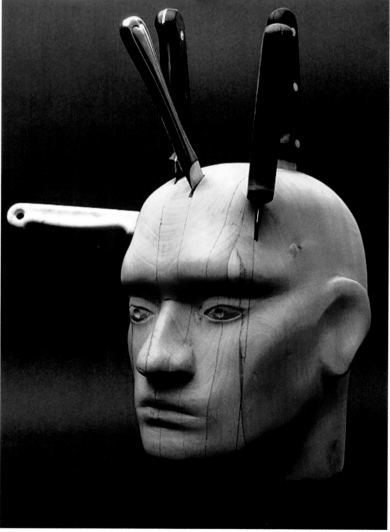

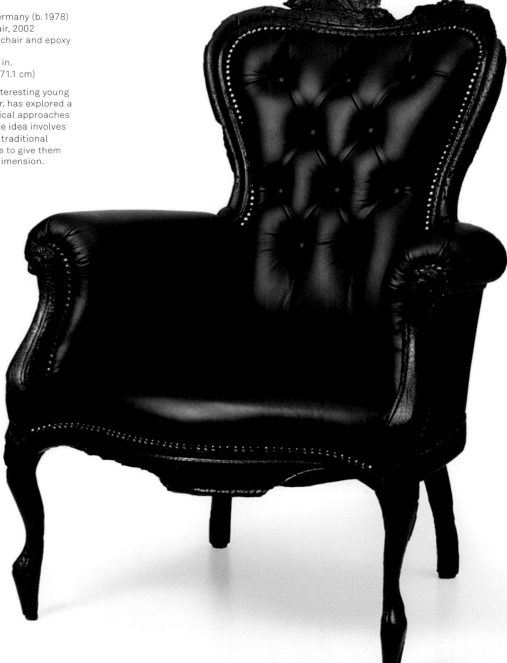

308
Maarten Baas
Dutch, born Germany (b. 1978)
Smoke Armchair, 2002
Burnt existing chair and epoxy
Mfr: Moooi
41⅜ × 28 × 28 in.
(104.9 × 71.1 × 71.1 cm)

Baas, a very interesting young
Dutch designer, has explored a
number of radical approaches
in his work. One idea involves
the burning of traditional
furniture forms to give them
a totally new dimension.

a human head into which multiple knives have been stuck—is gut-wrenching in its raw power.

Found objects
Baas is, in fact, one of a group of designers who are concerned with transforming found objects in unorthodox, Surreal manners. Among his best-known designs is a furniture series in which the existing forms have been burned, as illustrated by the *Smoke* armchair (2002; fig. 308). There are two important issues involved in creating such remarkable black objects: the technique and the form. For Baas, burning is the most extreme form of altering an object; but he also believes that burning is beautiful in that it produces a special black surface. The frames of these pieces demand a tremendous amount of hand-finishing, for a burned object requires multiple layers of epoxy resin to make the piece stable; a layer of matte lacquer is then added before the chair is upholstered in black leather.[226] The idea of using historical decorative forms—such as a Rococo Revival armchair—is equally important in this design. Baas is clearly expanding on the tradition of the Dutch Conceptual designers seen earlier, as well as Alessandro Mendini's iconic *Proust* lounge chair (1978; illustrated in fig. 16).[227] The *Hey Chair Be a Bookshelf!* assemblage (2005; fig. 309) is equally inventive. Here, Baas has created seemingly random ensembles out of existing objects and scraps of materials, the whole of which is then sprayed with a resin to give a uniform surface, not unlike that used in Jurgen Bey's *Kokon* furniture series (1997; figs. 253, 260).

John Angelo Benson's *Naked Confort* lounge chair (2003; figs. 310, 311), from his *Corrupted Classics* collection, also plays with the concept of altering an existing historical form.[228] In this case, Benson—to shock and amuse—has filled the

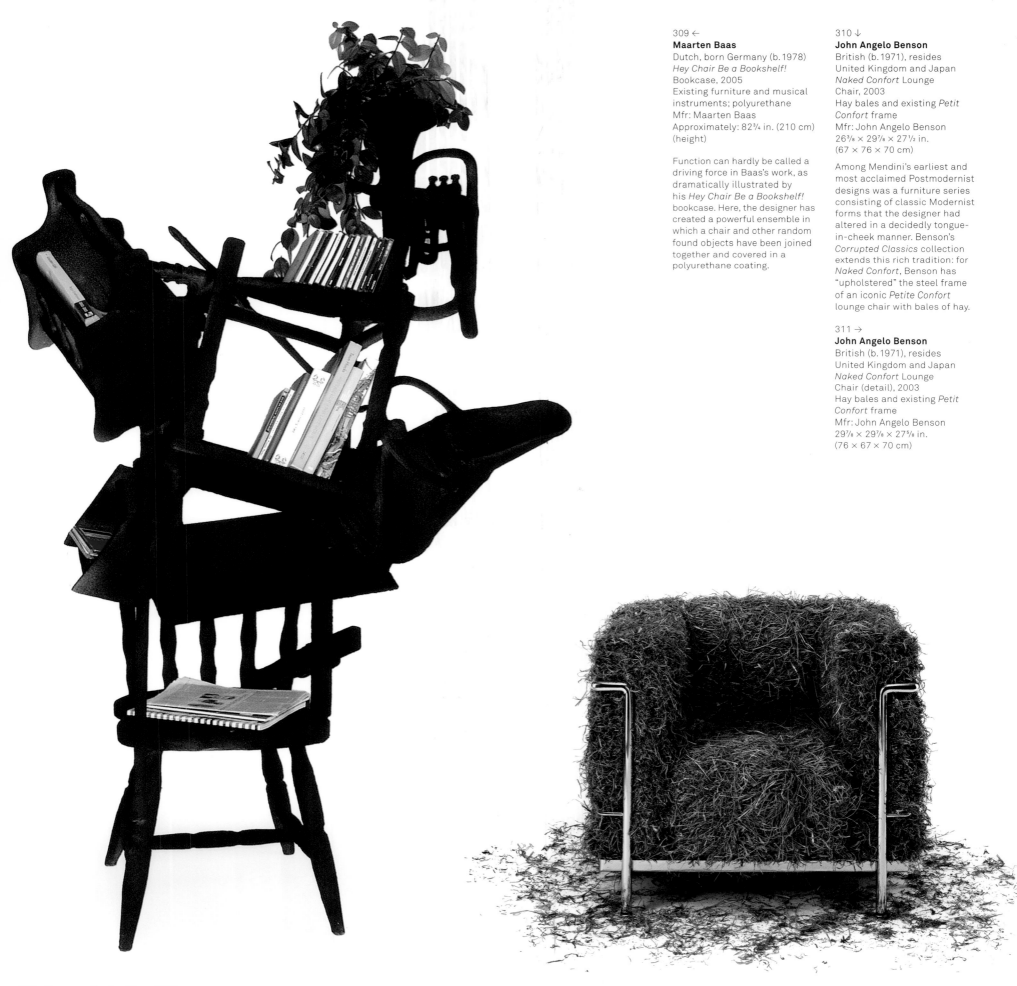

309 ←
Maarten Baas
Dutch, born Germany (b. 1978)
Hey Chair Be a Bookshelf!
Bookcase, 2005
Existing furniture and musical
instruments; polyurethane
Mfr: Maarten Baas
Approximately: 82¾ in. (210 cm)
(height)

Function can hardly be called a
driving force in Baas's work, as
dramatically illustrated by
his *Hey Chair Be a Bookshelf!*
bookcase. Here, the designer has
created a powerful ensemble in
which a chair and other random
found objects have been joined
together and covered in a
polyurethane coating.

310 ↓
John Angelo Benson
British (b. 1971), resides
United Kingdom and Japan
Naked Confort Lounge
Chair, 2003
Hay bales and existing *Petit
Confort* frame
Mfr: John Angelo Benson
26³⁄₈ × 29⁷⁄₈ × 27½ in.
(67 × 76 × 70 cm)

Among Mendini's earliest and
most acclaimed Postmodernist
designs was a furniture series
consisting of classic Modernist
forms that the designer had
altered in a decidedly tongue-
in-cheek manner. Benson's
Corrupted Classics collection
extends this rich tradition: for
Naked Confort, Benson has
"upholstered" the steel frame
of an iconic *Petite Confort*
lounge chair with bales of hay.

311 →
John Angelo Benson
British (b. 1971), resides
United Kingdom and Japan
Naked Confort Lounge
Chair (detail), 2003
Hay bales and existing *Petit
Confort* frame
Mfr: John Angelo Benson
29⁷⁄₈ × 29⁷⁄₈ × 27⁵⁄₈ in.
(76 × 67 × 70 cm)

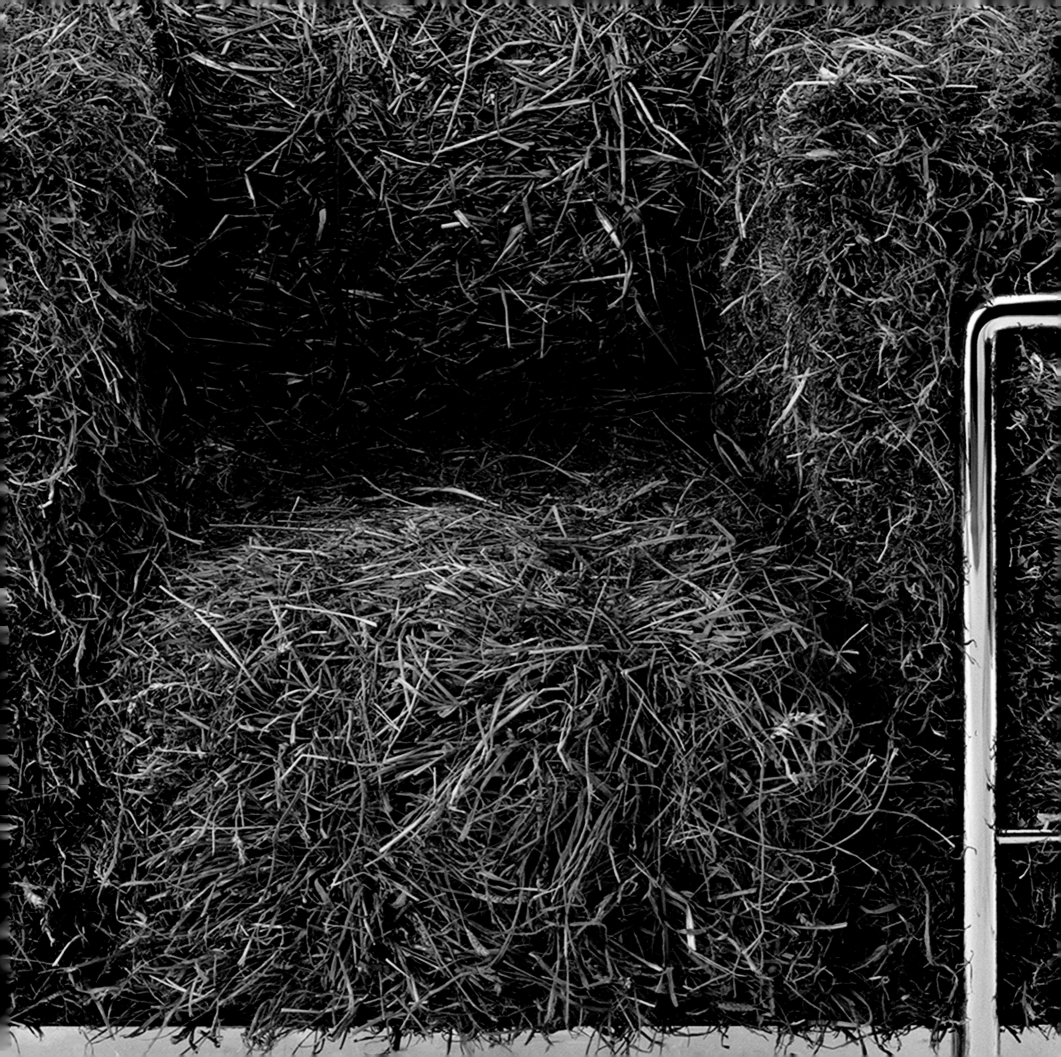

312 ↓
Martí Guixé
Spanish (b. 1964), resides
Spain and Germany
Do Frame Tape, 2000
Adhesive tape
Mfr: Droog Design
2 in. (5 cm) (width)

The Dada and Surreal legacy
has found particularly fertile
ground in Spain, and a number
of remarkably talented Spanish
designers are now working
across Europe. Guixé is one of
the more quixotic of this group.
His *Do Frame* tape is a witty
play on generic rub-on tape
and expensive traditional
gilded frames.

313 →
Martí Guixé
Spanish (b. 1964), resides
Spain and Germany
Galeria h2o Chair, 1998
Resin and existing books
Mfr: Galeria h2o
31½ × 17¾ × 7⅞ in.
(80 × 45 × 20 cm)

Galeria h2o in Barcelona has
been an influential advocate
for the Neo-Dada/Surreal
movement. It is fitting,
therefore, that Guixé has named
one of his most important—
and totally impractical—chair
designs after it, piling layer
upon layer of meaning on a
diminutive piece.

tubular steel frame of a reproduction *Confort* chair (designed by Le Corbusier, Pierre Jeanneret, and Charlotte Perriand in 1928) with bales of hay.

Ordinary forms used in unorthodox ways
Lastly, there are those Neo-Dada/Surreal designers who take ordinary or generic forms and use them in a new context. The form of such designs is often variable and interactive. It is here that one also sees the influence of a number of Spanish designers.

Martí Guixé's work is a reaction to the Modernism of the 1990s, which was so preoccupied with manufacturing objects. Following the precedent of Javier Mariscal, the majority of Guixé's work is concerned not with design *per se* but with other aspects of art that touch on design. Thus he calls himself an "ex-designer," a powerful statement in that he is seeking to break down the parameters of conventional design. Guixé's work is about ideas and intangible things—the metaphysical.[229]

Two designs by Guixé perhaps give some indication of his cerebral approach, which is laced with Dada and Surreal influences. With the *Do Frame* tape (2000; fig. 312), Guixé has taken everyday rub-on tape and transformed it with a gilded frame pattern. Thus the most mundane of objects tacked on the wall can become a "work of art."[230] Not unlike the dwarfs in Goya's paintings, the diminutive *Galeria h2o* chair (1998; fig. 313) introduces an element of the macabre to a room.[231] The legs are only a few inches high, so one must assemble stacks of books to achieve a normal seating height. There is a plethora of allusions here, from sitting on knowledge to the visual similarities to Arne Jacobsen's *Series 7 (No.3107)* side chair (1955).

Ana Mir is a partner, with Emili Padrós, in the Emiliana Design Studio. Much of her work features strong sexual, feminist, and political messages.[232] The *Rocking* chair (1993; fig. 314)

314
Ana Mir
Spanish (b. 1969)
Rocking Chair, 1993
Steel and polypropylene
Mfr: Emiliana Design Studio
25⅝ × 22⅛ × 16⅝ in.
(65 × 56 × 42 cm)

In recent years, after decades of Franco conservatism, Spain has emerged as one of the more liberal countries in Europe; and such designers as Mir have sought to establish women as equals in the field of design. Her work is replete with a feminist and social iconography, as can be seen in the provocative *Rocking* chair.

315 →
Héctor Serrano
Spanish (b.1974), resides
United Kingdom
Playboy Lamp, 2002
Acrylic and existing shirt
Mfr: Droog Design
Lamp without shirt:
8¾ × 16 × 2 in. (22 × 40.6 × 5 cm)

Serrano's *Playboy* lamp is a
reaffirmation of the idea that
less can be more—but with a
Neo-Dada/"Droog" twist.

316 ↘
RADI DESIGNERS
French (Florence Doleac,
b.1968; Laurent Massaloux,
b.1968; Olivier Sidet, b.1965;
Robert Stadler, Austrian,
b.1966, also resides Brazil)
Fabulation Floor Lamp, 1999
Silk-screened mirror, steel,
and epoxy
Mfr: Galerie kreo
70⅞ × 16⅛ in. (180 × 41.5 cm)
(height × diameter)

RADI DESIGNERS' sinister
Fabulation lamps demonstrate
the remarkable diversity that
exists in Neo-Dada/Surreal
lighting, especially when these
clustered fixtures are compared
to individual pieces by Starck
(fig. 297), Santachiara (fig. 300),
or De Rudder (fig. 302).

317 → →
Claudio Colucci
Italian, born Switzerland
(b.1965), resides Japan and
France
Mutant Chair, 2002
Polyurethane over existing chair
Mfr: E & Y
18⅛ × 17⅜ × 17⅜ in.
(46 × 44 × 44 cm)

The *Mutant* chair clearly shows
that Colucci, originally a
member of RADI DESIGNERS,
has developed a distinctive
design approach of his own.
He often grafts new elements
on to vernacular furniture
forms to create hybrid pieces.

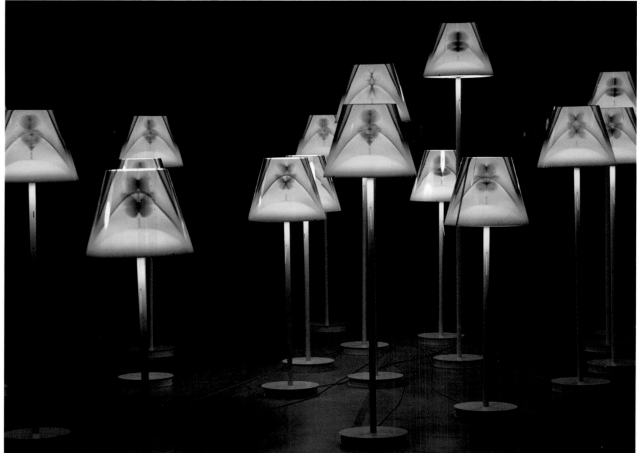

consists of a section of anonymous metal heating duct and a motorbike seat. Again, the design contains many layers of meaning: motorbikes are immensely popular with young people in Barcelona; there is a strong sexual element relating to how Spanish women might sit on such a stool; the seat is a reference to Achille and Pier Giacomo Castiglioni's *Mezzadro* tractor-seat stool (1957); and the piece's name is a subtle reference to the word "Dada," which means hobby-horse in French.[233]

Héctor Serrano also takes a cerebral approach in his work, especially in his lights. The *Playboy* lamp (2002; fig. 315) is nothing more than an acrylic coat-hanger and a bulb to which one adds an ordinary shirt; when illuminated in a dark space, however, it magically acquires a ghostly presence—a Dada light *par excellence*.[234]

A number of French intellectuals have also embraced this cerebral approach, which they see as an alternative to the traditions of the industrial and decorative modes that have been such strong forces in twentieth-century European design. Claudio Colucci, who was once part of RADI, often designs Neo-Dada/Surreal pieces of furniture for his interiors, to give them a rather controversial edge. The *Mutant* chair (2002; fig. 317) is an example of Colucci's practice of morphing an object, whereby he takes an ordinary form and alters it; in this case, a simple Thonet wooden café chair has been transformed with polyurethane foam and paint.[235] RADI DESIGNERS' *Fabulation* floor lamp (1999; fig. 316) is similar to Jurgen Bey's *Light Shade Shade* lamp (1999; fig. 259). When the light is off, one sees a simple metallic shade; but when it is illuminated, one is confronted with the image of spinning, razor-sharp scissors.[236] When grouped in clusters, the individual pieces are transformed into a forest of disconcerting lamps in which the viewer is invited to create his or her own evocative fairy tale.[237]

Although the Neo-Dada/Surreal design mode has obviously not become a mainstream movement, it has nonetheless opened up the boundaries of Postmodernism in significant ways. It also stands in marked contrast to another revival at the turn of the century—a Neo-Decorative movement that is now driving contemporary European design in important new directions.

Neo-Decorative Design

Concept

With the transition into a new century, the reactions to the Modernist resurgence of the late twentieth century grew dramatically. A group of influential designers began to look at the Decorative movement of the late 1980s and early 1990s from a new perspective. The result was the creation of a Neo-Decorative movement.

Given that it is such a nascent mode, there does not, at present, appear to be a particularly deep philosophical basis to this Neo-Decorative movement. Instead, it is primarily a stylistic manner rather than a strongly conceptual one. It is still, however, very much a mode in its formative stages.

There seem to be, at this time, three discernable themes within the Neo-Decorative movement spanning two generations: industrial production; limited production and handcrafted design; and a blending of industrial production, limited production, and handcrafted design.

Style

With a greater emphasis on the decorative and aesthetic qualities in their designs, there is a clearly discernable look to the work of Neo-Decorative designers. They are openly reviving or reinterpreting historical forms. Their work features bold color, pattern, and texture. They have a particular interest in textiles, through which they are inventing a new vocabulary of upholstered forms. There is also a renewed interest in naturalistic forms and decoration, not to mention a greater emphasis on the luxurious and the sensual.

Perhaps one of the most important aspects of the Neo-Decorative movement is its desire to define a new relationship between design and craft. Designers are reviving traditional craft techniques or using industrial technology to create craft effects; indeed, the Dutch designer Hella Jongerius is formulating the idea of "industrialized craft." There is an undeniable fluidity to the Neo-Decorative movement, for objects may be handcrafted or mass-produced, while the materials used range from the rare and luxurious to the everyday and industrial.

Time and Place

The Neo-Decorative movement coalesced at the very beginning of the twenty-first century and is still in its formative years. Its most influential advocates have been a group of designers working primarily in The Netherlands.

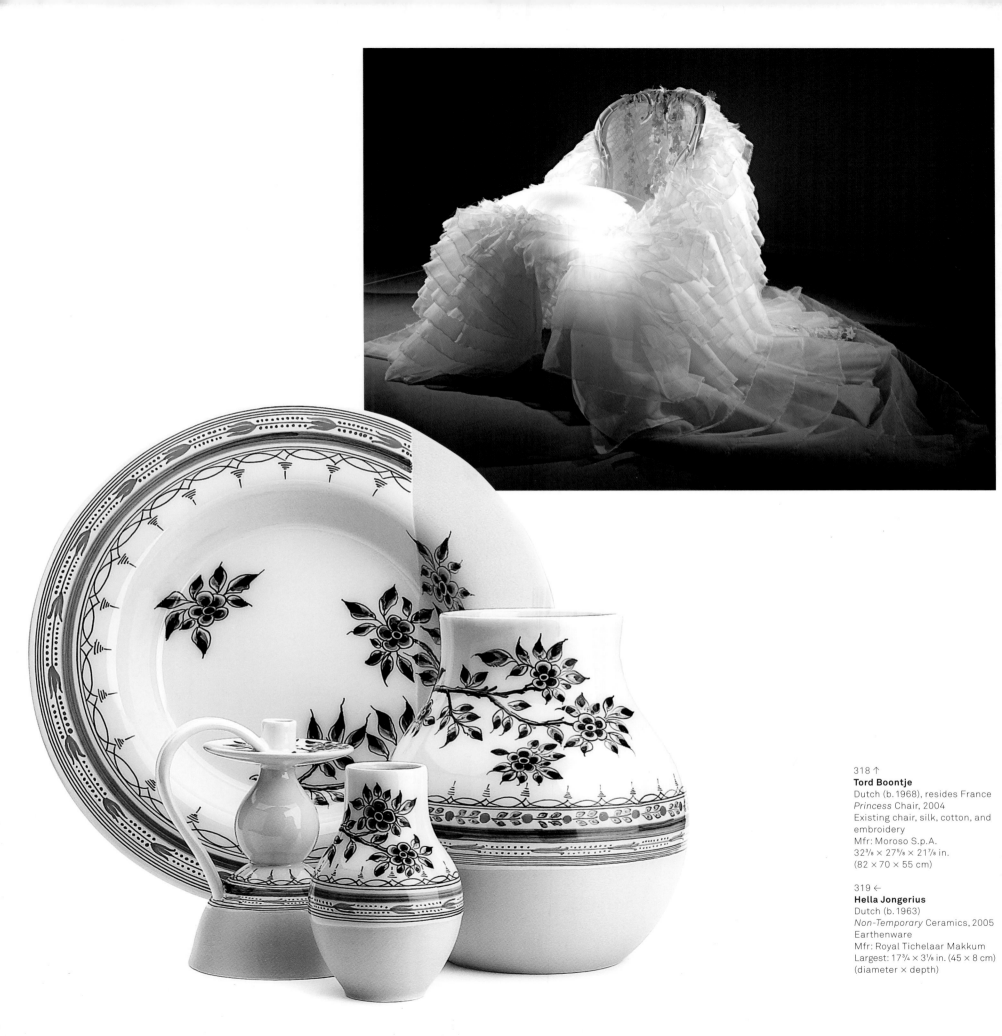

318 ↑
Tord Boontje
Dutch (b. 1968), resides France
Princess Chair, 2004
Existing chair, silk, cotton, and
embroidery
Mfr: Moroso S.p.A.
32⅜ × 27⅝ × 21⅞ in.
(82 × 70 × 55 cm)

319 ←
Hella Jongerius
Dutch (b. 1963)
Non-Temporary Ceramics, 2005
Earthenware
Mfr: Royal Tichelaar Makkum
Largest: 17¾ × 3⅛ in. (45 × 8 cm)
(diameter × depth)

Beginning in the early 2000s, there was a third major reaction to the tripartite Modernist movements that had exerted such a powerful influence on design since the mid-1980s. In little more than a decade, designers began to look back at the Postmodernist Decorative design movement of the late 1980s from a new perspective, thus the use of the term "neo."

This Neo-Decorative movement was more of a stylistic—rather than conceptual—mode with less of a strong philosophical basis. There were three general divisions within this movement, which, strangely enough, were largely the result of the method of production: designs that were industrially made; objects that were made in limited production or handcrafted; and pieces that were a mixture of the three. The Netherlands proved to be an important center for this new development; and, as with the Neo-Dada/Surreal movement, there were two generations of designers involved.

First generation
Industrial production
It should not be a surprise that Philippe Starck was one of the first designers to perceive this new direction in contemporary design, for he was, in a sense, reinventing himself, drawing on his major work from the late 1980s (discussed in the Decorative design section; see pp. 54–87). Starck was once again reviving historical forms but in a more literal sense, although he was characteristically using industrial materials and methods of production. The one new note here was his use of bold colors and patterns.

The *Louis Ghost* armchair (2002; fig. 321) is a cogent representation of the Neo-Decorative aesthetic. It mimics a Louis XVI design, but the form has no sense of mass since it is made of translucent polycarbonate.[238] The design recalls a delicious meringue in its effortless mixture of the sophisticated and the everyday. With the *Mademoiselle* chair (2003; fig. 322), Starck is playing with an Empire form, juxtaposing a translucent base against an upholstered seating unit. The jolt comes from the upholstery, where Starck uses electric colors and floral patterns. Such designs also illustrate an important development: a renewed interest on the part of the Neo-Decorative designers in upholstered forms and naturalistic patterns.

Other designers, such as Ferruccio Laviani, have used plastics and industrial production to create Neo-Decorative lights. An update of Starck's *Miss Sissi* light (1990), Laviani's *Take* lamp (2003; fig. 324) is a diminutive table fixture made in two cross-sections, as if the light had been split in half vertically. Laviani has used the inherent qualities of plastics to maximum effect. The light is a technical feat in its simplicity, in that it consists of two identical cast units that snap together; but Laviani has imparted a richness to the design by accentuating the reflective quality of translucent plastic, especially in the pleated shade. The fixture could also be made in clear plastic or a variety of vibrant colors using identical molds. In the *Bourgie* table lamp (2004; fig. 323), Laviani has wittily reinterpreted in polycarbonate a Renaissance candlestick and traditional pleated shade.[239] The *plissé*-like shade also creates a play of reflections when illuminated, once again emphasizing the importance of light and refractions in such Neo-Decorative designs.

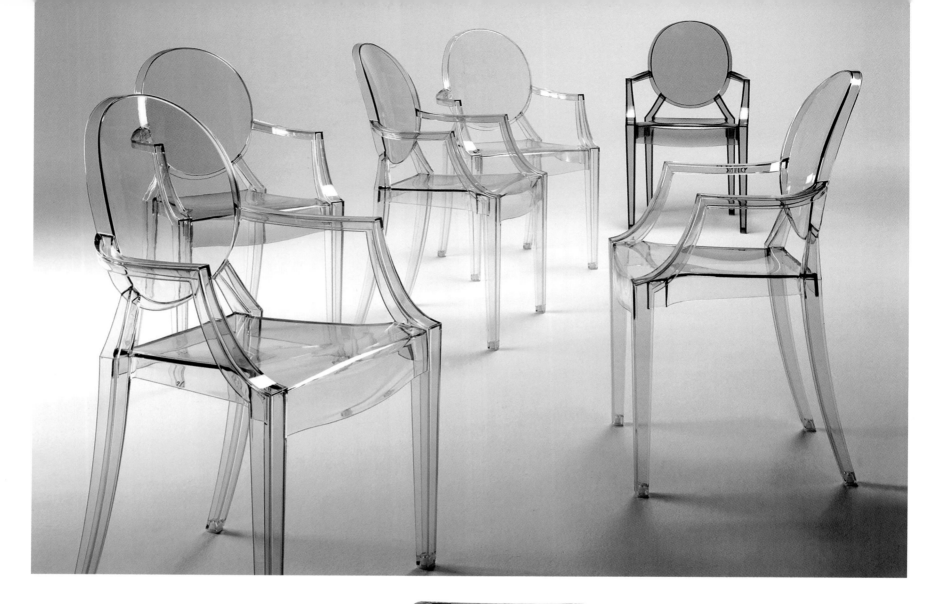

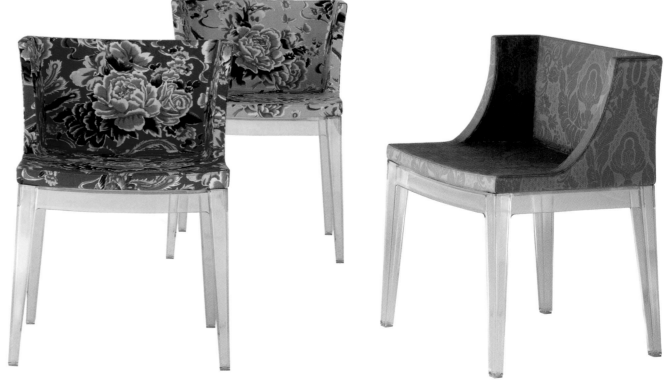

321 ←
Philippe Starck
French (b. 1949)
Louis Ghost Armchair, 2002
Polycarbonate
Mfr: Kartell S.p.A.
37 × 21½ × 22 in.
(93.9 × 54.6 × 55.8 cm)

Starck has had a long
relationship with Kartell,
extending over several decades;
he was one of the first foreign
designers to be hired by the
venerable Italian manufacturer,
long known for its innovative use
of plastics. Starck's most recent
work for the company illustrates
an interesting dichotomy: it
combines the latest advances
in technology—in this case,
translucent polycarbonate—
with overtly historical forms.

322 ↙
Philippe Starck
French (b. 1949)
Mademoiselle Chair, 2003
Polycarbonate and fabric
Mfr: Kartell S.p.A.
31½ × 21½ × 21 in.
(80 × 54.6 × 53.3 cm)

The *Mademoiselle* chair is an
atypical design for Kartell,
in that Starck has chosen to
juxtapose an upholstered form
with a transparent plastic base.
The design is also unusual in
its use of boldly colored and
patterned textiles.

323 →
Ferruccio Laviani
Italian (b. 1960), resides Brazil
and Italy
Bourgie Table Lamp, 2004
Polycarbonate
Mfr: Kartell S.p.A.
30⅜ × 14⅝ in. (77.9 × 37 cm)

324 ↘
Ferruccio Laviani
Italian (b. 1960), resides Brazil
and Italy
Take Lamp, 2003
Polycarbonate
Mfr: Kartell S.p.A.
11⅞ × 7⅛ × 6¾ in.
(30 × 18.5 × 17.5 cm)

Laviani's diminutive *Take* lamp
and his rather grand *Bourgie*
table lamp represent two
remarkable Neo-Decorative
lighting fixtures. In both designs,
Laviani has used the inherent
and variable qualities of plastic
to maximum effect.

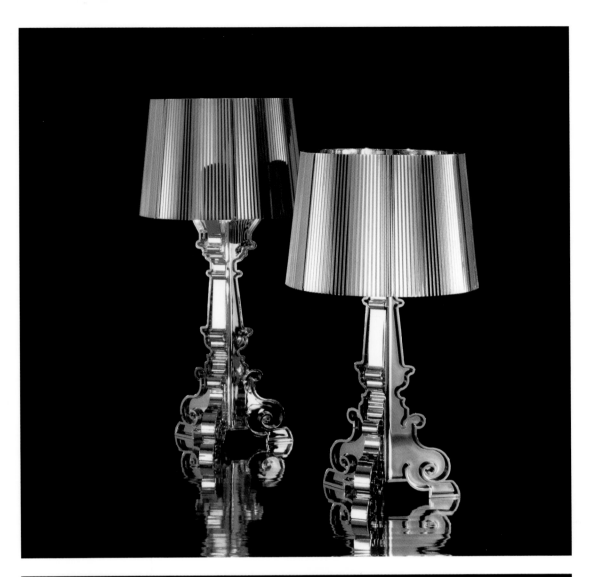

Marcel Wanders
Dutch (b.1963)
Patchwork Plates (clockwise from top left): *Vortrag* Breakfast Plate, *Tichelaar* Soup Bowl, *Makkum* Side Plate, *Coloured Lines* Side Plate, 2003
Porcelain
Mfr: Royal Tichelaar Makkum
Largest: 10¼ in. (26 cm) (diameter)

Wanders's ceramic designs for Royal Tichelaar Makkum were among his earliest experiments with bold patterns and colors. Such pieces helped to establish Wanders as a leader in the Neo-Decorative movement in The Netherlands.

Limited-production and handcrafted designs
A number of Dutch designers, including Marcel Wanders, Jurgen Bey, and Hella Jongerius, have taken a decidedly different approach within the Neo-Decorative movement. Their work is most often limited-production or handmade, but it also has a distinctly different visual appearance owing to its aesthetic underpinnings. The most recent work of these designers is also quite unlike their earlier Conceptual pieces, for the designers are now reinterpreting historical forms more overtly, as well as employing a rich palette of color and pattern. Characteristically, they are not concerned with inventing new forms or using innovative materials or technology.

As noted earlier, Wanders was unhappy with the Droog Design model of production and had sought in the late 1990s to find a new relationship between studio production and industry. In response, he founded Wanders Wonders in 1998 and then Moooi in 2000. Wanders believed he was creating a new concept for a design company, not just a series of products. Indeed, in many respects, the idea behind Moooi was more important than the objects produced; and many of Wanders's designs for Moooi were uneven, since he quickly had to generate a broad range of furnishings to create sales and a new business.[240] As a consequence, Wanders's reputation as a cutting-edge designer came into question, especially given his major designs of the 1990s.

Wanders's shift in the early 2000s toward a greater use of decorative motifs in his work thus marked a "revival" of his career. His first designs in

326
Marcel Wanders
Dutch (b. 1963)
New Antiques Chair, 2005
Wood and leather
Mfr: Cappellini S.p.A.
30¾ × 21¼ × 17¾ in.
(78.9 × 54.9 × 45 cm)

By the early 2000s, a number of Dutch designers, including Wanders, Bey, and Jongerius, had moved away from producing more Conceptual pieces toward a greater use of historical forms and bold patterns and colors—characteristics that would become leitmotifs of the Neo-Decorative movement. With the *New Antiques* chair, Wanders has reached back into history and updated a classic Italian *Chiavari* chair.

this new mode did not come easily, for Wanders had been trained in the Bauhaus tradition. He found it difficult to deal with a rich palette of color, texture, and pattern. Given his predisposition to place an emphasis on surface, Wanders, not surprisingly, initially "glued" on the decoration in his new work.[241]

By 2003, however, Wanders's work had become more assured, as can been seen in such designs as the *Patchwork* plates series (2003; fig. 325). With the *Vortrag* breakfast plate, Wanders is forthrightly challenging Adolf Loos's admonition regarding ornament being a crime by using typography as a decorative motif; in other pieces, such as the *Coloured Lines* side plate, *Makkum* side plate, and *Tichelaar* soup bowl, Wanders is playing with bold patterns and colors on a variety of shapes.

The *New Antiques* chair (2005; fig. 326), however, is a mature example of the Neo-Decorative movement—as its name candidly implies. Wanders has reinterpreted the classic Chiavari chair: the new design's proportions are broader, and Wanders has used black leather—often embossed—for the seat instead of the traditional rush.

The shifts in Bey's work are more subtle and incremental. In the *St. Petersburg* chair (2003; fig. 327), he is dealing with found objects and resin skins; but in this design, the Rococo Revival forms are frankly expressed. The visual impact of the piece comes from the brightly colored monochromatic skin, which is decorated with white floral patterns, recalling Delft porcelain. With great élan, Bey has produced a twenty-first-century interpretation of a Victorian side

Neo-Decorative Design 233

327 ↓
Jurgen Bey
Dutch (b. 1965)
St. Petersburg Chair, 2003
Existing chair and polyester
Mfr: Droog Design
18 × 20 × 41 in.
(45.7 × 50.8 × 104.1 cm)

In its use of Rococo Revival
forms, rich colors, and
exuberant naturalistic patterns,
Bey's *St. Petersburg* chair is a
quintessential example of the
work produced by designers
associated with the Neo-
Decorative movement.

328 →
Jurgen Bey
Dutch (b. 1965)
Minuten Dinnerware, 2003
Porcelain
Mfr: Royal Tichelaar Makkum
Largest: 12⅝ in. (32 cm) (height)

Bey has established a
unique approach within the
Neo-Decorative mode. For the
Minuten dinnerware, he has
characteristically used existing
ceramic forms and historical
decorative patterns with an
understated originality.

329 → →
Jurgen Bey
Dutch (b. 1965)
Minuten Dinnerware (detail), 2003
Porcelain
Mfr: Royal Tichelaar Makkum
Largest: 12⅝ in. (32 cm) (height)

chair. The *Minuten* dinnerware (2003; figs. 328, 329) was part of a project (which also involved Wanders and Jongerius) undertaken with the Royal Tichelaar Makkum factory, one of the oldest Dutch ceramic companies. Given the pressures of globalization, there was a fear that the highly skilled artisans who handpainted patterns on the ceramics could be made redundant and that a venerable craft would be lost as a result. Bey was asked to create a new design for dinnerware that would utilize the artisans' skills in a contemporary manner. He chose traditional, Baroque-like forms and applied multiple existing patterns at random to create a new category of forms. The painters choose the colors and portions of the various patterns to paint, so that each service is unique.[242] Thus, in both of these

designs, Bey is quietly blending the past and present using naturalistic ornament.

Two sets of designs show the remarkable changes in the work of Jongerius in the early 2000s. In the 1990s, of course, she built an international reputation for herself based on her ceramics; in her current work, Jongerius has continued to push the parameters of that medium. She is no longer just producing pieces at Jongeriuslab, however, but is now working for major companies.

The *Delft B-Set* dinnerware (2001; figs. 320, 330) represents one of Jongerius's earliest attempts to use traditional patterns, in this instance inspired by Delft blue porcelain.[243] Like Wanders, Jongerius had been taught that the use of any kind of decoration was "wrong."[244] Nevertheless, she began using historical motifs,

330 ↓
Hella Jongerius
Dutch (b. 1963)
Delft B-Set Dinnerware, 2001
Porcelain
Mfr: Jongeriuslab
Largest: 10¾ × 4¼ in.
(27.3 × 10.7 cm)
(height × diameter)

The Neo-Decorative movement is a rich and multifarious tradition that allows for a number of distinctive design approaches. This is particularly evident when one compares Jongerius's wonderfully idiosyncratic *Delft B-Set* dinnerware with such contemporaneous services as Wanders's *Patchwork* plates (fig. 325) and Bey's *Minuten* ceramics (figs. 328, 329).

331 ↘
Hella Jongerius
Dutch (b. 1963)
Non-Temporary Ceramics, 2005
Earthenware
Mfr: Royal Tichelaar Makkum
Largest: 17¾ × 3⅛ in. (45 × 8 cm)
(diameter × depth)

Jongerius's designs often reflect their method of production. The *Delft B-Set* dinnerware (fig. 330) is handcrafted in her studio, Jongeriuslab, while the *Non-Temporary* ceramics are made at the Royal Tichelaar Makkum factory by skilled artisans—hence the pronounced differences between these two remarkable dinner services.

which she found both beautiful and attractive, as a way of learning how to deal with color and decorative patterns. For the *Delft B-Set* dinnerware, Jongerius has employed a combination of stencils, embroidery, and handpainting to achieve her decorative motifs. Particular note should be made of the pitcher, which has an applied bronze handle attached with plastic straps. Jongerius, however, is also "distorting" the ideal of uniformity in industrial production: the pieces deliberately retain some imperfections, and the customer must select from a random assortment of items to form his or her own dinner service.[245]

The *Non-Temporary* ceramics (2005; figs. 319, 331) are much bolder in their use of decorative patterns and were part of the series devised to engage the skills of the artisans at Royal Tichelaar Makkum. Here, Jongerius introduces a new technique—dipping. The craftsperson dips the yellow, Dutch-clay pieces in a white glaze and then, as with Bey's *Minuten* dinnerware (figs. 328, 329), applies random floral motifs, drawn from the Makkum archives, as he or she sees fit.[246]

In 2005, a dramatic change occurred in Jongerius's career as she transformed herself into a major designer. There was a shift in scale and media as she moved from designing only ceramics to creating monumental furniture forms for Vitra and Moss; she also began to invent a new vocabulary for furniture using a rich palette of materials. Going back to her textile roots, Jongerius employs bold colors, patterns, and textures in her furniture designs, for she is using textiles as a catalyst for creating new forms. Most importantly, Jongerius is attempting to create a new method of production—what she calls "industrialized craft."[247] She is, in short, pushing the Neo-Decorative movement in radical new directions.

Two seminal designs illustrate this new development in Jongerius's career. *The Worker* lounge chair (2005–06; fig. 333) is one of her most assured furniture designs to date.[248] Jongerius has reinterpreted Starck's concept of a two-part composition for a chair. The front section is upholstered in various fabrics, leather, and buttons; and the back is an oak frame to which cantilevered arms have been attached with bold aluminum mounts. Here, Jongerius is seeking to create a new and remarkably original typography for furniture. Likewise, in the *Layers* vase series

(2005–06; fig. 332), Jongerius has used textiles as a means of creating a series of vessel forms that have the monumentality of Classical amphorae. Jongerius has taken examples of the *Red/White* vases (1998; fig. 278) and has upholstered them in various patterns from the *Layers* fabric series produced for Maharam, the textile company.[249] The pieces are almost totemic in their powerful use of multiple patterns and embroidery.

As with the late work of the Bouroullec brothers and Konstantin Grcic, there is an unsettling quality to the *Worker* and *Layers* designs, for Jongerius is in a moment of transition as she boldly seeks to charter a new direction for European design. Together with Wanders and Bey, however, Jongerius has laid a solid foundation for the Neo-Decorative design movement, which is now being pushed in even more innovative directions by a younger—and equally adventurous—generation of designers.

Second generation
A blending of industrial production, limited production, and handcrafted production
At this close perspective, one can detect only hints of where the second generation of Neo-Decorative designers is taking this movement. There are, however, two emerging talents, both charting distinctive directions: Tord Boontje and Studio Job.

Boontje is also a Dutch designer, but one who has worked primarily outside of The Netherlands, in the United Kingdom and now France. To date, he has perhaps produced a more consistent body of work than Studio Job. As with Jongerius, textiles play a major role in Boontje's work; in his furniture designs, the upholstery is more important than the frame and determines the form of the object, an approach that is strongly antithetical to Modernist tenets. Increasingly, Boontje is using

332
Hella Jongerius
Dutch (b. 1963)
Layers: Quilted Vase Red with Plaid Bottom, Quilted Vase Blue with Circles, Quilted Vase Two Plaids, 2005–06
Wool and embroidery
Mfr: Jongeriuslab
34 × 15 in. (86.3 × 38.1 cm)
(height × diameter)

Ceramics and textiles have always been two of Jongerius's fortes. Her *Layers* series combines these two media to great effect: a *Red/White* vase (shown in fig. 278 on the left) has been "upholstered" in elaborately patterned and embroidered "slipcovers."

333
Hella Jongerius
Dutch (b. 1963)
The Worker Lounge
Chair, 2005–06
Wood, aluminum, and fabric
Mfr: Vitra AG
30¾ × 31½ × 31¼ in.
(78.1 × 80 × 79.3 cm)

In the early 2000s, Jongerius, working in a number of design media, expanded her œuvre dramatically and, more fundamentally, sought to redefine the meaning of design. *The Worker* lounge chair is a prime example of this new direction in her work. Here, she has achieved a remarkable synthesis of highly original forms, unorthodox structure, and a lush palette of materials.

334 ↑
Tord Boontje
Dutch (b.1968), resides France
Rough-and-Ready Side
Chair, 1998
Wood, fabric, and metal
Mfr: Tord Boontje
33³⁄₈ × 17⁷⁄₈ × 18¹⁄₂ in.
(84.7 × 45.5 × 47 cm)

335 →
Tord Boontje
Dutch (b.1968), resides France
Cut Flower Side Chair, 2002
Wood, wool, cotton, and nylon
Mfr: Tord Boontje
33³⁄₈ × 17⁷⁄₈ × 18¹⁄₂ in.
(84.7 × 45.5 × 47 cm)

Two chair designs by Boontje
illustrate his evolution as a
leader of a second generation
of Neo-Decorative designers.
The *Rough-and-Ready* side
chair, an early piece, represents
for Boontje a basic, generic
form—the antithesis of a
mass-produced industrial
design. To create *Cut Flower*,
he has taken the *Rough-and-
Ready* chair and added layer
upon layer of sumptuous
textiles embellished with
elaborate hand-working.

336 → →
Tord Boontje
Dutch (b.1968), resides France
Princess Chair, 2004
Existing chair, silk, cotton, and
embroidery
Mfr: Moroso S.p.A.
32³⁄₈ × 27⁵⁄₈ × 21⁷⁄₈ in.
(82 × 70 × 55 cm)

An icon of the Neo-Decorative
movement, the *Princess* chair
is Boontje at his most sublime:
a traditional chair form
transformed by cascading,
shimmering layers of sheer,
white fabric.

rich color, pattern, and texture to impart a luxurious and sensuous quality to his designs. His production methods are a *mélange* of traditional handcraftsmanship, limited production, and the use of industrial technology to create craft effects. Boontje's design approach has, in fact, become a basic model for a number of the second generation of designers pursuing this Neo-Decorative aesthetic.[250]

The *Rough-and-Ready* side chair (1998; fig. 334), one of Boontje's early pieces, is still quite conceptual in feeling but very much represents a gauntlet to the Modernist industrial designs of the 1990s. Boontje's generic design can be downloaded from the Internet, and the chair can be made by anyone following the plans. The chair itself is a simple, De Stijl-like wooden frame with an upholstered felt pad attached with metal straps—a design with a startling appeal. Using this elemental form as a starting point, Boontje then began to create "slipcovers," with which he explored the sensuous quality of layered gossamer textiles, embroidery, beading, and *appliqués* of garlands, as can be seen in the *Cut Flower* chair (2002; fig. 335).[251] In this piece, the frame is now completely superfluous to the upholstery. As Boontje has matured as a designer, his pieces have become even more complex and elaborate. For the *Princess* chair (2004; figs. 318, 336), Boontje began with a traditional chair, recalling Bey's work (fig. 327), but then added cascades of sheer, white fabric, not unlike an elegant wedding veil. It is one of the most splendid exemplars of the Neo-Decorative movement: totally impractical, yet breathtakingly beautiful.

Boontje has also explored this aesthetic in his designs for lighting and tableware. The *Garland* hanging lamp (2002; fig. 337) is an early work in which a garland of flowers has been cut from an

337 ←
Tord Boontje
Dutch (b. 1968), resides France
Garland Hanging Light, 2002
Steel
Mfr: Artecnica
10 × 10 × 10 in.
(25.4 × 25.4 × 25.4 cm)

Boontje is a master of creating naturalistic ornament using a variety of materials. One of the earliest demonstrations of this remarkable ability was his *Garland* light. A spray of flowers cut from sheets of inexpensive metal (see p. 11) may be wrapped around a common light bulb to create a simple but breathtakingly beautiful object.

338 ↙
Tord Boontje
Dutch (b. 1968), resides France
Night Blossom Chandelier, 2003
Steel, glass, and LED lights
Mfr: Swarovski AG
57 × 65 × 35½ in.
(144.7 × 165.1 × 90.1 cm)

As Boontje's fame grew, he was approached by major companies to create designs using their products, in this case Swarovski and its glass "crystals." For this monumental chandelier, Boontje has paired black glass with twinkling blue LED lights to create a haunting and magical lighting fixture.

339 →
Tord Boontje
Dutch (b. 1968), resides France
Thinking of You: Now Vase
Cover, 2005
Steel
Mfr: Artecnica
8 × 5½ in. (20.3 × 13.9 cm)
(height × diameter)

The *Thinking of You: Now* vase cover builds on such earlier designs as the *Garland* light (fig. 337). In this instance, however, the sheet of floral ornament is folded precisely to create a polygonal vase form. In characteristic fashion, Boontje is consciously blurring the line between industry and craft, a leitmotif in his work.

340 ↘↘
Tord Boontje
Dutch (b. 1968), resides France
Table Stories Dinnerware, 2004
Glass and porcelain
Mfr: Artecnica
Largest: 1 × 13 in. (2.5 × 33 cm)
(height × diameter)

Boontje is capable of creating both *objets de luxe* and inexpensive, everyday products; the *Table Stories* dinnerware is an example of the latter. Generic ceramic and glass forms have been embellished with an array of animal and floral patterns in a variety of colors. Boontje—ever the radical—has cleverly subverted Modernist industrial technology to create Postmodernist designs.

341 ↗↗
Tord Boontje
Dutch (b. 1968), resides France
The Other Side Ceramics, 2005–06
Ceramic
Mfr: Moroso S.p.A.
Largest: 15¾ × 10⅞ × 6⅜ in.
(40 × 27.5 × 16 cm)

In *The Other Side* series, Boontje, with great élan, has used the surfaces of simple ceramic forms as canvases for the application of joyful and colorful floral patterns.

Boontje's *Table Stories* dinnerware (2004; fig. 340) stands in marked contrast to the designs of Wanders, Bey, and Jongerius. Boontje's glass and ceramic forms are almost generic in their mass and simplicity. It is the myriad of colorful and original patterns—evoking a fairy-tale world filled with exotic fauna and flora—that distinguishes the design; like his Art Nouveau precursors a century earlier, Boontje has a remarkable ability as an ornamentalist.[252] The *Thinking of You: Now* vase cover (2005; fig. 339) is part of a series in which Boontje has once again employed laser cutting to create a naturalistic pattern from a sheet of metal. The piece is then folded to recall polygonal eighteenth-century ceramic forms and becomes, in essence, an iridescent cover that can be slipped over any

etched and finely detailed sheet of metal; the piece can then be suspended around a generic light bulb. This diminutive and inexpensive design was initially made in batch production but then adapted to mass production using laser cutting, an example of Boontje employing industrial technology to create craft effects. An *objet de luxe*, the *Night Blossom* chandelier (2003; fig. 338) features a large, branch-like form made of black cut-glass "crystals" with blue LED lights. This sculptural piece has a mysterious elegance when suspended in space, rather like a Calder mobile.

kind of generic tumbler or glass vessel.[253] Boontje's emphasis on surface and decoration is also illustrated by *The Other Side* ceramics (2005–06; fig. 341), in which form is secondary to the muted colors and exuberant patterns.

Indeed, this second generation of Neo-Decorative designers has displayed an almost over-the-top tendency to create objects that evoke a world of the fantastic. This is very much in evidence in the designs of Studio Job, a Dutch/Belgian group. Job Smeets and Nynke Tynagel have received considerable attention in recent years. They are young designers still in the process of developing a clear conceptual approach, but there is unquestionably a powerful energy and raw bravura about their work that is almost Baroque or Mannerist in its intensity, not unlike the early, over-the-top designs of Garouste & Bonetti (see pp. 70, 76).

Studio Job is seeking to break down the barriers between design and art—between the

object and the *objet d'art*. Some of its early work possesses a decidedly kitsch or cartoon-like quality. Like Boontje, the designers use floral and animal motifs to evoke a fantasy-like world; but Smeets and Tynagel have gone much further in their search for the fantastic, creating objects that defy easy categorization—riotous pieces that also employ insects, crystalline forms, or a variety of architectural and decorative motifs from the Renaissance to Disneyland.

Two works perhaps best illustrate Studio Job's design approach in the early twenty-first century. The *Still Life* series (2004; fig. 342) is a collection of ceramics for Royal Tichelaar Makkum, consisting of a vase, a clock, a box, a candle holder, and a piggy bank. Each of these kitsch forms has been decorated with colorful, cartoon-like motifs. In

more recent designs, Studio Job has created pieces with exaggerated proportions and monumental scale; the group has also employed such unusual materials as pewter, bronze, papier mâché, and mosaic. Moreover, Studio Job's designs are loaded with symbolism and a myriad of iconographic messages, from "high" art to "low" art, which are sometimes difficult to discern. Indeed, its work often contains a powerful and unresolved juxtaposition of the "violent" with the "beautiful." The *Oxidized* series (2003; fig. 343) was a breakthrough collection for the studio in terms of evolving its fantasy aesthetic.[254] In theory, the tripartite design is a clock but one without parallel; it is an extraordinary *mélange* of an Ionic capital, a crystalline case, and a sword jutting out of the top—all made of bronze.

While the Neo-Decorative movement is still very much in its formative stages, it appears—at least at this moment in time—to be harnessing the necessary ingredients to form a critical mass. It is being led by a group of significant designers. They are producing a body of powerful work. These artists, moreover, have the support structure not only to produce but also to promote their work on an international scale. More importantly, perhaps, these designers seem to have an unbridled vision and ambition that could allow this nascent Neo-Decorative movement to decisively shape European design in the near future. Clearly, contemporary design in Western Europe is once again in a state of remarkable flux.

342 ↙↙
Studio Job
Dutch and Belgian (Job Smeets,
Belgian, b. 1970; Nynke Tynagel,
Dutch, b. 1977)
Still Life Ceramics, 2004
Porcelain
Mfr: Royal Tichelaar Makkum
Largest: 11 × 6 × 6 in.
(27.9 × 15.2 × 15.2 cm)

Studio Job has established
itself as one of the leaders of
a second generation of Neo-
Decorative designers; in doing
so, it has pushed the aesthetic
to an almost kitsch level.
This is evident in such riotous
and irreverent pieces as the
Still Life series, vernacular
forms embellished with raised
decoration and painted patterns.

343 ←
Studio Job
Dutch and Belgian (Job Smeets,
Belgian, b. 1970; Nynke Tynagel,
Dutch, b. 1977)
Oxidized Clock, 2003
Bronze
Mfr: Studio Job
55⅛ × 25⅝ × 19¾ in.
(140 × 65 × 50 cm)

With the *Oxidized* series, Studio
Job found its true voice and
began to produce designs that
almost defy categorization.
These pieces, with their wildly
exuberant combinations of over-
the-top forms and materials,
are examples *par excellence* of
the Neo-Decorative movement's
aesthetic.

Shaping the
New Century?

Certainly, *European Design Since 1985: Shaping the New Century* has been no small undertaking. It has expeditiously identified and assessed many of the seminal movements, designers, and works in contemporary design over the last few decades. It has demonstrated that Europe clearly played a pre-eminent role in shaping design internationally. It has challenged the assumption that a Modernist resurgence had made Postmodernism *passé* and irrelevant. On the contrary, *European Design* has shown that there was a powerful dynamic between these two movements during the post-1985 period. In its three essays, it has sought to place the present in a larger historical context from a variety of perspectives. *European Design*, as its name implies, has also shown how the entire field was radically changed with the evolution of the European Union, not to mention the significant cultural, economic, political, and technological shifts that have occurred during this period.

European Design, however, has also raised the question, perhaps indirectly, of who and what will direct the course of design in the twenty-first century. Will Europe remain in a *fin-de-siècle* period of transition or will it make a decisive leap into a new century? In other words, will a period of evolution become one of revolution, comparable to the cataclysmic events that followed the First World War almost a century earlier? A few observations or questions are thus perhaps relevant.

A change of generations
One development is certain. Europe is going to see the passing—probably within the next decade—of an extraordinary generation of designers who shaped the field from the 1960s onward. Achille Castiglioni, Vico Magistretti, and Ettore Sottsass are just three of the most recent losses. With almost a quarter of a century of work behind them, a central question becomes whether members of this older generation who are now in their fifties—Ron Arad, Jasper Morrison, Philippe Starck, *et al.*—are capable of moving beyond the status quo and reinventing themselves. In short, are they capable of pushing European design in radical new directions? After all, both Sottsass and Alessandro Mendini were in their sixties and fifties respectively when they fostered such groups as Memphis and Alchymia, movements that decisively redefined the direction of contemporary design in the late 1970s and early 1980s. Such legacies present formidable challenges to uphold, let alone surpass. Alternatively, will a second or nascent third generation replace these older designers as the driving force in Europe? The stakes here are not inconsequential.

A new, vastly expanded Europe
A second development is also quite apparent. While the countries that made up the old Western Europe are still extremely strong, many Eastern European nations, once part of the Soviet bloc for almost half a century but now members of an expanded European Union, are anxious not only to catch up economically but also to assert themselves as a cultural force internationally. For the moment, a number of these countries' designers, such as Boris Berlin and Aleksej Iskos, are working in the West; but some, including such major designers as Bořek Šípek, have returned to their native lands and will no doubt exert a powerful influence on design in those countries.

It is also important to note that Western Europe's leadership role in contemporary design has been driven in no small part by a remarkable consortium of designers, manufacturers, and schools working with governmental and cultural institutions. Will this infrastructure continue, and can it be expanded into Eastern Europe to promote an even larger vision of European design?

The counterbalance between Modernism and Postmodernism
Since the mid-1980s, European design has also been shaped by an action/reaction between two major conceptual movements, Modernism and Postmodernism—or, if you will, between design as industry and design as art. Will this counterpoint continue? Given the unrelenting pressures of globalization, will the industrial might of Europe be sufficient to sustain its Modernist designers, or will they have to envisage a new approach to industrial design that will still allow them to be international leaders? Conversely, will the Postmodernist design approach—with its emphasis on conceptual ideas and more limited production—allow European designers to remain intellectual leaders in a new century? Or, quite simply, will this powerful dynamic be sufficient to keep Europe in a leadership position?

A continued leadership role for Europe
Designers around the world are now faced with the daunting task of defining a new conceptual and aesthetic basis for design in the twenty-first century. One may pose the question of what role Europe might continue to play in the volatile field of contemporary design. A forthright assessment of the competition is revealing. The United States and Japan are in disarray on a multitude of levels. China and India are certainly important manufacturing centers but are still emerging as design powers. South America and Africa are, in large part, somewhat dormant for the moment. So it is perhaps to Europe that one must look for global leadership in the design arts, at least for the foreseeable future. Thus the fundamental question becomes one of whether a new and vastly expanded Europe will accept the formidable challenges of laying the foundations for global design and decisively shaping a new century.

Notes

1 Both Rolf Fehlbaum and Marcel Wanders have spoken of the designers of this period as not being as revolutionary in their goals as earlier twentieth-century designers, particularly when compared to the first generation of Modernists between the world wars and a second generation that appeared after the Second World War. Indeed, Wanders sees this evolutionary approach to design as one that allows designers to move freely from one era to another for inspiration. It also accounts for the fascination of this group of designers with found objects and archetypal forms, two ideas that are discussed at some length in this chapter. Rolf Fehlbaum, interview by R. Craig Miller, March 9, 2005; Marcel Wanders, interview by R. Craig Miller, July 20, 2005.

2 Hella Jongerius, interview by R. Craig Miller, November 14, 2005.

3 Indeed, in the early part of her survey of European design from 1945 to 1985, Penny Sparke is still able to talk about European design in terms of individual countries. It is only later in this time frame, when the forces of globalization began to dissolve national and international boundaries, that one can speak of a larger European design.

4 Alessandro Mendini was one of the first people to hire foreign designers for an Italian company, when he directed the program to create the first set of silver tea services for Alessi in 1983. Alessandro Mendini, interview by R. Craig Miller, April 19, 2005. For the tea services, see Alessi, *Tea & Coffee Piazza*, Brescia (Officina Alessi/Shakespeare & Company) 1983. Paolo Moroni has also spoken of the hostility that Sawaya & Moroni encountered from the Italian design community when they began to hire such foreign designers as Zaha Hadid and Michael Graves. Paolo Moroni, interview by R. Craig Miller, April 14, 2005.

5 Michele De Lucchi, interview by R. Craig Miller, April 15, 2005.

6 *Ibid*.

7 Bouroullec brothers, interview by R. Craig Miller, November 15, 2004.

8 In terms of highly influential galleries in the 1980s and early 1990s, one can point to Galerie Neotu in Paris and the Design Gallery in Milan. Their successors include Galerie kreo in Paris and Gallery Mourmans in The Netherlands. During these decades, however, almost every major city in Europe had a gallery of some scale that promoted the work of contemporary designers.

9 With the decline of so many European industries, designers—who work in a myriad of different styles—have increasingly resorted to the studio production method to make their work and get it into the market, as discussed in this chapter.

10 Claudio Luti, the head of Kartell, believes that this shift in importance, from the Italian designer to the Italian manufacturing system, began in the mid-1980s with the battle between Modernism and Postmodernism, which broke the sense of a unified Italian design style. Claudio Luti, interview by R. Craig Miller, April 18, 2005.

11 There were notable exceptions, such as Antonio Citterio and Michele De Lucchi; but the latter's career stretches back into the 1970s and 1980s, when he was involved with such radical design groups as Studio Alchymia and Memphis.

12 Luti, interview.

13 It is, of course, such strong CEOs who have been able to thwart the growing power of marketing people in setting the artistic direction of design companies. Ettore Sottsass, interview by R. Craig Miller, April 21, 2005.

14 Rolf Fehlbaum, Chairman of Vitra in Switzerland, is one of the notable exceptions outside of Italy.

15 Comment by the Japanese artist Foujita, quoted in Christopher Benfrey, "School of Paris," *New York Times Book Review*, January 14, 2007, p. 13.

16 Jasper Morrison, interview by R. Craig Miller, November 12, 2004.

17 In the mid-1980s, a number of European museums sensed the shift that was occurring in contemporary design and organized exhibitions to reflect this change. These included *Gefühlscollagen: Wohnen von Sinnen* at the Kunstmuseum in Düsseldorf (1986) and *Nouvelles Tendances: Les Avant-gardes de la fin du XXe siècle* at the Centre Georges Pompidou, Paris (1987).

18 Piet Hein Eek, interview by R. Craig Miller, July 26, 2005.

19 *Ibid*.; Luti, interview.

20 In a parallel manner, Henry-Russell Hitchcock and Philip Johnson helped to define the broad tenets of Modernism between the world wars in their seminal treatise *The International Style: Architecture Since 1922*, New York (W.W. Norton) 1932. However, when one looks at the individual careers of such major figures as Alvar Aalto, Le Corbusier, and Ludwig Mies van der Rohe, there are pronounced differences in their designs as well as in their architecture, even though they are an integral part of the larger Modernist movement.

21 Notable precursor designs include the *Costes* café chair (1981) and the *Richard III* lounge chair (1984–85). Both designs were made by Baleri Italia.

22 Starck was exploring at this time a number of interesting ideas for tables, shelving, and lighting; but they did not come together as successful designs to the same degree as his work for seating.

23 It should be noted that both chairs were made by an Italian (not French) design company, Driade, which was instrumental in the development of the Postmodernist movement in the 1980s.

24 The desk was also available in a wood veneer. A larger model was created for the offices of Jack Lang when he was the Minister of Culture for France.

25 Much of Szekely's work during this period was made and sold through Galerie Neotu in Paris. At the time, there were a number of such galleries in major European cities; collectively they became one of the most important advocates for Postmodernist design, discovering new designers as well as promoting and selling their work through influential exhibitions and publications.

26 Both Gili and Gagnère were working with old European luxury design houses: Salviati in Italy and Bernardaud in France, respectively.

27 Indeed, it is important to note that Ohira continues to explore the "vessel" tradition; furthermore, he is not part of the Studio Glass Movement, which was so influential during these decades, with its fine arts approach that regards glass as "sculpture."

28 Ohira works with a team to produce his work: Livio Serena, his glass blower; Giacomo Barbini, his glass carver; and Renzo Ferro, the owner of Anfora di Renzo Ferro Glassworks.

29 This design is quite different from De Lucchi's earlier ceramics for such groups as Studio Alchymia and Memphis, which featured strong color and pattern.

30 Šipek was born in Czechoslovakia but lived and worked for many years in The Netherlands. When the Czech Republic joined the EU, he began to reside more in his native country. Thus the captions for the designs made during the early phase of his career note that he "resided The Netherlands."

31 Šipek was most active as a designer in the 1980s and early 1990s, at which point he shifted the emphasis of his career from design to architecture.

32 Since the mid-1980s, Šipek has reinterpreted the folding metal chair, the bentwood café chair, the Recamier couch, and the wicker chair.

33 This fascination with folk art would increasingly become a strong element in Šipek's work. The interest exhibited by Postmodernist designers in vernacular forms, or "low" art, will be discussed in greater detail below.

34 This bipartite composition for a chair, with separate front and back elements, was also used with great alacrity by Philippe Starck during the same period (see fig. 84).

35 Garouste & Bonetti was another design firm associated with Galerie Neotu in Paris.

36 Much of this work was handmade by artisans for a very chic and affluent clientele; in the post-1985 period, it was much favored by high-end interior decorators.

37 Again, note should be made of the manufacturer. Källemo, a Swedish company, was a strong supporter of Postmodernist designers in Scandinavia.

38 The center unit is a vase and can hold flowers.

39 More than a decade later, other Dutch designers, such as Hella Jongerius and Jurgen Bey, would likewise be inspired by earlier Dutch ceramics as part of the Neo-Decorative movement; however, they would actually be working with traditional ceramic factories in The Netherlands.

40 The last three Šipek designs were made by the Italian company Driade.

41 The *Trapanis* series was made by one of the most venerable French design houses, Daum.

42 Driade has, of course, been mentioned earlier; but its products were luxurious, largely handmade *objets*.

43 Kartell is primarily a plastics company and was family owned. During the heyday of Italian Modernist design, it was a major manufacturer. With the advent of Postmodernism, however, it lost much of its energy. In 1983, Claudio Luti, who had married into the Kartell family, left Versace and joined the company with a vision of

creating a new image for Kartell. Luti pushed the company in two decisive directions: he began to hire a younger generation of designers, who created innovative forms; and he pushed Kartell to develop a new and more sophisticated generation of plastics. As is so often true in the fashion world, Luti believed that the way to maintain leadership is to maintain quality, with an attention to subtle changes in material, finish, and detail. Kartell thus represents a remarkable synthesis between the worlds of fashion and design. Luti, interview.

44 Alessi was a noted Italian manufacturer for decades, well known for its metalwork for hotels and restaurants. When Alberto Alessi Anghini took over the business, he began to hire new designers and transformed the company into one of the international leaders in contemporary design.

45 In Italy, in particular, a marked change occurred in the late 1980s when manufacturers there increasingly began to hire such international designers as Starck in order to stay in the design vanguard.

46 The table came in two versions, with either a square or a round top.

47 The soft finish was achieved by putting talcum powder inside the mold to produce a matte rather than glossy finish. Claudio Luti, director of Kartell, wanted to create a completely new and more elegant look for plastics. Luti, interview.

48 De Lucchi is unusual for a designer in that he is able to perceive his career objectively. From 1973 to 1977, he was involved with Radical Architecture and associated with architectural firms in Florence. From 1978 to 1989, he worked with such avant-garde design groups as Alchymia and Memphis. From 1990 to 1999, reacting to the provocative work of Memphis and the turbulent times, he sought to introduce a greater sense of calm into his work by creating more traditional designs. From 2000 onward, he has returned to a more radical stance. De Lucchi, interview.

49 Like the *Bianco* vase (1990; fig. 67) discussed earlier, the *Fata* lamp is made by a company, Produzione Privata, started by De Lucchi. It was set up so that De Lucchi could experiment with new ideas, materials, and craftsmanship. It therefore plays a role in De Lucchi's later career that is similar to the one played by Studio Alchymia and Memphis in his earlier work.

50 De Lucchi also likes to play with the opaque and translucent surfaces of glass. De Lucchi, interview.

51 FLOS, along with Artemide and Luceplan, was one of the major Italian lighting companies of the late twentieth century. In the 1960s and 1970s, new lights designed by architect–designers came from innovations in form, material, and the type of bulb. When FLOS began to work with such designers as Starck, there was a conceptual shift, for the innovation was no longer coming from technology. Starck's work, and that of artists like him, is about ideas or sensations. Gianluca Vicenconte at FLOS, interview by R. Craig Miller, April 18, 2005.

52 Olivetti ceased production in Italy in 2002. It no longer exists as a company and is now just a trademark. De Lucchi, interview.

53 *Ibid*.

54 Early versions of the fax machine were conceived in bright, shiny colors. When the machines were actually put into production, they were made only in gray. Olivetti was in serious financial trouble at the time, and they felt that gray machines would work better with other brands and be more marketable. De Lucchi, interview.

55 As noted earlier, one may see a parallel development in some of the work by Šípek that was strongly influenced by Czech folk art.

56 After the Franco decades, design in Spain was seen as a powerful means of giving the country a new identity, both culturally and economically.

57 Eek clearly acknowledges the influence of Sottsass and Memphis in this conceptual approach to design; he also notes that such was the power of Memphis in the early 1980s that people tended to copy the style rather than the spirit or conceptual basis behind the movement. Eek also sees historical ties between his designs and the earlier work of Gerrit Rietveld and the Amsterdam School. Rietveld started out as a cabinet-maker, and the Amsterdam School placed a strong emphasis on material and construction. Eek, interview.

58 In this sense, there are strong parallels between the early work of Eek and Ron Arad, although their conceptual approach and forms are quite different.

59 In his early career, Eek made his own work, which was then sold through galleries. Later, he established a large studio to manufacture

his pieces; more recently, some of his designs have gone into industrial production with such companies as Lansvelt. Like Mariscal, Eek acknowledges that his concern with imperfect objects was a reaction to the elegant industrial products of such designers as Starck. Eek, interview.

60 The chair is a parody of a small, three-wheeled Spanish car made in the 1960s. Javier Mariscal, interview by R. Craig Miller, February 23, 2005.

61 The Mickey Mouse-like forms also harken back to an earlier Mariscal design, the *Garriri* side chair, in which the cartoon-like references are more overt. The chair was made in two versions: one upholstered in black leather and made by Akaba in Spain (1987) and another with black-and-white upholstery made by Moroso in Italy (1995). E-mails from Loles Duran at Studio Mariscal, July 30, 2008, and August 1, 2008.

62 Eek also later made versions veneered in rolls of period wallpaper. Eek, interview.

63 Pakhalé also acknowledges the influence of Sottsass on his design approach. Satyendra Pakhalé, interview by R. Craig Miller, July 20, 2005.

64 Bell metal is a type of bronze, containing a mixture of copper and tin, normally used in the making of bells. Only two examples of Pakhalé's chair were actually made in bell metal. A fiberglass variation with a flock finish, the *Star Horse* chair, was made by Cappellini in 2001. Pakhalé, interview.

65 The *STL* basket is made using stereolithography. For the *Akasma* baskets, sheets of glass are cut, heated and pressed on a mold, and then glued together; the baskets are manufactured by RSVP, an auto glass company. Pakhalé, interview.

66 Indeed, Arad has noted that the most important influences on his early work were such artists as Marcel Duchamp, Claes Oldenburg, and Jasper Johns. The Expressionist designer Gaetano Pesce is an exception in this regard. It was only later, when Arad began to work as a real industrial designer, that he first looked at the work of such designers as Jean Prouvé and Achille Castiglioni. Ron Arad, interview by R. Craig Miller, November 22, 2004.

67 The last two phases of Arad's œuvre will be dealt with in the section on the Biomorphic design movement; see pp. 142–67.

68 Arad has noted that his model at this early point in his career was not someone like

Starck, a designer who was beginning to work for industry, but rather someone like Pesce, an artist–designer who was making more limited-edition pieces. Arad, interview.

69 Arad has commented that to work in such alternative materials as wood, one needs to have the skills of a highly trained craftsman, skills that he was just acquiring as a young designer. Arad, interview.

70 As emerging artists in London, Arad, Danny Lane, and Tom Dixon—the designers of these chairs—struggled to get their work made, since there was little interest by British manufacturers in such cutting-edge design. In fact, both Lane and Dixon initially sold their work through Arad's shop, One Off, in London. Danny Lane, interview by R. Craig Miller, November 26, 2004.

71 Arad also used glass with various kinds of metal in a number of his designs in the 1980s, but they were not as strong or innovative as Lane's work in glass.

72 Lane has noted that he does not want to use glass in a precious manner, as do many Studio Movement artists. Rather, he thinks of glass as fast and cheap. Lane likes the green color of glass; he likes the effect of the transmission of light through glass; he particularly likes the irregular edge in sheet glass, which he feels has the metaphysical quality of the flaw. Lane primarily uses "cold processes" rather than the "hot processes" of Studio Movement artists: he therefore chips, cuts, sandblasts, stacks, and glues sheets of glass together. Lane, interview.

73 A comparison of the careers of Lane and Dixon is interesting in that both were self-taught and did not train as architects, as did Arad. Lane has remained more of an artist working in glass. Dixon, on the other hand, has worked primarily as a designer; but his work seems to lack a consistency or clear conceptual basis, as he has moved from one style to another over the last two decades.

74 Hvass has noted that willow has a beautiful color in the stems and a strong smell. Like Jonas Bohlin in Sweden, Hvass was one of the first Scandinavian designers in the 1980s to question the strong Modernist design tradition in the Baltic countries. As a young designer, he was a member of the radical Octo group; his students have included such cutting-edge Postmodernist designers as Mathias Bengtsson and the Panic group. Niels Hvass, interview by R. Craig Miller, September 15, 2004.

75 Both Die Neue Sammlung Museum in Munich and the Vitra Design Museum in Weil am Rhein have exceptional collections of this movement's work.

76 This design is rather atypical for Lane in that it employs colored glass.

77 Lindfors's work posseses a certain ambiguity insofar as it can be quite theoretical in terms of concept but expressionist in terms of form. There is also a pronounced difference between his more limited-edition designs and his mass-produced work. With the latter, the forms at times become so simplified that they are almost biomorphic in nature, as we shall see later. Stefan Lindfors, interview by R. Craig Miller, September 23, 2004.

78 Lighting is one of the few other design media in which Arad has consistently worked during his career.

79 Hadid's designs were featured in a retrospective of her work, *Zaha Hadid*, at the Guggenheim Museum, New York, in 2006 and in an exhibition, *Zaha Hadid: Architecture & Design*, at the Design Museum, London, in 2007.

80 It should be noted that Hadid often collaborates with other artists when creating her designs.

81 The series included a collection of seating pieces and tables that could be upholstered or made of painted wood.

82 The elegant painted finishes of the wooden pieces in the *Z-Scape* series deny their very materiality. Likewise, a bench (2003) done for the Max Protetch Gallery in New York is made of aluminum but has a lacquered finish.

83 The bookcase was made in a large and small version, the latter being fabricated of stainless steel. Arad, interview.

84 The design was made in two versions: a wide model, *Papardelle*, which has a "tongue" element to the front, and a narrow version, *Looploop*.

85 The idea of a continuous chair goes back to such *fin-de-siècle* designers as Carlo Bugatti and his *Cobra* chair (1902) and was used by other designers throughout the twentieth century. It would remain an important theme in Arad's work for some fifteen years.

86 Bengtsson is another Scandinavian designer who broke with the strong Modernist tradition in the Baltic countries. As noted earlier, he is a Dane who initially studied with Niels Hvass but now works in London and Sweden.

87 Bengtsson believes his chaise is one of the first pieces of carbon fiber furniture to be made completely by a machine rather than handcrafted. Mathias Bengtsson, interview by R. Craig Miller, September 22, 2004. Earlier designers, such as Alberto Meda, had made chairs of carbon fiber; but they required expensive molds and a considerable amount of hand work. Bertjan Pot, interview by R. Craig Miller, July 22, 2005.

88 With the aid of a complex computer program, the chair is made layer by layer using a laser beam. This method allows a designer to make virtually any kind of form that can be created with a computer program. The designer is thus free of the restrictions of the more conventional shapes created by using a mold.

89 This technology was developed by the International Development Center Adam Opel GmbH.

90 Pot believes that his design is the first chair where the actual carbon-fiber thread is exposed. In 2006, Pot transferred production of the lounge chair from his studio to the Dutch company Goods. Pot, interview; e-mail from Frank Blom, February 2, 2008.

91 Setsu Ito initially worked for Angelo Mangiarotti, which, no doubt, accounts for the use of highly sculptural forms in some of his designs.

92 Morrison maintains small offices in both London and Paris so that he can retain complete control over each project; he also works with a prescribed group of manufacturers on a one-on-one basis. Morrison assiduously avoids, to a remarkable degree, the design media circus. Morrison, interview.

93 In this sense, Morrison's approach to design is decidedly different from that of such post-Second World War Modernists as Charles and Ray Eames and also from that of such Italian Modernists of the 1960s and 1970s as Mario Bellini. Their work was very much driven by a preoccupation with new materials and technological innovations. Morrison has also noted that, given the tremendous expenses involved in developing new technologies, designers could adapt existing technologies in new manners to control the costs of their products. Morrison, interview.

94 While Morrison is outspoken in his dislike of Postmodernist design, this movement allowed designers—even Modernist ones— to look at the past with a more open perspective. Hella Jongerius has been quite articulate in talking about the freedom to look at history that such groups as Alchymia and Memphis afforded to designers of this period. Jongerius, interview. There is also a certain "Englishness" here, in Morrison's respect for tradition and the desire to do something new but not too radical. Moreover, Morrison's initial designs from the early 1980s often made use of found objects, "an economic way of simulating industrial design." As he matured as a designer, this fascination with found objects would evolve into an interest in archetypal forms, a subtle but important conceptual development. Morrison, interview.

95 This has been particularly true in Scandinavia, where Morrison became something of a cult figure. There, the Modernism of the post-Second World War period never completely went out of fashion; and when Morrison's work began to be recognized and published in the 1980s, a new generation of Nordic designers embraced his design approach, albeit often in a more cursory manner.

96 Morrison, interview.

97 *Ibid*.

98 Max Borka has noted that Van Severen was initially more of an artist than a designer. He believes that Van Severen's thinking was very much affected by his Flemish and Catholic background and that there was a strong mystical side to his personality; Van Severen's ideal was thus to create not just *a* chair but *the chair to end all chairs*. It was only late in his career, when he was working with large manufacturers, that Van Severen became more of an industrial designer. Max Borka, interview by R. Craig Miller, July 27, 2005.

99 Johan Valke, interview by R. Craig Miller, July 27, 2005.

100 When Van Severen began to experiment with such industrial materials as polyurethane, out of necessity he had to work with manufacturers that had the requisite equipment. Moniek Bucquoye, interview by R. Craig Miller, July 28, 2005. Van Severen was also very concerned with the finish on his pieces and with how wood and aluminum objects aged. He wanted his designs to show the wear of the user, since it would create a bond and history for the piece. Nick Top of Top-Mouton, interview by R. Craig Miller, July 28, 2005.

101 Top, interview; e-mail from Delphine Verplanke, March 4, 2008.

102 Van Severen began to work for Vitra in late 1994 but did not produce his first design, the *.03* chair, until 1999. E-mail from Rolf Fehlbaum, February 7, 2008.

103 In his later years, Van Severen also devoted considerable attention to his work as a photographer. Bucquoye, interview.

104 A comparison of the two designers perhaps affords some larger perspective on the complexities and contradictions of design during these decades. Both Van Severen and Arad were trained as architects; they initially established studios to handmake their pieces; their designs were driven by the materials and the making of the objects; both eventually turned over the production of their early designs to other companies; and both made the transition to being industrial designers. Yet their work could not be more different.

105 The seating panel was originally available in beech or aluminum. A variation with a polyester seating panel was made in 1994.

106 The design came in an array of colors, including orange, fuchsia, sky blue, and various shades of green.

107 The chair came in two versions: a side chair, and a stackable chair. It was originally made in five colors: black, blue, red, green, and light gray.

108 The sofa also came in white, green, and black.

109 The differences are striking when one compares Morrison's designs to those of Citterio (the *Mobil* and *Apta 9630* storage units: 1994, fig. 143; 1996, fig. 151) and NPK (the *Perception* storage system: 1992, fig. 154).

110 The *K7V90* wall-mounted bookcase (1990) is perhaps the most obvious example.

111 The polycarbonate panels are sanded to create a subtle texture. Top, interview.

112 The different backgrounds of the brothers have made for an effective team. Ronan (b. 1971) studied design, while Erwan (b. 1976) studied art. They began to work together in 1999.

113 Indeed, the Bouroullecs have noted that the Dutch clearly identified many of the problems facing European design in the 1990s but, from their perspective, failed to answer them adequately. Bouroullec brothers, interview.

114 Rolf Fehlbaum has noted that the brothers have a maturity beyond their age: the skills

to mediate in a large industrial company and yet translate their ideas into tangible objects. He has also noted that they have an uncanny ability, like the Eameses, to supervise the photography of their work so that they are able to capture its essence and thus communicate it to the media. Fehlbaum, interview.

115 Bouroullec brothers, interview.

116 Grcic's heritage is complicated. He was actually born in Munich but had a Serbian or Yugoslavian father. He then did his schooling in the United Kingdom. Because of visa problems with the European Union, he ultimately settled in Munich, where he finally became a German citizen in 1993. Konstantin Grcic, interview by R. Craig Miller, March 28, 2005; e-mail from Irina Sasse, February 28, 2008.

117 With his knowledge of the history of twentieth-century design, Grcic is fascinated by the complexities and connections that have occurred between major movements in different countries. He has also studied the careers of individual designers as they have been forced to relocate with the upheavals in European history. Grcic, interview.

118 Grcic has noted that it was Makepiece who instilled in him a "spirit," an appreciation for quality and a respect for good work, i.e. a realization that his life was his work. Grcic further noted that it was while he was at the Makepiece school that he began to study the history of design and discover such artists as Gerrit Rietveld. The tradition of the craftsman/designer would become very important for Grcic, as it would for many Dutch designers in the 1990s, as we shall see shortly. Grcic, interview.

119 Morrison was Grcic's teacher at the Royal College of Art, and Grcic briefly worked for Morrison in London. Grcic, interview.

120 The Eames design had a metal frame and wood panels, many of which were quite colorful.

121 The story has often been told that Citterio learned how to design an office chair by repeatedly taking apart and reassembling Eames office chairs.

122 The "ribs" in the seat and back panels are the result of Pensi's desire to use the minimum amount of material. The *Toledo* chair may also be seen as an elegant update of Hans Coray's aluminum *Landi* armchair (1938). Jorge Pensi, interview by R. Craig Miller, February 24, 2005.

123 The table is available in black, white, and birch versions. BarberOsgerby, interview by R. Craig Miller, February 9, 2005.

124 NPK was one of the first industrial design firms to be established in The Netherlands. Bruno Ninaber van Eyben, whose work is featured elsewhere in *European Design*, was a member of the firm from 1985 to 1997.

125 The Bouroullec brothers, in particular, have spoken about how they like having this duality in their work. Bouroullec brothers, interview.

126 Van Severen began his studies for a new series of cutlery in 2002 and built a large study collection as part of the design process. In 2004, he produced a booklet, *Food & Tools for Food*, to present his ideas to Alessi. The project was under consideration by the Italian manufacturer for a year but was ultimately transferred to the Belgian company When Objects Work in 2006. E-mail from Moniek Bucquoye, February 6, 2008; Borka, interview.

127 The service was handmade in a limited edition of 999. The extraordinary attention to detail is perhaps best illustrated by the spoon. The inside of the spoon is white lacquer, while the exterior comes in blue, mint green, or red. The spoon is lacquered in Japanese *urushi* lacquer sixty-five times to achieve the proper surface. E-mail from Beatrice De Lafontaine of When Objects Work, May 7, 2007.

128 There were eight pieces in the series. Bruno Ninaber van Eyben, interview by R. Craig Miller, July 22, 2005.

129 Originally made by Element Design, the *Arcus* candlestick was later produced in ceramic by Rörstrand.

130 His designs are generally handmade in editions of seven.

131 Törnell's design consists of square, rectangular, and round forms decorated with blue and green glazes.

132 For the entire series, see Gregoire Gardette and Michel Baverey, eds, *Des designers à Vallauris, 1998–2002*, Paris (Centre National des Arts Plastiques) 2003.

133 The vase was made in an edition of 1000.

134 It has often been widely assumed that the major developments in the glass field during this period were being made by Studio Movement artists.

135 Stefan Yetterborn in Stockholm was asked by Iittala to select a group of international designers to create a new collection. The

Relations series was a considerable success for the company in terms of creating a new image in the European design market but was less successful financially.

136 The *Essence* series is a true industrial design: the bowl of the goblet is blown in a mold, while the stems are created using injection molding; 50,000 pieces can be made in a day. Alfredo Häberli, interview by R. Craig Miller, March 8, 2005.

137 The carafe was originally made in blue and pink glass; there was also a clear model.

138 Monica Guggisberg and Philip Baldwin were trained in Sweden, and only later in their careers began to work in Venice with Italian glassmasters and such firms as Venini. Likewise, Møhl initially studied glassmaking in Denmark and later worked with Venetian masters, such as Lino Tagliapietra at Pilchuck (1996) and Haystack (1997 and 2000) in the United States.

139 The designers were concerned primarily with using a minimum amount of material to make the hanger and a minimum amount of shipping space; 200 hangers could be stacked in a single box. The shirt-hanger was made in limited numbers for Levi Strauss displays but could readily be adapted for mass production.

140 The vase was originally made of ceramic by Ewans et Wong but was later produced in injected ABS (a common type of plastic) by Cappellini.

141 De Lucchi, interview.

142 De Lucchi has noted that he had been studying Scandinavian lights, such as Jacob Jacobsen's *Luxo L-1* task lamp (1937). De Lucchi, interview.

143 Grcic, interview.

144 While Levy works in a prolific design office, perhaps his most creative work as an artist is in the lighting field. Levy's lighting designs are generally created independently of his studio, although the *XM3 Duo* light is actually made by Ldesign. Arik Levy, interview by R. Craig Miller, November 16, 2004.

145 Indeed, Heine's *D-Lux* camera consciously recalls the shape and structure of the classic *Ur Leica* camera (1913).

146 This design is characteristic of Crasset's early work when she was collaborating with Starck at Tim Thom, Thomson's multimedia research center. There were, in fact, a number of young French designers who worked for Starck in the 1990s and who would go on to have individual careers of note. Crasset's later, mature work is much more conceptual

in nature and perhaps grew out of her early training with Denis Santachiara in Milan. Crasset has noted that she liked his way of thinking: to use technology as a means of introducing a sensibility to design. Matali Crasset, interview by R. Craig Miller, November 9, 2004.

147 The Bouroullecs' *Rock* storage system (2006) for Vitra also hints at an increased complexity of form in their work.

148 Grcic has noted that, by 2000, he felt that the Minimalism of the 1990s was no longer powerful or fresh; what had once been simple and elegant had now become banal and somewhat boring. He wanted to try to define a new direction and perhaps put a little "ugliness" into design. Grcic, interview.

149 Morrison's remarks were quoted in Alice Rawsthorn, "A Designer Who Marries Practicality with a Distinctive Style," *International Herald Tribune*, iht.com/articles/2006/12/10/opinion/design11.php, December 10, 2006, accessed July 2007.

150 At the same time, Newson created the *Pod of Drawers* cabinet (1988), which is more overtly Postmodernist, since it was inspired by an Art Deco piece designed by André Groult.

151 The chair was available in black, red, pink, yellow, and green neoprene. Cappellini also produced versions with fabric upholstery.

152 Arad has also noted that there was a dramatic change in his office in about 1993. He closed One Off and opened Ron Arad Associates. There was also a shift in personnel, from craftsmen handmaking objects to people operating computers. Arad, interview.

153 Arad's early mass-produced designs were not especially innovative. Manufacturers often simply took his highly sculptural metal forms and made them in polyurethane with stretch-fabric upholstery. It would take him some years to make the transition to creating original designs for industry.

154 This blurring of the lines between Postmodernism and Modernism was characteristic of a number of major designers in the mid-1990s, including Starck and De Lucchi, for contemporary European design was in a period of ambiguous transition.

155 B.O.O.P. stands for Blown Out of Proportion. Arad also produced a variation of these forms for a tableware series for Alessi called the *Baby Boops* (2001).

156 Arad has noted that he initially thought of leaving the rough weld marks as part of

the design but ultimately made the decision to make the pieces more pristine. Arad, interview.

157 According to Arad, it takes about two weeks to make a single lamp using the rapid prototyping process. Arad, interview.

158 Ann Wahlström, interview by R. Craig Miller, September 18, 2004.

159 The vase was also available in a black ceramic version.

160 Arad made a number of limited-edition variations of this design in metal, carbon fiber, and even uncut shell forms.

161 This was an idea that resonated throughout the design arts in the nineteenth century, particularly in the field of architecture. Some designers were creating more "industrial" public buildings made of iron, glass, and concrete—train stations, exposition halls, etc.—which, at the time, were considered great feats of engineering. Simultaneously, others were designing eclectic buildings in almost every historical style. This dichotomy of design approaches has continued right up to the present.

162 Among the first products to receive wide attention for their use of translucent plastics were James Dyson's DC 02 vacuum cleaner (1993) and the Apple Design Team's Apple iBook laptop computer (1999) and Power Mac G4 desktop computer (2000).

163 The café chair, in particular since Starck's early success with the Dr. Glob armchair (1988; figs. 50, 84), has become the "test" for an emerging industrial designer: to create an inexpensive but iconic form that sells by the hundreds of thousands for an international market.

164 The teapot was first introduced in 1993 by the Copenhagen furniture company Paustian A/S. In 1997, it became part of a series for Royal Copenhagen that included an orange squeezer, salad bowl, and cup. Jensen has noted that he chose yellow—rather than the traditional Danish blue—for the glaze since he wanted "a radical color for radical forms." Ole Jensen, interview by R. Craig Miller, September 15, 2004; e-mail from Jensen, February 18, 2008.

165 The cult of the star designer was so popular in this period that manufacturers of everyday products—such as bottled water—resorted to hiring famous designers to give their product publicity and a slight edge in the market. Didier and Clémence Krzentowski at Galerie kreo in Paris were extremely savvy

in building the reputations of some of the designers in their stable by having them design similar utilitarian products for major French companies. Clémence Krzentowski, interview by R. Craig Miller, November 6, 2004; Didier Krzentowski, interview by R. Craig Miller, November 7, 2004.

166 The term "neo" was not used in the analyses of the Geometric Minimal and Biomorphic movements since, in many respects, they were continuations of Modernist movements that began in the post-war period and persisted into the late twentieth century unabated, particularly in Scandinavia, Switzerland, and The Netherlands.

167 Penny Sparke has noted in her essay that the early Pop movement "was the intermediary between Modernism and its 'other,' " i.e. Postmodernism.

168 In the early 1990s, Dixon adapted a number of his early designs for production by Cappellini; among the most notable pieces was the Bird chaise longue (1990). In 1997, he started the Space Gallery in London as a means of producing and selling his work. In 1999, Dixon joined Habitat and tried to give the English company a new image. In 2004, he became creative director for Artek in Finland and its various divisions. Tom Dixon, interview by R. Craig Miller, November 24, 2004.

169 Jerszy Seymour, interview by R. Craig Miller, July 14, 2005.

170 The Monkey Boys was founded by Bertjan Pot and Daniel White and existed as a design group from 1999 to 2003. The Knitted lights are, of course, a variation of Marcel Wanders's Egg vase (1997; fig. 266), in which a condom is stuffed with eggs and then dipped in porcelain. Pot, interview.

171 Compared to similar Italian designs, the piece is not that advanced technologically; however, the Flower table/stool is one of the few Scandinavian Modernist designs that breaks from the norm of using bent wood or simple metal frames.

172 The history of the evolution of the Snowcrash group in the late 1990s is rather complicated. It initially grew out of an exhibition in Milan and the Valvomo group in Finland. Eventually, it was acquired by the Swedish company Proventus and was based in Stockholm. It became more of a theoretical think-tank and lasted only into the early 2000s, since it was ultimately not able to create a niche for itself in the commercial market. Daniel Sachs, interview by R. Craig

Miller, September 20, 2004; e-mail from Ilkka Suppanen, January 28, 2008.

173 The Sacco seating (1969; fig. 10), designed by Piero Gatti, Cesare Paolini, and Franco Teodoro, was one of the most famous examples of the early beanbag chairs.

174 The Bouquet and Hot Stuff watches were designed by the Swatch Lab. The Space People watch was designed by J.C. de Castelbajac.

175 The Netherlands played an important role in the development of the International Style and also produced other major movements, such as De Stijl and the Amsterdam School.

176 Loosely speaking, there are three phases to Droog Design. In the first half of the 1990s, it was just getting off the ground; its designs were straightforward pieces made by the designers in limited editions. In the second half of the decade, the work became more sophisticated; pieces were being made with other companies or institutions. Now, in the 2000s, with many of the original designers having moved on, Droog Design is currently working with a younger generation of international designers.

177 This is an idea that has been expanded upon by other Dutch designers, such as Maarten Baas, as we shall see in the context of the Neo-Dada/Surreal design movement.

178 Jurgen Bey, interview by R. Craig Miller, July 21, 2005.

179 Jongerius, interview.

180 This PVC coating is used to cover and protect airplanes when they are put into long-term storage. Bey, interview.

181 Renny Ramakers and Gils Bakker, eds, Droog Design: Spirit of the Nineties, Rotterdam (010 Publishers) 1998, p. 124.

182 There were three versions of Birgisson's cupboard; each one featured a different eighteenth-century image. Hrafnkell Birgisson, interview by R. Craig Miller, July 16, 2005.

183 One of his most famous designs is the Concrete chair (1981), which caused considerable consternation among Swedish Modernists when it first appeared.

184 The following analysis of Wanders's design approach is taken from an extensive interview with the designer. Wanders, interview.

185 It was, of course, such groups as Memphis that made the past and vernacular objects respectable again. But Wanders also sees his generation as one of evolution, not revolution, in contrast to earlier periods in

the twentieth century; hence the ability of designers today to move freely from one era to another for inspiration. Wanders, interview.

186 Indeed, Wanders became frustrated with Droog Design because he felt it did not have the capabilities in its early years to readily fabricate and distribute its designs. In response, he founded Wanders Wonders in 1998 to make his own work, which eventually evolved into Moooi in 2000. Wanders tried with Moooi to create a new kind of industrial company, one that would allow him to grow and experiment as a designer; this idea was not altogether successful and would eventually lead to questions about Wanders's reputation. There is a certain irony here in that the conceptual basis for Moooi may ultimately prove to be more important than the work actually produced. Wanders, interview.

187 Ibid.

188 There were three sizes in the series: small, medium, and large. Wanders, interview.

189 The Pollinosis vase was part of the Airborne Snotty series that also included the Ozaena, Influenza, Sinusitis, and Coryza models.

190 Crasset began her career working for Philippe Starck, developing a series of product designs for Thomson Multimedia. Like Starck, she has assiduously built a considerable reputation for herself with the media, such that her personality is now often as important as her actual work.

191 The design was made for the Deliciously Decadent exhibition at the Princesshof Museum in The Netherlands, March–October, 2004. Wieki Somers, interview by R. Craig Miller, July 22, 2005.

192 In Roman times, animals were a "symbol of richness," hence the choice of a skull form for a high tea ceremony. Somers, interview.

193 Here, Somers is making a sly comment on the use of fur as a luxury material in the fashion industry; she is also making, like other activists, a protest about the killing of animals. Somers, interview.

194 The pot was produced using either bone china or porcelain. As its name suggests, the former contains real bone and makes for a whiter finish. Somers, interview.

195 Jongerius, interview.

196 Jongerius plays with traditional craft techniques as well as industrial methods, often at the same time. She does not, however, consider herself to be a craftsperson. Increasingly, Jongerius is blurring the lines between craft and industry

as she tries to achieve serial or mass production of her work. Jongerius also wants the user to see how her objects are made. Jongerius, interview.

197 Jongerius has noted that while the Postmodernist movement had little influence in The Netherlands in the 1970s and 1980s, one of the most important offshoots of Memphis was that the past no longer created negative emotions for designers. Jongerius, interview.

198 This design approach was quite controversial at the time, since Jongerius had not designed a new form. Jongerius, interview.

199 Ibid.

200 There were two versions in the series: the Princess vase had a floral pattern, and the Prince vase had a dragon decoration.

201 A second version of the vase features embroidery in the holes. For Jongerius, ceramics and textiles have historically been regarded as "decorative." Jongerius believes that the ceramics examined here are the closest she has come to working in the art—versus design—arena. Jongerius, interview.

202 Ibid.

203 Robert Wettstein, interview by R. Craig Miller, March 8, 2005.

204 Ibid.

205 A number of these designers, including Wettstein and Pierre Charpin, have also acknowledged the important influence of Ettore Sottsass and Memphis on their work. Wettstein, interview; Pierre Charpin, interview by R. Craig Miller, November 18, 2004; François Bauchet, interview by R. Craig Miller, November 18, 2004.

206 Wettstein, interview.

207 Ramakers and Bakker, Droog Design, p. 26.

208 While many of these Neo-Dada/Surrealist designers were Spanish by birth, they were soon scattered across Europe.

209 In 2007, the exhibition Surreal Things: Surrealism and Design appeared at the V&A in London and two other major European museums. See Surreal Things: Surrealism and Design, exhib. cat., ed. Ghislaine Wood, London, V&A Museum, March–July 2007.

210 One should also add that Starck often creates with great élan, Surreal theatrical effects in the interiors of his hotels and restaurants.

211 As with other Modernist lighting companies, FLOS's innovations of the 1960s and 1970s were the result of an interaction between form, material, and the type of bulb employed. Vicenconte, interview (see note 51). This same design approach may be seen even more forcefully in Starck's Gun collection (2005; fig. 297).

212 Regarding Starck's Gun collection, hivemodern.com notes: "The gold of the weapons represents the collision between money and war. Table Gun symbolizes the East, Bed Side Gun symbolizes Europe, Lounge Gun stands for the West. The black shade signifies death. The crosses on the inside [of the shade] are to remind us of our dead ones." The same site quotes Starck as saying: "weapons are our new icons. Our lives are only worth a bullet." Accessed July, 2007.

213 Denis Santachiara, interview by R. Craig Miller, April 18, 2005.

214 The tongue is a piece of red fabric animated by a fan and light in the base of the sofa.

215 Nora De Rudder, interview by R. Craig Miller, July 28, 2005.

216 Ibid.

217 As the firm has grown, it has produced more conventional industrial design work, although the partners continue to experiment and create Surreal work on their own. RADI DESIGNERS, interview by R. Craig Miller, November 10, 2004.

218 Maarten Baas, interview by R. Craig Miller, July 25, 2005.

219 The original version, illustrated here, had a metal-and-wood frame covered with foam and printed upholstery. It was later made in a curved resin version. RADI DESIGNERS, interview.

220 Ibid.

221 The Mico can be used in a number of configurations, as either a toy or a seat.

222 El Último Grito, interview by R. Craig Miller, February 10, 2005.

223 Cathrine Maske, interview by R. Craig Miller, September 10, 2004.

224 Maske is a quite beautiful woman; and the human photos are shots of herself, intended to capture and preserve her youth. Maske, interview.

225 Ibid.

226 Baas, interview.

227 For Proust, Mendini also used a Rococo Revival chair but painted the surface in a Seurat-like manner.

228 Again, one may cite Mendini's pervasive influence: in the late 1970s, he created a series of controversial furniture designs consisting of altered Modernist classics.

229 Martí Guixé, interview by R. Craig Miller, February 22, 2005.

230 This idea of using tape as a design element is contemporaneous with Hella Jongerius's Groove and Long Neck bottles (2000; fig. 280).

231 The chair is named for the Galeria h2o in Barcelona, one of the primary advocates of this kind of radical Neo-Dada/Surreal design in Spain. In the design of the h2o chair, Guixé is perhaps also referring back to a distinctive Spanish furniture form, the taburete or silita de estrado, which appeared as early as the seventeenth century and continued for several hundred years. Reflecting the influence of Muslim customs, these chairs have very short legs and were used on a raised platform (estrado). They were often called "dwarf chairs" because of their diminutive size. I am indebted to Donna Pierce, Curator of Spanish Colonial Art at the Denver Art Museum, for pointing out this historical reference.

232 This is particularly true of her designs for sheets, T-shirts, and underwear, as well as chocolates and tampons.

233 Emiliana Design, interview by R. Craig Miller, February 22, 2005.

234 Serrano now calls the Playboy fixture the Clothes Hanger light.

235 Colucci also frequently saws a piece of furniture "in half" and then creates a new addition to the existing form, generating discordant but compelling designs. Claudio Colucci, interview by R. Craig Miller, November 8, 2004.

236 The lamp was also made using other spinning forms for an exhibition at the Cartier Foundation in Paris, April–May, 1999. RADI DESIGNERS, interview.

237 The idea that objects have layered meanings or tell stories is a recurring theme with many of the Neo-Dada/Surreal designers. Colucci, interview; RADI DESIGNERS, interview.

238 The use of polycarbonate to create a translucent piece of furniture was an important technical feat for Kartell. Starck had designed the La Marie chair in 1999 using one mold and one point of injection. The more complex shape of the Louis Ghost chair required three points of injection to create a completely translucent design. Luti, interview.

239 The lamp was made in a number of finishes: clear, smoke black, chrome-plated, and 24-carat gold plate.

240 Wanders, interview.

241 Ibid.

242 Bey, interview.

243 This service was designed for the Delft in Detail exhibition at the Gemeentemuseum in The Hague in 2001.

244 The seams and imperfections in Jongerius's early vases may, in retrospect, be seen as a kind of rudimentary surface decoration, which she would enlarge upon as she became more comfortable working with historical motifs and patterns.

245 Jongerius, interview.

246 Ibid.

247 Ibid.

248 This design is a variation on a series of prototypal designs, the Layers furniture collection, produced for Moss in New York in 2006.

249 Jongerius, interview.

250 A number of talented designers across Europe are pursuing a similar design approach; however, they have not—at least at this point in time—produced a large enough body of work to merit inclusion in such a major survey as this. They include such figures as Louise Campbell in Denmark and the Spanish designer Eduardo Navarro, who resides in Germany.

251 Boontje characteristically uses combinations of sheer fabrics, such as organza and chiffon, with cotton in brilliant colors. The garlands and decorative appliqués are also important elements in Boontje's designs, for he likes to incorporate animal forms (cows, rabbits, horses, butterflies, etc.) and naturalistic motifs (vines, flowers, etc.) as a means of triggering memories and as a way of creating stories.

252 The Table Stories series was made in red, blue, and white patterns; it also included a line of textiles.

253 This design harks back to the earlier TranSglass [sic] series (1997) by Boontje, in which he used recycled bottles to make decanters, tumblers, and vases.

254 This series was produced for an exhibition at the Groninger Museum in Groningen, The Netherlands, May–September, 2003.

Designers' Biographies

Christopher Masters
Meredith Evans
Robin Enstrom

Ron Arad (b.1951, Israel; resides United Kingdom; ronarad.com; Jerusalem Academy of Art, Israel, 1971–73; Architectural Association, London, England, 1974–79). Ron Arad's work ranges from architecture and furniture to product design. His clients include Gallery Mourmans, Kartell, Moroso, One Off, the Ron Arad Studio, and Vitra.

Arad has achieved considerable international success. In 1994, he was named Creator of the Year at the Salon du Meuble, Paris. In 1999, he received the Design Plus award and the Baden-Württemberg International Design Award. The year 2001 was particularly prolific: he was co-winner of the Perrier-Jouët Selfridges Design Award, and winner of the Primavera International Award for Design, the Gio Ponti International Design Award, and the Oribe Art and Design Award. In 2004, Arad was named Designer of the Year by *Architektur & Wohnen* magazine; a year later, he was named Designer of the Year in the FX Awards. Additional awards received include the Jerusalem Prize for Arts and Letters in 2006; the Visionaries! Award, presented by the Museum of Arts and Design, New York, also in 2006; and the Contemporary Art Prize, presented by the French Friends of the Tel Aviv Museum of Art, Paris, in 2007.

Maarten Baas (b.1978, Germany; resides The Netherlands; maartenbaas.com; Hendrik Pierson College, Zetten, The Netherlands, 1990–95; Design Academy Eindhoven, The Netherlands, 1996–2002; Politecnico di Milano, Italy, 2000). Maarten Baas is a furniture, interior, and product designer. His work is produced by himself, Moooi, and Baas & den Herder.

Bär + Knell. A German company founded in 1992 (baer-knell.de). The co-founders were Beata Bär (b.1962, Germany); Gerhard Bär (b.1959, Germany); and Hartmut Knell (b.1966, Germany). The firm's work, which includes furniture, interior design, and product design, is self-produced, and is available through its website. In 1986, it was awarded the Franz Vogt Prize for studio/partnership work.

BarberOsgerby. A British company founded in 1996 (barberosgerby.com). The co-founders were Edward Barber (b.1969, United Kingdom) and Jay Osgerby (b.1969, United Kingdom). BarberOsgerby's work includes furniture and product design for such clients as Cappellini, Coca-Cola, Established & Sons, FLOS, Levi Strauss, Magis, and Stella McCartney.

In 1998, the studio won the prize for Best New Designer at the ICFF (International Contemporary Furniture Fair) in New York. It was awarded the Jerwood Prize for the Applied Arts in 2004, and was *Blueprint* magazine's Designer of the Year in 2005. Additional honors include Designers of the Future (with Established & Sons), Design Miami/Basel, 2006; Designers of the Year, *Elle Decoration*, 2007; and the Royal Designer for Industry award, also in 2007.

François Bauchet (b.1948, France; francoisbauchet.com; École Nationale Supérieure d'Art de Bourges, France, 1970–75). François Bauchet works in a particularly wide range of media, from furniture and installations to ceramics, glass, and metalwork. His clients include Ercuis, Galerie kreo, Galerie Neotu, Haviland, and Ligne Roset.

Bauchet has received numerous awards, including an Appel Permanent grant from the VIA (French Furniture Association) for the *c'est aussi une chaise* chair (awarded in 1982); a VIA Carte Blanche grant for *à table* dishes and serving pieces (2001); the L'Oeil du Design award from *L'Oeil* magazine (2001); the VIA Label award for the *Yang* lounge chair (2002); Observeur du Design from the APCI (Agency for the Promotion and Creation of Industrial Design; 2002); the Prix du Salon du Meuble, Brno, Czech Republic (2002); and the VIA Label for the *Pluriel* chairs (2006).

Mathias Bengtsson (b.1971, Denmark; resides United Kingdom and Sweden; bengtssondesign.com; Art Center College of Design (Europe), La Tour-de-Peilz, Switzerland, 1990–94; Danmarks Designskole, Copenhagen, Denmark, 1994–97; Royal College of Art, London, England, 1997–99). Mathias Bengtsson designs interiors as well as limited-edition furniture. He has worked with several manufacturers, including Bang & Olufsen, Fritz Hansen, Georg Jensen, and Louis Poulsen. He was an awards finalist at the Copenhagen Furniture Fair, 1998; in the Ness/ *Blueprint* magazine furniture competition, 2000; and in the Peugeot Design Contest, 2001. In 2004, he received the Future City/St. James Group Outdoor Furniture award. Bengtsson is currently working with Danish manufacturer Openspace on a new carbon-fiber furniture project.

John Angelo Benson (b.1971, United Kingdom; resides United Kingdom and Japan; johnangelobenson.com; the Bartlett School

of Architecture, University College London, England, 1995–98; Art Foundation, Kingsway College, London, England, 1992–93). John Benson worked in the architecture studio of Ettore Sottsass before establishing his own, cross-disciplinary practice, in which design and conceptual art overlap. His work includes furniture, metalwork, and product design, which he produces in collaboration with art galleries and selected manufacturers.

Berghof, Landes, Rang. A German company founded in 1981 (since disbanded). The co-founders were Norbert Berghof (b.1949, Germany); Michael Landes (b.1948, Germany); and Wolfgang Rang (b.1949, Germany). The company's work ranged from architecture to interior design and furniture; its clients included Draenert. In 1987, Berghof was elected to Bund Deutscher Architekten (BDA).

Clarissa Berning (b.1967, South Africa; resides United Kingdom; Chelsea School of Art, London, England, 1987–88; Glass Center of Barcelona, Spain, 1993–95; University of Design, Helsinki, Finland, 1995–97). Clarissa Berning is a glass designer. Her clients include Hong Kong International Airport, Jigsaw, architect John Pawson, and When Objects Work.

Maria Berntsen (b.1961, Denmark; mariaberntsen.dk; Royal Danish Academy of Fine Arts School of Architecture, Denmark, 1987–90; L'École d'Architecture de Bordeaux, France, 1991–92). Maria Berntsen works as a glass, metalwork, and product designer; her clients include Georg Jensen. In 2003, Berntsen's *Quack* thermos flask won the Red Dot Design Award and the Formland Price award.

Carlotta de Bevilacqua (b.1957, Italy; Politecnico di Milano, Italy, 1978–83). Carlotta de Bevilacqua's work ranges from architecture to interior and product design. Her clients include Artemide and Danese.

Jurgen Bey (b.1965, The Netherlands; jurgenbey.nl; Design Academy Eindhoven, The Netherlands, 1984–89). Jurgen Bey's work comprises ceramics, furniture, and interior and public installation design, and is produced by Bey himself, Droog Design, Royal Tichelaar Makkum, and Moooi. Bey's awards include the Lensvelt de Architect Interieurprijs, 2003; the Prins Bernhard

Cultuurfonds prize, 2005; and the Harrie Tillieprijs, also 2005.

Hrafnkell Birgisson (b.1969, Iceland; resides Iceland and Germany; hrafnkell.com; Reykjavik School of Art, Iceland, 1991–92; Icelandic College of Arts and Crafts, Reykjavik, Iceland, 1992–93; Technical College of Hafnarfjordur, Iceland, 1993–94; Academy of Art, Saarbrücken, Germany, 1995–2000; University of the Arts, Berlin, Germany, 1999). Hrafnkell Birgisson is a furniture and product designer. His clients include Artificial, Details, Vikurprjon, and Zapping; he also produces his own work. In 1997, Birgisson received the Derag Design Award for *The Hotel Room of the Future*. In 2004, his *Lights of the Future* received first prize in the European Design Competition. Birgisson's work was recently featured in *The International Design Yearbook 2007*.

Jonas Bohlin (b.1953, Sweden; Konstfack, University College of Arts, Crafts, and Design, Stockholm, Sweden, 1981). Jonas Bohlin's work includes architecture, ceramics, furniture, glass, and interior and product design. His pieces are produced by himself, and also by Iittala, Källemo, Kasthall, Klong Interior, Klong Intermestic, and Örsjö Belysning. Bohlin received the Utmärkt Svensk Form (Excellent Swedish Design) award in 2001, and the Forum AID Award for best interior in 2003.

Tord Boontje (b.1968, The Netherlands; resides France; tordboontje.com; Design Academy Eindhoven, The Netherlands, 1986–91; Royal College of Art, London, England, 1992–94). Tord Boontje's work ranges from installations to furniture, glass, and product design. It is produced by himself, as well as by Artecnica, Moroso, Philips, and Swarovski.

Boontje has received numerous design awards. These include the Bombay Sapphire Prize for glass design (awarded in 2002); nomination, Designer of the Year, Design Museum, London (2003); Designer of the Year, *Elle Decoration* (2003); Best Lighting Design, *Elle Decoration*, for *Garland* light (2003); Reader's Choice for Future Classic, *Elle Decoration*, also for *Garland* light (2003); Best Product, New York Gift Fair, for *Midsummer* light (2004); the Dedalus Design Award (2004); Best Lighting Design, Elle Decoration International Design Awards, for *Blossom* chandelier (2004); the Interior Innovation Award,

IMM Cologne (2005); Dutch Designer of the Year (2005); the iF Product Design Award, for *Table Stories* (2006); and the Red Dot Design Award, for *Little Field of Flowers* (2007).

Ronan Bouroullec and Erwan Bouroullec.
A French design team (bouroullec.com) co-founded in 1999 by Ronan Bouroullec (b. 1971, France) and Erwan Bouroullec (b. 1976, France). Their work includes architecture, ceramics, furniture, and product design, for such clients as Cappellini, Galerie kreo, Habitat, Issey Miyake, Kartell, Kvadrat, Ligne Roset, Magis, and Vitra. They have received various awards, including the Grand Prix de la Création de la Ville de Paris (awarded in 1998); the Grand Prix de la Critique de la Presse Internationale at the Salon du Meuble, Paris (1998); nomination, the Premio Compasso d'Oro ADI, for *Spring* armchair (2001); the Nombre d'Or at the Salon du Meuble, Paris, shared with Cappellini (2001); Creator of the Year at the Salon du Meuble, Paris (2002); and Designer of the Year, Elle Decoration International Design Awards (2002). In 2005, their *Facett Collection* received the Red Dot: Best of the Best award in the living-room and bedroom furniture category. In 2006, they were named as Designer of the Year by *Elle Deco* (Japan).

Fernando Brízio (b. 1968, Angola; resides Portugal; Fine Arts Faculty of Lisbon, Portugal, 1996). Fernando Brízio's work includes ceramics, furniture, glass, and product design, for such clients as Cor Unum, Details, DIM-Die, Droog Design, Experimenta Design, Fabrica, Galerie kreo, the choreographer Rui Horta, Intramuros, Lux/Atalaia, M Glass, Modalisboa, and Protodesign. As a professor and Head of Design at ESAD.CR (School of Art and Design, Caldas da Rainha), and as Visiting Professor at ECAL (the University of Art and Design Lausanne), he has participated in numerous conferences. His work has been exhibited and published internationally.

Pierre Charpin (b. 1962, France; pierrecharpin.com; École Nationale Supérieure d'Art de Bourges, France, 1980–84). Pierre Charpin works with ceramics, furniture, and glass; his clients include Alessi, Galerie kreo, Manufacture Nationale de Sèvres, Montina, Post Design, Venini, and Zanotta. In 1996, Charpin received a Carte Blanche grant (for the *Camp Meeker* rocking chair) from the VIA (French Furniture Association). In 2005, he was named Creator of the Year at the Salon de Meuble, Paris.

Antonio Citterio (b. 1950, Italy; antoniocitterioandpartners.it; Politecnico di Milano, Italy, 1968–72). Antonio Citterio works in the fields of architecture, furniture, and interior and product design, creating pieces for such clients as B&B Italia, FLOS, Hackman, Iittala, Kartell, and Vitra. He has received numerous awards, including the Premio Compasso d'Oro ADI in 1987, 1991, 1994, 1995, and 1998. In 2007, he was the recipient of the Royal Designer for Industry award.

Claesson, Koivisto, Rune. A Swedish company founded in 1995 (claesson-koivisto-rune.se). The three co-founders were Mårten Claesson (b. 1970, Sweden); Eero Koivisto (b. 1958, Sweden); and Ola Rune (b. 1963, Sweden). The company's work includes architecture, furniture, and interior and product design, for such clients as Asplund, Cappellini, David design, E & Y, Iittala, and Offect.
From 1993 to 1996, and from 1998 to 2000, Claesson, Koivisto, Rune won the Utmärkt Svensk Form (Excellent Swedish Design) award. In 1998, it was awarded the grand prize (for exhibition design) at the Formex Design Fair in Stockholm. In 2000, it received the Guldstolen ("Golden Chair") bi-annual award (for the Sony Music headquarters, Stockholm) from the National Association of Swedish Interior Architects (SIR), and the jury award (for *The Future of Wood in Our Homes* housing project) at the Bo01 building fair, Malmö.

Claudio Colucci (b. 1965, Switzerland; resides France and Japan; colucci-design.com; École des Arts Décoratifs, Geneva, Switzerland, 1983–88; École Nationale Supérieure de Création Industrielle (ENSCI), Paris, France, 1988–92; Kingston University, London, England, 1989–90). Claudio Colucci's self-produced designs encompass architecture, furniture, and interior and product design. In 2000, he was one of the Creators of the Year—together with the RADI DESIGNERS group—at the Salon du Meuble in Paris; he also received an Appel Permanent grant (for a lamp) from the VIA (French Furniture Association), and was the winner of the "Marche" project, Daikanyama, Tokyo. Colucci's many other awards and honors include winner of the Suzi Wan competition, 2001; Designer of the Year, *Elle Decoration* (France), 2003; and winner of the Tokyo Designers Block prize for best exhibition, 2004. In 2005, he was awarded the Janus du Commerce for the Délicabar restaurant in Paris.

Sophie Cook (b. 1974, United Kingdom; sophiecook.com; Camberwell College of Art, London, England, 1994–97). Sophie Cook is a ceramics designer, who produces her own work in her London studio. She has received several honors for her work, including, in 1997, the "Gotta Have It" award for new designers from *Elle Decoration*. In 2002, Cook was shortlisted for the Evening Standard Homes and Property Interior Product Award, and received the Adrian Sassoon Award for Arts of the Kiln. She was the winner, in 2006, of the "Best in Show" Grand Designs award at Origin, London.

Matali Crasset (b. 1965, France; matalicrasset.com; École Nationale Supérieure de Création Industrielle (ENSCI), Paris, France, 1991). Matali Crasset's furniture, glass, and interior and product designs are produced for a variety of clients, including Danese, Domodinamica, Galerie Gilles Peyroulet and Lexon with Thomson Multimedia, Galerie Thaddaeus Ropac, and the Hi Hotel.
Crasset's awards include Étoile de l'Observeur du Design from the APCI (Agency for the Promotion and Creation of Industrial Design), for *Soundsation*, designed with Philippe Starck (awarded in 2000); the Baden-Württemberg International Design Award (2002); the Nombre d'Or at the Salon du Meuble, Paris (2003); the International Interior Designer of the Year at the British Interior Design Awards (2004); and Creator of the Year at the Salon du Meuble, Paris (2006).

Creadesign Oy. A Finnish company founded in 1981 (creadesign.com). Its founder was Hannu Kähönen (b. 1948, Finland). The company's work includes product design for such clients as Abloy Oy, Benefon Oyj, and Neste Oy. In 2000, it was awarded a jubilee medal on the occasion of Helsinki's 450th anniversary, and in 2001, it received the Pro Finlandia medal from the Finnish government. Other awards include an Honorable Mention at Finndesignnow-02, Design Forum Finland, 2002; a Special Diploma granted by the World Cultural Council, 2003; a Focus Know-how Silver at the Baden-Württemberg International Design Awards, 2005; and the iF Product Design Award, 2007.

Björn Dahlström (b. 1957, Sweden; dahlstromdesign.se). Björn Dahlström is a self-taught furniture and product designer, whose clients include Iittala. He was presented with the

Utmärkt Svensk Form (Excellent Swedish Design) award every year from 1991 to 1999, and again in 2002; in 1995, he was also given the Furniture of the Year award by *Sköna Hem* magazine. His many other awards and honors include a Design Plus award, for the *Primus* blowtorch (awarded in 1996); Design Prizes in Excellent Swedish Design, for a bench and a motor-driven breaker (1996 and 1997); an Honorable Mention in Excellent Swedish Design, for Iittala cookware (1998); a Design Plus award, also for Iittala cookware (1999); and a Design Award Finland, for Hackman cookware (1999). In 2000, Dahlström received a Special Prize for Excellent Swedish Design; a year later, he was awarded the Torsten and Wanja Söderberg Prize. In 2002, Dahlström received the iF Design Award for Swedish Designer of the Year. In 2006, he was awarded the +1 Design award by Forum AID for best in show at the Stockholm Furniture Fair. In the same year, he received the Swedish Arts Grants Committee Design Award.

Michele De Lucchi (b. 1951, Italy; micheledelucchi.com; University of Florence, Italy, 1969–75). Michele De Lucchi's designs range from architecture and interior design to ceramics, furniture, glass, and product design. His clients include Artemide, Olivetti, and Produzione Privata. He was awarded the Premio Compasso d'Oro ADI in 1987, 1989 (for the *Tolomeo* table, floor, and wall lamp), 1991, 1994, and 2001 (for the *Artjet 10* printer). In 2000, he received the iF Product Design Award. His other awards include Design Plus awards, for the *Dioscuri* wall and ceiling lamp (awarded in 2000), and for the *Castore* table, floor, and suspension lamp and the *Logico* mini suspension lamp (2004); the Designpreis der Bundesrepublik, for the *Palme* outdoor light (2001); Observeur du Design from the APCI (Agency for the Promotion and Creation of Industrial Design), for the *Tolomeo* micro lamp (2001); and Red Dot Design awards, for the *Logico* table, floor, and suspension lamp (2002), the *Tolomeo* mega floor lamp (2003), and the *Castore* table, floor, and suspension lamp (2004).

Nora De Rudder (b. 1958, Belgium; noraderudder.com; Royal Academy of Art, Ghent, Belgium, 1978–82). Nora De Rudder produces her own work, which includes furniture, installations, interior design, and product design. She has recently collaborated with Philippe Starck on projects in China and (with Yoo Interiors) in New York. Her work in lighting has received high

acclaim, and has recently been acquired by Marriott Hotels; the Province of East Flanders; the Design Museum, Ghent; and the Museum of Modern Art, Ghent. De Rudder is currently working with Vitrapoint Gent.

Tom Dixon (b.1959, Tunisia; resides United Kingdom; tomdixon.net; Chelsea Art School, London, England, 1978). Tom Dixon's work, ranging from furniture, installations, and interior design to glass, metalwork, and product design, is made for such clients as Cappellini and Eurolounge. In 2000, he was honored with an OBE for services to design and innovation. In 2007, Dixon won Best Retail Design at the Condé Nast Awards, and Best Lighting in Show at the ICFF (International Contemporary Furniture Fair) Editors Awards.

André Dubreuil (b.1951, France; Inchbald School of Design, London, England, 1969–70; Académie Charpentier, Paris, France, 1972–73). André Dubreuil's designs, for furniture and metalwork, are produced in his studio, A.D. Decorative Arts. He regards himself as a craftsman and artist dedicated to the traditions of the goldsmith. His work is available through Galerie Mougin, Paris.

Sylvain Dubuisson (b.1946, France; sylvaindubuisson.com; École Supérieure d'Architecture de Saint-Luc, Tournai, Belgium, 1975). Sylvain Dubuisson's work, which includes architecture, furniture, glass, interior design, metalwork, and product design, is produced by himself, as well as by Algorithme and édition Fourniture. In 1989, he received a Carte Blanche grant (for a desk for Jack Lang) from the VIA (French Furniture Association). In 1990, he was named Creator of the Year at the Salon du Meuble, Paris.

James Dyson (b.1947, United Kingdom; dyson.com; Byam Shaw School of Art, London, England, 1965–66; Royal College of Art, London, England, 1966–70). James Dyson's self-produced designs range from furniture to interior and product design, but it is for his eponymous vacuum cleaners that he is best known. He has received many international prizes: an award from the Design Council, UK, and the Duke of Edinburgh's Special Prize, for *Sea Truck* (awarded in 1975); the Building Design Innovation award, for *Ballbarrow* (1977); the International Design Fair prize, Japan, for *G-Force* (1991); and the Industrial Design Prize of America, the Institute of Engineering

Designers Gerald Frewer Trophy, and the Chartered Society of Designers Minerva Award, all for the vacuum cleaner.

Piet Hein Eek (b.1967, The Netherlands; pietheineek.nl; Design Academy Eindhoven, The Netherlands, 1986–90). Piet Hein Eek's work includes furniture, made for his own company.

El Último Grito. A company established in 1997 (elultimogrito.co.uk) by co-founders Roberto Feo (b.1964, United Kingdom); Rosario Hurtado (b.1966, Spain); and Francisco Santos (b.1966, Spain; resides United Kingdom), who left the organization in 2000. The current partners divide their time between London and Berlin. The company's work includes furniture, installations, and interior and product design, for such clients as Magis, British Airways, and Marks & Spencer. It also manufactures its own designs.

Thomas Eriksson (b. 1959, Sweden; tea.se; Royal Institute of Technology, Stockholm, Sweden, 1981–85). Thomas Eriksson's designs include architecture, furniture, and interior design, for such clients as Cappellini and IKEA. Eriksson has won many awards. In 1995, the Stockholm Design Lab (SDL; co-founded by Eriksson) received an award for the *PS* furniture range by IKEA. In 1999, Eriksson and SDL were honored with an Utmärkt Svensk Form (Excellent Swedish Design) award for their corporate identity program for Scandinavian Airlines. In 2001, the same project gained first prize in the Core Design Awards.

Christian Flindt (b.1972, Denmark; christianflindt.dk; Aarhus School of Architecture, Denmark, 1995–2002). Christian Flindt's work, which includes furniture, lighting, and product design, is self-produced and available through his website.

In 2003, Flindt was awarded a travel grant to Japan for the IDEE Design Competition, and a three-month working grant, from the State Workshop for Art/Design, to develop a new stacking chair. He also received grants in successive years from the Statens Kunst Fond in Denmark and the Danish National Bank. In 2005, he received *Bo Bedre* magazine's Design Award, for the world's first side-stacking chair. More recently, in 2006, he was named *Bo Bedre*'s Designer of the Year, and, in 2007, won *Bolig Magasinet*'s Best Design award, for *Orchid*. In

2008, he was nominated for the Forum AID Award, for his *Flindt Lamps* series for Louis Poulsen Lighting.

Monica Förster (b.1966, Sweden; Anders Beckman College of Design, Stockholm, Sweden, 1995; Konstfack, University College of Arts, Crafts, and Design, Stockholm, Sweden, 1997). Monica Förster's work, which includes furniture and product design, is made for such clients as David design, E & Y, Nola, Offecct, Poltrona Frau, Skruf, Tacchini, and Väveriet. In 1998 and 1999, she won awards from the Sweden Innovation Center. In 2000, she received the Design Plus award, for her *Silikon* lamp. Other awards include the Utmärkt Svensk Form (Excellent Swedish Design) award with Honorable Mention (received in 2002); the FutureDesignDays Award (2002); Designer of the Year, Yo! Stockholm (2003); Coolest Invention, *Time* magazine (2004); and Best Product, *Time* magazine (2005).

Massimiliano Fuksas and Doriana Mandrelli Fuksas. An Italian partnership (fuksas.it) comprising Massimiliano Fuksas (b.1944, Lithuania; resides Italy) and Doriana Mandrelli Fuksas (b. after 1946, Italy). Their work, which includes architecture, furniture, and metalwork, for such clients as Alessi, has been widely acclaimed. In particular, they have received numerous honors in the field of architecture. In 2002, Doriana, who directs Fuksas Design, was named Officier de l'Ordre des Arts et des Lettres de la République Française.

Olivier Gagnère (b.1952, France; gagnere.net). Olivier Gagnère is a self-taught designer of ceramics, furniture, glass, interior design, metalwork, and product design. His clients include Bernardaud, Cartier, Christian Dior Parfums, Cristallerie de Saint-Louis, Fourniture, Fukagawa Porcelain, Galerie kreo, Galerie Maeght, Lancôme Parfums, and Van Cleef. In 1983, he received an Appel Permanent grant from the VIA (French Furniture Association); in 1990, the VIA awarded him a Carte Blanche grant. In 1998, he was declared Creator of the Year at Maison & Objet, Paris.

Garouste & Bonetti. A French company, founded in 1980. The co-founders were Elizabeth Garouste (b.1949, France) and Mattia Bonetti (b.1952, Switzerland; resides France). The company's designs include ceramics, furniture, interior design, metalwork, and product design, for such

clients as Daum and Galerie Neotu. Its awards include sponsorship in 1981 (for the *Chaise Barbare*) and a Carte Blanche grant in 1989 (for the Patchwork Collection) from the VIA (French Furniture Association).

Anna Gili (b.1960, Italy; annagili.com; Istituto Superiore per le Industrie Artistiche (ISIA), Florence, Italy, 1980–84). Anna Gili's designs include ceramics, furniture, glass, installations, metalwork, and product design, for such clients as Salviati.

Konstantin Grcic (b.1965, Germany; konstantin-grcic.com; John Makepeace School for Craftsmen in Wood, Parnham College, England, 1985–87; Royal College of Art, London, England, 1988–90). Konstantin Grcic's work in ceramics, furniture, glass, installations, and product design has been for a variety of clients, including Agape, Authentics, Cappellini, ClassiCon, Cor Unum, Driade, FLOS, littala, Krups, Magis, Moroso, and Serafino Zani. He is currently working on projects with BASF, Herzog & de Meuron, and Plank.

Grcic has received numerous awards, including the Premio Compasso d'Oro ADI, for the *Mayday* lamp (awarded in 2001); Red Dot Design awards, for the *Chaos* side chair (2001), the *Tip* pedal-bin (2002), and the *Diana* tables (2002); the iF Product Design Award, for *Chaos* and *Diana* (2002); the Design Plus award, for *Tip* (2004); and the Chicago Athenaeum Good Design Award, for *chair_One* (2004). Other awards include the Blueprint Award: Best Interior Product, 100% Design London Awards, for the *Miura* bar stool (2005); the Design Award of the Federal Republic of Germany, Silver, for *chair_One* (2006); the iF Gold Award, for *Miura* (2006); the Interior Innovation Award, IMM Cologne, for *Miura* (2006); the Red Dot: Best of the Best award (2006); and the Design Award of the Federal Republic of Germany, Silver, for *Miura* (2007).

Dögg Gudmundsdóttir (b.1970, Iceland; resides Denmark; doggdesign.com; Istituto Europeo di Design, Milan, Italy, 1992–96; Institute of Product Design, Danmarks Designskole, Copenhagen, Denmark, 1996–98). Dögg Gudmundsdóttir's work includes furniture, glass, installations, metalwork, and product design. As well as working for such companies as Christofle, B-Sweden, and Ligne Roset, she produces her own designs at Dögg Design. In 2001, her work was recognized in the Knokke-Heist design competition, Belgium. In

2002, she was awarded the Light of the Future Award at Light + Building, Frankfurt, and was nominated for *DV* newspaper's culture prize. More recently, in 2006, she was nominated in the Orkuveita Reykjavikur design competition, Iceland, for her *Cod* lamp.

Guggisberg & Baldwin. A Swiss/American design partnership based in France, which began in 1982 (bgnonfoux.com). The co-founders were Monica Guggisberg (b.1955, Switzerland) and Philip Baldwin (b.1947, United States). Their work includes designs for glass, for such clients as Venini. In 1994, they received an award from the IKEA Foundation. This was followed, in 1997, by the Bavarian State Prize, Gold Medal, and, in 1999, the Grand Prix des Arts Appliqués from the Fondation Vaudoise pour la Promotion et la Creation Artistique, Lausanne.

Martí Guixé (b.1964, Spain; resides Spain and Germany; guixe.com; Escola Superior de Disseny, Barcelona, Spain, 1983–85; Scuola Politecnica di Design, Milan, Italy, 1986–87). Martí Guixé works in the fields of furniture, interior design, and product design, for such clients as Camper, Droog Design, Galeria h2o, Nani Marquina, and Saporiti. He won an ARQ-INFAD medal for interior design in 1985; a Ciutat de Barcelona design prize in 1999; and the National Design Prize of the Generalitat de Catalunya in 2007.

Alfredo Häberli (b.1964, Argentina; resides Switzerland; alfredo-haeberli.com; Höhere Schule für Gestaltung, Zurich, Switzerland, 1987–91). Alfredo Häberli's work, which includes ceramics, furniture, glass, and product design, has been made for such clients as Alias, Camper, Iittala, Kvadrat, and Luceplan. In 1991, he won the Diploma Prize at the Höhere Schule für Gestaltung, an SID (Swiss Industrial Designer) Prize, and an IKEA Foundation grant. This was followed by an Achievement Prize from the Hochschule für Gestaltung, Zurich (awarded in 1994); a Carte Blanche grant from the VIA (French Furniture Association; 1998); and the Designer of the Year award at Now! Design à Vivre, Paris (2004). Other awards include the Design Preis Schweiz (2005), and Guest of Honor at the 20th Biennale Interieur, Kortrijk, Belgium (2006).

Zaha Hadid (b.1950, Iraq; resides United Kingdom; zaha-hadid.com; American University of Beirut, Lebanon, 1968–71; Architectural Association, London, England, 1972–77). Although primarily an architect, Zaha Hadid also designs furniture and interiors; her clients include Sawaya & Moroni. Hadid has received several honors over the years, including a CBE in 2002 and, in 2003, the Mies van der Rohe Award for Contemporary Architecture, for the Honheim-Nord Terminus. In 2004, she was named as the Pritzker Architecture Prize Laureate; the following year, she became a Member of the Royal Academy of Arts, and was shortlisted for the RIBA Stirling Prize. Hadid won the American Institute of Architects/UK Award in 2006, for Maggie's Centre, and, in 2007, received the Thomas Jefferson Foundation Medal in Architecture.

Annaleena Hakatie (b.1965, Finland; University of Art and Design, Helsinki, Finland, 1991–95). A glass designer, Annaleena Hakatie has various clients, including Iittala.

Ineke Hans (b.1966, The Netherlands; inekehans.com; Academy of Fine Arts, Arnhem, The Netherlands, 1986–91; Royal College of Art, London, England, 1993–95). Ineke Hans's work includes ceramics, furniture, and product design, for such clients as Ahrend, Cappellini, Cooper Hewitt Design Museum, EKWC, Reset Design, RoyalVKB, and Swarovski; she also produces her own designs. Her awards include first prize for a floor design for Forbo Krommenie (awarded in 1993); a Furniture Futures Award from *Design Week* magazine (1997); first prize in the Dutch Pewter Prize, for *Pewter on the Table* (2004); Red Dot Design awards, for *Garlic Crusher* (2005) and *Bowls & Spoons* (2006); and the Design Plus award for *Garlic Crusher* (2006).

Hareide Designmill. A Norwegian company founded in 2000 (hareide-designmill.no) by Einar Hareide (b.1959, Norway). Its work includes automotive design, design strategy, and product design, for such clients as ABB, Brose, Electrolux, Ericsson, IKEA, Helle Fabrikker, Jordan, Startloop AS, and Volvo.
 The company has won several awards for its designs, including the Award for Design Excellence in 2001, for *Soom*, and in 2002, for *Startloop*, *Vikingstop*, *AutoSock*, *Ur*, and the *Microfiber* cloth; *Microfiber* also received the Worldstar and Scanstar awards in 2002. Other products to be given the Award for Design Excellence include *Joystick* (in 2003), *Maneuvering Handle* (2004), *Knife* (2004), and *Protective Footwear* (2005). In 2007, the company received the Red Dot: Best of the Best award for its wood-burning stove.

Achim Heine (b.1955, Germany; achim-heine.de; Johann Wolfgang Goethe University, Frankfurt, Germany, 1975–77; Academy of Art and Design, Offenbach, Germany, 1977–84). Achim Heine's work includes furniture and product design, for such clients as Audi, Leica Camera, Rosenthal, Thonet, and Vitra. Heine has won numerous design awards, including the iF Communication Design Award; TDC New York; ADC Europe; and ADC Germany.

Herzog & de Meuron. Swiss architecture and design partnership founded in 1978 by Jacques Herzog (b.1950, Switzerland) and Pierre de Meuron (b.1950, Switzerland). The practice is currently led by ten partners: Christine Binswanger, de Meuron, Harry Gugger, Wolfgang Hardt, Herzog, Robert Hösl, David Koch, Stefan Marbach, Ascan Mergenthaler, and Markus Widmer. Its work includes architecture and product design, for such clients as Artemide; the de Young Museum, San Francisco; the Miami Art Museum; the Parish Art Museum, New York; Tate Modern, London; and the Walker Art Center, Minneapolis.

Richard Hutten (b.1967, The Netherlands; richardhutten.com; Design Academy Eindhoven, The Netherlands, 1991). Richard Hutten is a ceramics, furniture, glass, interior, metalwork, and product designer, whose work is made for his own company, as well as for Cor Unum, Droog Design, E & Y, Gispen, Idée, Moooi, and Sawaya & Moroni. He has won several awards, including the Dutch Furniture Award (in 1992 and 1996); the Golden Monkey Award, *Casa Brutus* magazine (2001); and Honorable Mention for the Dutch Design Award (2005). He has also received nominations for the German Design Award (2006), the Dutch Design Award (2007), the Great Indoors Award (2007), and the LAI Interior Award (2007).

David Huycke (b.1967, Belgium; Karel de Grote-Hogeschool, Sint-Lucas, Antwerp, Belgium, 1985–89; currently studying for PhD at Katholieke Universiteit Leuven, Belgium). David Huycke produces his own designs, which include metalwork. In 1990, he received the Province of East Flanders Provincial Prize for Applied Arts, and an Honorable Mention in the *Eat with Art* exhibition at the Galerie Théorèmes, Brussels. In 1992, he was awarded the Talentbörse Handwerk Metal Prize at the Internationale Handwerksmesse, Munich. This was followed, in 1994, by the Henry van de Velde VIZO Award for Young Talent, and the Henry van de Velde VIZO Public Prize; and, in 1998, by the European Prize for Contemporary Art and Design-Led Crafts for artists and designers under thirty-five, presented by WCC-Europe. In 2007, Huycke was awarded the Bavarian State Prize at the Internationale Handwerksmesse.

Niels Hvass (b.1958, Denmark; strand-hvass.com; Danmarks Designskole, Copenhagen, Denmark, 1987). Niels Hvass is a furniture designer, and makes his work for his own company. In 2006, he received the Danish Furniture Prize and the Red Dot Design Award.

Inflate. A British company founded in 1995 (inflate.co.uk). It is led by its founder, Nick Crosbie (b.1971, United Kingdom), Paul Croft (b.1973, United Kingdom), and Mark Sodeau (b.1970, United Kingdom); Michael Sodeau (b.1969, United Kingdom) was associated with the company until 1997. Inflate produces its own designs, which range from architecture to furniture and product design. The company won Blueprint/100% Design London awards in 1996 (for a table light) and 1999 (for an exhibition stand and product). They received the Peugeot Design Award in 2001 (for *Snoozy*).

Aleksej Iskos (b.1965, Ukraine; resides Denmark; aleksej-iskos.dk; ornametrica.com; Kharkiv State Technical University of Construction and Architecture, Ukraine, 1982–87; Kharkiv State Pedagogic University, Ukraine, 1987–90; Danmarks Designskole, Copenhagen, Denmark, 1994–96). Aleksej Iskos is a furniture, installations, and product designer, whose clients include Källemo and Montana Furniture; he also produces his own work. In 2001, he received a three-year grant from the Danish Arts Council.

Ole Jensen (b.1958, Denmark; Arts and Crafts College, Kolding, Denmark, 1981–85; Royal Academy of Arts, Copenhagen, Denmark, 1985–89). Ole Jensen is a ceramics, glass, and product designer, whose clients include Normann Copenhagen and Royal Copenhagen. Jensen has been honored with several awards, including, in 1996, the Design Prize of the Design Foundation,

Denmark, and, in 1997, the Kay Bojesen Memorial Grant. In 1998, he received a three-year work bursary from the Danish Arts Foundation, and the Design Plus award for his *Ole* porcelain service. Other awards include the Design Plus award for *Washing-up Bowl and Brush* (received in 2002); the Thorvald Bindesbøll Medal of the Royal Academy of Fine Arts (2004); the Design Plus award for *Jensen Bowl* (2005); the Torsten and Wanja Söderberg Prize (2006); the Red Dot Design Award for *Familia* dinnerware (2007); and the iF Product Design Award, also for *Familia* (2008).

Hella Jongerius (b.1963, The Netherlands; jongeriuslab.com; Design Academy Eindhoven, The Netherlands, 1988–93). Hella Jongerius's work ranges from ceramics and glass to furniture and product design. Her clients include Droog Design, Jongeriuslab (her own company), Royal Tichelaar Makkum, and Vitra. In 1998, she received the Incentive Award from the Amsterdam Art Foundation for Industrial Design, for *Soft Washbowl*. Her other awards include the Designprijs Rotterdam (received in 2003), and Creator of the Year at the Salon du Meuble, Paris (2004).

Patrick Jouin (b.1967, France; patrickjouin.com; École Nationale Supérieure de Création Industrielle (ENSCI), Paris, France, 1992). Patrick Jouin is a ceramics, furniture, interior, and product designer, whose clients include Materialise.MGX. He has been presented with numerous awards. In 1998, he received the Prix de la Presse Internationale at the Salon du Meuble, Paris; the VIA (French Furniture Association) Label award for the *Facto* chair; and the VIA Carte Blanche grant. This was followed by the VIA Label (for the sofa/bed *Morphée*) in 1999; by the Prix de l'Innovation Monoprix (for the toy *Pistache la Vache*) in 2002; and by the Prix de l'Enseigne d'Or (for the store BE) in 2003, in which year he was also made Creator of the Year at Maison & Objet, Paris. More recently, in 2006, he received the award for Best Restaurant at the Travel + Leisure Design Awards, for Mix in Las Vegas, and the Étoile de l'Observeur du Design from the APCI (Agency for the Promotion and Creation of Industrial Design), for his *Evol* dinnerware. In 2007, he was given the Best Shop of the Year award by *Travel + Leisure* and *Interior Design* magazines; the Prix de l'Innovation at Maison & Objet, for *NightCove*; the Designer of the Year award, *Elle Decoration* (France); and the Passeport Créateur sans Frontières from the French Ministry of Foreign Affairs.

Eero Koivisto (b.1958, Sweden; claesson-koivisto-rune.com; Stockholm School of Arts, Sweden, 1990; Parsons School of Design, New York, 1992; University of Art and Design (UIAH), Helsinki, Finland, 1993; Konstfack, University College of Arts, Crafts, and Design, Stockholm, Sweden, 1994; Design Leadership, UIAH, Helsinki, Finland, 1995). Eero Koivisto is an architect and furniture designer, whose clients include Offecct. In 1991, he was awarded a Scandinavia–Japan Sasakawa Foundation grant; in 1992, he won first prize (for an apartment design with Ola Rune) at the HSB Stockholm competition; in 1993, he was given a Nordplus grant (together with Rune); and in 1997, he received an award from the Swedish Artists Fund.

Komplot. A Danish company founded in 1987 (komplot.dk). Its co-founders were Boris Berlin (b.1953, Russia; resides Denmark) and Poul Christiansen (b.1947, Denmark). Its work includes furniture and product design, for such clients as Källemo. The company's various honors include the Møbelprisen (awarded in 2002); inclusion in *Metropolitan Home*'s "Design 100" issue, for *Non* chair (2003); Gold Award, Best of NeoCon Competition, for *Genus* chair (2003); and the Danish Design Prize, for *Gubi* chair (2004). In 2007, Komplot was awarded the Crafts and Design Biennial Prize for *Nobody* chair, and the Red Dot: Best of the Best award for *Gubi Chair II*.

Harri Koskinen (b.1970, Finland; harrikoskinen.com; Institute of Design, Lahti University of Applied Sciences, Finland, 1989–93; University of Art and Design (UIAH), Helsinki, Finland, 1994–98). Harri Koskinen is a ceramics, furniture, glass, and product designer, and works for such clients as Hackman and Iittala. His *Block* lamp won an Utmärkt Svensk Form (Excellent Swedish Design) award (in 1998), a Design Plus award (1999), and a Best New Products award at the *Accent on Design* exhibition at the New York International Gift Fair (1999). He was named Finland's Young Designer of the Year in 2000.

Joris Laarman (b.1979, The Netherlands; jorislaarman.com; Academy of Fine Arts, Arnhem, The Netherlands, 1997–98; Design Academy Eindhoven, The Netherlands, 1998–2003). Joris Laarman is a ceramics, furniture, installations, metalwork, and product designer, whose clients include Artecnica, Droog Design, FLOS, and Swarovski; he also produces his own designs. In 2004, Laarman was named Young Designer of the Year by *Wallpaper** magazine, and received the Interior Innovation Award at IMM Cologne. Other honors include the Red Dot Design Award (received in 2006); the Woon Award (2007); and Talent of the Year at the Elle Decoration International Design Awards (2008).

Danny Lane (b.1955, United States; resides United Kingdom; dannylane.co.uk; Byam Shaw School of Art, London, England, 1975–77; Central School of Arts and Crafts, London, England, 1977–80). Danny Lane designs and produces his own innovative furniture and public sculptures. His work is held in museums and private and corporate collections worldwide. His international clients include Bechtel/Hilton Hotels Corporation, Egypt; General Motors; Morgan Stanley; Swire Properties, Hong Kong; the Victoria & Albert Museum, London; and the Why Company, Japan.

Ferruccio Laviani (b.1960, Italy; laviani.com; Politecnico di Milano, Italy, 1980–86). Ferruccio Laviani's work includes architecture, furniture, installations, and interior and product design, for such clients as Cassina, Cosmit, FLOS, Emmemobili, Fontana Arte, Foscarini Murano, Imel, Kartell, Mito, and Moroso.

Arik Levy (b.1963, Israel; resides France; ariklevy.fr; Art Center College of Design (Europe), La Tour-de-Peilz, Switzerland, 1987–91). Arik Levy's work encompasses furniture, installations, and interior and product design. His many clients include Baccarat, Baleri Italia, Belux, Desalto, Ligne-Roset, Materialise.MGX, Vitra, Vizona, and Zanotta. He has received numerous honors, including Seiko Epson's International Art Center Award (in 1991); Movement Français de la Qualité, Les Affiches pour la Qualité 97 (1997); the Design Plus award, for the *Seed* porcelain lamp (1999); the Grand Prix International de la Critique, Salon du Meuble, Paris, for the *Cloud* lamp (1999); the VIA (French Furniture Association) Label award (1999–2001) and the VIA Carte Blanche grant (2000); Best of Category, *L'Express* magazine, for a lamp (2000); the iF Product Design Award (2000); and the George Nelson Award, *Interiors* magazine (2001). Recent awards include the Observeur du Design from the APCI (Agency for the Promotion and Creation of Industrial Design; 2002); the Interior Innovation Award, "Best of the Best," at IMM Cologne (2003 and 2005); the Design Plus award (2006); the Janus de l'Industrie (2007); and Designer of the Year at the Elle Decoration International Design Awards (2008).

Olavi Lindén (b.1946, Finland; Tekniska Läroverket i Helsingfors, Finland, 1966–70). Olavi Lindén's work includes product design, for such clients as Fiskars, for whom he has made garden tools; he has also constructed stringed musical instruments. In 2002, he was awarded the Finnish State Prize for Crafts and Design; in 2005, he was named Finland's Designer of the Year. He received the Kaj Franck Design Prize in 2006.

Stefan Lindfors (b.1962, Finland; lindfors.net; University of Art and Design (UIAH), Helsinki, Finland, 1982–88). Stefan Lindfors's work encompasses architecture, furniture, glass, installations, interior design, metalwork, and product design. His clients include Hackman, Ingo Maurer, and Neste Oil. In 1986, Lindfors received a Silver Medal at the Triennale di Milano; in 1992, he was given the Väinö Tanner Trailblazer Award, and the Georg Jensen Prize. His other awards include the Association of Finnish Interior Architects: Best Interior (received in 1993); the Chicago Athenaeum Good Design Award (1996); the Design Plus award (1999); and the Tokyo Design Award (2001).

Ross Lovegrove (b.1958, Wales, United Kingdom; rosslovegrove.com; Manchester Polytechnic, England, 1976–80; Royal College of Art, London, England, 1981–83). Ross Lovegrove is a ceramics, furniture, glass, interior, metalwork, and product designer, and an architect. His clients include Airbus Industries, Apple Computers, Cappellini, Driade, Idée, Kartell, Luceplan, Moroso, and Ty Nant; he also produces his own work. He is a Fellow of the Chartered Society of Designers.

Lovegrove has received numerous international awards, including, in 1998, the Medaille de la Ville de Paris, and the George Nelson Award, *Interiors* magazine. Additional honors include the iF Product Design Award (received in 1999); *I.D.* magazine's Good Design Award (2000); the Janus de l'Industrie (2003); the Royal Designer for Industry award (2004); the World Technology Award (2005); and a Design Award from *Wallpaper** magazine (2006).

Cecilie Manz (b.1972, Denmark; ceciliemanz.com; Danmarks Designskole, Copenhagen, Denmark, 1992–97; University of Art and Design (UIAH), Helsinki, Finland, 1995). Cecilie Manz's work includes ceramics, furniture, glass, and product design, for such clients as Nils Holger Moormann.

In 2000, Manz won *Bo Bedre* magazine's Design Award and the Klaessons Design Team Prize; in 2003, she received an award from the Inga and Ejvind Kold Christensen's Foundation; and, in 2004, she was awarded the Danish Design Prize and a three-year grant from the Danish Arts Foundation. In 2007, she won Design Plus and iF Product Design awards, as well as the Finn Juhl Architectural Prize.

Javier Mariscal (b.1950, Spain; mariscal.com; Universitat de Valéncia, Spain, 1967; Escola Superior de Disseny, Barcelona, Spain, 1970–71). Javier Mariscal's work includes architecture, ceramics, furniture, interior design, and product design, for such clients as AKABA, America's Cup Management, Bancaja, Camper, Cosmic, Hoteles Silken, Magis, Moroso, Nani Marquina, *The New Yorker*, Phaidon, Porcelanas Bidasoa, and Vinçon. In 2008, Mariscal received the Hall of Fame award at the European Design Awards, an event sponsored by twelve prestigious design magazines.

Cathrine Maske (b.1966, Norway; University of Art and Design, Oslo, Norway, 1989–93; University of Art and Design (UIAH), Helsinki, Finland, 1993–96; University of Art and Design, Bergen, Norway, 1996–97). Cathrine Maske is a glass designer; her clients include Klart A/S and Magnor. In 1997, she won the Norsk Form prize for young designers; in 1998, the Norwegian Design Council's Young Talent Award; and, in 1998, the Scheiblers Legat, a prize for young artists.

Ana Mir (b.1969, Spain; emilianadesign.com; Universidad Politecnica de Valencia, Spain, 1988–92; Central Saint Martins College of Art and Design, London, England, 1992–94). Ana Mir's work includes furniture and product design, for such clients as AKABA, Emiliana Design Studio (her own), Punt Mobeles, Richter Spielgeräte, Samsung, Toyota, and Women's Secret. In 1999, she received the Barcelona City Award in Design; in 2000, the FAD Prize and first prize in the Domus BBJ Design Competition; and, in 2005, the Adifad Prize for the *Collector* lamp.

Tobias Møhl (b.1970, Denmark; mohl-drivsholm.dk; apprenticeship, Holmegaard, Denmark, 1989; Master, Holmegaard/Royal Copenhagen, Denmark, 1992; masterclass with Lino Tagliapietra and Checco Ongaro, Pilchuck, USA, 1996; masterclass with Lino Tagliapietra, Haystack, USA, 1997 and 2000). Tobias Møhl's glass designs are produced by his own company, Møhl & Drivsholm Glas. He has received various awards—a Christian Grauballe Memorial Grant (1999); the Reticello Prize, from the Glasmuseum Ebeltoft (2001); and an Ole Haslund Artist's Foundation Award (2002)—as well as several work grants from the Danish Art Foundation.

Jasper Morrison (b.1959, United Kingdom; jaspermorrison.com; Kingston Polytechnic, London, England, 1979–82; Royal College of Art, London, England, 1982–85; Berlin University of the Arts, Germany, 1984–85). Jasper Morrison's work is extremely varied, embracing ceramics, furniture, glass, installations, interior design, metalwork, and product design. His clients are equally diverse, and include Alessi, Antoine Betta, Cappellini, FLOS, Ideal Standard, Magis, Olivetti, Rowenta, Samsung, and Vitra. In 1997, he received the iF Product Design Award and the Ecology Award (both for work on the Hanover tram system). Other honors include being named Creator of the Year at the Salon du Meuble, Paris (in 2000), and at Maison & Objet, Paris (2001); and the Royal Designer for Industry award (2001). In 2005, Morrison founded Super Normal with Naoto Fukasawa. The following year, he received an honorary doctorate from Kingston University in London.

Monika Mulder (b.1972, The Netherlands; resides Sweden; Design Academy Eindhoven, The Netherlands, 1992–97). Monika Mulder is a furniture and product designer. Her clients include IKEA.

Marc Newson (b.1963, Australia; resides United Kingdom; marc-newson.com; Sydney College of the Arts, Australia, 1980–83). Marc Newson's work encompasses furniture, interior design, and product design. His clients include Cappellini, EADS Astrium, Ford, Goto, Magis, Nike, Qantas, and Smeg. He was named Designer of the Year at the Salone del Mobile, Milan, in 1992, and Creator of the Year at the Salon du Meuble, Paris, in 1993. Other awards include *I.D.* magazine's Top 50 Designers Award (received in 1998); the Red Dot Design Award (1999); the George Nelson Award,

Interiors magazine (1999); the Chicago Athenaeum Good Design Award (2001); the Australian Design Award (2003); and the Good Design Award, Japan Industrial Design Promotion Organization (2004). More recently, Newson was included in *Time* magazine's list of the world's 100 most influential people (2005), and was named Designer of the Year at Design Miami/Basel (2006). In 2007, he was awarded the LEAF International Interior Design Award for the Qantas First Lounge, Sydney International Airport.

Bruno Ninaber van Eyben (b.1950, The Netherlands; ninaber.nl; Academy of Visual Arts, Maastricht, The Netherlands, 1967–71). Bruno Ninaber van Eyben's work includes ceramics, furniture, metalwork, and product design, for such clients as Lovink-Terborg. In 1979, he was awarded the Kho Liang le prize, presented by the Amsterdam Fonds voor de Kunst. In 1982, Ninaber won a competition organized by the Dutch Ministry of Finance to design a set of Dutch coins; he won a similar competition in 1998, this time to design the Dutch euro coins. He has recently received several design awards, including, in 2008, the Oeuvre Award from Fonds BKVB (The Netherlands Foundation for Visual Arts, Design, and Architecture).

Nokia. Finnish company founded in 1865 by Fredrik Idestam (nokia.com). Nokia is a leader in world mobile communications, and its innovative mobile telephones have become popular the world over. The Nokia 8800 was awarded the Red Dot: Best of the Best award in 2006 for its outstanding design qualities.

NPK. Dutch company, founded in 1978 (npk.nl). Its co-founders were Wolfram Peters (b.1952, The Netherlands) and Peter Krouwel (b.1952, The Netherlands; partner until 2003). Also associated with the company are Janwillem Bouwknegt (b.1973; became partner in 2006); Bruno Ninaber van Eyben (b.1950; partner from 1985–97); Jos Oberdorf (b.1962; became partner in 1998); Detlef Rhein (b.1969; joined in 2001, became partner in 2006); Herman van der Vegt (b.1968; became partner in 2006); and Jan Witte (b.1966; became partner in 1998). NPK's work includes furniture and product design, for such clients as UMS Pastoe.

Yoichi Ohira (b.1946, Japan; resides Italy; Accademia di Belle Arti, Venice, Italy, 1973–78).

Yoichi Ohira is a glass designer. His work is produced by Anfora di Renzo Ferro, and is represented in Europe and the United States by Barry Friedman Ltd. His awards include the Premio Murano "Premio Selezione" prize (received in 1987), and the Rakow Commission from the Corning Museum of Glass, New York (2001).

Jérôme Olivet (b.1971, France; jeromeolivet.com; École Nationale Supérieure de Création Industrielle (ENSCI), Paris, France, 1993). Jérôme Olivet's repertoire includes furniture, metalwork, and product design, for such clients as Alessi, Baccarat, Louis Vuitton, Nissan, Roche-Bobois, and Thomson. In 2008, Olivet was named Creator of the Year at the Paris Capital of Creation design fair.

Satyendra Pakhalé (b.1967, India; resides The Netherlands; satyendra-pakhale.com; Visvesvaraya National Institute of Technology, Nagpur, India, 1985–89; Industrial Design Center, Indian Institute of Technology, Bombay, India, 1989–91; Art Center College of Design (Europe), La Tour-de-Peilz, Switzerland, 1992–94). Satyendra Pakhalé's work includes ceramics, furniture, metalwork, and product design, much of which is made for his own company, Atelier Satyendra Pakhalé. He also designs pieces for such clients as Alessi, Bosa, Cappellini, Magis, Moroso, and Offecct. In 1993, he was awarded a bronze medal in the LG Electronics Design Competition. In 1994, 1998, and 1999, he received Design Distinction awards from *I.D.* magazine. More recent honors include the National Design Grant from The Netherlands Foundation for Fine Art, Architecture, and Design (received in 2002); an ICFF (International Contemporary Furniture Fair) Editors Award (2003); and an International Design Award, Los Angeles, in the interior furniture category (2007).

John Pawson (b.1949, United Kingdom; johnpawson.com; Architectural Association, London, England, 1981). John Pawson's work ranges from architecture and interior design to ceramics, furniture, glass, metalwork, and product design. His clients include When Objects Work. Pawson has received several awards for his architecture projects, as well as being named Architect of the Year at the Blueprint Sessions of 2005. Awards in design include, in 2007, the prestigious Chicago Athenaeum Good Design Award, for his floor lamp, and, in 2008, Best

Design in *Wallpaper** magazine's Design Awards, for his cooking pot collection.

Jorge Pensi (b.1946, Argentina; resides Spain; Facultad de Arquitectura, Universidad de Buenos Aires, Argentina, 1965–73). Jorge Pensi's work includes architecture, furniture, and interior and product design, for such clients as AMAT SA, B.Lux, Kron, and Thonet. Pensi has received several awards for his *Toledo* chair, including first place in the SIDI Selection (in 1988), the Silver Delta Award from the Associazione per il Disegno Industriale (1988), and a Design-Auswahl 90 Award from the Design Center Stuttgart (1990). In 1989, he was awarded a prize by the Gremio Provincial de Comerciantes de Muebles. In 1997, he received a National Design Prize from the Ministerio de Industria y Energía, Spain, and two Red Dot Design awards, for his *Capa* and *Hola!* chairs.

Nestor Perkal (b.1951, Argentina; resides France; nestorperkal.fr; Facultad de Arquitectura, Universidad de Buenos Aires, Argentina, 1973–77). Nestor Perkal is an architect, as well as a ceramics, furniture, glass, metalwork, and product designer; his clients include Algorithme. In 1994, he received an Appel Permanent grant from the VIA (French Furniture Association). In 1998, he was awarded the National Grand Prize by the Ministère de la Culture, France, for the *Combien de Temps* vase. He is a Chevalier de l'Ordre des Arts et des Lettres.

Philips Design (Royal Philips Electronics). Philips was founded in 1891 by Gerard and Anton Philips (philips.com). The firm designs and produces a wide range of electronic goods. Recent awards have included a Designprijs Rotterdam in 1995 (awarded to Jan Erik Baars, Caroline Brouwer, and Jan Paul van der Voet/Philips Corporate Design); the Kho Liang le prize in 1996 (for Philips Alessi household products); iF Product Design awards in 2000 and 2001; twenty citations for the Erkenningen Goed Industrieel Ontwerp (Good Industrial Design Award) in 2000–01; and the Red Dot Design Award in 2001 and 2003.

Christophe Pillet (b.1959, France; christophepillet.com; École Nationale Supérieure des Arts Décoratifs, Nice, France, 1981–85; Domus Academy, Milan, Italy, 1985–86). Christophe Pillet's work ranges from furniture and glass to interior and product design, for such clients as Cappellini. His honors include Creator of the Year

at the Salon du Meuble, Paris (in 1994); a Carte Blanche grant from the VIA (French Furniture Association; 1994); and the Excellence Prize in Lighting at the Salon International du Luminaire, Paris (1995).

Bertjan Pot (b.1975, The Netherlands; bertjanpot.nl; Design Academy Eindhoven, The Netherlands, 1992–98). Bertjan Pot is a ceramics, furniture, and product designer; his clients include Arco, Domestic, Goods, and Moooi. In 2003, Pot was awarded the Materiaalfondsprijs for his *Random* chair (cited as the best recent materials experiment in design). Other honors include, in 2004, the Profielprijs (for using textiles in an extraordinary way), and, in 2005, "Best in Seating" at the Elle Decoration International Design Awards, for the *Carbon* chair (made with Marcel Wanders). In 2006, Pot's *Slim Table* received the Dutch Design Award, Best Interior Product; the Woon Award, Best Interior Product; and the iF Gold Award.

RADI DESIGNERS. French company ("Research, Auto Production, Design, Industrial Designers") founded in 1992 (radidesigners.com). The co-founders were Laurent Massaloux (b.1968, France), Olivier Sidet (b.1965, France), and Robert Stadler (b.1966, Austria; resides France and Brazil). Claudio Colucci (b.1965, Switzerland; resides Japan and France) was associated with RADI from 1994 to 2000; and Florence Doleac (b.1968, France) was associated with the company from 1997 to 2003. Its output includes ceramics, furniture, glass, installations, and interior and product design. The company produces its own work, but also creates designs for such clients as Air France, Fondation Cartier, Galerie kreo, and Groupe SEB.

RADI was named Creator of the Year at the Salon du Meuble, Paris, in 2000. In the same year, it received prizes for a public drinking fountain at the Hôtel de Ville in Paris; for a light switch, awarded at the Seventh International Design Competition in Japan; and for garden furniture, awarded at Le Jardin, Paris. In 2001, it received a Carte Blanche grant from the VIA (French Furniture Association).

Prospero Rasulo (b.1953, Italy; Accademia di Belle Arti di Brera, Milan, Italy, 1973). Prospero Rasulo's work ranges from ceramics and glass to furniture, installations, and product design. During the 1980s, Rasulo began his collaboration

with Studio Alchimia and Alessandro Mendini. In 1987, he founded Oxido, a design, art, and architecture gallery. Oxido subsequently became a trademark for a collection of furniture and *objets d'art*, called Oxido Zoo. Rasulo works with many leading firms, including Antonio Lupi, BRF, Fabbian, Fine Factory, Foscarini, Gessi, Terzani, and Zanotta.

Tejo Remy (b.1960, The Netherlands; remyveenhuizen.nl; Hogeschool voor de Kunsten, Utrecht, The Netherlands, 1986–91). Tejo Remy's work includes furniture and product design, for such clients as the Arts Council, UK, Droog Design, RijksgebouwenDienst, and SKOR. He was recognized in 1992 at the Internationale Handwerksmesse, and received the Edward Marshall Trust Award in 1995.

Rolf Sachs (b.1955, Switzerland; resides United Kingdom; rolfsachs.com; Menlo College, Menlo Park, California; London School of Economics, England). Rolf Sachs's studio produces most of his work, which includes architecture, furniture, glass, interior design, metalwork, and product design.

Denis Santachiara (b.1950, Italy). Denis Santachiara is a self-taught furniture, metalwork, and product designer. His clients include Baleri Italia, Campeggi, Domodinamica, Duepuntosette, FontanaArte, and Quattrocchio. He received the Chicago Athenaeum Good Design Award in 1999, and first prize from *Design World* in 2000.

Laura de Santillana (b.1955, Italy; School of Visual Arts, New York, 1975–76). Laura de Santillana's designs include glass and metalwork, for such clients as Arcade, Eos, Rosenthal, and Venini. Awards received include the Annual Prize for Design from *Elle Decoration* (France), and the Coburger Glaspreis for Modern Glassmaking in Europe.

William Sawaya (b.1948, Lebanon; resides Italy; sawayamoroni.com; National Academy of Fine

Arts, Beirut, Lebanon, 1969–73). William Sawaya is a furniture, glass, interior, metalwork, and product designer. His clients include Baccarat, FIFA, Heller, Museo Bagatti Valsecchi (Milan), Swiss Air, and Zucchetti. He has received several awards for his chair designs; in 2002, the *Maxima* chair was recognized by the Catas Italian Institute for Quality "as the most significant example of design combined with technology and resistisance, three qualities which are not found very frequently together."

Héctor Serrano (b.1974, Spain; resides United Kingdom; hectorserrano.com; ESDI CEU San Pablo, Valencia, Spain, 1992–98; Royal College of Art, London, England, 1998–2000). Héctor Serrano is a furniture, installations, interior, and product designer; his clients include B-sign, Droog Design, ICEX (Spanish Ministry of Industry, Tourism, and Trade), Metalarte, and Moooi. He has received the Peugeot Design Award, and the Premio Nacional de Diseños no Aburridos.

Jerszy Seymour (b.1968, Germany; jerszyseymour.com; South Bank Polytechnic, London, England, 1990; Royal College of Art, London, England, 1993). Jerszy Seymour's work ranges from furniture and glass to installations and product design. His clients include Covo, Galerie kreo, Hermes, IDEE, Magis, Moulinex, SFR, Smeg, Sputnik, Swatch, and Vitra. He received the Dedalus Award for European Design in 2000, and the Taro Okamoto Memorial Award for Contemporary Art in 2003.

Bořek Šípek (b.1949, Czechoslovakia; studiosipek.eu; School of Arts and Crafts, Prague, Czechoslovakia, 1964–69; Hochschule für bildende Künst, Hamburg, Germany, 1970–74; Technical University of Delft, The Netherlands, 1974–79). Bořek Šípek is an architect, and a furniture, glass, and metalwork designer. His clients include Ajeto, Driade, Maletti, Sawaya & Moroni, Steltman Gallery, Swarovski, and Vitra. Šípek has received several awards, including an honorable mention, for a glass house, in the German Architecture Competition (1983); the Kho Liang le prize from the Amsterdam Fonds voor de Kunst (1989); the Croix de Chevalier de l'Ordre des Arts et des Lettres (1991); the Prins Bernhard Fonds Prize for Architecture and Applied Arts (1993); and the Talent de l'Originalité award at Le Sommet du Luxe et de la Creation, Paris.

Snowcrash. A Finnish company founded in 1997 and disbanded in 2002. The co-founders were Teppo Asikainen (b.1968, Finland); Timo Salli (b.1963, Finland); Ilkka Suppanen (b.1968, Finland); and Ilkka Terho (b.1968, Finland). Its work included architecture, furniture, and product design. Some of its designs were produced by Snowcrash itself, while others were produced by such clients as David design.

Wieki Somers (b.1976, The Netherlands; wiekisomers.com; Design Academy Eindhoven, The Netherlands, 1995–2000). Wieki Somers is a ceramics, furniture, glass, metalwork, and product designer. Her clients include Chi Ha Paura, Cor Unum, Droog Design, the European Ceramic Workcenter (EKWC), Galerie kreo, and the Museum Boijmans van Beuningen. She has received several nominations for design awards, including the Designprijs Rotterdam, Young Designer's award (in 2001); the Designprijs Rotterdam, Materialprize (2003); the Dutch Ceramic Prize (2005); and the European Ceramic Context (2006).

Philippe Starck (b.1949, France; philippe-starck.com; École Nissim de Camondo, Paris, France, 1968). Philippe Starck is one of the leading figures of his generation, whose work ranges from architecture and interior design to furniture, metalwork, and product design. His clients include Alessi, Daum, Driade, FLOS, Kartell, and Vitra. He has received many prizes, including, in 1995, two Red Dot Design awards (for the *Axor Starck* faucet and the *Philippe Starck* bathroom furniture series), and, in 2001, two Red Dot: Best of the Best awards (for the *Gaoua* luggage and *Yap* backpack).

Studio I.T.O. Design. An Italian company, founded in 1997 (studioito.com). Its founders were Setsu Ito (b.1964, Japan) and Shinobu Ito (b.1966, Japan). The company's work includes architecture, furniture, glass, metalwork, and product design, for such clients as Edra.

Studio Job. A Dutch/Belgian company founded in 2000 (studiojob.be) by Job Smeets (b.1970, Belgium) and Nynke Tynagel (b.1977, The Netherlands). Studio Job's work ranges from ceramics and furniture to metalwork and product design. Its clients include Bisazza, Bulgari, Moooi, Royal Tichelaar Makkum, and Swarovski; it also produces its own designs. Studio Job has received

several awards, including recognition in the Elle Decoration International Design Awards in 2005, 2006, and 2007.

Swatch Ltd. Swiss company founded in 1983 (swatch.com). Swatch designs and makes the hugely successful watches for which it has become famous, as well as jewelry and accessories.

Martin Szekely (b.1956, France; martinszekely.com; École Estienne, Paris, France, 1972–74; École Boulle, Paris, France, 1977). Martin Szekely's work includes ceramics, furniture, glass, interior design, metalwork, and product design, for such clients as Bernardaud, Christofle, Galerie Neotu, Hermès, and Roger & Gallet. He has received various awards: a Carte Blanche grant from the VIA (French Furniture Association) in 1983; the Agora Award in 1984; Creator of the Year at the Salon du Meuble, Paris, in 1987; and a first prize from French art critics and the VIA in 1988. In 1999, he was honored with the title of Chevalier de l'Ordre des Arts et des Lettres, and received the Alfred Dunhill prize, "Homme Remarquable de l'Année." In 2003, he was awarded the Talent d'Or at Le Sommet du Luxe et de la Création, Paris.

Mats Theselius (b.1956, Sweden; theselius.com; Konstfack, University College of Arts, Crafts, and Design, Stockholm, Sweden, 1979–84). Mats Theselius's work includes architecture, furniture, interior design, and product design, for such clients as Arvesund, David design, Die Blindenanstalt, Källemo, Ruben, and W.A. Bolin. In 1984, Theselius obtained an IKEA scholarship, and in 1986 and 1988, he received awards from the Swedish state art foundation. In 1989, he won a travel scholarship from Svensk Form; in 1991 and 1995, he was honored with design awards from the same organization. In 1991, he was presented with the DuPont Comfort Prize, and with a design prize from the *Dagens Nyheter* newspaper. In 1997, he received the Torsten and Wanja Söderberg Prize, and the Bruno Mattson Design Prize.

Ólafur Thórdarson (b.1963, Iceland; resides United States and Iceland; olafurthordarson.com; University of Wisconsin-Milwaukee, 1983–86; Columbia University, New York, 1986–90). Ólafur Thórdarson is an architect, and a furniture, metalwork, and product designer. He produces his own work for such clients as the Museum of

Design and Applied Arts, Iceland, and numerous private collectors in the US and Iceland.

Frank Tjepkema (b.1970, Switzerland; resides The Netherlands; tjep.com; Technical University of Delft, The Netherlands, 1989–91; Design Academy Eindhoven, The Netherlands, 1992–96; Sandberg Institute, Amsterdam, The Netherlands, 1996–98). Frank Tjepkema is a ceramics, furniture, glass, interior, metalwork, and product designer, whose clients include Droog Design. Tjepkema has a design partnership, with Janneke Hooymans, called Tjep. In 2004, Tjep. won the Dutch Design Award for two of its designs: *Bling Bling* and *Airco Tree* (for the British Airways Executive Club lounge at Heathrow Airport, London).

Pia Törnell (b.1963, Sweden; piatornell.se; studiok.nu; Grundskolan för Konstnärlig Utbildning, Stockholm, Sweden, 1984–85; Birkagårdens Folkhögskola, Stockholm, Sweden, 1985–87; Konstfack, University College of Art, Crafts, and Design, Stockholm, Sweden, 1989–94). Pia Törnell is a ceramics and metalwork designer. Her clients include Arabia, Hackman, Hammarplast, and Rörstrand; she also produces many of her own designs (as StudioK, co-owned with Hans-Jörgen Lindquist). In 1997, Törnell was awarded the Utmärkt Svensk Form (Excellent Swedish Design) award for her *Mantello* and *Sinus* vases. In the same year, she received the Prix de la Decoration at Maison & Objet, Paris, for her *Cirrus* vase. Other honors include the Design Plus award for *Tilda* (received in 1998); the Excellent Swedish Design award (2000) and the Design Plus award (2001), both for *Grade*; and the Swedish Elle Decoration International Design Award from *Elle Interiör* for *Convito*.

Uglycute. Swedish company founded in 1999 (uglycute.com). The co-founders were Markus Degerman (b.1972, Sweden); Andreas Nobel (b.1966, Sweden); Jonas Nobel (b.1970, Sweden); and Fredrik Stenberg (b.1971, Sweden). The company's work, which it produces itself, encompasses architecture, ceramics, furniture, installations, and interior and product design.

Maarten Van Severen (1956–2005, Belgium; Architectuurinstituut Saint-Lucas, Ghent, Belgium, 1975–78). Maarten Van Severen worked in the fields of architecture, furniture, and interior and product design; his clients included Edra, Top-Mouton, and Vitra. Van Severen's many

honors include the Henry van de Velde Prize at Interieur 92, Courtrai; iF Design awards in 1998, 1999, and 2001; the Design Award of the Flemish Government in 1998, when he was Cultural Ambassador of Flanders; the Chicago Athenaeum Good Design Award (with other designers) in 1999; and the Design Preis Schweiz, also in 1999. In 2001, he was named Creator of the Year at the Salon du Meuble, Paris.

Johan Verde (b.1964, Norway; verde.no; Einar Granum School of Art, Oslo, Norway, 1984–85; Institute for Metal, National School of Arts and Crafts, Oslo, Norway, 1985–87; Institute for Industrial Design, National School of Arts and Crafts, Oslo, Norway, 1987–90). Johan Verde's work includes ceramics, furniture, glass, metalwork, and product design, for such clients as Diplomis, Figgjo, Fora Form, Magnor Glassverk, Nidar, and Stokkegruppen. He has received numerous awards, including the Young Talent Award from the Norwegian Design Council for *Utensils* (in 1991); the Norwegian Design Award from the Norwegian Design Council for the *Jøtul* stove (1992) and *Åsnes* skis (1993); first prize in the National Design Competition, Norway, and a Norwegian Design Award for *Canteen* (1996); and the Norwegian Design Award for *Vase* (1997). In 1999, Verde received the Norsk Form award for young designers. In 2002, his *Loop* lounge chair won the Norwegian Design Award.

Giorgio Vigna (b.1955, Italy; giorgiovigna.com). Giorgio Vigna produces his own designs, which include glass and metalwork, as well as designs for such clients as Salviati and Venini. His active design career incorporates teaching, lecturing, and presiding over design workshops. He has participated in numerous exhibitions, and his work is on permanent display at the Studio Stefania Miscetti contemporary art gallery in Rome; at the Naila de Monbrison artists' jewelry gallery in Paris; in Venini's showroom in Murano; and in his own atelier in Milan.

Ann Wåhlström (b.1957, Sweden; annwahlstrom.com; Capellagården, Vickleby, Sweden, 1977–78; Orrefors Glass School, Sweden, 1979; Pilchuck Glass School, Seattle, USA, 1979; Rhode Island School of Design, Providence, USA, 1980; Konstfack, University College of Arts, Crafts, and Design, Stockholm, Sweden, 1981). Ann Wåhlström is a glass designer; her clients include BodaNova, Cappellini, IKEA, and Kosta Boda. In

1984, Wåhlström received the Artists' Grant from the Kulturförvaltningen, Stockholm. She was honored with the Utmärkt Svensk Form (Excellent Swedish Design) award in 1988 (for *Mezzo*), 1989 (for *Cultura Metal*), 1992 (for the *Johansfors* series), 1995 (for her *Cypress* candlesticks), and in 2000 (for *Hot Pink*).

Marcel Wanders (b. 1963, The Netherlands; marcelwanders.com; Academie voor Industriële Vormgeving, Eindhoven, The Netherlands, 1981–82; Academie voor Toegepaste Kunsten, Maastricht, The Netherlands, 1982–85; Academie voor Schone Kunsten, Hasselt, The Netherlands, 1983–85; Hogeschool voor de Kunsten, Arnhem, The Netherlands, 1985–88). Marcel Wanders works in ceramics, furniture, glass, interior design, metalwork, and product design, for such clients as Cappellini, Droog Design, Marcel Wanders Studio, Moooi, Royal Tichelaar Makkum, and Wanders Wonders.

Wanders's awards are extremely varied. He received first prize in the Café Modern (Nescafé) design competition (in 1986); two citations for the Designprijs Rotterdam (1993 and 2000); the Kho Liang le applied arts consolation prize, from the Amsterdam Fonds voor de Kunst (1996); the Designprijs Rotterdam for *Knotted Chair* (1997); and the George Nelson Award, *Interiors* magazine (2000). In 2002, he participated in an invitational competition (with twenty-three others) at the Museum Het Kruithuis, 's-Hertogenbosch, for the design of a crown for the wedding of Prince Willem-Alexander and Maxima Zorreguita. Recent awards include Designer of the Year at the Elle Decoration International Design Awards (2006), and the Visionaries! Award for artists, presented by the Museum of Arts and Design, New York (2007).

Robert A. Wettstein (b. 1960, Switzerland; wettstein.ws). Having trained in orthopedic technology, Robert Wettstein became a furniture, metalwork, and product designer in 1985. His work is produced by himself and by Anthologie Quartett. In 1992, he received the Design Plus award for his *Pilot* chair. In 1993, he won a Swiss Design Prize for the *Airos* chair (designed with Stanislaus Kutac).

Acknowledgments
Picture Credits
Index

Acknowledgments

Working on such a groundbreaking project as European Design Since 1985 has been a daunting but exciting adventure. A myriad of academics, auction houses, collectors, curators, designers, galleries, government agencies, historians, journalists, manufacturers, photographers, and studios have shared their knowledge and given very generously of their time. I should like to thank the following:

A

A.D. Decorative Arts; Tuija Aalto-Setälä; Marianne Aav; Helena Lidenfors Åberg; Abloy Oy; Olivier Adamson; Claude Aiello; Werner Aisslinger; Ajeto; AKABA S.A.; Hirofumi Akimoto; Alessi S.p.A.; Algorithme; Gunilla Allard; Richard Allen; Amat S.A.; Conrad Amat; Fernando Amat; Carmen G. de Amezúa; Simon Andrews; Anfora di Renzo Ferro; Silvana Annicchiarico; Anthologie Quartett; Paola Antonelli; Sari Anttonen; Francesca Appiani; Fabiana Vidal Leão de Aquino; Ron Arad; Arcade; Antoni Arola; Arni Aromaa; Artecnica; Artemide S.p.A.; Teppo Asikainen; Asplund; Atelier Satyendra Pakhalé; Keren Avni; Minna Axford; Jeremy Aynsley; Azumi Design Ltd.;

B

B&B Italia S.p.A.; B.D. Ediciones de Diseño; Maarten Baas; Bettina Back; Mahani Baharum; Lene Balleby; Bär + Knell Design; Gerhard Bär; BarberOsgerby; Barbican Art Gallery; Luisa Barbieri; Gloria Barcellini; Marina Barovier; François Bauchet; Jennifer Belt; Mathias Bengtsson; John Angelo Benson; Bernadette Berger; Berghof, Landes, Rang; Sebastian Bergne; Lena Bergström; Sofia Bergström; Boris Berlin; Bernardaud; Cristiana Bernardini; Bernhardt Design USA; Clarissa Berning; Dominic Berning; Maria Berntsen; Antoine Betta; Carlotta de Bevilacqua; Jurgen Bey; Cristiano Bianchin; Christian Biecher; Hrafnkell Birgisson; Ivar Björkman; Krysta Blazaitis; Ruth Blench; Bless; Tessa Blokland; Frank Blom; Jill Bloomer; Bodylines; Jonas Bohlin; Mattia Bonetti; Isabelle Bonjean; Tord Boontje; Max Borka; Martina Borraccia; Chiara Bosetti; Lucia Bosso; Erwan Bouroullec; Ronan Bouroullec; Stephane Barbier Bouvet; John E. Bowen; Marianne Brabant; Sue Bradburn; Erik Brahl; Rachel Brishoual; Nina Brisius; Fernando Brízio; Daniel Brown; Kirk Brown; Yvonne Brunhammer; Gerda Brust; Moniek Bucquoye; Clara Buoncristiani; Büro für Form; Giorgio Busnelli;

C

Ashley Cameron; Louise Campbell; Juli Capella; Birgitta Capetillo; Cappellini S.p.A.; Giulio Cappellini; Barbara Carraretto; Tamara Caspersz; Emanuela Cattaneo; Philippe Chancel; Adrienne Chanson; Giles Chapman; Pierre Charpin; Adele Chatfield-Taylor; Pénélope Chester; Jocelyn Childs; Marina Chiucchiuini; Elisabetta Citati; Antonio Citterio; Claesson, Koivisto, Rune; ClassiCon GmbH; Sheridan Coakley; Patrick Coan; Rochelle Cohen; Christine Colin; Paola Colombo; Claudio Colucci; Rachel Compton; Sophie Cook; Cosmic; Mylène Costa Dos Santos; Matali Crasset; CreaDesign; Susanna Crisanti; Jane B. Cummings; Yksi Leonne Cuppen; Simona Cusini;

D

Osvald Da Silva; Björn Dahlström; Linda-Anne D'Anjou; Daum; David design; John Davis; Marij De Brabandere; Beata De Campos; Giovanni De

Filippo; David De Long; Michele De Lucchi; Daniela De Ponti; Matteo De Ponti; Nora De Rudder; Femke De Wild; Alexandra Deblaere; Markus Degerman; Monica Del Torchio; Hallie Delaney; Bas den Herder; Design Flanders; Design Gallery Milano; Christian Deuber; Deutsche Gesellschaft für Kunstoff-Recycling (DKR); Siska Diddens; Dingaling Studio; Tom Dixon; Dögg Design; Draenert Studio GmbH; Driade S.p.A.; Trine Drivsholm; Droog Design; Nathalie du Pasquier; André Dubreuil; Aurore Dubuisson; Sylvain Dubuisson; Nina Due; Duepuntosette-Erreti S.r.l.; Thimo te Duits; Dyson Ltd; James Dyson;

E

E & Y; Stacy Edelstein; édition Fourniture; Edra S.p.A.; Piet Hein Eek; Sigrún Einarsdóttir; El Último Grito; Annabel Elston; Emiliana Design Studio; Annabel Engels; Beatrice Epstein; Thomas Eriksson; Eurolounge; European Ceramic Workcentre (EKWC); Jennifer Evans;

F

Elena Federighi; Rolf Fehlbaum; Beatrice Felis; Roberto Feo; Vittorio Ferro; Francis Fichot; Figgjo A/S; Martin Filler; Fine Factory; Fiskars Brands Finland Oy Ab; Xavier Flavard; Sapia Flavia; Christian Flindt; Jana Flohr; FLOS S.p.A.; Arthur Floss; Jacopo Foggini; Simon Ford; Dominique Forest; Monica Förster; Federica Fratoni; The Frozen Fountain; Johanna Frydman; Doriana Mandrelli Fuksas; Massimiliano Fuksas;

G

Olivier Gagnère; Carmela Galace; Galeria h2o; Galerie Binnen; Galerie Giles Peyroulet & Cie; Galerie kreo; Galerie Maeght; Galerie Neotu; Gallery Mourmans; Paul Galloway; Sergio Gallozzi; Niels Gammelgaard; Martino Gamper; Piero Gandini; Garouste & Bonetti; Kerry Garwood; Roberto Gasparotto; Kristian Gavoille; Amy Gendler; Franklin Getchell; Christian Ghion; Federica Giacchetto; Simona Giacomelli; Anna Gili; David Gill; Ernesto Gismondi; Marco Giuliani; Elisabetta Giuliano; Dianelle Gobbato; Mario Godani; Goods; Eberardo Gortana; Goto; Emilia Gozza; Konstantin Grcic; Theo Gschwind; Rosi Guadagno; Elena Guarnaccia; Dögg Gudmundsdóttir; Guggisberg & Baldwin; Constance Guisset; Martí Guixé; Tinna Gunnarsdóttir; Sigurdur Gústafsson;

H

Alfredo Häberli; Habitat; Hackman; Zaha Hadid; Håg; Annaleena Hakatie; Elisabeth Halvarsson-Stapen; Blair Hance; Ineke Hans; Thomas Happel; Hareide Designmill; Einar Hareide; Pekka Harni; Nathalie Hartjes; Luke Hayes; Thomas Heatherwick; Tom Hedquist; Iacob Heiberg; Kati Heikkilä; Hannes Heimisson; Achim Heine; Amelie Heinsjo; Mendel Heit; Susanne Helgeson; Heller S.r.l.; Kristine Helm; Herzog & de Meuron; Iwona Hetherington; Sheila Hicks; Vesa Hinkola; Páll Hjaltason; Ineke Hoevenaar; Jana Hojsáková; Mark Holmes; Trine Holst; Pernilla Höök; Christina Huemer; Paul Hughes; Rosario Hurtado; Richard Hutten; David Huycke; Niels Hvass; Jatta Hytönen;

I

Idée Co.; Iittala; IKEA; Inflate; Giuseppe Ingallina; Ingo Maurer GmbH; Adalsteinn Ingólfsson; Aleksej Iskos; Anu Iso-Kokkila-Vähänen; Setsu Ito;

J

J. Bolin Design; Lucy James; Daniele Janton; Jouko Järvisalo; Laurent Sully Jaulmes; Georg Jensen;

Ole Jensen; Claes Jernaeus; Marilynn Johnson; Catherine Johnston; Marisa Jones; Sam Jones; Hella Jongerius; Jongeriuslab; Mac Joseph; Patrick Jouin; Marie Laure Jousset; Aurelie Julien; Caroline Jumeau;

K

K8 Industrial Design; Hannu Kähönen; Källemo; Ilkka Kalliomaa; Kartell S.p.A.; Kristian Kastoft; Anouk Kef; Catherine Kenyon; Anja Kjær; Klart A/S; Robert Kloos; Knell; Inga Knölke; Amie Knox; Eero Koivisto; Ruud-Jan Kokke; Pasi Kolhonen; Komplot; Margo Konings; Konstfack; Pekka Korvenmaa; Anu Koskinen; Harri Koskinen; Kosta Boda; Peggy Kovacic; Anne Mette Krabbe; Irene Krarup; Peter Krouwel; Didier and Clémence Krzentowski; Barbro Kulvik; Erik Jan Kwakkel;

L

Joris Laarman; Tabi Lacerda; Beatrice de Lafontaine; Ann Lagergren; Gérard Laizé; Pearl Lam; Lammhults; Danny Lane; Vilhelm Lange Larsen; Clodagh Latimer; Kirsi Lauttia; Ferruccio Laviani; Ldesign; Eric Le Saëc; Sophie Lecorre; Patrizia Ledda; Leica Camera Inc.; Arik Levy; Susan Grant Lewin; Lexon; Claude Lichtenstein; Ligne Roset; Olavi Lindén; Stefan Lindfors; Yrsa Lindstrom; Linja Oy; Sophie Linne; Lester Little; Mats Ljungstrom; Rachel Lloyd; Linda Lloyd-Jones; Josep Lluscà; Donna Loveday; Ross Lovegrove; Lovink Terborg; Luceplan S.p.A.; Erik Lundh; Xavier Lust; Claudio Luti;

M

Chuck Mack; Petr Mader; Françoise Maertens; Magis S.p.A.; John Maguire, with support from the British Council; Laure-Anne Maisse; Dorte Mandrup; Catharina Mannheimer; Cecilie Manz; Marcel Wanders Studio; Javier Mariscal; Ruth Marler; Michael Marriott; Beatriz Mas; Cathrine Maske; Jean Marie Massaud; Materialise.MGX; Audrey Mathieu; Laurence Mauderli; Wolfgang Maurer; Tim McCarthy; Rob McIndoe; Quirine Meij; Marco Melander; Alessandro Mendini; Bart Merkelbach; Kate Messerer; Joaquim Ruiz Millet; Ana Mir; Camilla Moberg; Tobias Møhl; Molteni; Moooi; Angela Moore; Pam Moran; Cassy Morgan; Cédric Morisset; Moroso S.p.A.; Celeste Morozzi; Jasper Morrison; Mosaici; Murray Moss; Gladys Mougin; Ernest Mourmans; Monika Mulder; Muodos Oy; Barbini Murano; Noreen Murphy; Patrick Myles;

N

Neste Oil Oyj; Markus Nevalainen; Marc Newson; Jessica Nicewarner; Nils Holger Moormann; Bruno Ninaber van Eyben; Marie Nodbrink; Nokia; Billy Nolan; Shane Nolan; Aurore Nolf; Anna Nordstedt; Patrick Norguet; Normann Copenhagen; Norway Says; Keith Nowak; NPK; Andreas Nutz; Nuutajarvi; Nya Nordiska Textiles GmbH; Linda Nye;

O

Offecct; Helen O'Gorman; Yoichi Ohira; Fumiko Okudera; Jérôme Olivet; Olivetti; Jean-Luc Olivié; Danek Olsen; One Off Ltd.; Peter Opsvik; Orrefors; Marianne Orstad; Os2 Industridesign; Erla Sólveig Óskarsdóttir; Marina Ostrowski;

P

Pekka Paikkari; Satyendra Pakhalé; Jussi Pallassma; Ingibjörg Pálmadóttir; Alice Panzer; Bernard Paré; Hanna Parodi; Pina Pasquantonio; Pastoe; Stefania Patrini; John Pawson; Jorge

Pensi; Pentagon Design; Mabel Peralta; Eugenio Perazza; Manuel Silva Pereira; Nestor Perkal; James Peto; Anette Pfeifer; Philips Design; Marloes Philipse; Camille Pichon; Andrea Pietrosino; Anka Pietrzyk-Simone; Christophe Pillet; Carlo Pintacuda; POD; Cynthia H. Polsky; Porcelanas Bidaso; Jill Porter; Post Design; Bertjan Pot; James Potsch; Meirion Pritchard; Pro Helvetia, Arts Council of Switzerland; Produzione Privata; Program for Cultural Cooperation between Spain's Ministry of Culture and United States Universities; Marloes Pronk;

R

Outi Raatikainen; RADI DESIGNERS; Paul Rascoe; Prospero Rasulo; Janne Räty; Lone Ravn; Sandra Reek; Tejo Remy; Philipe Ribon; Allen Rice; Heini Riitahuhta; Cilla Robach; Corrine Roberts; Kenton Robertson; Eva Christensen-Røed; Corinna Roesner; Simona Romano; Ron Arad Studio; Ingeborg de Roode; Susan de Roode; Rörstrand; Rikke Rosenberg; Maria Grazia Rosin; Anne Roussel; Rowenta; Royal Copenhagen A/S; Royal Philips Electronics; Royal Tichelaar Makkum; RSVP-Curvet Ambienti S.p.A.; Annette Ruggiero; Nob Ruijgrok; Martín Ruiz de Azúa; Frédéric Ruyant;

S

Rolf Sachs; Marie-Claude Saia; Régis de Saintdo; Timo Salli; Salviati; Eva Sánchez-Cuenca; Denis Santachiara; Laura de Santillana; Irina Sasse; Jukka Savolainen; Katja Sävström; Sawaya & Moroni; William Sawaya; Sylvain Schatton; Nicole Schechter; Heide-Mieke Scherpereel; Anna von Schewen; Sabine Schreiner; Matthijs Schrofer; Monika Schwaiger; Juliet Scott; Martin Scott-Jupp; Fikriye Selen-Okatan; Teemu Seppälä; Alceo Serafini; Héctor Serrano; Jerszy Seymour; Louise Shannon; David Shearer; Steinunn Sigurdardóttir; Earl Singh; Bořek Šípek; Stefán Snæbjörnsson; Snowcrash; Goska Sobkowiak; David Sobotka; Megan Soltysinski; Wieki Somers; Yvonne Sörensen; Yrjö Sotamaa; Ettore Sottsass; Steve Speller; Robert Stadler; Anita Star; Philippe Starck; Startloop A/S; Pierre Staudenmeyer; Adalsteinn Stefansson; Steltman Gallery; Gerrit Steltman; Mattias Stenström; Mrs. David M. Stewart; Stiletto; Josef Strasser; Levi Strauss; Kippy Stroud; Annemieke Strous; Studio Aisslinger; Studio I.T.O. Design; Studio Job; Sauli Suomela; Ilkka Suppanen; Anna Maria Svensson; Swarovski AG; Swatch Ltd.; Dr. Michael Sze; Martin Szekely;

T

Kaarin Taipale; Jussi Takkinen; Blanche Tannery; Ilkka Terho; Theo Theodorou; Mats Theselius; Think; Ólafur Thórdarson; Caroline Thorman; Matteo Thun; Willemijn Tichelaar; Frank Tjepkema; TKO Design; Tommaso Tofanetti; Top-Mouton; Nick Top; Pia Törnell; Frederick Torsteinsen; Spencer Tsai; Kati Tuominen-Niittylä; Marcella Turchetti; 20/21 Gallery; Two Zero C Applied Art Ltd.; Ty Nant; Nynke Tynagel;

U

Takehiko Uemura; Uglycute; Roberta Ugo; Heidi Uppa; Cristiano Urbani;

V

Johan Valcke; Gaetano Valecce; Valvomo Architects; Anne-Sofie van den Born Rehfeld; Suzanna van der Aa; Jauko van Donselaar; Sanne van Engen; Bart Van Leuven; Ab van Overbeeke;

265

Anna Varakas; Rane Vaskivuori; Alexander von Vegesack; Lorena Velasquez-Rietveldt; Venini; Danny Venlet; Johan Verde; Delphine Verplanke; Vessel Gallery; Giorgio Vigna; Valeria Villa; Eva M. Vincent; Vitra AG; Vivid; Vizo; Vogt + Weizenegger; Margriet Vollenberg;

W

Ann Wåhlström; Marcel Wanders; Amelia Webb; Gwen Webber; Daniel Weil; Robert A. Wettstein; When Objects Work; Ania Wiacek; Karin Widnäs; Christopher Wilk; Danica Willi; Jill Wiltse; Nina Witkiewicz;

Y

Woody Yao; Patsy Youngstein; Vanessa Peng-Yu Yuan;

Z

Zerodisegno – Quattrocchio S.r.l.; Emily Ziedman; Daniela Zilocchi; and Stefan Zwicky.

The European Design project was initiated at the Denver Art Museum (DAM) in 2002. I should first like to thank Lewis Sharp and Cindy Ford Abramson, who believed in the importance of this exhibition and publication and who have supported the project from the start. Numerous other individuals at the DAM have also helped to make it a reality, providing invaluable assistance with the research for the exhibition and catalog and with the monumental task of producing such a major publication. They include:

Nerea Aspiazu; Roberta L. Bhasin; Miranda D. Callander; Vivian L. Cassell; Becky Ceravolo; Lucy Clark; Jennifer Darling; Noelle Delage; Aubrey François; Arlene Galchinsky; Lori Iliff; Christina Jackson; Jane Johnson; Donna Kerwin; Samantha Kratzet; Liz Larter; Lisa Levinson; Evan M. Litvin; Anita Lynes; Spice Maybee; Bridget O'Toole; Katharina Papenbrock; Angela Pizzolato; Elizabeth A. Murphy; John Roozen; Lisa Anne Tate; Jason Walton; Jeff Wells; Yone Wells; Liz Westerfield; Margaret Young-Sanchez; and their respective support staff. Special thanks are also due to the Design Council of the Denver Art Museum.

With my move to the Indianapolis Museum of Art (IMA) in 2007, I have had the good fortune of being able to work with another team of extraordinary professionals. Max Anderson has given his full support to the European Design project, and envisioned it not only as a means of launching the Department of Design Arts at the IMA but also as an impetus for rethinking the role of modern design in American museums. Sue Ellen Paxson and the staff at the IMA assumed responsibility for the organization and tour of the exhibition. The following individuals should be noted:

Brittany Blackburn; David Chalfie; Jessica Di Santo; Linda Duke; Fred Duncan; Tad Fruits; Pam Godfrey; Kathryn Haigh; Daniel Incandela; Jack Leicht; David Miller; Ann Munsch; Marsha Oliver; Ruth Roberts; David Russick; Leann Standish; Rob Stein; and their respective support staff. The Design Arts Society of the Indianapolis Museum of Art is also deserving of a special thank you.

One could not have imagined a more creative or supportive partner than Merrell Publishers. They have made the daunting tasks of writing, gathering illustrations, and meeting demanding deadlines a pleasure. Special thanks are due to the following:

Paul Arnot; Nicola Bailey; Claire Chandler; Michelle Draycott; Mark Ralph; Nick Wheldon; and their respective support staff. The support of the invincible Hugh Merrell must also be noted.

Finally, there are a number of special individuals who have been an integral part of European Design over the years; quite simply, this project could not have been completed without their dedication, hard work, and good humor. Catherine McDermott and Penny Sparke at Kingston University in London have been the most extraordinary colleagues, sharing their knowledge and love of contemporary design in helping to shape the exhibition and produce the accompanying catalog. David A. Hanks believed that American museums should be playing an active role in defining modern design and has helped with the organization of the European Design undertaking on a multitude of levels. Julian Honer at Merrell Publishers has been involved with the project almost from its inception and has proved, once again, that the perfect editor is a priceless gift. But it is, perhaps, to my assistants that I owe the greatest thanks; they believed in the vision and made it a reality. At the DAM, there was first Shannon K. Corrigan and then Meredith M. Evans, as well as Laura Rountree Bennison and Robin L. Enstrom. Likewise, my special assistants at the IMA, Claudia Johnson and Myrna Nisenbaum, have proved to be essential in completing the European Design project. To all of these associates, my deepest thanks.

R. Craig Miller
April, 2008

Picture Credits

Åbäke: fig. 44; AFP/AFP/Getty Images: fig. 14; Ole Akhøj: fig. 107; Claudio Amadei: fig. 300; Archive Studio Šípek: figs. 48, 68, 77; Courtesy Archivio Fotografico – La Triennale di Milano: fig. 1; Atelier Satyendra Pakhalé: fig. 99; B&B Italia S.p.A.: figs. 150–53; Rune Baashus: fig. 250; Ivan Baj for Arcade – Italy: fig. 211; © Aldo Ballo: figs. 12, 200; Bär + Knell: fig. 108; BarberOsgerby: fig. 174; Barry Friedman Ltd.: figs. 64–66; Clive Bartlett: fig. 110; Corné Bastiaansen: fig. 282; Frank Bauer/*Icon* magazine (iconeye.com): fig. 30 (top, right); Guido Baviera: fig. 241; Bengtsson Design Ltd.: fig. 123; © John Angelo Benson: figs. 310, 311; Anders Bergman: fig. 164; Bernardaud: fig. 60; Bernhardt Design – Kenton Robertson: fig. 209; Riccardo Bianchi: figs. 199, 296; Louise Billgert: fig. 155; *Blueprint* magazine: fig. 30 (top, left); Isabelle Bonjean/*Wallpaper** magazine: fig. 30 (bottom, left); Ronan and Erwan Bouroullec: figs. 142, 185, 206; Erik Brahl, Brahl Fotografi: figs. 126, 269; David Brook: fig. 147; Daniel Brown: fig. 47; bsmart, Stockholm: fig. 162; Santi Caleca: page 4 (second from left), figs. 101, 121, 223; Santi Caleca and Cappellini S.p.A.: fig. 140; Ashley Cameron: fig. 234; Jerry Camper: fig. 307; Cappellini – Cap Design S.p.A.: figs. 106, 136, 176, 236, 239, 274, 326; François Caterin: fig. 284; Central Press/Getty Images: fig. 9; © Philippe Chancel: fig. 316; China Photos/Getty Images: fig. 32; ClassiCon GmbH: figs. 149, 186, 187; Ian Cook: fig. 212; Creadesign Oy: fig. 251; Daum: figs. 82, 83, 293; Michele De Lucchi: figs. 67, 88; Henri del Olmo and Grégoire Gardette: fig. 165; Dilmos, Milan: fig. 343; Thomas Dix and © Vitra (vitra.com): fig. 191; Draenert Studio GmbH: fig. 57; Driade S.p.A.: page 4 (far left), figs. 23, 49, 51, 52, 291; Droog Design: page 5 (second from left), figs. 37, 253, 256–60, 275, 277, 287, 315; Thomas Duval: fig. 124; Dyson Ltd.: fig. 248; Edra S.p.A.: fig. 137; Marc Eggimann and © Vitra (vitra.com): fig. 333; Curt Ekblom: figs. 75, 146; Annabel Elston: figs. 338, 339; Emiliana Design Studio: fig. 314; Estudio Mariscal: figs. 22, 92, 93, 97, 98; Ramak Fazel: fig. 297; Frans Feijen: fig. 95; Fiskars Brands Finland Oy Ab: fig. 226; FLOS S.p.A.: fig. 178; Courtesy of Ford Motor Company: fig. 7; Michael Förster: fig. 198; Fulvio Fragomeni: fig. 286; Friedman Benda: figs. 103, 118, 192, 194; Bart Gabriel: figs. 301, 302; Egon Gade: fig. 213; Egon Gade and Royal Copenhagen A/S: fig. 215; Galerie kreo: fig. 193; © Galerie Maeght: figs. 55, 58; Galerie Neotu: figs. 56, 73; Morgane Le Gall: page 4 (second from right), figs. 129, 166, 179; Ilvio Gallo: fig. 20; Gareth Gardner: fig. 29; Georg Jensen: fig. 216; Giles Chapman Library: fig. 6; Bob Goedewaagen: fig. 261; Patrick Gries: fig. 271; Dögg Gudmundsdóttir: fig. 304; Léon Gulikers: fig. 72; Walter Gumiero and Magis S.p.A.: figs. 134, 138; Pascal Guyot/AFP/Getty Images: fig. 26; Hans Hansen/Marc Eggimann and © Vitra (vitra.com): figs. 41, 130, 135, 144, 204; Heller Inc.: fig. 207; Poul Ib Henriksen: fig. 172; Wilfried Hockmann: fig. 299; David Huycke: fig. 161; littala: figs. 131, 156–58, 167, 168, 217; Imagekontainer: figs. 312, 313; Courtesy Indianapolis Museum of Art, Photograph by Mike Rippy: fig. 214; Ingo Maurer GmbH: fig. 112; Inter IKEA Systems B.V., used with permission: figs. 225, 238; Laurent Sully Jaulmes: fig. 53; Jongeriuslab: figs. 279, 280, 330; Lennart Kaltea: fig. 263; Kartell S.p.A.: figs. 50, 84, 85, 143, 201–203, 321–24; Christoph Kicherer: fig. 182; Stefan Kirchner: figs. 86, 87, 173; Mitsutaka Kitamura: fig. 317; Florian Kleinefenn: fig. 180;

Magnus Klitten: fig. 148; Knoll, Inc.: fig. 145; Frank Kouws: fig. 273; S. Krier: fig. 232; Ninna Kuismanen: figs. 230, 244; Joris Laarman: fig. 125; Carlo Lavatori: figs. 61, 221, 237; Les Arts Décoratifs Musée des Arts Décoratifs, Paris/Jean Tholance: fig. 63; Lexon: fig. 184; Liu Jin/AFP/Getty Images: fig. 40; Saverio Lombardi Vallauri: fig. 43 (bottom); Anna Lönnerstam: fig. 42; Luke Hayes Photography: figs. 34, 115; Magis S.p.A.: fig. 305; Marc Newson Ltd.: page 4 (far right), figs. 188, 208, 218; Marcel Wanders Studio: figs. 254, 264, 265, 325; Tuomas Marttila: fig. 246; Cathrine Maske: figs. 290, 306; Ian McKinnell: fig. 109; Quirine Meij/Lilian van Stekelenburg: fig. 39; Marco Melander: fig. 219; The Metropolitan Museum of Art/Gift of Geoffrey N. Bradfield, 1986 (1986.398.3) Image © The Metropolitan Museum of Art: fig. 18; The Metropolitan Museum of Art, Promised Gift of Mathew Wolf, Image © The Metropolitan Museum of Art: fig. 16; The Montreal Museum of Fine Arts, Christine Guest: fig. 54; © Angela Moore: jacket/cover, page 11, fig. 336; Jasper Morrison: fig. 25; Moss: fig. 332; The Museum of Modern Art/Licensed by SCALA/Art Resource, NY: figs. 2, 11, 13; António Forjaz Nascimento and Galerie kreo: figs. 255, 281; Chris Niedenthal/Time Life Pictures/Getty Images: fig. 27; Nokia: fig. 249; Normann Copenhagen: fig. 147; OCCHIOMAGICO: page 5 (far left), figs. 229, 240; Offecct: figs. 235, 242; David Oldfield: fig. 262; Norbert Onna: fig. 38; Alessandro Paderni, courtesy Moroso S.p.A.: fig. 318; Alessandro Paderni, Studio Eye S.r.l.: fig. 205; Carlo Paggiarino: fig. 295; Nestor Perkal: fig. 62; Philips de Pury & Company: fig. 116; Philips Design: fig. 183; Simon Phipps: fig. 31; Bertjan Pot: fig. 127; RADI DESIGNERS: figs. 288, 303; Marino Ramazzotti/Zanotta S.p.A.: fig. 10; Christian Richters/*Frame* magazine: fig. 30 (bottom, right); Ron Arad Associates: figs. 104, 114, 119, 120, 195; Rosenthal USA, Ltd.: fig. 5; John Ross: figs. 210, 220, 224, 227; Royal College of Art: fig. 28; Royal Tichelaar Makkum: page 5 (far right), figs. 278, 319, 331, 342; Nob Ruijgrok: figs. 94, 96; Alessandro Russotti: fig. 43 (top); Rolf Sachs: fig. 283; Salviati: fig. 59; Gerrit Schreurs: fig. 160; Gerrit Schreurs, Courtesy NPK Industrial Design: fig. 154; Matthijs Schrofer: fig. 15; Martin Scott-Jupp: page 2, fig. 122; Michael Sieber: fig. 285; Uriel Sinai/Getty Images: fig. 46; Sony Corporation: fig. 4; Sotheby's © 2006: fig. 190; Starck Network: figs. 89, 292; Steve Speller: fig. 36; Strüwing: fig. 3; Studio Makkink & Bey: figs. 327–29; Studio Pointer: figs. 171, 197; Studio Tord Boontje: figs. 334, 335, 337, 340, 341; Andreas Sütterlin and © Vitra (vitra.com): figs. 132, 294; Swatch Ltd.: figs. 21, 252; Paul Tahon: fig. 163; Jussi Takkinen: fig. 170; Luca Tamburlini: fig. 91; Ivan Terestchenko, courtesy Contrast Gallery: page 5 (second from right), fig. 289; Terraillon Corporation: fig. 17; Tjep.: fig. 272; Leo Torri: figs. 69–71, 76, 79–81, 189; Jason Tozer: fig. 245; Yoshikazu Tsuno/AFP/Getty Images: fig. 33; Uglycute: fig. 270; Ugo Camera: fig. 35; Enrico Sua' Ummarino: figs. 113, 117; Urban Hedlund: fig. 243; V&A Images/Victoria and Albert Museum: figs. 8, 19; Tom Vack: figs. 24, 78, 90, 181, 196; Edina van der Wyck: fig. 74; Maarten van Houten: figs. 266–68, 276, 308, 309; Bart Van Leuven: figs. 133, 139, 141; José van Riele: fig. 320; Veretta: fig. 111; Verne: figs. 159, 169, 175; Jim Watson/AFP/Getty Images: fig. 45; Peter Wood: fig. 105; Wright and Brian Franczyk Photography: fig. 102; Nobu Yano: fig. 233; Miro Zagnoli: figs. 100, 177, 228, 231, 247, 298; David Zanardi: fig. 128.

Index

Figures in *italics* refer to illustrations

First published 2009 by Merrell Publishers Limited

81 Southwark Street
London SE1 0HX

merrellpublishers.com

in association with

Denver Art Museum
100 West 14th Avenue Parkway
Denver, CO 80204

denverartmuseum.org

and

Indianapolis Museum of Art
4000 Michigan Road
Indianapolis, IN 46208-3326

imamuseum.org

Published on the occasion of the exhibition
European Design Since 1985: Shaping the New Century
Indianapolis Museum of Art
March 8–June 21, 2009
High Museum of Art, Atlanta
January 23–April 25, 2010

A catalog record for this book is available from the
Library of Congress

British Library Cataloguing-in-Publication data:
Miller, R. Craig
European design since 1985 : shaping the new century
1. Design – Europe – History – 20th century
2. Design – Europe – History – 21st century
I. Title II. Sparke, Penny III. McDermott, Catherine
IV. Denver Art Museum V. Indianapolis Museum of Art
745.4'094

ISBN 978-1-8589-4340-4 (hardcover edition)
ISBN 978-1-8589-4457-9 (softcover edition)

Produced by Merrell Publishers Ltd
Designed by Paul Arnot
Art direction by Nicola Bailey
Copy-edited by Michael Bird
Proof-read by Elizabeth Tatham
Indexed by Vicki Robinson

Printed and bound in China

R. Craig Miller is a curator and design historian. He is currently Curator of Design Arts and Director of Design Initiatives at the Indianapolis Museum of Art and was previously at the Denver Art Museum and the Metropolitan Museum of Art, New York. His many publications include *Modern Design in the Metropolitan Museum of Art, 1890–1990* (1990), *Masterworks: Italian Design, 1960–1994* (1996), and **US***Design 1975–2000* (2001).

Penny Sparke is Pro-Vice-Chancellor of Kingston University, London, where she is also Professor of Design History. She is the author of more than a dozen books on modern and contemporary design, including *A Century of Design: Design Pioneers of the 20th Century* (1998) and *An Introduction to Design and Culture: 1900 to the Present* (2004). She has also curated a number of design-related exhibitions, and has broadcast widely on the subject.

Catherine McDermott is Professor of Curating Design at Kingston University, London, where she is also Course Director of the MA in Curating Contemporary Design, taught in partnership with the Design Museum, London. She has published extensively in the design field, and is the co-author of *Vivienne Westwood: A London Fashion* (2000). She has also curated several exhibitions on contemporary European design.

Jacket/cover
Tord Boontje, *Garland* Hanging Light, 2002 (see fig. 337)

Page 2
Mathias Bengtsson, *03 Slice* Lounge Chair (detail), 1999 (see fig. 122)